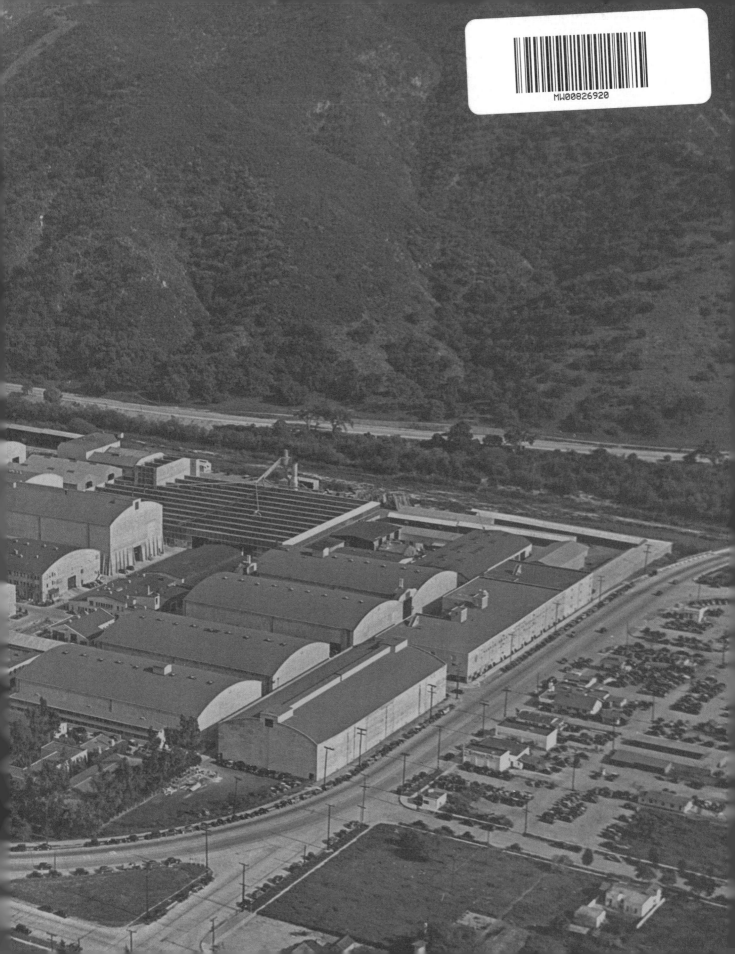

WARNER BROS.

100 YEARS OF STORYTELLING

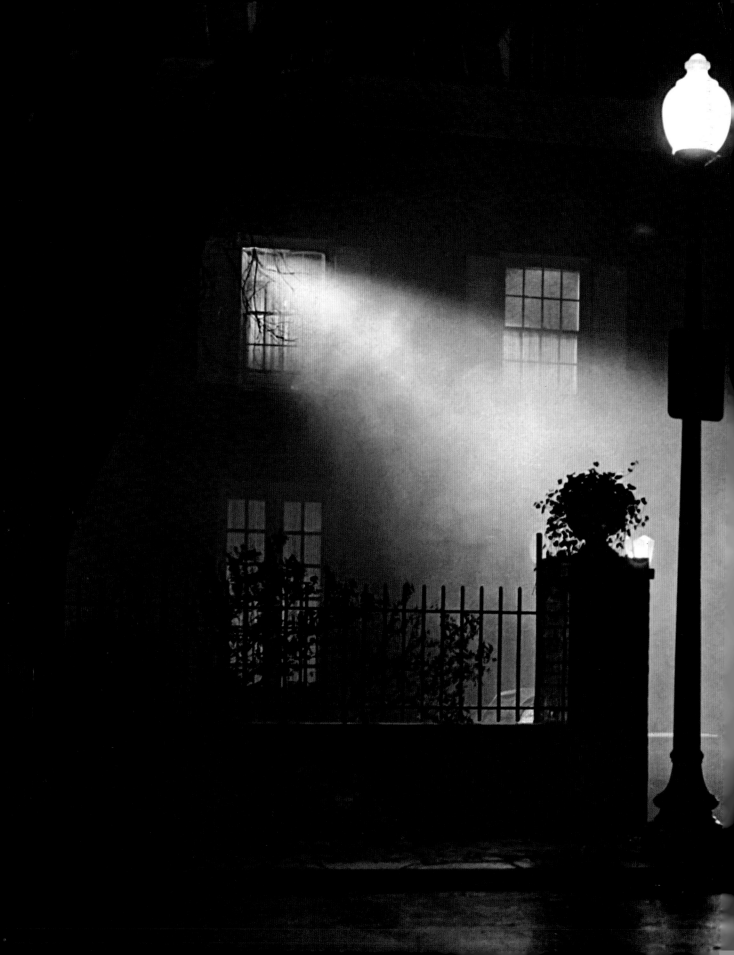

WARNER BROS.

YEARS OF
STORYTELLING

MARK A. VIEIRA

Research Advisors:
ALEXA L. FOREMAN and **SLOAN DE FOREST**

RUNNING PRESS
PHILADELPHIA

TCM TURNER CLASSIC MOVIES

PAGE i: Humphrey Bogart and Ingrid Bergman film *Casablanca* (1942).
PAGE ii: The turning point in William Friedkin's *The Exorcist* (1973).
OPPOSITE: Daniel Radcliffe as Harry Potter in *Harry Potter and the Order of the Phoenix* (2007).

Running Press
Hachette Book Group
1290 Avenue of the Americas, New York, NY 10104
www.runningpress.com
@Running_Press

Printed in China

First Edition: May 2023

Published by Running Press, an imprint of Perseus Books, LLC,
a subsidiary of Hachette Book Group, Inc. The Running Press
name and logo are trademarks of the Hachette Book Group.

The Hachette Speakers Bureau provides a wide range of
authors for speaking events. To find out more, go to
www.hachettespeakersbureau.com or or email
HachetteSpeakers@hbgusa.com.

Running Press books may be purchased in bulk for business,
educational, or promotional use. For more information, please
contact your local bookseller or the Hachette Book Group
Special Markets Department at Special.Markets@hbgusa.com.

The publisher is not responsible for websites (or their content)
that are not owned by the publisher.

This book is published in partnership with Turner Classic Movies, Inc.

Print book cover and interior design by Susan Van Horn.

LCCN: 2022030206

ISBNs: 978-0-7624-8237-5 (hardcover),
978-0-7624-8238-2 (ebook)

RRD-S

10 9 8 7 6 5 4 3 2 1

CONTENTS

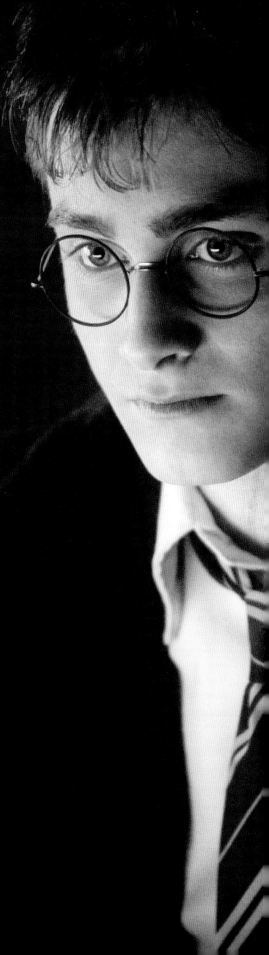

Foreword by Ben Mankiewicz .*vi*

Preface . *1*

Chapter One
THE 1920S: A STEEP CLIMB TO THE TOP 6

Chapter Two
THE 1930S: STRONG WOMEN, TOUGH MEN,
AND THE CHORUS . 30

Chapter Three
THE 1940S: DEFENDING THE COUNTRY
AND THE INDUSTRY . 66

Chapter Four
THE 1950S: GIMMICKS, EPICS, AND DESIRE 104

Chapter Five
THE 1960S: AN ERA FADES 136

Chapter Six
THE 1970S: THE ERA OF THE AUTEUR 168

Chapter Seven
THE 1980S: HIGH CONCEPT, BOTTOM LINE200

Chapter Eight
THE 1990S: MERGING, EMERGING, AND SURGING 236

Chapter Nine
THE 2000S: MEDIA FOR THE MILLENNIUM 270

Chapter Ten
THE 2010S: IT'S A DIGITAL WORLD, AFTER ALL . .300

Chapter Eleven
THE 2020S: STILL WARNER BROS.
AFTER ALL THESE YEARS . 334

Acknowledgments . 346

Selected Bibliography . 347

Index .350

FOREWORD

BY BEN MANKIEWICZ

In the summer of 1988, I spent two weeks in Los Angeles. Somehow, at twenty-one years old, this was only my second visit to L.A. Though I'm a descendent of a Hollywood family, I grew up in Washington, DC, another company town. And my father, Frank Mankiewicz, worked in politics, the business of Washington.

Dad made a conscious decision not to work in the family business. His father, Herman, was for a time one of the highest paid screenwriters in Hollywood and in 1941 wrote the screenplay that defined his career, *Citizen Kane*. Herman's brother Joe was even more successful. At the height of his career in Hollywood, Joe won four Academy Awards in two years (two each for directing and writing) for *A Letter to Three Wives* and his own career-defining film, *All About Eve*. My father's older brother, Don, became a successful screenwriter himself. Somehow, none of that held much appeal to my father, who was drawn to politics and journalism, which is where I presumed my future lay.

Then came that 1988 summer trip to Los Angeles. A cousin of mine invited me to a party. When I was introduced to the host, he registered my name and asked, "Are you a movie Mankiewicz?" When I answered yes, he sort of clicked his heels together, and then, rather unbelievably, bowed his head slightly and said, "Hollywood royalty." I'll never know for sure the impact of that four seconds in my life, but I suspect if it had never happened, I might not be where I am now: twenty years into a career as a host on Turner Classic Movies, working for Warner Bros. Discovery, a company founded by four brothers who define the term "Hollywood royalty."

TCM is the only television network dedicated to showcasing classic films from Hollywood's Golden Age, many of those pictures produced at Warner Bros. MGM may well have been the most prestigious movie

PHOTO BY JOHN NOWAK

studio during the heyday of studio filmmaking, but Warners was doing the most important work. Those four brothers—Harry, Albert, Sam, and Jack—weren't born into Hollywood royalty. As you're about to read, they earned their piece of the throne.

They did by engaging in consistently bold behavior: They bought theaters to present the pictures they produced; they were early investors in sound, recognizing the speed at which the movie business was changing. But their enduring legacy is built of the pictures they produced.

During the early years of the Great Depression, Warner Bros. made *Gold Diggers of 1933*, where Joan Blondell sings a moving ode to World War I veterans, "Remember My Forgotten Man." "Look. See. Don't forget," she cries out in the song. "There are people who

need who need your help. Remember them. In the midst of your own pain, remember them." To many in 1933, suggesting the country wasn't doing enough to provide health care services to veterans was considered unpatriotic. But the Warner brothers were not afraid. Moreover, the film clearly isn't solely discussing veterans. When Blondell sings "in the midst of your own pain," it's an acknowledgement of the shared suffering of tens of millions of Americans, plagued by the economic hardship and uncertainty of the depression.

A year earlier, in 1932, Warner Bros. released *I Am a Fugitive from a Chain Gang*, exposing the barbaric treatment of prisoners in the American South, shackled to each other and forced into back-breaking labor. The last line of the film speaks not merely to prisoners, but every American unsure of where to find their next meal. Paul Muni, a big star playing the fugitive, risks being recaptured to see the woman he loves. As he leaves her and fades into the darkness, she offers him money. He refuses. "But you must, Jim," she says. "How do you live?" "I steal," he says as his face vanishes completely in the blackness of the night in one of the most haunting finishes in cinematic history.

In 1939, Warner Bros. made *Confessions of a Nazi Spy*, the first movie made by a major Hollywood studio to specifically identify the threat Hitler's Germany presented to the world. Warners made it in the face of significant headwinds from the Production Code Administration, the Hollywood censorship board that at the time consistently reflected a world view concerned primarily with coddling the German-American audience at home, and with maintaining a strong foreign market for American films.

Then, in 1942, Warner Bros. took on the Nazis with its biggest star, Humphrey Bogart, in *Casablanca*. In the process, they made the finest studio film to come out of Hollywood's Golden Age.

Over the last 100 years, the WB shield has come to symbolize quality, often with a delightfully subversive edge. Along the way, the studio has produced so many important movies, from the genre-defining gangster films of 1930s to pictures like *Casablanca, Mildred Pierce, The Treasure of the Sierra Madre*, and *A Face in the Crowd,* Elia Kazan's brilliantly prophetic 1957 exposé on the demagogic power of television to dictate politics.

Warner Bros. has made more of my favorite movies than any other studio, many of them coming long after the domination of the studio system in Hollywood ended at the start of the 1960s. In 1967, Warren Beatty and Faye Dunaway starred in *Bonnie and Clyde*, a Depression-era crime drama laced with an anti-establishment 1960s attitude. *The Candidate*, from 1972, featured Robert Redford as an idealistic U.S. Senate candidate forced to abandon his principals to satisfy the needs of a campaign beholden to television and the corrupting influence of money in politics.

In 1976, Warners made *All the President's Men*, still the best newspaper movie ever made, taking us step-by-step through Bob Woodward and Carl Bernstein's reporting as they exposed the criminal behavior of an American president.

Sixteen years later, in 1992, director and star Clint Eastwood breathed life back into the American western with *Unforgiven*. And in 2007, the gripping paranoia of dramatic thrillers from the '70s returned to the screen for modern audiences in *Michael Clayton*, written and directed by Tony Gilroy and starring George Clooney, Tom Wilkinson, and Tilda Swinton.

Turner Classic Movies is proud to continue its association with the company launched by Harry, Albert, Sam, and Jack Warner, now under the banner of Warner Bros. Discovery. We've been working to keep these movies alive and relevant for modern audiences since TCM signed on to the air in 1994.

From *Angels with Dirty Faces* and *Jezebel* to *Harry Potter* and *The Dark Knight*, the movies made by Warner Bros. continue to feel as fresh and vital as they did when they first hit theaters. And I remain an eager movie fan, anxious to see and experience what Warner Bros. has in store for the next 100 years.

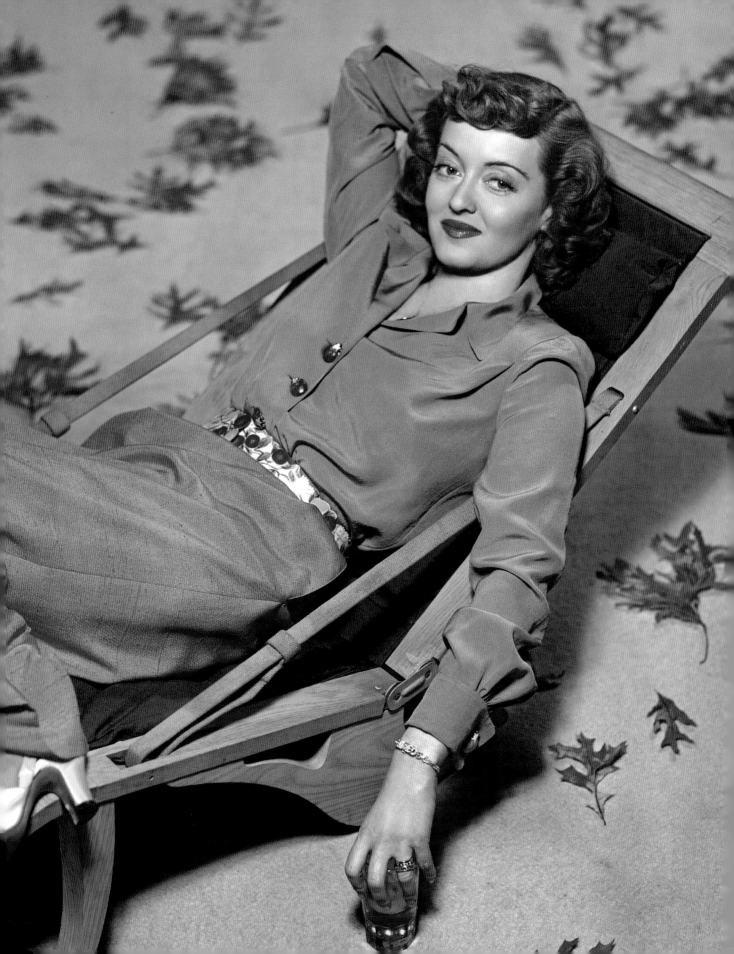

PREFACE

What does Warner Bros. see in the hundred-year road from the shiny white studio on Sunset Boulevard? How does it feel to look back on a century? There's a great deal to see. Four brothers from Ohio started a film company. Their first star was a dog. Their next star was Broadway's greatest actor. They climbed to the top of the industry with the technology of sound, but they lost a brother in the process. They not only survived the Great Depression but also thrived by making musicals such as *Footlight Parade*. Their studio was the home of unique stars: Joan Blondell, James Cagney, Kay Francis, Edward G. Robinson, Bette Davis, Humphrey Bogart, Paul Muni. Theirs was the only studio to blow the whistle on fascism. They boosted morale during World War II with films such as *Casablanca*. In the 1950s, after adapting to 3-D, widescreen, and stereo, Warner Bros. was one of the first Hollywood studios to enter television production.

After the brothers relinquished control of the company, its new owners continued to lead the industry. In the 1970s, it became Warner Communications and encouraged young directors to make *Mean Streets* and *The Exorcist*. In the 1980s the company became a diversified subsidiary and moved into cable television, video games, comic books, and music. Its film output was distinguished, but it learned from the 1989 *Batman* what merchandising could do for a film—and vice versa.

In 1990, Warner Communications merged with Time Inc. to form Time Warner Inc., the largest media and entertainment corporation in the world. Warner Bros. was just one element of Time Warner's portfolio. Warner Bros. studio releases of the '90s included *The Fugitive, Twister* (co-produced with Universal), and *The Matrix*.

Then came the new millennium. How did the old company perform? Thanks to the Harry Potter franchise—one of the new "global entertainment machines"—Warner Bros. did its part to sustain the preeminence of the parent company, while delivering several hits a year with films like *Million Dollar Baby*, the result of a decades-long partnership with Clint Eastwood. Managing the intellectual properties that generate blockbuster franchises, Warner Bros. has topped other studios by earning $1 billion at the domestic box office almost every year since 2000.

Warner Bros. started as a family business. This book could be the family album. When you turn the pages of a family album, you see highlights. You're reminded of times, places, and people. Entries under snapshots take you back to another time. In this book, each chapter opens with a decade-long overview of studio business and industry trends, plus descriptions of important releases; then comes a collection of photos, illuminating highlights year by year. It's a record of extraordinary entertainment history, a panoply of the greatest names, faces, and talents in Hollywood lore. This is an album to peruse, share, and cherish. Films made by Warner Bros., from whatever era, have endeared themselves to the world. It's important to have them bound between the covers of a book so we can see the breadth and depth of the Warner achievement, the Warner artistry, the Warner story—a story that began not in Hollywood, or even in Youngstown, Ohio, but in a ghetto in Eastern Europe.

OPPOSITE: In the twentieth century, Bette Davis was the quintessential Warner Bros. star. Her films were so profitable that she was amusingly credited with building a soundstage. She was with the company for eighteen years, returned several times afterwards, and became its unofficial historian forty years later. For many filmgoers, she was the face of this studio.

The Warner Bros. saga began in 1876 in Krasnosielc, Poland, which was then part of the Russian Empire. This was a community of Jews. They wanted to own property and build businesses. They could do neither. Instead, they were threatened by marauding Cossacks who came on horseback to whip Jewish men and rape their women. In this charged atmosphere, a young man named Benjamin Wonsal fell in love with a girl named Pearl Eichelbaum. They were both nineteen. They married and began a family. A daughter, Cecillia, was born in 1877. A son, Hirsz (later Harry), was born in 1881. Aaron (later Albert or Abe) was born in 1883. Schmul (later Sam) was born in 1886. Reisel (later Rose) was born in 1888. Cecilia died in infancy because medical care was unavailable. Life in Russia was grim.

In January 1888, Benjamin Wonsal said goodbye to his wife and children and sailed for America. Pearl had sewn a gold watch—a family heirloom—into his coat. Once in America, Benjamin changed the family name to Warner.

Benjamin Warner worked in Baltimore as a cobbler until he had enough money to send for Pearl and the children. They sailed for America in late 1889. After the Warner family settled in Baltimore, more children came; there would be twelve in all, although two more died in infancy. When Harry was old enough to cross streets, he sold newspapers to help feed the family.

In 1890 Benjamin moved his family to Bluefield, West Virginia, and opened a general store to sell goods to a railroad construction company. Just as he was getting established, the railroad company was transferred to Roanoke, Virginia. The Warners could not follow this company all over the country, so Benjamin closed his store and took his family to Detroit and then to London, Ontario, where he invested all his capital in a fur venture—and promptly lost it to a swindler. This was in 1892, the year Jacob (later Jack) was born. Benjamin was tough, and he was enterprising, so he collected scrap iron and brass, and he traded with fur trappers.

The family next moved to Lynchburg, Virginia, where Benjamin opened a shoe repair shop. By this time,

Harry was fourteen and aware of the William McKinley presidential campaign. Harry traveled two days in a freight car, sleeping on straw-covered floors, to get to Canton, Ohio, where he planned to offer on-the-spot shoe repair to the crowds who would come for McKinley's speeches. He found no takers, but the steel-factory town of Youngstown, Ohio, looked promising. He found takers there; in fact, they were so receptive that he sent for Benjamin. "Shoes Repaired While You Wait" became the first successful Warner business.

Eighteen-hour days were the norm, and Benjamin's tasks were shared by the growing boys. He reminded his sons to work as a team and to show loyalty and respect for one another. This became a family theme, one that was repeated with each new venture. Unanimity was not a virtue; it was *the* virtue. Quoting the Alexandre Dumas book *The Three Musketeers*, he said, "All for one, one for all." This was the family's guiding principle. As the boys labored with their father, each began to develop his own traits. Albert took charge and managed financial aspects of the business. Harry was adept at persuading and selling. Sam was mechanically minded. Jack was imaginative and loved to get up in front of an audience.

By 1898, the three oldest boys were running a bicycle shop. In a few more years, Sam introduced ice cream cones to Youngstown, while boy soprano Jack sang to audiences at the Dome Theatre. In 1903, the three oldest boys, now young men, hit the road. Harry sold cider vinegar and worked in Kauffman's Department Store in Pittsburgh. Albert sold soap for Swift & Company. Sam became a fireman on the Erie Railroad. Then something happened.

Sam was doing repair work one day when he was asked to look over a shiny, odd-looking box, an Edison Kinetoscope. Once he learned how to operate this "moving-picture projecting machine," he was hooked. Beyond the mechanical interaction of gears and belts, sprockets and cellulose nitrate, there was a mysterious element. Something touched his emotions. He began working as a projectionist for $8 a week. He saw that a film could be purchased with a projector, plus posters

and lantern slides of songs. The film was Edwin S. Porter's *The Great Train Robbery*. Sam was excited. For just $150, he could buy into the movie exhibition business. Benjamin cautioned Sam not to move too fast. Sam brought the machine to the family kitchen and gave a show. The mysterious element affected the family, too. They were enthralled. Then and there, Benjamin decided to underwrite Sam's venture. The next day, Benjamin pawned the family's treasured gold watch.

After a year of barnstorming towns with projector and film, Sam and Albert converted a store in New Castle, Pennsylvania, into a theater. The Cascade had ninety-nine folding chairs, borrowed from a funeral parlor. As usual, the entire family pitched in. Jack sang songs projected onto the screen from lantern slides, while sister Rose played the piano, after first selling out the house at the ticket booth. Albert kept the books. Harry, who was still working in Pittsburgh, ordered films from exchanges, paying $15 a reel, plus a $100 deposit. After a while, it was time to move into film distribution.

Harry's uncle-in-law bought a trunk full of films from New York, and the Warners established a film exchange. A $400 cache of films became the rental library of their exchange, quickly registered as the Duquesne Amusement Supply Co., Inc. Because renting film was as profitable as exhibiting it, the Warners were soon running exchanges in Norfolk, Virginia, and Baltimore. They were beginning to feel prosperous when a bogeyman appeared.

Thomas A. Edison, the nominal inventor of the motion picture camera, formed the Motion Picture Patents Company, and, if a film company insisted on using equipment that had not been patented by Edison's so-called Trust, he enforced his domain by wrecking the equipment and beating the "outlaw" filmmakers. The Trust distributed through a subsidiary, General Film, and it didn't need competition from Duquesne. The Warner boys were threatened, then roughed up. In 1910, they had no choice but to relinquish their license. They briefly tried running an "independent" exchange,

but that fooled no one. They had been chased out of the moving-picture business.

The brothers licked their wounds and surveyed the landscape. Carl Laemmle was gathering support for his Independent Moving Picture Company (IMP), which sought to challenge the Trust. By 1912 IMP had taken its case to the Supreme Court, and it looked as if the Edison Trust would be ruled illegal. The Warner boys saw their opening. In August 1912 they put capital into a new venture—the Warner's Feature Play Company—collaborating with freelance filmmakers in St. Louis to make their own film, a two-reeler (roughly twenty minutes) called *Peril of the Plains*. It was no masterpiece. A second film was no better. They couldn't sell these unpolished efforts, and they couldn't distribute them. But Harry had a plan.

After opening exchanges in San Francisco and Los Angeles, the brothers distributed their films and numerous others. They had a going concern, and soon they had $15,000 put aside, enough capital to make another film. Harry hired a distinguished British director to shoot a film in Santa Paula, sixty miles north of Los Angeles. After hearing nothing from the director for weeks, Harry went there to investigate. The self-described artist had spent the money on a fine car and was ardently wooing the heroine of the film. Harry went to the laboratory, confiscated the film, and released it—to great indifference. The brothers had to start over again.

Distributing films kept the business going, especially if the film was topical. In 1916, *War Brides* starred the stage star Alla Nazimova in a blood-and-thunder melodrama about the war that was being fought in Europe. The Warners paid $50,000 for the right to distribute the film in Nevada, Arizona, and California, and they made a substantial profit. Their next release was eclipsed by the news that America had entered the European war, another apparent setback. Jack Warner was glumly walking down the street after a fruitless meeting at the Alexandria Hotel in Los Angeles when he

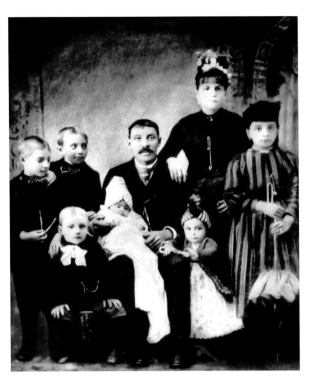

FROM LEFT: This portrait of the Warner family was made in 1891, a year before Jacob (Jack) was born. Seen here are: back row (from left), Abe, Harry, Benjamin, Pearl, and Annie; front row (from left), Sam, Fannie, and Rose. • This is the film that, in 1918, gave the struggling Warner company the boost it needed to continue in the film industry.

AN AUTHORIZED
FILM VERSION OF

MY FOUR YEARS
IN
GERMANY
BY AMBASSADOR
JAMES W. GERARD

Adapted for the screen by
CHARLES A. LOGUE
Directed by
WILLIAM NIGH

saw a poster for a sensational new book, *My Four Years in Germany* by Ambassador James W. Gerard. Something clicked.

The brothers sent Harry to persuade the ambassador to sell him the literary rights. Gerard had received offers from Lewis J. Selznick (producer of *War Brides*), but he decided to go with William Fox, the bigger company. Still, he agreed to meet with Harry. The earnest young man looked the statesman in the eye and claimed to have capital and a studio. Gerard signed the contract, not knowing that the brothers had neither.

Harry knew a financier who was willing to put up $50,000 for 54 percent. *My Four Years in Germany* was then directed by the established filmmaker William Nigh at a rented space in the Bronx Biograph Studio; scenes of outdoor atrocities committed by the "Huns" of the story

were filmed at a rural property in Grantwood, New Jersey, lent to the brothers by the Hearst journalist Arthur Brisbane. To add impact, newsreel footage was cut into the film and scenes were shot for transitions. This was not a tabloid version of Gerard's book. The treatment was restrained, tasteful, and propagandistic. The premiere of *My Four Years in Germany* took place in New York on March 10, 1918, and the film received a standing ovation. First National distributed it, and it grossed $800,000. Of course, after paying the ambassador, the financier, and the distributor, the brothers didn't have much left, but it was enough for their next step.

The Warners' first Los Angeles studio was a space leased from LKO Comedies at Sunset Boulevard and El Centro Avenue in Hollywood. The brothers next leased space in David Horsley's Bostock Jungle and Film Com-

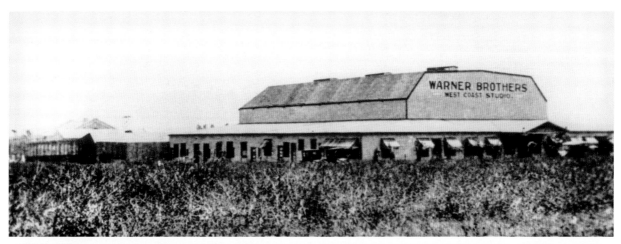

FROM TOP: A ten-acre lot on Sunset Boulevard was the site of the Warners' first real studio. • As 1919 ended, the company name was still spelled "Warner Brothers."

pany, a lot located at 1919 South Main Street in Downtown Los Angeles. They filmed mostly comedy shorts and serials, using Horsley's animals to menace their heroes and heroines. The Warners next rented space in a Culver City studio at Ince and Washington Boulevards called the Romayne Superfilm Company. Jack called it "a dump." Their next move was to the William Horsley Studios at 6050 Sunset Boulevard, the stretch of Sunset called "Poverty Row" because of its numerous fly-by-night companies. Accordingly, the Warners' next move was lateral, to a small outfit on Sunset called the Gordon Street Studio. They made only a few features, and their exchanges were making only a little money. How could they leave Poverty Row?

Harry, Albert, Sam, and Jack were enthusiastic. They enjoyed dreaming up situations and then filming them. Their energy impressed a number of bankers and landlords. William Beesemeyer owned ten acres, including a barnlike building, at Sunset and Bronson. In 1920, he agreed to sell his lot to the brothers for $25,000, nothing down, and $1,500 a month. He was a kind, patient man, because some months he saw Sam arrive empty-handed. But Beesemeyer had faith in the brothers, as did their parents and wives. The Warner brothers had tenacity, resourcefulness, and, most importantly, unanimity. It was only a matter of time before they found the formula for Hollywood success.

THE 1920s:

A STEEP CLIMB TO THE TOP

THE 1920S WOULD BE AN AUSPICIOUS DECADE FOR THE WARNER BROTHERS, BUT IT began quietly. The brothers—Harry, Albert, Sam, and Jack—were making a modest living at their property on Sunset Boulevard. Their sole output in 1920 was a serial populated by circus animals and directed by Jack and Sam. After being bitten by a chimpanzee, Jack gave up directing, especially as the serial failed at the box office.

In 1921, Harry Rapf, formerly a producer at the Lewis J. Selznick company in New York, helped streamline production and prepare scenarios for the sixteen Warner films released that year. The last was an evocation of small-town life called *School Days*, and its star, a freckle-faced youth named Wesley Barry, caught on with the public. There was income, and there was momentum. There was also luck, in the person of a venture capitalist named Motley Flint, whose faith in the brothers led

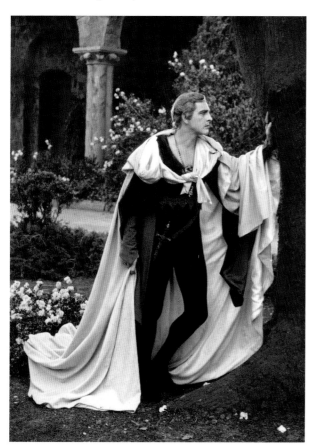

John Barrymore was Warner Bros.' most prestigious star of the 1920s.

to substantial loans from Waddell Catchings, a prominent financier. Thus the brothers were able to embellish their property with "dark" stages, which were better for filming larger scenes than the existing glass-roofed stages. They could also afford a stately façade fronting Sunset. It had more white columns than the Goldwyn and Ince studios combined, which mattered in Hollywood.

The brothers were ready for an important step.

On April 4, 1923, their company was incorporated and "Warner Bros." became its official name. Uses of "Warner Brothers" would be phased out by decade's end. The spelling had changed, but the unanimity continued.

The good luck also continued with the arrival of their first star, one they could depend on for genuine appeal, consistent performances, and cooperation. His name was Rin-Tin-Tin, and he was a German shepherd who had been found as a newborn pup in a World War I trench.

The brothers had barely released their fourteen films of 1923 when they lost Harry Rapf to Louis B. Mayer Productions, a small studio in North Los Angeles. Before the brothers could advertise for a replacement, in walked a short, skinny, bucktoothed kid. He claimed to have published a novel, and, sure enough, he had; he was carrying a copy. He wanted to write for Warner Bros.! Before he could complete his pitch, Darryl F. Zanuck was hired as a screenwriter. A human dynamo, Zanuck turned out several scripts in the time most writers took to write one. He made Rin-Tin-Tin a star. His influence on Warner Bros. cannot be overstated. As a writer, assistant producer, and eventually head of production, he created a style that synthesized the four brothers' personalities. Warner films would be fast-paced,

respectful of tradition, eager for innovation, impatient with injustice, and hopeful of just rewards. When a young publicist named Hal Wallis came looking for a job, Jack Warner found in him the complement to Zanuck, a cool, precise, deliberate executive. Wallis would distill the Warner essence into quality projects.

The brothers had a corporation, a fine producing and writing staff, a new plant, and projects in the works. What they lacked was distribution. First National had theaters and film exchanges, and the new Metro-Goldwyn had Marcus Loew's theaters and Louis B. Mayer's distribution. Adolph Zukor, the cold-blooded Napoleon of the movies, made films at his Lasky Studios, distributed them through his Paramount exchanges, and played them in his Paramount theaters. This was vertical integration, the business model to which all companies aspired. Zanuck, Wallis, and Jack Warner recalled how Zukor had gotten there—by bringing Sarah Bernhardt, a theatrical legend, to star in a film.

John Barrymore was known as America's greatest living actor. His 1922 production of *Hamlet* had introduced a bold new interpretation of Shakespeare. To have a star like that would lift Warner Bros. to the level of the "major" studios. Jack Warner went to New York to offer Barrymore a one-picture deal. The amount was never revealed, but it must have been substantial, because a later contract called for $76,000 per film. The Warners got their money's worth; with 1924's *Beau Brummel*, Barrymore became the newest screen sensation, a forty-two-year-old matinee idol who displaced Rudolph Valentino. With no less fanfare, the Warners hired a star director from Germany. Ernst Lubitsch was the wild and witty filmmaker whose name on the marquee was as much a guarantee of quality to audiences of the day as D. W. Griffith, Cecil B. DeMille, or Erich von Stroheim.

Even with artists like Barrymore and Lubitsch, Warner Bros. was handicapped—by lack of theaters, lack of exchanges, and lack of liquidity. What was there to do but borrow more money? Harry Warner got another

loan and in April 1925 bought Vitagraph, which had more than fifty exchanges, plus studios in East Hollywood and New York. The Barrymore films continued to make money, so Sam Warner began researching the possibility of sound films. A demonstration by Western Electric and Bell Laboratories of their synchronized film and sound-on-disc technology had convinced Sam of its potential, but persuading his brothers to invest proved more challenging.

The idea of watching a film in a picture palace in which actors spoke was so alien that it was derided by film folk and film fans alike.

The idea of watching a film in a picture palace in which actors spoke was so alien that it was derided by film folk and film fans alike. The picture palace had a churchlike atmosphere, with fluted columns and organ music. For actors to speak out loud would be profane. However, films of orchestras playing classical music would be not only edifying but also economical, explained Sam. The orchestra would not have to be paid for each performance, something that Harry in particular found appealing. Despite the brothers' reservations, Sam persuaded them to license the technology, and a partnership was announced in April 1926.

"Vitaphone"—so named by the Warners to build on their acquisition of the Vitagraph company the year prior—was presented to the public in August, and not only with short subjects of musical performances. It was used in a feature film, *Don Juan*, to provide musical accompaniment (by the New York Philharmonic)—and sound effects. Sam was anxious to have his pet project accepted, and it was. Only a few theaters were "wired for sound"— with Vitaphone projection equipment in the booth and loudspeakers hidden behind a perforated movie screen— but *Don Juan* grossed nearly $2 million. Still, a talking film was not inevitable; there was resistance to it in the indus-

try, and Warner Bros. was considered a second-string company, far beneath Paramount, William Fox, and Metro-Goldwyn-Mayer (M-G-M). Stung by industry condescension, Sam Warner was determined to innovate a true talking picture. He endured worsening headaches and sinus problems as he pushed himself to oversee the development of Vitaphone; he had learned that William Fox was developing a rival sound process, Movietone. (Whereas Vitaphone recorded sound on an accompanying sixteen-inch disc, Movietone used patterns of light and dark in a track on the edge of the film strip itself.)

The brothers discussed the subject of their first talking film. Samson Raphaelson's play *The Jazz Singer* was a plea for religious and racial tolerance. A cantor's son must decide whether to follow in his father's footsteps or to become an entertainer. Harry Warner bought the rights and contracted with George Jessel, the star of the play, to repeat his performance on film. When signing, Jessel failed to comprehend that the contract was for a talking film. When he realized this, he asked for more money. Jack Warner stepped in and refused to give Jessel a letter of intent for the increase—or any cash up front. Jessel pointed out that two Warner checks had recently bounced. The conversation came to a halt. Was it true? Was the company in trouble? Sam had spent several million on Vitaphone, and a number of theaters were still rejecting Warner Bros.' product, so there may have been a cash flow problem.

Jack Warner turned to Eddie Cantor, but the stage star had heard the talk and politely declined. That left Al Jolson, who billed himself as the "World's Greatest Entertainer." He could certainly give a great performance, and he would certainly charge more than Jessel. The project was vital to the company. Jolson was signed.

As Sam learned in the summer of 1927, making the first sound film was difficult—for the director, actors, crew, everyone—even though the talking sequences were limited to six songs. There was no precedent for what was needed to synchronize image and sound. The whirring camera had to be encased in a soundproof booth. There was almost no air in it, so long takes caused the camera operator to grow faint from heat and lack of oxygen. *The Jazz Singer* had to be completed for its scheduled October 6 premiere. Sam Warner continued to suffer headaches. When they became too severe, he was hospitalized. Doctors diagnosed a mastoid infection. This need not be fatal, but his weakened condition led to complications. On October 5, 1927, Sam died at the age of forty.

The family was devastated, but even with the impending premiere, they had to observe Jewish law and conduct the funeral within two days. It would be impossible to reach New York in less than a week. They would miss the premiere of the film to which Sam had given the last years of his life. No family member attended the event.

The sensation of synchronized dialogue startled viewers— then had them begging for more.

The premiere of *The Jazz Singer* took place as promised at the Warner flagship theater in Manhattan. The first-night audience was accustomed to musical performances in Vitaphone shorts, but they were unprepared for the visceral impact of the short, ad-libbed speech Jolson made during a song. Against his better judgment, Sam Warner had allowed the film editor to retain a short section in which Al Jolson has an animated conversation with Eugenie Besserer. There were gasps, then shouts, then a standing ovation. The sensation of synchronized dialogue startled viewers—then had them begging for more. A technical effect had short-circuited an audience's emotions.

Of twenty thousand theaters in America, fewer than four hundred were equipped for Vitaphone, yet *The Jazz Singer* quickly became the most profitable film that Warner Bros. had ever made, though it was soon overtaken by its follow-up, *The Singing Fool*. The first two all-talking Warner films, *Lights of New York*

and *The Terror*, were also monstrously profitable. Their revenues allowed Harry Warner to purchase the Stanley Theatre Chain as well as a majority stake in First National. Over the next few years, the studio bought music publishing firms Harms Inc., M. Witmark & Sons, and Remick Music Corp., creating the Music Publishers Holding Company. The resulting control of music by George Gershwin and other hitmakers assured Warner Bros. of a yearly million in profits.

There was still much to be done. Existing dark stages had to be soundproofed, and newfangled "sound stages" had to be built on three lots: Sunset, Vitagraph, and Burbank (First National). As other studios followed suit, it became obvious that Warner Bros. was no longer a second-string company. Sam Warner's tenacity, the faith of the brothers in the project, and the talents of many artists and technicians had pushed Warner Bros. to the top of the heap. Indeed, the company from nowhere had released 269 features since its inception. In 1929 the formerly cash-poor Warner Bros. company would report a profit of $17 million.

Hollywood was in turmoil through 1928 and much of 1929 as production facilities adapted to new technology. As each talking film was released, it appeared to be more successful than the last one, and the public's appetite for sound films—no matter what the theme—was insatiable. Just as the studios were tallying their highest grosses ever, something utterly unexpected occurred. On October 24, 1929, the New York Stock Exchange trembled, swayed, and crashed. In a week, $3 billion of real and imagined wealth evaporated. At first there was no appreciable effect at the box office. By the end of the year, though, banks began to fail. Warner Bros. had survived a decade. Other film folk felt that they were staring into an abyss. The three surviving brothers kept their own counsel and pressed on.

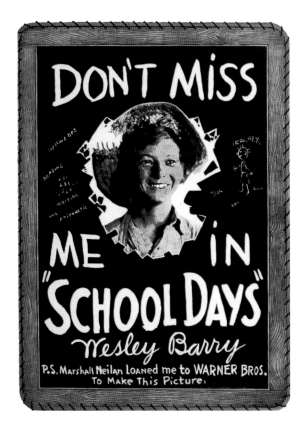

LEFT: With worldwide rentals of $578,000, William Nigh's *School Days* (1921) was the turning point for the struggling Warner brothers' company.
OPPOSITE, CLOCKWISE FROM TOP: In 1922, the brothers began upgrades to the Sunset Boulevard property, adding stages and this office facility. • The first post-incorporation Warner Bros. release, starring Alan Hale and Louise Fazenda, was Harry Beaumont's *Main Street* (1923). • On April 4, 1923, the company became Warner Bros., Incorporated. This event merited a front-page article in *Film Daily*.

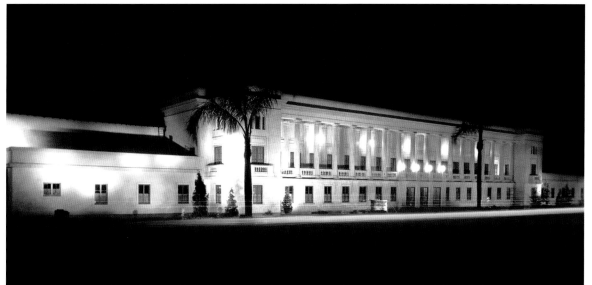

A $50,000,000 Unit

Warner Bros. Form Highly Capitalized Company for Expansion—$4,000,000 for Production

(Special to THE FILM DAILY)

Dover, Del.—Warner Bros. have formed a $50,000,000 company under the laws of the State of Delaware. The incorporation provides for the issuance of 500 shares of stock without nominal or par value.

Warner Bros. have in the past few weeks formed three distinct corporations. One of these has been organized under California laws as a holding company for various studio properties and other real estate. A second, with only a nominal capitalization has been incorporated in New York to control the company's activities in this State, but the Delaware company, which incidentally represents one of the most highly capitalized units in the motion picture business, will act as the holding company for all of the Warner enterprises.

While no one at the Warner office yesterday could be reached to comment on the flotation of the huge company, it is understood that production plans for next year and a general program of expansion have brought about the necessity of additional financing. The Warners plan 18 pictures to be released within a year. In that number, as noted, there will be two with John Barrymore, one with Lenore Ulric and one with Hope Hampton.

Is Your Wedding Ring~

WARNER BROS
Classic of the Screen

BRASS

O

From the book by
CHARLES G. NORRIS

Directed by
SIDNEY FRANKLIN

Scenario by
JULIEN JOSEPHSON

Produced by
HARRY RAPF

A Story of Marriage and Divorce

The Cast
MONTE BLUE
MARIE PREVOST
FRANK KEENAN
IRENE RICH
HARRY MEYERS
MISS DUPONT
PAT O'MALLEY
HELEN FERGUSON
MARGARET SEDDEN

FROM TOP: The so-called woman's problem film was already a Warner staple in 1923. • Norma Shearer (left) was borrowed from little Louis B. Mayer Productions on Mission Road to act in *Lucretia Lombard* with Irene Rich.
OPPOSITE: Rin-Tin-Tin made his debut in Chester Franklin's *Where the North Begins* (1923), and the studio gained its first star. Rin-Tin-Tin had his own personal scenarist in Darryl F. Zanuck, seen here at left with Jack L. Warner. Working with production head Hal Wallis, these men shaped the Warner Bros. style.

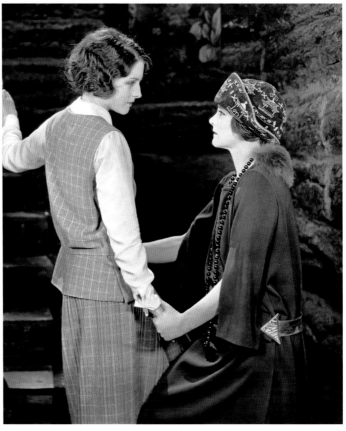

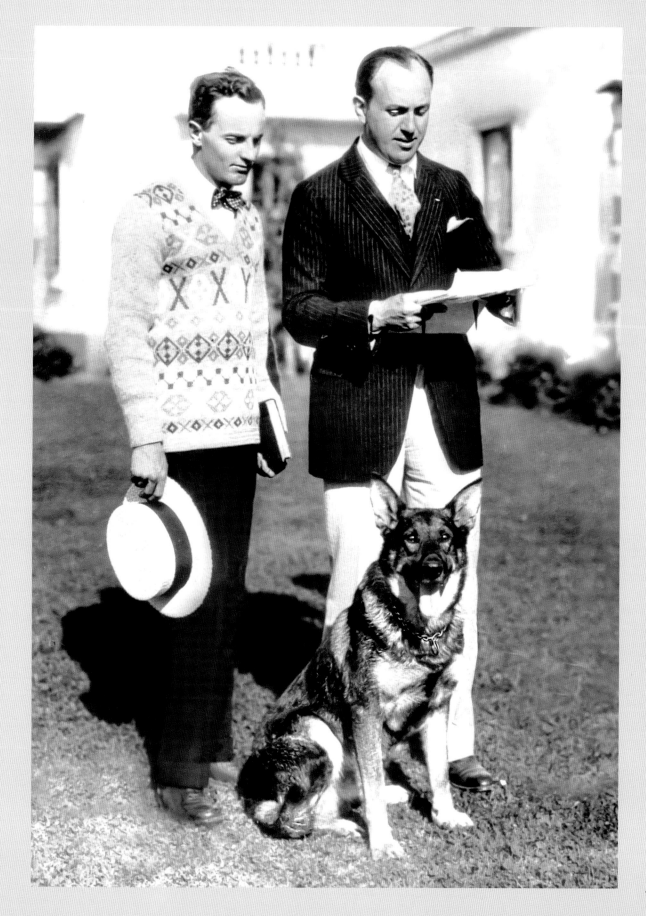

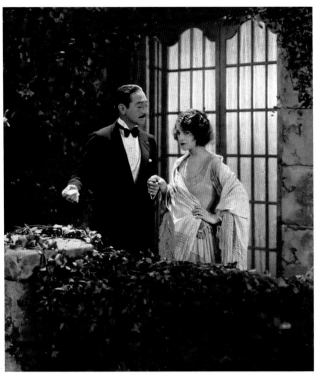

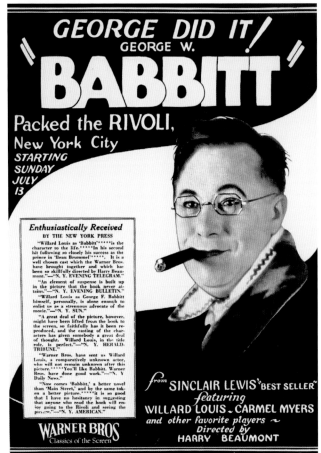

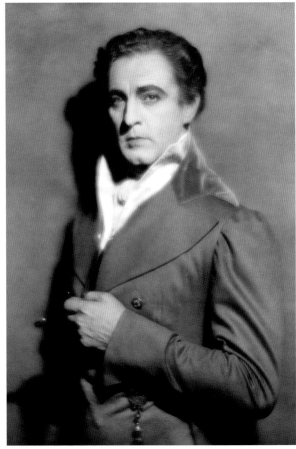

CLOCKWISE FROM TOP: Adolphe Menjou and Norma Shearer acted in Monta Bell's *Broadway After Dark*, after which Shearer joined the newly merged Metro-Goldwyn studio; later Metro-Goldwyn-Mayer (M-G-M). • "America's Greatest Actor," John Barrymore was an eminent presence in Harry Beaumont's *Beau Brummel* (1924). • Willard Louis played the eponymous Middle American in Harry Beaumont's *Babbitt* (1924).

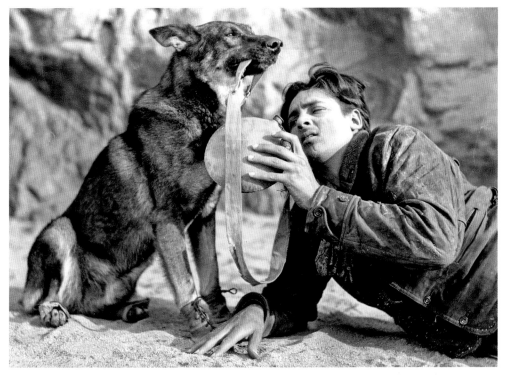

FROM TOP:
Rin-Tin-Tin
succors a thirsty
Charles Farrell
in Noel M.
Smith's *Clash
of the Wolves*
(1925). • Ernst
Lubitsch made
a hit of *Lady
Windermere's
Fan* (1925),
starring Ronald
Colman and
Irene Rich.

FROM TOP:
Regional audiences weren't interested in decadent Europeans, but they loved films like Erle C. Kenton's *Red Hot Tires* (1925), starring Patsy Ruth Miller and Monte Blue.
• In 1925, Warner Bros. bought the Vitagraph Company, whose assets included this twenty-acre studio at 4151 Prospect Avenue in East Hollywood.

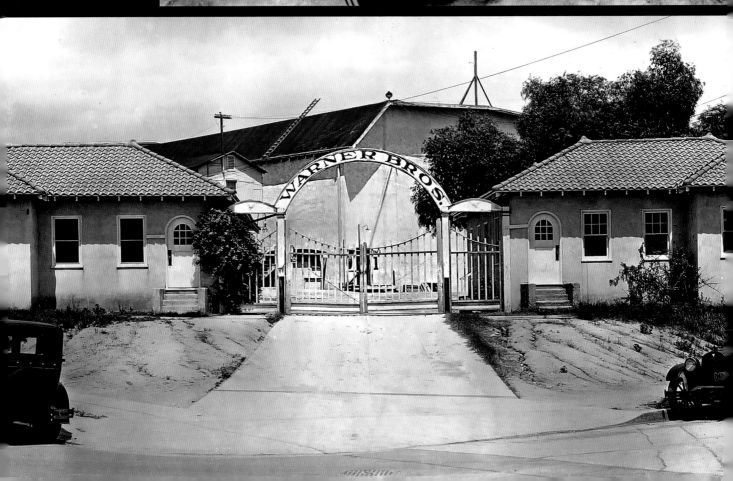

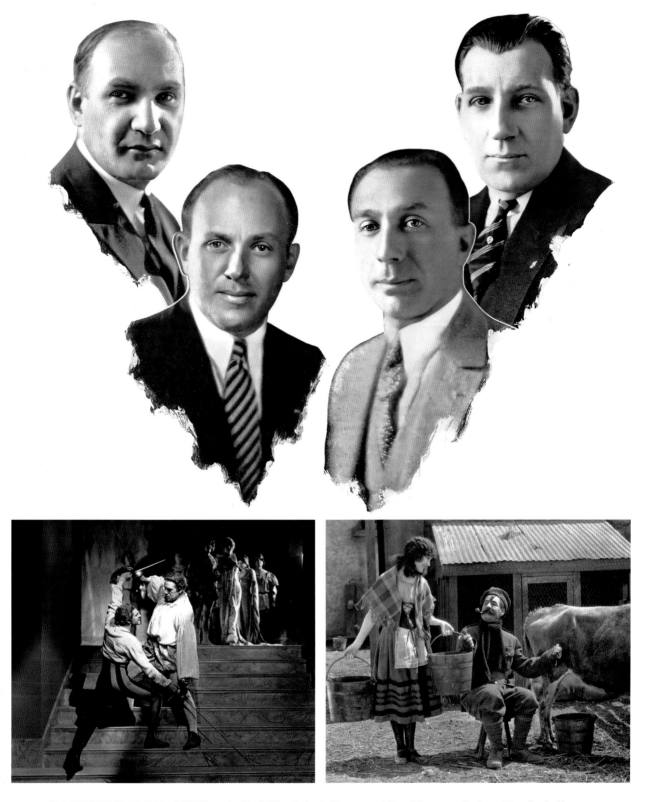

CLOCKWISE FROM TOP: A 1926 portrait of Albert, Jack, Harry, and Sam Warner. • Sydney Chaplin, half-brother of Charles Chaplin, starred in Charles Reisner's *The Better 'Ole* (1926). • When Barrymore crossed swords with Montagu Love in *Don Juan* (1926), audiences heard the clash of metal and a symphony orchestra accompanying it. This was Vitaphone.

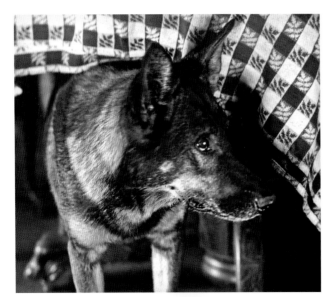

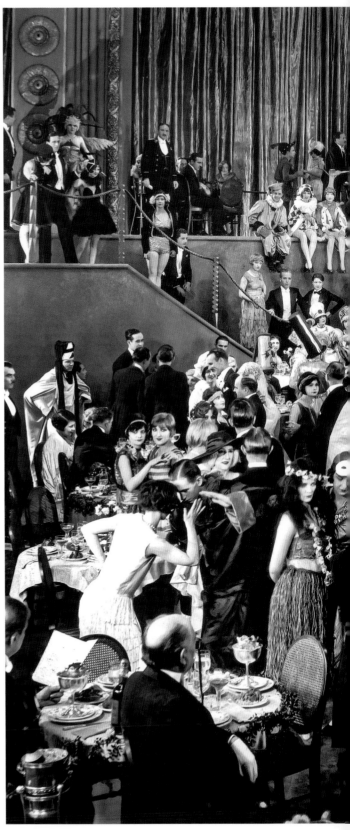

FROM TOP: Rin-Tin-Tin in Herman C. Raymaker's *The Night Cry* (1926). • Sam Baker played Queequeg, and John Barrymore played Ahab in Millard Webb's *The Sea Beast*, an adaptation of *Moby-Dick* and Warner's top grosser of 1926.
OPPOSITE: There was Gallic exuberance in Ernst Lubitsch's *So This Is Paris* (1926).

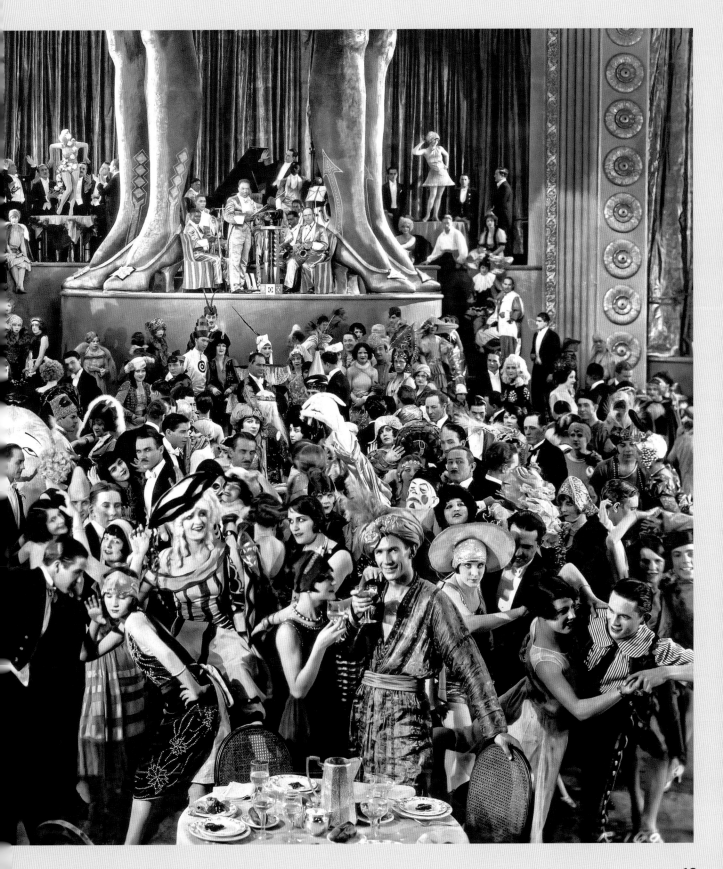

Jack Warner visits the set of *When a Man Loves*, directed by Alan Crosland (far right). The title was an inside joke in 1927. John Barrymore was infatuated with his leading lady, Dolores Costello.

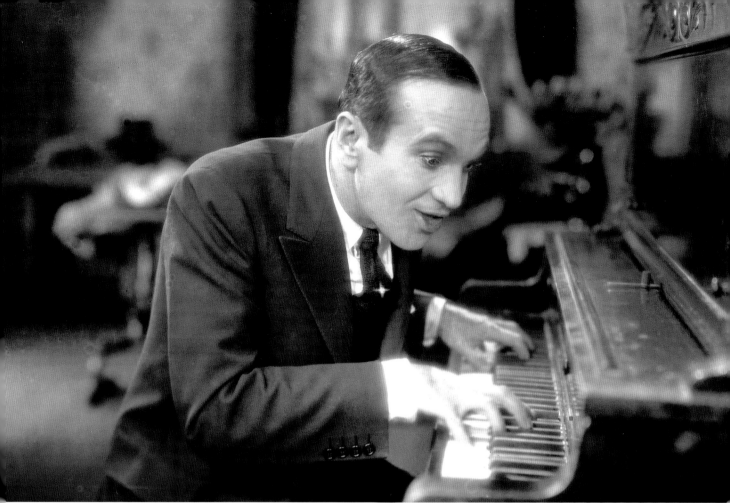

FROM TOP: Al Jolson signed on to Sam Warner's pet project, hoping the American public would respond to a feature with a few songs in Vitaphone. • This scene featuring Eugenie Besserer and Al Jolson in Alan Crosland's *The Jazz Singer* electrified unsuspecting audiences in 1927.

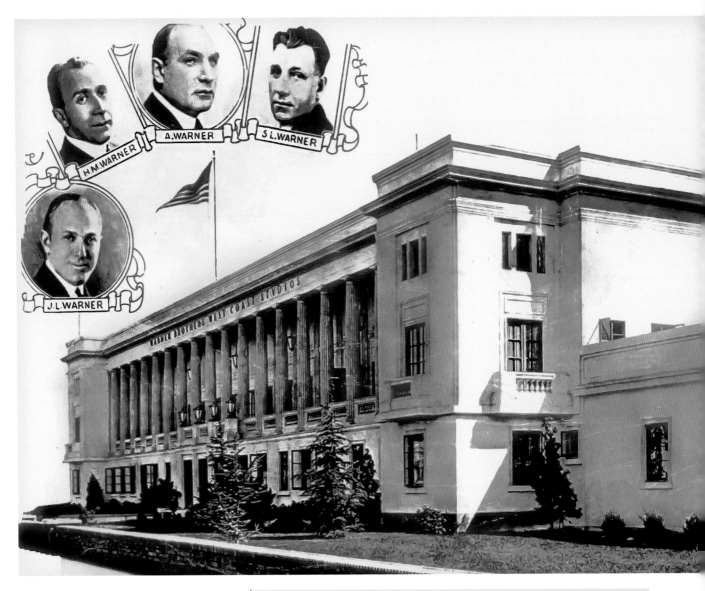

Triumph was built on tragedy in 1927 as one of the Warner brothers died.

1927–1928 ACADEMY AWARDS

WINS
Special Award:
- ★ Warner Bros., for producing *The Jazz Singer*, the pioneer outstanding talking picture, which has revolutionized the industry

NOMINATIONS
Actor:
- Richard Barthelmess in *The Noose* and *The Patent Leather Kid*

Writing (Adaptation):
- *Glorious Betsy*, Anthony Coldeway
- *The Jazz Singer*, Alfred Cohn

Writing (Title Writing):
- *The Private Life of Helen of Troy*, Gerald Duffy

Engineering Effects:
- Ralph Hammeras
- Nugent Slaughter

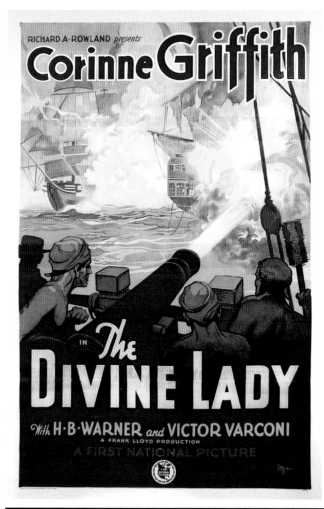

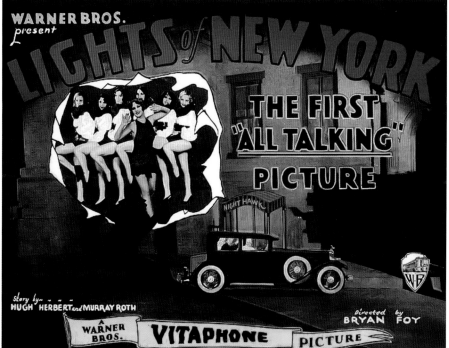

CLOCKWISE FROM TOP LEFT:
Frank Lloyd's *The Divine Lady* had a musical score, sound effects, and singing, but no spoken dialogue, typical of the 1928 transition to sound films. • Dolores Costello (aka Mrs. John Barrymore) starred in Alan Crosland's part-talking Napoleonic romance, *Glorious Betsy* (1928). • Bryan Foy's film *Lights of New York* (1928), the first all-talking feature, made an impressive $1.2 million.

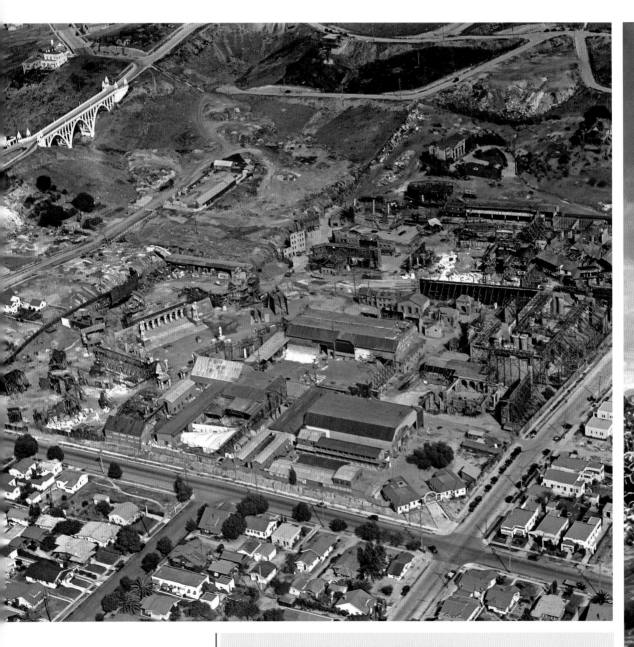

1928–1929 ACADEMY AWARDS

WINS

Directing:

★ Frank Lloyd for *The Divine Lady*

NOMINATIONS

Directing:

• Frank Lloyd for *Drag* and *Weary River*

Actress:

• Betty Compson in *The Barker*
• Corinne Griffith in *The Divine Lady*

Cinematography:

• *The Divine Lady*, John Seitz

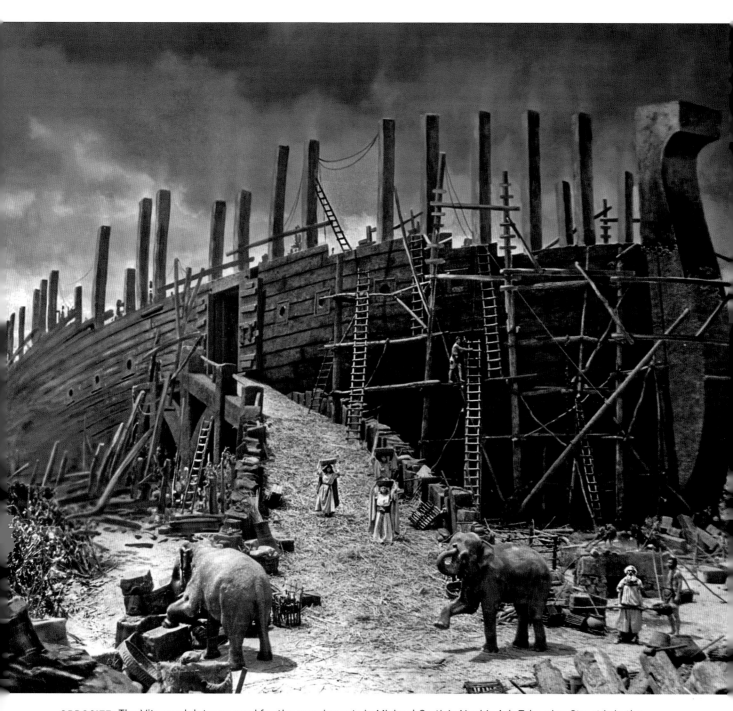

OPPOSITE: The Vitagraph lot was used for the massive sets in Michael Curtiz's *Noah's Ark*. Talmadge Street is in the foreground, with Prospect crossing it. The temple sets are at center, and the familiar Shakespeare Bridge is at upper left. **ABOVE:** This scene was filmed at the Vitagraph lot, but the Los Feliz neighborhood is not visible because a painted "glass shot" was used to superimpose Noah's landscape on top of the Franklin Hills.

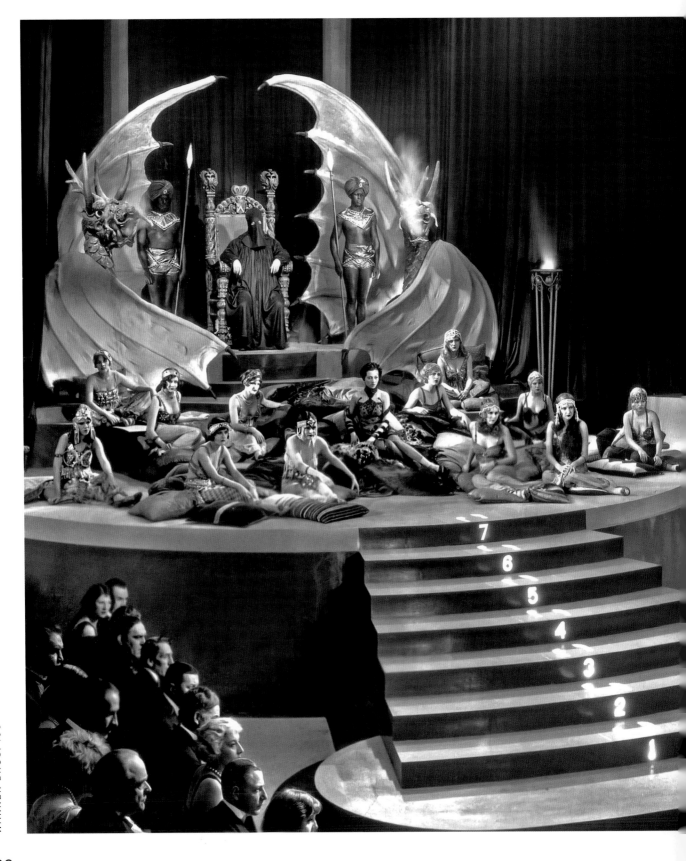

FROM TOP: Ethel Waters sang "Am I Blue?" in the first all-talking, all-color musical, Alan Crosland's *On with the Show!* (1929). • Colleen Moore, not Louise Brooks, introduced the shingle cut; here is Colleen in William A. Seiter's *Synthetic Sin* (1929). **OPPOSITE:** Benjamin Christensen's *Seven Footprints to Satan* (1929) was a wacky exercise in horror.

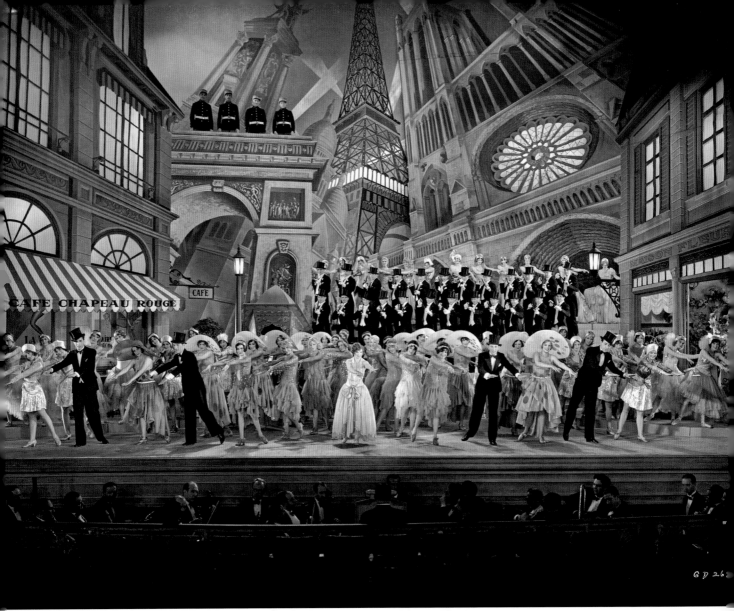

John Barrymore performed the Gloucester soliloquy from *Henry VI, Part III* in John Adolfi's *Show of Shows* (1929), an all-star revue that included Loretta Young, Myrna Loy, and the melodious Nick Lucas. **OPPOSITE, CLOCKWISE FROM TOP:** Roy Del Ruth's two-color Technicolor musical *Gold Diggers of Broadway* was a massive hit in 1929, grossing $5 million. • Warner Bros. released a number of features each year under the First National pennant. William A. Seiter's *Why Be Good?* was a 1929 Colleen Moore vehicle with Neil Hamilton. • George Arliss and Joan Bennett in a scene from Alfred E. Green's *Disraeli*, another Warner hit of 1929.

1929–1930 ACADEMY AWARDS

WINS

Actor:
- ★ George Arliss in *Disraeli*

NOMINATIONS

Outstanding Production:
- *Disraeli*, Warner Bros.

Actor:
- George Arliss in *The Green Goddess*

Writing:
- *Disraeli*, Julian Josephson

Art Direction:
- *Sally*, Jack Okey

Sound Recording:
- *Song of the Flame*, First National Studio Sound Department, George Groves, Sound Director

CHAPTER TWO

THE 1930S:

STRONG WOMEN, TOUGH MEN, AND THE CHORUS

THE DECADE OF THE 1930S HAS BEEN CALLED THE GREATEST IN HOLLYWOOD'S Golden Era. As the motion picture industry survived the Great Depression and became America's sixth largest, the studio system hummed like a massive sewing machine, joining the fabric of dreams to the national consciousness. Warner Bros. had been accepted by Paramount, RKO Radio, Metro-Goldwyn-Mayer, and the Fox Film Corporation as one of the five "major-major" studios. During this rich period, Warner doubled its output, releasing 577 features, and Jack Warner, assisted by Hal Wallis and Darryl F. Zanuck, cultivated the studio's signature subjects: crime films, biographies of statesmen and scientists, and self-possessed heroines, whether in melodramas or musicals.

Warner began the thirties with the wry power brokers played by George Arliss in *Old English*, *Alexander Hamilton*, and *Voltaire*. These biographies were consistently popular; thus, when the studio lost Arliss and John Barrymore, its two "great actors," Wallis signed Paul Muni, a chameleon-like stage actor. Muni became a Warner star in *I Am a Fugitive from a Chain Gang*, but his real success was in epic biographies like *The Life of Emile Zola*.

Little Caesar and *The Public Enemy* were game-changers in the crime film genre, and their graphic realism shocked audiences accustomed to "teacup dramas," the static talkies made by M-G-M and Paramount from plays about upper-class romances. Wallis had instituted the policy of having screen stories mirror newspaper headlines, and Zanuck used case histories to produce these films. Their success made overnight stars of stage actors Edward G. Robinson and James Cagney and spawned the "gangster cycle." Every company soon made crime films, hoping to match Warner's grosses.

By mid-1930 the recession that had followed the stock market crash was an actual depression; thousands of banks failed, and millions of jobs were lost. At first Hollywood appeared immune to what was soon called the "Great Depression." Revenues were stable. Then theaters started closing. The first victim of the slump was the musical film. In early 1929, Warner Bros. had signed a contract with the Technicolor Corporation for use of the two-color Technicolor process. In a year and a half, Warner had made a dozen musicals, most in color;

Edward G. Robinson was a multifaceted Warner Bros. star for most of the 1930s.

so had the other studios. Without warning, audiences turned a cold shoulder on offerings such as *Viennese Nights*, *Kiss Me Again*, and *Fifty Million Frenchmen*. Millions were lost. Musicals were dead.

In 1931, Warner Bros. needed female stars, and Jack Warner had no compunction about using a shakeup at Paramount to raid that studio of Ruth Chatterton and Kay Francis. These glamorous actresses enabled Warner to create the women's pictures that became a studio staple: college romances, working-girl stories, and every type of marriage story. With its immense picture palaces, the urban audience could make or break a film in a few days. This audience was 75 percent women, and they wanted red-hot romance with strong female characters. A Production Code was instituted in 1930 to regulate film content, but diminished box office pushed Warner to flout it with sexy films like *Illicit*, *My Past*, and *Under Eighteen*. These frisky programmers helped the studio get through the Depression.

The Code was administered by the Studio Relations Committee (SRC) on Hollywood Boulevard. For four years, Jason Joy and his fellow censors tried to get Warner, Wallis, and Zanuck to abide by the Code. First the SRC banned gangster films. Then it tried to get Warner Bros. to put more clothes on actresses. Then it tried to get racy dialogue toned down. Paramount and M-G-M cooperated to a certain extent, and Fox Film to a lesser extent, but not Warner. With its semi-nude chorus girls and racy exchanges, Warner was the most flagrant violator of the Code. The last straw was the notorious *Convention City*, a lewd and lusty comedy that ended its run as the most chopped-up feature of the period. It was cut in nearly thirty places—by state censor boards, regional censor boards, local censor boards, and even by exhibitors. The reason for Warner's recalcitrance could be read in *Box Office* magazine: the studio was running $14 million in the red.

In March 1933, the nationwide economic crisis forced studios to institute company-wide salary cuts. Zanuck promised employees that the cuts would be temporary and that their salaries would be restored when business improved. The studio continued at peak production levels, creating the first musicals since the craze had burned out three years earlier. In *42nd Street*

With its semi-nude chorus girls and racy exchanges, Warner was the most flagrant violator of the Code.

and *Footlight Parade*, choreography designer Busby Berkeley dispensed with staginess and used purely cinematic technique to fashion musical numbers; his bold, sexy effects revived interest in musicals.

When Zanuck was ready to restore the salary cuts, the Warners were unwilling to honor his promise. Zanuck felt this made him look like a liar. He first wrote a raunchy script for the price of $1, then left to start his own studio, Twentieth Century Pictures (later merged with the Fox Film Corporation). Wallis produced Zanuck's script, and *Baby Face* became a hot potato that required the studio to retake large portions and then soft-pedal advertising. Ruth Chatterton, who was frankly forty—a fact played up in both the trades and fan magazines—lost no chance to undress on the screen in *Lilly Turner*, *Frisco Jenny*, and her best Warner film, *Female*, in which the head of an automobile company is a modern version of man-hungry Catherine the Great. The bawdy tone of Warner films between 1930 and 1934 was muffled in July 1934 by a reconstituted Production Code and its Production Code Administration (PCA). William Dieterle's *Madame Du Barry*, a leering sex comedy that had been completed shortly before the new Code went into effect, endured months of cuts and retakes before the PCA would allow its release.

Hal Wallis had assumed Zanuck's duties, but Jack Warner made Henry Blanke, Robert Lord, and other producers share the work. These executives realized that the studio must move from sex and scandal to stories in which history mirrored current events and great men

made discoveries that benefited society, as in *The Story of Louis Pasteur*. Gangster films, banned since 1932, were replaced by crime detection stories like *G Men*.

Mervyn LeRoy had directed numerous hits for Warner since *Little Caesar* and *Five Star Final*. Tireless and likable, he made every kind of story, from *Gold Diggers of 1933* to the sprawling *Anthony Adverse*. His most significant projects, though, addressed social ills. His 1932 film, titled *I Am a Fugitive from a Chain Gang*, decried the cruel and unusual punishment administered in the South. His 1937 hit *They Won't Forget* condemned lynching. Though LeRoy had married Doris Warner, the daughter of Harry Warner, he left the studio in 1938 to become an M-G-M producer.

As required by the new Code, Kay Francis made a transition from fallen women to suffering wives. Her films were popular, but another actress was pushing her way to the top. Bette Davis was ambitious, fiery, and frighteningly talented. She wanted vehicles that would

Films like *The Petrified Forest* and *Jezebel* were so profitable that by the late '30s Bette Davis began to be jokingly called the "Fourth Warner Brother."

give her a chance to show her stuff, but Warner, unlike M-G-M, had little interest in cultivating female stars, so Davis began a series of battles with Jack Warner. With each defeat, Davis gained ground, winning smarter, more showy roles. Like Muni, she had to score a hit at another studio; he scored in *Scarface* at United Artists, she in *Of Human Bondage* at RKO. Only then would Jack Warner take her seriously.

Once Davis hit her stride, her gallery of portrayals drew a nation of women to her. Unlike Kay Francis, Davis was willing to forsake glamour in pursuit of a characterization, and she won acclaim for playing an alcoholic actress in the 1935 film *Dangerous*. Films like *The Petrified Forest* and *Jezebel* were so profitable

that by the late '30s she began to be jokingly called the "Fourth Warner Brother." The success of her four 1939 films—*The Old Maid, Juarez, The Private Lives of Elizabeth and Essex*, and *Dark Victory*—supposedly paid for a soundstage on the Burbank lot. By the decade's end, Bette Davis was the queen of that lot.

At the Sunset lot, another department at Warner Bros. was creating its own stars. In 1930, the studio had contracted with producer Leon Schlesinger to produce "Looney Tunes" and "Merrie Melodies" cartoons, devices through which they could promote new songs written for Warner films. Animators Hugh Harman and Rudolf Ising oversaw the initial shorts and introduced the popular character Bosko, but they left Schlesinger in 1933 with new talents to take over. The animation studio—housed in a run-down building affectionately known as "Termite Terrace"—would find its first big star almost by accident in 1935 with the appearance of Porky Pig in *I Haven't Got a Hat*. Soon to follow were Daffy Duck and Bugs Bunny, all coming from the talented animation staff who became legends, including "Tex" Avery, "Friz" Freleng, Frank Tashlin, Bob Clampett, Chuck Jones, and Robert McKimson.

The Production Code mandated a shift from urban grit to classical grandeur, and Warner Bros. met the challenge in 1935 with the enchanting Max Reinhardt production of *A Midsummer Night's Dream*, which was the first film that Olivia de Havilland made (two other films were released to theaters first). She next appeared in Michael Curtiz's pirate epic, *Captain Blood*. When British star Robert Donat dropped out of the lead before shooting began, Wallis cast an unknown Australian actor named Errol Flynn who had just arrived at the studio. Pairing him with de Havilland made two stars overnight and created a screen team that would grace eight Warner Bros. pictures.

The two-color Technicolor process had, of course, enlivened Warner's late silents and early talkies, but the lab contract lapsed in 1933 with *Mystery of the Wax Museum*, one of the studio's few horror films. In 1932,

the Technicolor Corporation had introduced a new process—three-strip Technicolor—with Disney's cartoon *Flowers and Trees*. At Warner Bros., the three-strip process debuted in 1934 with the short subject *Service with a Smile*, the first live-action three-color film. By 1937, the technology had improved to the point that Warner Bros. booked a number of features, thereby outstripping M-G-M, Paramount, and Zanuck's newly merged Twen-

If the studios could buy high-profile plays and books and make big-budget films to play in road-show presentations throughout 1939, the industry might be cushioned against the loss of European revenue in the fall, when war was predicted to break out.

tieth Century-Fox. The first Warner three-color feature was *God's Country and the Woman*, which had pleasing hues, even if they did favor pastels.

In 1938, Technicolor hues became more natural, just in time for the next Errol Flynn–Olivia de Havilland project. *The Adventures of Robin Hood* showed Hollywood that Warner Bros. could make a blockbuster. This epic—supervised initially by *God's Country* director

William Keighley, who was replaced mid-production by Michael Curtiz—had the literacy of Zanuck's Twentieth, the lavishness of M-G-M, and the panache of Paramount. *The Adventures of Robin Hood* became a beloved hit and an instant classic.

Warner Bros. ended the 1930s in cooperation with the other studios in a campaign known as "Hollywood's Greatest Year." Nominally celebrating the respective anniversaries of motion picture exhibition and the studio system, the campaign was in truth a joint effort to outrun the war in Europe, which threatened to deprive the industry of a third of its yearly income. If the studios could buy high-profile plays and books and make big-budget films to play in road-show presentations throughout 1939, the industry might be cushioned against the loss of European revenue in the fall, when war was predicted to break out.

Thus, the year 1939 saw an unprecedented number of fine films, as each studio did its utmost to "open big." Warner Bros. put Bette Davis in *Dark Victory*, Errol Flynn in *Dodge City*, James Cagney in *The Roaring Twenties*, Edward G. Robinson in *Confessions of a Nazi Spy*, and Paul Muni in *Juarez*. Although none of these cracked the Top Ten List of 1939, the studio, with a roster of profitable films, was ready in September 1939 when war was declared in Europe, hastening the end of a remarkable decade.

OPPOSITE: Lowell Sherman (on throne) grants an audience to John Barrymore in Alan Crosland's *General Crack* (1930).

Corinne Griffith played a disillusioned young mother hiding out on Broadway in Alexander Korda's *Lilies of the Field* (1930). **OPPOSITE:** Richard Barthelmess and Douglas Fairbanks Jr. in a publicity pose for Howard Hawks's *The Dawn Patrol* (1930).

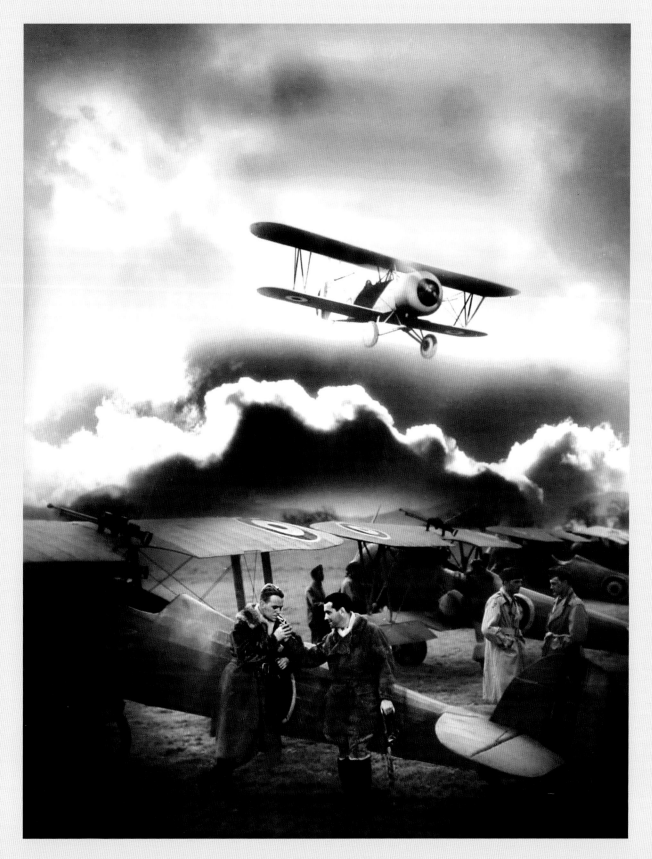

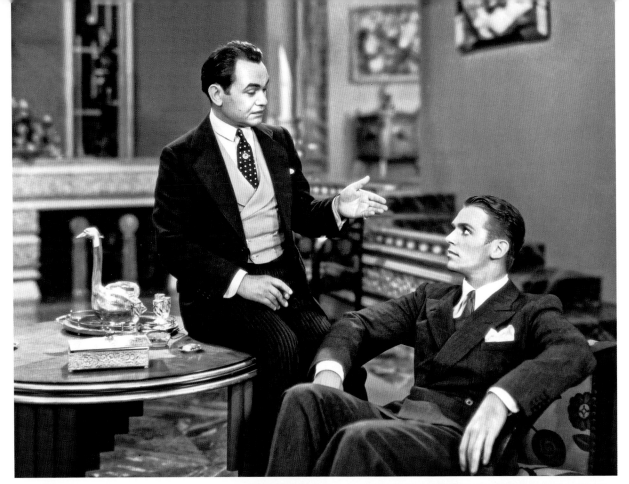

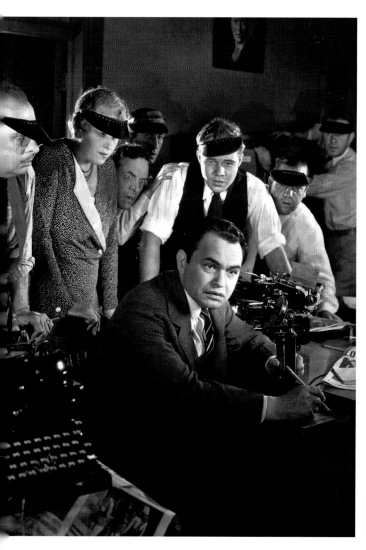

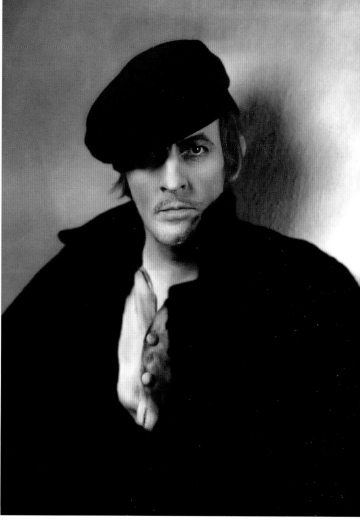

ABOVE, FROM LEFT: Edward G. Robinson played a tabloid newspaper editor in Mervyn LeRoy's topical *Five Star Final* (1931). • A portrait of John Barrymore by Bert Longworth for Michael Curtiz's *The Mad Genius* (1931). **OPPOSITE, FROM TOP:** Edward G. Robinson, seen here with Douglas Fairbanks Jr., became a star overnight in Mervyn LeRoy's *Little Caesar* (1931). • Audiences gasped at James Cagney's violence toward Mae Clarke in *The Public Enemy*.

1930–1931 ACADEMY AWARDS

WINS

Writing (Original Story):

★ *The Dawn Patrol*, John Monk Saunders

NOMINATIONS

Writing (Adaptation):

- *Little Caesar*, Francis Faragoh and Robert N. Lee

Writing (Original Story):

- *The Doorway to Hell*, Rowland Brown
- *The Public Enemy*, John Bright and Kubec Glasmon
- *Smart Money*, Lucien Hubbard and Joseph Jackson

Art Direction:

- *Svengali*, Anton Grot

Cinematography:

- *Svengali*, Barney "Chick" McGill

FROM TOP: Edward G. Robinson is a victim of fate in Mervyn LeRoy's *Two Seconds* (1932). • Noel Francis solicits money from Paul Muni in Mervyn LeRoy's *I Am a Fugitive from a Chain Gang* (1932).

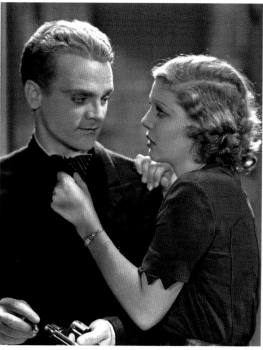

CLOCKWISE FROM TOP LEFT: Lee Tracy became a star by playing a vicious gossip columnist in Roy Del Ruth's *Blessed Event* (1932). • James Cagney and Loretta Young in a scene from Roy Del Ruth's *Taxi* (1932). • Bette Davis, Joan Blondell, and Ann Dvorak enact a risky ritual in Michael Curtiz's *Three on a Match* (1932).

1931–1932

ACADEMY AWARDS

NOMINATIONS

Outstanding Production:
- *Five Star Final*, First National

Writing (Original Story):
- *Star Witness*, Lucien Hubbard

Short Subject (Cartoon):
- *It's Got Me Again*, Leon Schlesinger, Producer

Sound Recording:
- Warner Bros.-First National Studio Sound Department

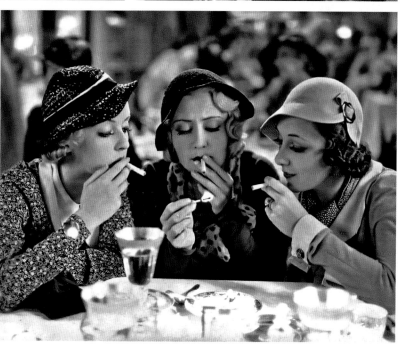

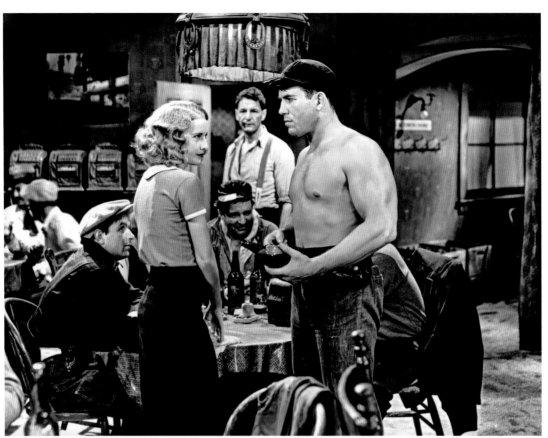

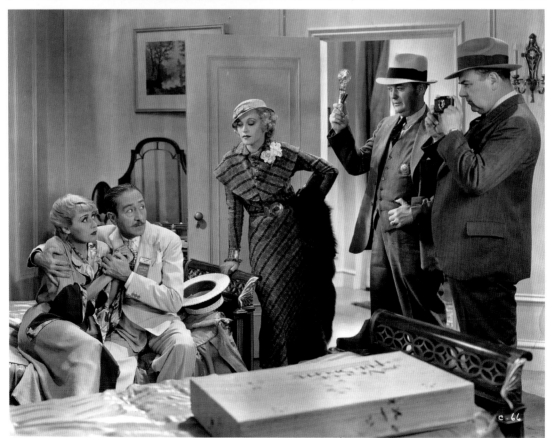

FROM TOP: Lionel Atwill played a sinister artist in Michael Curtiz's *Mystery of the Wax Museum* (1933). • Dorothy Coonan and Frankie Darro help Edwin Phillips, who has been run over by a train, in William Wellman's *Wild Boys of the Road* (1933). **OPPOSITE, FROM TOP:** Barbara Stanwyck confronts Nat Pendleton as Robert Barrat looks on in Alfred E. Green's *Baby Face* (1933). • Sheila Terry and her photographers entrap Adolphe Menjou and Joan Blondell in Archie Mayo's *Convention City* (1933), a film supposedly destroyed by Warner Bros. to appease censors; recent archival research suggests nitrate decay is the reason the film has not been seen since the early 1940s.

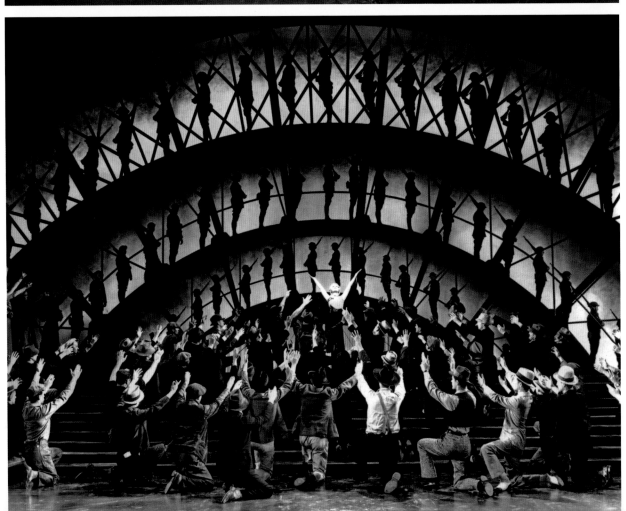

Busby Berkeley rehearses layers of chorines for his dazzling musical number "By a Waterfall" in Lloyd Bacon's *Footlight Parade* (1933).
OPPOSITE, FROM TOP: Busby Berkeley's musical numbers each told stories of their own and in purely cinematic terms, in Lloyd Bacon's *42nd Street* (1933). • Busby Berkeley created "Remember My Forgotten Man" to music by Harry Warren and Al Dubin in Mervyn LeRoy's *Gold Diggers of 1933* (1933).

1932–1933 ACADEMY AWARDS

WINS

Writing (Original Story):
★ *One Way Passage*, Robert Lord

Assistant Director:
★ Gordon Hollingshead

Scientific or Technical Award (Class III):
★ To Fox Film Corp., Fred Jackman and Warner Bros. Pictures, Inc., and Sidney Sanders of RKO Studios, Inc., for their development and effective use of the translucent cellulose screen in composite photography

NOMINATIONS

Outstanding Production:
• *42nd Street*, Warner Bros.
• *I Am a Fugitive from a Chain Gang*, Warner Bros.

Actor:
• Paul Muni in *I Am a Fugitive from a Chain Gang*

Assistant Director:
• Al Alborn
• Frank X. Shaw

Sound Recording:
• *42nd Street*, Warner Bros. Studio Sound Department, Nathan Levinson, Sound Director
• *Gold Diggers of 1933*, Warner Bros. Studio Sound Department, Nathan Levinson, Sound Director
• *I Am a Fugitive from a Chain Gang*, Warner Bros. Studio Sound Department, Nathan Levinson, Sound Director

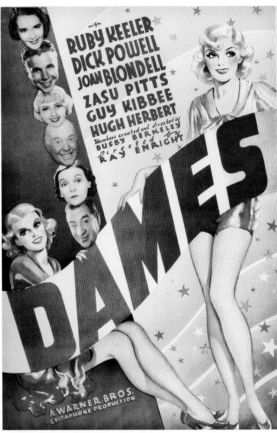

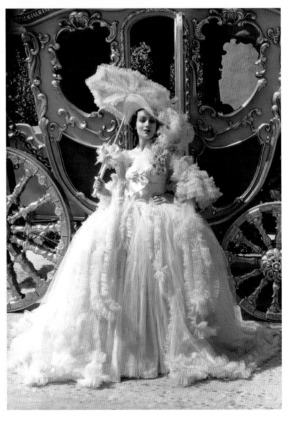

CLOCKWISE FROM TOP LEFT: Ann Dvorak gave a fine performance as a quiet girl working at a desert gas station in Mervyn LeRoy's *Heat Lightning* (1934). • This poster for Ray Enright's *Dames* (1934) shows the effect of the Production Code on Busby Berkeley's chorus girls: revealing costumes were no longer allowed. • The reconstituted Production Code took effect on July 1, 1934, so Dolores Del Rio's portrayal of the fabled courtesan in William Dieterle's *Madame Du Barry* was toned down. • Ray Enright's *Wonder Bar* (1934) was pre-Code, but this scene of Dolores Del Rio and Al Jolson in bed was cut—not because the Code prohibited it, but because the industry had an unwritten agreement with the British Censor Board not to show characters in bed. Revenues from the British Isles and Commonwealth were vital to Hollywood, so this agreement remained in force until the 1950s, when various Production Code and British censor strictures were relaxed.

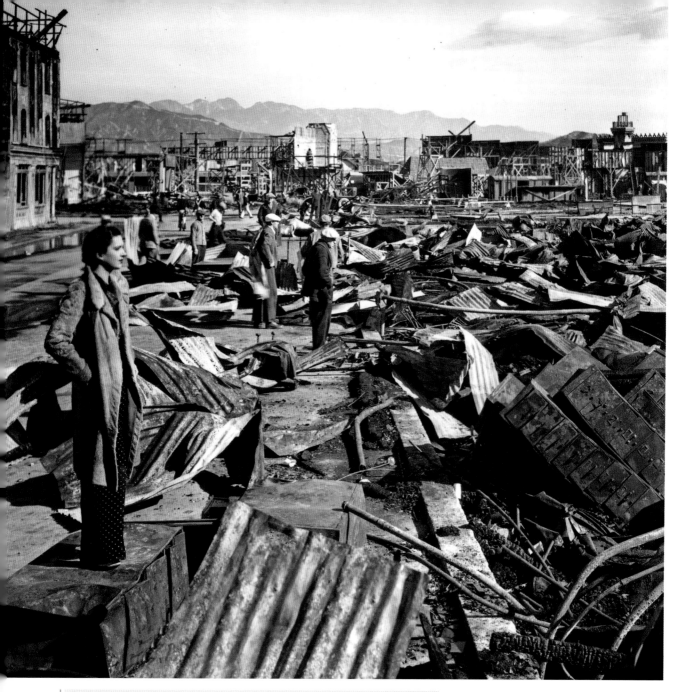

On December 4, 1934, a fire swept through the Burbank lot. In this photograph, Kay Francis surveys the ruins, which included most of the New York street as well as the crafts department, soundstages, and a prop warehouse—a total of fourteen acres. Many silent films and early Technicolor talkies were also destroyed.

1934 ACADEMY AWARDS

NOMINATIONS

Outstanding Production:
- *Flirtation Walk*, First National
- *Here Comes the Navy*, Warner Bros.

Short Subject (Comedy):
- *What, No Men!*, Warner Bros.

Sound Recording:
- *Flirtation Walk*, Warner Bros.–First National Studio Sound Department, Nathan Levinson, Sound Director

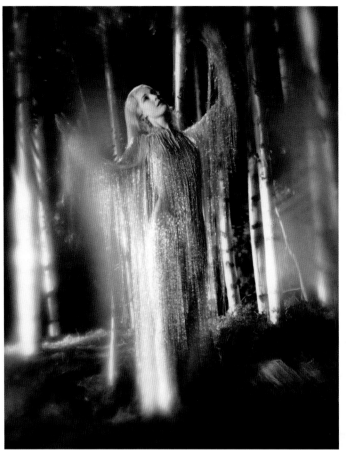

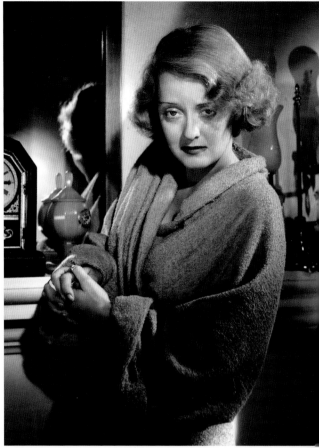

CLOCKWISE FROM TOP LEFT:
Anita Louise shimmered
as Titania in Max Reinhardt
and William Dieterle's
production of Shakespeare's
A Midsummer Night's Dream
(1935) • Bette Davis in a
scene from her breakthrough
film, Alfred E. Green's
Dangerous (1935). • *I Haven't
Got a Hat* (1935), directed
by Friz Freleng, marked
the debut of Porky Pig who
would go on to become the
first Looney Tunes star.

Errol Flynn's instant stardom was in part due to his enthusiastic swordplay in *Captain Blood* (1935), and the film was blessed with a musical score by the gifted Erich Wolfgang Korngold.

Busby Berkeley was the credited director of *Gold Diggers of 1935*, but he also created his trademark musical numbers.

1935 ACADEMY AWARDS

WINS

Actress:

★ Bette Davis in *Dangerous*

Cinematography:

★ *A Midsummer Night's Dream*, Hal Mohr

Film Editing:

★ *A Midsummer Night's Dream*, Ralph Dawson

Music (Song):

★ "Lullaby of Broadway" from *Gold Diggers of 1935*, Music by Harry Warren; Lyrics by Al Dubin

Scientific or Technical Award (Class III):

★ To William A. Mueller of Warner Bros.–First National Studio Sound Department for his method of dubbing, in which the level of the dialogue automatically controls the level of the accompanying music and sound effects

★ To Nathan Levinson, Director of Sound Recording for Warner Bros.-First National Studio Sound Department, for the method of intercutting variable density and variable area soundtracks to secure an increase in the effective volume range of sound recorded for motion pictures

NOMINATIONS

Outstanding Production:

· *Captain Blood*, Cosmopolitan

· *A Midsummer Night's Dream*

Dance Direction:

· Busby Berkeley for "Lullaby of Broadway" and "The Words Are in My Heart" numbers from *Gold Diggers of 1935*

· Bobby Connolly for "Latin from Manhattan" number from *Go into Your Dance* and "Playboy from Paree" number from *Broadway Hostess*

Sound Recording:

· *Captain Blood*, Warner Bros.-First National Studio Sound Department, Nathan Levinson, Sound Director

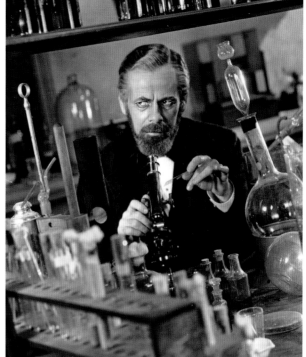
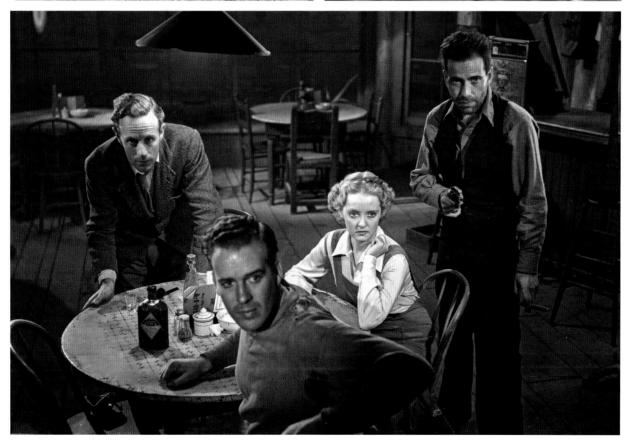

CLOCKWISE FROM TOP LEFT: A Bert Longworth portrait of Fredric March in Mervyn LeRoy's epic *Anthony Adverse* (1936). • Even though Paul Muni played a heavily bearded, happily married scientist, he drew an audience to William Dieterle's *The Story of Louis Pasteur* (1936). • Leslie Howard, Dick Foran, Bette Davis, and Humphrey Bogart in the hostage scene from Archie Mayo's *The Petrified Forest* (1936).

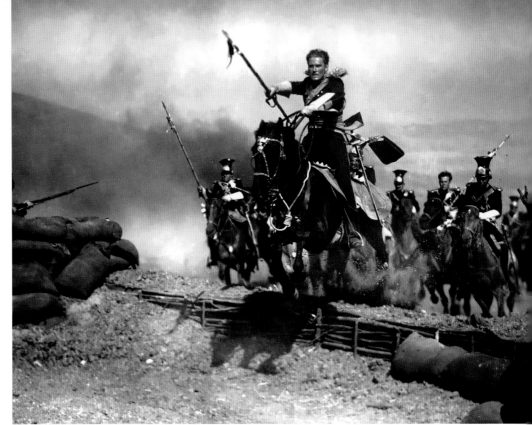

Errol Flynn's stardom was confirmed in Michael Curtiz's production of *The Charge of the Light Brigade* (1936). The film also featured the first musical score composed by Max Steiner for a Warner Bros. film. Steiner would create memorable melodies for the studio through 1965.

1936 ACADEMY AWARDS

WINS

Actor:
★ Paul Muni in *The Story of Louis Pasteur*

Supporting Actress:
★ Gale Sondergaard in *Anthony Adverse*

Writing (Original Story):
★ *The Story of Louis Pasteur*, Pierre Collings and Sheridan Gibney

Writing (Screenplay):
★ *The Story of Louis Pasteur*, Pierre Collings and Sheridan Gibney

Assistant Director:
★ *The Charge of the Light Brigade*, Jack Sullivan

Cinematography:
★ *Anthony Adverse*, Gaetano Gaudio

Film Editing:
★ *Anthony Adverse*, Ralph Dawson

Music (Scoring):
★ *Anthony Adverse*, Warner Bros. Studio Music Department, Leo Forbstein, head of department

Short Subject (Color):
★ *Give Me Liberty*, Warner Bros.

NOMINATIONS

Outstanding Production:
• *Anthony Adverse*, Warner Bros.
• *The Story of Louis Pasteur*, Cosmopolitan

Art Direction:
• *Anthony Adverse*, Anton Grot

Assistant Director:
• *Anthony Adverse*, William Cannon

Dance Direction:
• Busby Berkeley for "Love and War" number from *Gold Diggers of 1937*
• Bobby Connolly for "1000 Love Songs" number from *Cain and Mabel*

Music (Scoring):
• *The Charge of the Light Brigade*, Warner Bros. Studio Music Department, Leo Forbstein, head of department

Short Subject (Two-Reel):
• *Double or Nothing*, Warner Bros.

Sound Recording:
• *The Charge of the Light Brigade*, Warner Bros. Studio Sound Department, Nathan Levinson, Sound Director

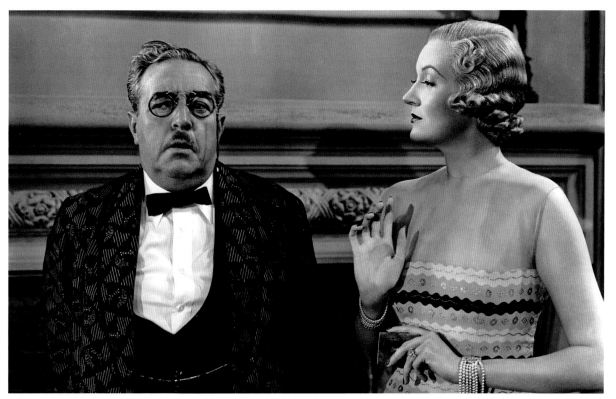

FROM TOP: Stanley Logan's *First Lady* (1937) was a Kay Francis vehicle, yet Walter Connolly and Verree Teasdale stole the show. • Bette Davis, seen here with Jack Norton, had a flashy role as a café "hostess" in Lloyd Bacon's *Marked Woman* (1937).

THE 1930S: STRONG WOMEN, TOUGH MEN, AND THE CHORUS

53

KAY FRANCIS
Confession

IAN HUNTER • BASIL RATHBONE
JANE BRYAN • DONALD CRISP • MARY MAGUIRE
Directed by Joe May, original Screen Play by Hans Rameau
Adaptation by Julius J. Epstein and Margaret LeRoy
A First National Picture

Presented by
Warner Bros.

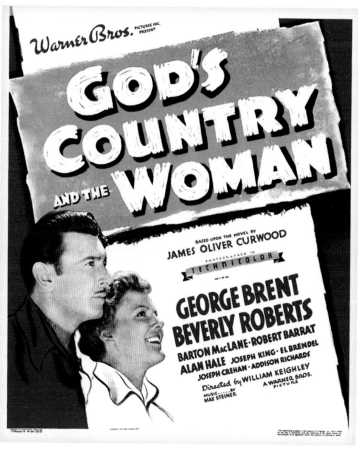

WARNER BROS. PICTURES INC. PRESENT

GOD'S COUNTRY AND THE WOMAN

BASED UPON THE NOVEL BY
JAMES OLIVER CURWOOD

PHOTOGRAPHED IN
TECHNICOLOR

WITH

GEORGE BRENT
BEVERLY ROBERTS

BARTON MacLANE • ROBERT BARRAT
ALAN HALE JOSEPH KING • EL BRENDEL
JOSEPH CREHAN • ADDISON RICHARDS

Directed by WILLIAM KEIGHLEY A WARNER BROS.
 PICTURE
MUSIC.......BY
MAX STEINER

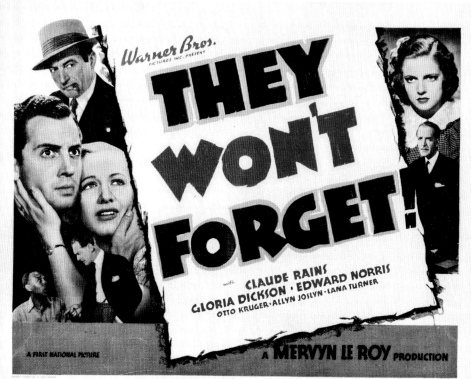

WARNER BROS.
PICTURES INC. PRESENT

THEY WON'T FORGET!

with
CLAUDE RAINS • EDWARD NORRIS
GLORIA DICKSON
OTTO KRUGER • ALLYN JOSLYN • LANA TURNER

A FIRST NATIONAL PICTURE

A MERVYN LE ROY PRODUCTION

CLOCKWISE FROM TOP LEFT: After five years at Warner, Kay Francis still had legions of fans, but the studio had so little interest in her that it forced director Joe May to do a shot-for-shot remake of a 1935 Pola Negri film, *Mazurka*. • The first Warner Bros. feature shot in three-strip Technicolor was William Keighley's *God's Country and the Woman* (1937). • Mervyn LeRoy's *They Won't Forget* (1937) had everything that this lobby card promised. **OPPOSITE:** Paul Muni is inspired to write a novel in William Dieterle's *The Life of Emile Zola* (1937).

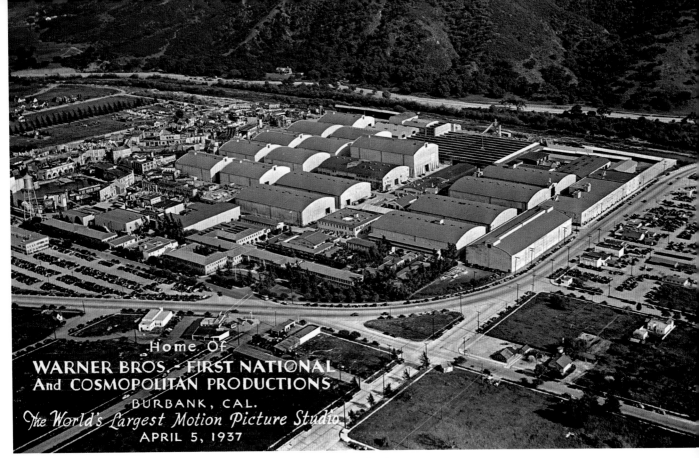

A 1937 aerial photograph shows the Warner Bros. plant in Burbank.

1937 ACADEMY AWARDS

WINS

Outstanding Production:
- ★ *The Life of Emile Zola*, Warner Bros.

Supporting Actor:
- ★ Joseph Schildkraut in *The Life of Emile Zola*

Writing (Screenplay):
- ★ *The Life of Emile Zola*, Heinz Herald, Geza Herczeg, and Norman Reilly Raine

NOMINATIONS

Directing:
- William Dieterle for *The Life of Emile Zola*

Actor:
- Paul Muni in *The Life of Emile Zola*

Writing (Original Story):
- *Black Legion*, Robert Lord
- *The Life of Emile Zola*, Heinz Herald and Geza Herczeg

Art Direction:
- *The Life of Emile Zola*, Anton Grot

Assistant Director:
- *The Life of Emile Zola*, Russ Saunders

Dance Direction:
- Busby Berkeley for "The Finale" number from *Varsity Show*
- Bobby Connolly for "Too Marvelous for Words" number from *Ready, Willing and Able*

Music (Scoring):
- *The Life of Emile Zola*, Warner Bros. Studio Music Department, Leo Forbstein, head of department

Music (Song):
- "Remember Me" from *Mr. Dodd Takes the Air,* Music by Harry Warren; Lyrics by Al Dubin

Short Subject (Color):
- *The Man Without a Country*, Warner Bros.

Sound Recording:
- *The Life of Emile Zola*, Warner Bros. Studio Sound Department, Nathan Levinson, Sound Director

FROM TOP: James Cagney was an unfit role model for the slum boys of Michael Curtiz's *Angels with Dirty Faces* (1938).
• A portrait of Bette Davis and Errol Flynn in Anatole Litvak's *The Sisters* (1938), a domestic drama climaxed by the 1906 San Francisco earthquake.

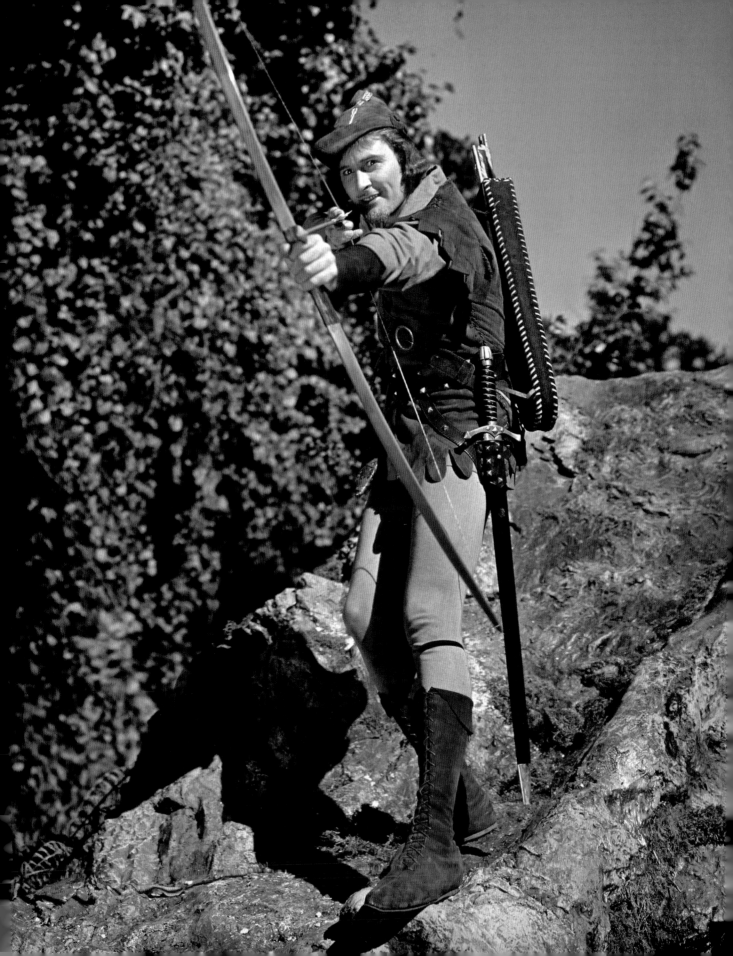

CLOCKWISE FROM
TOP: Fay Bainter and
Bette Davis wait for
a cue from director
William Wyler on the
set of *Jezebel* (1938). •
John Garfield made his
debut in Michael Curtiz's
Four Daughters (1938).
Portrait by George
Hurrell. • Errol Flynn
gave a fine performance
in Edmund Goulding's
The Dawn Patrol (1938).
OPPOSITE: Errol Flynn
had the role of a lifetime
in Michael Curtiz and
William Keighley's *The
Adventures of Robin
Hood* (1938).

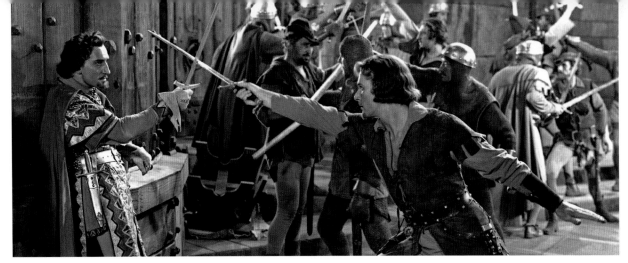

Basil Rathbone's Sir Guy of Gisbourne showed why, at $5,000 a week, he was Hollywood's highest-paid supporting player. He matches swords with Errol Flynn in *The Adventures of Robin Hood*.

1938 ACADEMY AWARDS

WINS

Actress:
★ Bette Davis in *Jezebel*

Supporting Actress:
★ Fay Bainter in *Jezebel*

Art Direction:
★ *The Adventures of Robin Hood*, Carl J. Weyl

Film Editing:
★ *The Adventures of Robin Hood*, Ralph Dawson

Music (Original Score):
★ *The Adventures of Robin Hood*, Erich Wolfgang Korngold

Short Subject (Two-Reel):
★ *Declaration of Independence*, Warner Bros.

Irving R. Thalberg Memorial Award:
★ Hal B. Wallis

Special Award:
★ To Harry M. Warner in recognition of patriotic service in the production of historical short subjects presenting significant episodes in the early struggle of the American people for liberty

Scientific or Technical Award (Class III):
★ To Byron Haskin and the Special Effects Department of Warner Bros. Studio for pioneering the development and for the first practical application to motion picture production of the triple-head background projector

NOMINATIONS

Outstanding Production:
• *The Adventures of Robin Hood*, Warner Bros.–First National
• *Four Daughters*, Warner Bros.–First National
• *Jezebel*, Warner Bros.

Directing:
• Michael Curtiz for *Angels with Dirty Faces* and *Four Daughters*

Actor:
• James Cagney in *Angels with Dirty Faces*

Actress:
• Fay Bainter in *White Banners*

Supporting Actor:
• John Garfield in *Four Daughters*

Writing (Original Story):
• *Angels with Dirty Faces*, Rowland Brown

Writing (Screenplay):
• *Four Daughters*, Lenore Coffee and Julius J. Epstein

Cinematography:
• *Jezebel*, Ernest Haller

Music (Scoring):
• *Jezebel*, Max Steiner

Music (Song):
• "Jeepers Creepers" from *Going Places*, Music by Harry Warren; Lyrics by Johnny Mercer

Short Subject (Two-Reel):
• *Swingtime in the Movies*, Warner Bros.

Sound Recording:
• *Four Daughters*, Warner Bros. Studio Sound Department, Nathan Levinson, Sound Director

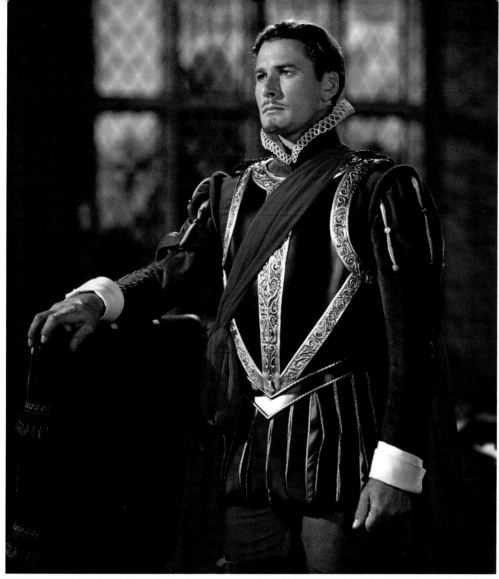

FROM TOP: The beauty of three-strip Technicolor was captured in a Kodachrome transparency of Errol Flynn as Lord Essex in Michael Curtiz's *The Private Lives of Elizabeth and Essex* (1939). • Warner Bros. made political history with Anatole Litvak's *Confessions of a Nazi Spy* (1939). Pictured are Dorothy Tree, Francis Lederer, and George Sanders.

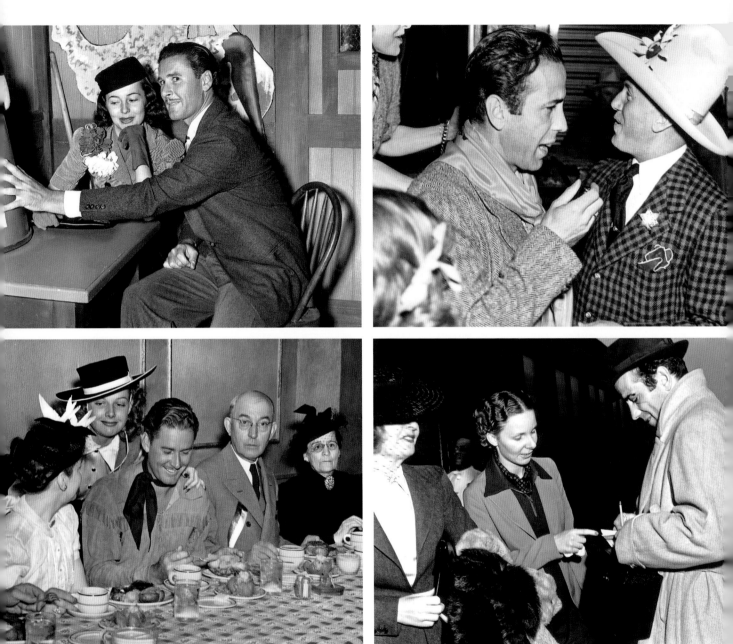

When a group of Warner stars entrained to Dodge City, Kansas, for the gala premiere of the film *Dodge City*, a good time was had by all, including Olivia de Havilland, Errol Flynn, Humphrey Bogart, Ann Sheridan, and Jack Warner (in white hat). **OPPOSITE:** George Hurrell's portraits of Ann Sheridan helped make her the newest Warner star in 1939.

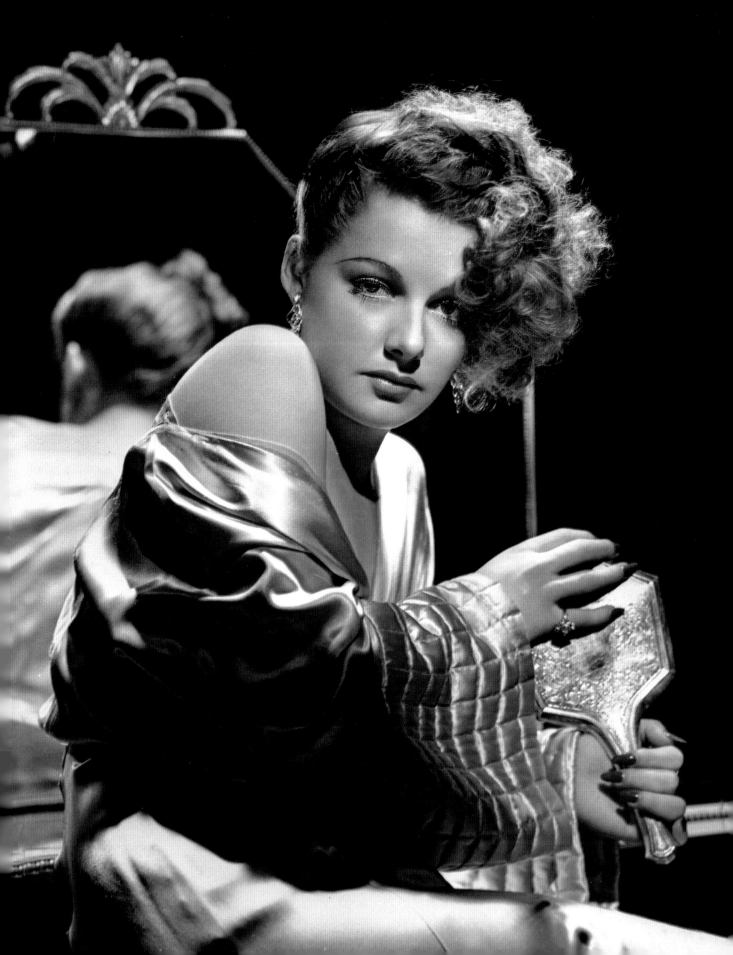

A Kodachrome portrait by Hurrell of Errol Flynn and Bette Davis in Michael Curtiz's *The Private Lives of Elizabeth and Essex* (1939). **OPPOSITE, FROM LEFT:** Bette Davis played the Empress Carlotta in William Dieterle's *Juarez* (1939). Portrait by George Hurrell. • A George Hurrell portrait of Frank McHugh, James Cagney, and Humphrey Bogart made for Raoul Walsh's *The Roaring Twenties* (1939).

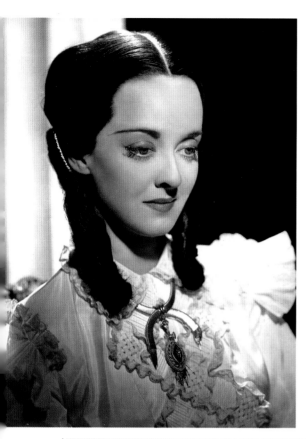

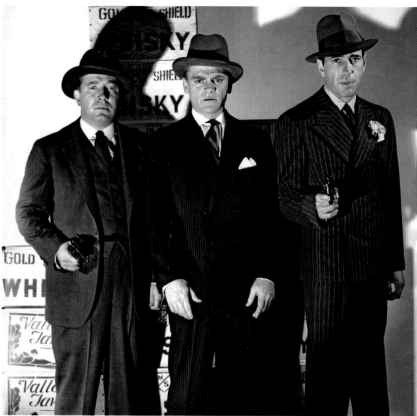

1939 ACADEMY AWARDS

WINS

Short Subject (Two-Reel):

★ *Sons of Liberty*, Warner Bros.

Scientific or Technical Award (Class III):

★ To George Anderson of Warner Bros. Studio for an improved positive head for sun arcs

★ To Harold Nye of Warner Bros. Studio for a miniature incandescent spot lamp

★ To A. J. Tondreau of Warner Bros. Studio for the design and manufacture of an improved soundtrack printer

NOMINATIONS

Outstanding Production:

• *Dark Victory*, Warner Bros.– First National

Actress:

• Bette Davis in *Dark Victory*

Supporting Actor:

• Brian Aherne in *Juarez*

Art Direction:

• *The Private Lives of Elizabeth and Essex*, Anton Grot

Cinematography (Color):

• *The Private Lives of Elizabeth and Essex*, Sol Polito and W. Howard Greene

Music (Original Score):

• *Dark Victory*, Max Steiner

Music (Scoring):

• *The Private Lives of Elizabeth and Essex*, Erich Wolfgang Korngold

Short Subject (Cartoon):

• *Detouring America*, Warner Bros.

Short Subject (One-Reel):

• *Sword Fishing*, Warner Bros.

Sound Recording:

• *The Private Lives of Elizabeth and Essex*, Warner Bros. Studio Sound Department, Nathan Levinson, Sound Director

Special Effects:

• *The Private Lives of Elizabeth and Essex*, Byron Haskin and Nathan Levinson

THE 1940s:

DEFENDING THE COUNTRY AND THE INDUSTRY

THERE WAS TENSION IN THE AIR AS HOLLYWOOD GREETED 1940. GERMANY'S aggression had polarized the planet, triggering World War II. Americans who were still grieving World War I losses wanted neutrality, but global violence was impossible to ignore. A dozen countries had already entered the fray. Since the film industry had lost access to much of Europe, domestic box office was vital. Warner Bros. had not done particularly well with the Technicolor productions of the past few years, not because they were poorly attended but because they took longer to film. Once a film went a certain percentage over budget, it could never make a profit; there were only so many theater seats in the world. Warner's 1939 profit had been a mere $1.7 million, far below that of Paramount and M-G-M.

The new Warner policy was to make A pictures in black and white with all-star casts in remade stories. Remakes released in 1940 included *The Sea Hawk*, *'Til We Meet Again*, and *The Letter*. In 1929, Bette Davis had seen Jeanne Eagels in *The Letter* and vowed that one day she would play that role. In 1940, she was Warner's top-drawing star, and she told Jack Warner to buy *The Letter* from Paramount. The W. Somerset Maugham story gave Davis a signature role and showed that money spent on important literary properties was money well spent. Davis's other 1940 film was also based on a best seller, Rachel Field's *All This, and Heaven Too*. In future years, Warner would snap up best sellers by Edna Ferber, Ernest Hemingway, and Ayn Rand.

Of course, the studio had its share of original screenplays, and with Hal Wallis as head of production, they drew on headlines or history. *Dr. Ehrlich's Magic Bullet* was directed by William Dieterle but was made without Paul Muni, who had abrogated his Warner contract, so Edward G. Robinson played the Nobel Prize–winning Dr. Paul Ehrlich. Because of the charged political atmosphere, the Production Code Administration required the film's screenwriters (including John Huston) to avoid mentioning that Dr. Ehrlich was Jewish and to avoid showing him treating a syphilis patient, even though his treatment of this deadly disease was the point of the story; compromises were, of course, reached.

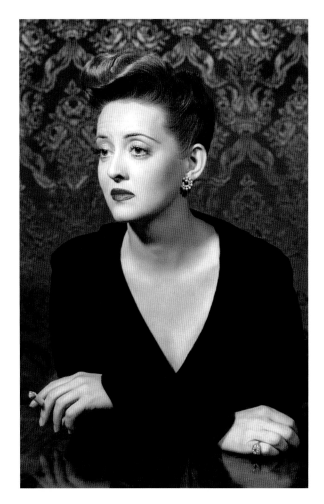

A portrait of Bette Davis made for Irving Rapper's *Now, Voyager* (1942). Davis would earn consistently high box-office returns for most of the 1940s.

One function of the B picture, at whatever studio, was to groom newly contracted talent. Ann Sheridan had been dropped by Paramount and picked up by Warner Bros., where she again languished in B pictures. Then someone got the bright idea of having Warner photographer George Hurrell make glamour portraits of Sheridan. These were entered in a contest at the Town House, a swank hotel where a panel of publicists voted her the "Oomph Girl." The dubious title increased her stock, getting her into films like *City for Conquest* and *Torrid Zone*, where her husky voice and no-nonsense sexiness made her the perfect foil for James Cagney. Ann Sheridan became another Warner star, and the studio's 1940 profit was an encouraging $2.7 million.

The big Warner hit of 1941 came from outside the studio. Jesse L. Lasky had, with Cecil B. DeMille, brought the film industry to the city of Hollywood in 1913, when it was nothing more than orange groves and pepper trees. After fifteen years as Paramount's head of production, Lasky fell victim to a 1932 studio coup;

Young men leaving movie theaters after seeing *Sergeant York* were inspired to enlist. Twelve million American men and women joined the war effort, and many studio employees were among them.

he had been trying to regain his footing ever since. His dream was to produce a film about Alvin York, the pacifist who became a war hero. The nation was torn between isolationism and mobilization as Lasky pitched his idea to York and to Gary Cooper, somehow convincing each man that the other was eager to work with him. Incredibly, Lasky made his sale. With Howard Hawks directing, *Sergeant York* became a fine film. It could not have had better timing.

On December 7, 1941, the United States was attacked by Japan and drawn into World War II. Young men leaving movie theaters after seeing *Sergeant York* were

inspired to enlist. Twelve million American men and women joined the war effort, and many studio employees were among them. Some saw action, and some were drafted into the Signal Corps, making training or informational films. John Huston left the Humphrey Bogart film *Across the Pacific* unfinished because he had to report for duty at the Army Service Forces Signal Corps. George Hurrell also served there, making portraits of generals such as Dwight D. Eisenhower. Meanwhile, *Sergeant York* became the number-one box-office hit of 1941 and the biggest hit of all time for the studio up to that point.

The government instructed the film industry to support the war effort, so Warner Bros. made films about fascism (*Watch on the Rhine*), films about resistance (*Edge of Darkness*), films about Fifth Columnists (*All Through the Night*), films about allies (*Mission to Moscow*), and, of course, war films (*Action in the North Atlantic, Air Force*, and *Destination Tokyo*). The company also donated millions in cash, and it abided by regulations that were announced weekly; for example, budgets for new sets were limited to $5,000 by the War Production Board.

Errol Flynn's collaboration with both Michael Curtiz and Olivia de Havilland ended in 1941, but all parties remained top earners. De Havilland saw her grosses ascending while she worked long hours and did not receive raises. In 1943, when her contract was about to end, the studio extended it to penalize her for sick days and suspensions (when she had refused to accept unsatisfactory assignments). De Havilland sued Warner Bros. for subjecting her to peonage. She endured two trials before the California Court of Appeal ruled in her favor, establishing the De Havilland Law, which held that a contract could not exceed seven years. Flynn also spent time in court, defending himself against two consecutive rape charges of which he was eventually acquitted.

Flynn and de Havilland had both achieved instant stardom after signing with Warner Bros. Screenwriter John Huston and actor Humphrey Bogart had been

working at the studio for four years without significant advancement when Huston's script for *High Sierra* lifted Bogart to stardom. The next step was one that Huston had planned—to direct his own script. He adapted Dashiell Hammett's *The Maltese Falcon* without altering the novel's structure and got Warner and Wallis to cast Humphrey Bogart for once as a hero, albeit a tarnished one. The film was a remake, and executives reasoned that a small crime film would be no great loss if a first-time director ruined it. *The Maltese Falcon* was a surprise success, earning more than three times its cost, confirming Bogart's stardom, introducing Sydney Greenstreet, and establishing the hard-boiled genre. In addition, Huston's direction highlighted a familiar but unsung talent.

Mary Astor had gotten her first important role at Warner as John Barrymore's love interest in the 1924 *Beau Brummel*, both on-screen and off. In 1941, two Warner films confirmed her brilliance as a supporting player. In *The Maltese Falcon*, she was a perfect foil for Bogart. In *The Great Lie*, she almost acted Bette Davis off the screen.

Davis could afford to share her spotlight. She was the Queen of the Warner lot, and she would score an enviable twenty hits before the inevitable slowdown occurred in the late '40s. Beloved by fans, if not by her coworkers, Davis strove, slaved, and suffered for her art, and she only lost faith in her studio (after eighteen years) when she saw Jack Warner doing the same thing to her that he had done to Kay Francis and Miriam Hopkins, shoving her into unworthy vehicles and, worse, giving her unflattering lighting.

James Cagney was another Warner Bros. star who had fought for his rights in court, but while de Havilland went on to become a highly successful freelancer and Davis had gotten what she wanted at Warner, Cagney had more of a back and forth with Warner Bros. across the years of his association with the studio. He spent several years as an independent but came back to Burbank for his biggest hits, *Yankee Doodle Dandy* (1942) and *White Heat* (1949).

By 1942, the war effort was topic number one, mostly because the Axis powers (Germany, Italy, and Japan) stood a chance of defeating the Allies (Britain, the United States, Russia, and China). After a certain point, audiences living on the "home front" grew weary of patriotic films and hankered for some good old escapism. This the studios were happy to provide. Warner had the third-highest-grossing film of 1942 (after *Bambi* and *Mrs. Miniver*) with Michael Curtiz's *Yankee Doodle Dandy*, in which Cagney sang and danced his way through a biography of Broadway legend George M. Cohan.

Americans could not escape war headlines when Allied forces landed in the Axis-occupied city of Casablanca in November 1942, and Warner Bros. once again cashed in on some extraordinary luck, since Michael Curtiz's *Casablanca* was ready to be released. Here was a production in which Hal Wallis ensured that every filmic element was functioning at its highest level. If the film had been released in peacetime, it would still have been a massive hit, but appearing on the heels of a historic victory, it ascended to the "event" level of *Gone with the Wind*, making Humphrey Bogart and Ingrid Bergman into superstars.

The Warner animation department was still going strong, and the cartoon canary Tweety made his first appearance in 1942. In addition, Merrie Melodies and Looney Tunes added more characters in the mid-1940s with Pepé Le Pew, Sylvester the Cat, Yosemite Sam,

The Warner animation department was still going strong, and the cartoon canary Tweety made his first appearance in 1942.

Foghorn Leghorn, the Road Runner, and Wile E. Coyote. Leon Schlesinger eventually sold his cartoon studio to Warner in 1944, and the company was renamed Warner Bros. Cartoons Inc.

Curtiz directed another film that combined patriotism and escapism. *This Is the Army* was a Technicolor

tune-fest based on an Irving Berlin play and featuring the beloved composer singing "Oh, How I Hate to Get Up in the Morning." It also featured Kate Smith singing "God Bless America" to a montage of radio listeners. Berlin's hit Broadway musical was notable for having a cast entirely comprised of enlisted members of the Army. Most of the original stage cast arrived in Burbank for the film. Some of the soldiers were even housed in tents on the lot during production. The film earned $10.4 million, which made it the highest-grossing musical up to that time.

Another Curtiz film achieved a different kind of status. *Mission to Moscow* was based on the 1941 book by Joseph E. Davies, former US ambassador to the Soviet Union. Following a request from President Franklin D. Roosevelt, Jack Warner turned *Mission to Moscow* into a

> **Because motion pictures were nearly the only form of entertainment available to wartime audiences dealing with gasoline rationing, movie attendance skyrocketed in 1943 and 1944, reaching eighty million.**

pro-Soviet film that tried to excuse Josef Stalin's purges as conspiracy trials. Because of the film's confused intentions, executives had second thoughts about shipping it to theaters; by the end of the decade, their second thoughts would become regrets.

After *The Old Maid* and *Dark Victory,* Edmund Goulding continued to make unusual, sensitive films for the studio. *The Constant Nymph* was his adaptation of a controversial novel, then play, then silent film about a gifted teenager in love with her middle-aged (and married) music teacher, a story that could not end well. As usual, Goulding got resonant performances from his cast, in this case Joan Fontaine and Charles Boyer. The 1941 Broadway hit, *Arsenic and Old Lace,* was filmed by Warner late that year for a planned release in Septem-

ber 1942, but the contract with the play's producer stipulated that the play had to finish its run before the film could be released. No one expected the play to run for three and a half years. When *Arsenic and Old Lace* was finally released in the fall of 1944, there were no comments about the fashions in the film looking outdated, but this had happened to a number of studios, since a backlog situation had occurred.

Because motion pictures were nearly the only form of entertainment available to wartime audiences dealing with gasoline rationing, movie attendance skyrocketed in 1943 and 1944, reaching eighty million. This audience expressed its displeasure when a new film was pulled too quickly from an urban theater; films that usually ran a week were staying three weeks. This caused a backlog in the studio shipping departments, and when films were released months behind schedule, "new" fashions looked a bit passé. The studios could do nothing about it—except sit back and count their receipts. Warner's profits rose from $5.4 million in 1941 to $8.6 in 1942, stabilized at $8.2 million in 1943, and dropped slightly in 1944, to $7.0 million, which was still much higher than the 1930s average.

Hal Wallis was the next in a procession of artists and executives who lost patience with the stingy Warner brothers. He had found satisfaction producing projects such as *Casablanca,* so he was humiliated and outraged at the Academy banquet when Jack Warner pushed him aside to accept the Best Picture Oscar that traditionally went to that film's producer. Wallis was ready to leave in March 1944 when he was told that he owed the company another month on his contract. When he came to his office to work off the time, Warner had locked him out. Wallis, not wanting a lawsuit, worked on the lawn outside the office. Warner sent a truck to dump a load of horse manure on the grass next to Wallis. After a month of this treatment, Wallis was finally free to set up independent production at Paramount, and he flourished there. Jack Warner promoted casting director Steve Trilling to fill Wallis's position, although Trilling did not possess the same creative vision.

The hard-boiled trend that began in 1941 with *Citizen Kane* and *The Maltese Falcon* went into high gear in 1944; in spite of (or perhaps because of) its fatalism, the trend found favor with wartime audiences, especially in Paramount's *Double Indemnity* and RKO's *Murder My Sweet*, which gave Warner alumnus Dick Powell a new career. Warner Bros. contributed more films to this cycle, beginning with *To Have and Have Not*, for which Howard Hawks discovered nineteen-year-old Lauren Bacall, teaming her with the increasingly popular Humphrey Bogart. Warner continued with one or two crime films each year, even giving Bogart the honor of playing Raymond Chandler's detective Philip Marlowe in *The Big Sleep*, another Hawks hit.

Freelancer Barbara Stanwyck signed with Warner for the romantic romp *Christmas in Connecticut* and stayed for the wartime drama *My Reputation* and two mysteries: *The Two Mrs. Carrolls*, in which she was menaced by a psychotic Humphrey Bogart, and *Cry Wolf*, in which she was menaced by a psychotic Errol Flynn. Fans liked their stars dangerously handsome but not dangerous, so these films failed.

The Hollywood Canteen was a club where servicemen and -women could mingle with movie stars. This concept originated with Bette Davis and John Garfield, and it inspired the all-star Warner film *Hollywood Canteen*. On-screen entertainers included the Andrews Sisters, Jack Benny, Peter Lorre, Jane Wyman, and bandleader Jimmy Dorsey. One of the cameo appearances was made by a newly contracted player Joan Crawford, who had left M-G-M after fourteen years of stardom in hopes of finding better roles at Warner Bros.

Fortunately, Crawford found a sympathetic producer in Burbank. Jerry Wald had been a contract writer since 1934 and was promoted to producer by the respected journalist-turned-producer Mark Hellinger. With fifteen films under his belt, Wald knew enough to put Crawford in Michael Curtiz's *Mildred Pierce*. It became a great success, restored Crawford's career, and added another title to the growing list of hard-boiled crime films. Wald shepherded Crawford through a series of profitable melodrama-mysteries, keeping her in the front ranks, even as Bette Davis started to fall behind.

Objective, Burma! pulled Errol Flynn out of swashbucklers and Westerns and dropped him into World War II. Directed by Flynn's pal Raoul Walsh, the picture was based on the famed Merrill's Marauders. Another war story brought to the screen was *God Is My Co-Pilot*. Starring Dennis Morgan, the Robert Florey film was based on Robert Lee Scott's action-packed autobiography.

Movies continued to boom with a force not seen since the early talkies. World War II ended in Europe in May 1945 and in Asia in September 1945. After the celebrations quieted down, citizens trooped religiously into neighborhood theaters, where Warner presented them with more escapist fare. The musical biography was not new, but its subjects were. The life of the late George Gershwin was barely recognizable in Irving Rapper's *Rhapsody in Blue* (1945), which starred newcomer Robert Alda. The gifted, pixieish Cole Porter was the living subject of Michael Curtiz's *Night and Day*, played by Cary Grant, and in Technicolor, which wartime box office could afford.

Band singer Doris Day signed a personal contract with Michael Curtiz, who made the nervous girl a star with the tune-filled Technicolor *Romance on the High Seas* and *My Dream Is Yours*. Young Elizabeth Taylor was borrowed from M-G-M for Curtiz's production of the popular play *Life with Father*. Its star, William Powell, was also borrowed from M-G-M, and the charming film made number five for 1947, a year that would be remembered.

While Warner Bros. reported an all-time high of $22.1 million in profits, total industry grosses dropped from the 1946 high of $119 million to $87 million. This was attributed to a change in demographics caused by eleven million returning servicemen and -women, and by rising unemployment.

Next there was an unexpected (but not unprecedented) attack from the government. The House Un-American Activities Committee (HUAC) came from the House of Representatives, and its members

had long believed that Hollywood was a nest of communists. Hearings began in Los Angeles and then moved to Washington. Complacent and overconfident, actors like Robert Taylor and executives like Jack Warner were made to trip on their own words and were intimidated into saying that they had unwittingly been fed communist propaganda in the scripts of films like *Mission to Moscow*.

HUAC then subpoenaed ten writers who had allegedly created subversive content intended to overthrow America's democratic government. A group of liberal actors, including Humphrey Bogart and Marsha Hunt, formed a Committee for the First Amendment and flew to Washington in support of the so-called "Hollywood Ten," only to discover that a number of the Ten had indeed been Communist Party members. Worse, every member of the Ten read an angry statement to the HUAC committee, creating chaos at the hearings, which gave them jail terms for contempt. Some of the Ten broke down and gave names of other party members to HUAC, and the hearings degenerated into a witch hunt. Before it was over, more than five hundred Hollywood artists would lose their jobs and be blacklisted, in many cases because someone wanted their jobs or held a grudge, not because of communist leanings.

While this real-life drama was playing out, Warner Bros. executives tried to carry on with business as usual, but the industry was rife with mistrust and suspicion.

When Humphrey Bogart finished his public statements disavowing his involvement with the Committee of Ten, he returned to Warner to make *Key Largo* with John Huston. Also in the cast was Edward G. Robinson, who was about to be "gray-listed" by the studios because he had unwittingly donated money to communist groups years earlier. Huston and his stellar company crafted a superior film, but it had disappointing rentals.

Huston had already been to Mexico with Walter Huston, his father, to film an unusual Bogart vehicle, *The Treasure of the Sierra Madre*. In it, Bogart played a grubby, grasping expatriate who double-crosses his partners in an expedition to find gold, only to see it slip through his fingers as bandits close in on him. The film was uncompromising in its depiction of greed, and it was fairly well attended.

On May 3, 1948, the Supreme Court ruled that the five "major-major" studios (M-G-M, Paramount, RKO Radio, Twentieth Century-Fox, and Warner Bros.) were operating in violation of antitrust laws and would have to divest themselves of their theater chains. This was a body blow. And there would be more.

Why had industry grosses dropped to $48 million? One word: television. Radio had failed to displace the movies' share of the entertainment dollar. It looked as if television might do just that. The number of households with TVs was climbing toward two million with no lag in sight. There were ninety-eight TV stations. Hollywood was seeing the ritual of weekly movie attendance (sometime three times weekly) impacted by unemployment, a recession, disenchantment with predictable studio product—and television. If 1947 had been difficult, 1948 was downright disturbing. Warner Bros. laid off employees and tried to carry on as if nothing had changed, even if profits of $11.8 million were half of the previous year's.

Following his accomplishments of *Humoresque* and *Deep Valley*, Jean Negulesco directed *Johnny Belinda*, the affecting story of a deaf-mute girl. He took a chance on Jane Wyman, a longtime Warner

contract player who usually played bright comedy roles. Wyman deglamorized herself and gave a fine performance, and earned the Best Actress Oscar for her efforts.

Alfred Hitchcock, a newly independent producer after leaving a fractious partnership with David Selznick, saw his next two films distributed by Warner Bros. The first of these was *Rope*, in which he essayed the cinematic experiment of shooting an entire film magazine without turning off the camera; this was ten minutes. As edited, the shots changed only at

Hollywood was seeing the ritual of weekly movie attendance (sometime three times weekly) impacted by unemployment, a recession, disenchantment with predictable studio product—and television.

double-reel changes, which were every twenty minutes. *Rope* was also Hitchcock's first Technicolor film, and while it starred the ever-popular James Stewart, the film found no audience, perhaps because seeing so few cuts was subliminally disturbing to an audience used to dialectical montage. After *Rope* and *Under Capricorn*, Hitchcock would produce several films in-house at Warner Bros., starting with the 1950 release *Stage Fright*.

James Cagney returned to Warner in 1949 to play a gangster for the first time in a decade. The latest film released by his production company, *The Time of Your Life*, had done poorly, and the bank was worrying him for its money, so he gritted his teeth and signed onto Raoul Walsh's *White Heat*. He enjoyed playing a vicious criminal who has a mother fixation, but he did not enjoy the undercutting he got from Jack Warner,

who told producer Lou Edelman to reduce the size of any scene requiring more than a few extras. *White Heat* was a hit for Warner Bros. and the last Cagney film of its Golden Era.

As 1949 wound down, the studio expected a year-end profit of $10.5 million. Warner Bros. had released 286 features in the 1940s, a drop from the previous decade. Joan Crawford films were still making money, although Jack Warner tried to downplay their profits in memos to executives who had only to check ledgers or *Box Office* magazine to see that Crawford films were lucrative. (No one argued with Jack L.; there was no winning.) However, Bette Davis had suffered several disappointments in a row. Two of the films—*Deception* and *June Bride*—had been well written and directed, but *Winter Meeting* had been a misfire about a sophisticated poet and an ex-priest. For Davis's next film, producer Henry Blanke got her grudging approval of *Beyond the Forest*, a sexy best seller in the vein of *Madame Bovary*.

The studio brought in King Vidor to direct, and in short order he was turning *Beyond the Forest* into a sequel to his fevered, operatic *Duel in the Sun*. Although the film started production as *Rose Moline*, the character's name migrated to "Rosa," and *Beyond the Forest* began to look like Vidor's idea of what would have happened if Jennifer Jones had married Joseph Cotten and been stuck in a hick town—she would have gone mad trying to escape.

Davis defiantly rose to the occasion, making *Rosa Moline* a cartoon-like vamp. As Davis tried to finish *Beyond the Forest* without going as mad as her character, she made headlines by attempting to walk out of both the film and her contract. The messy business was finally cleaned up "by mutual consent." Davis's last official act was to dub a line required by the PCA: "If I don't get out of here, I'll die. If I don't get out of here, I hope I die. And burn." Then, after eighteen years, Bette Davis walked out of Warner Bros.

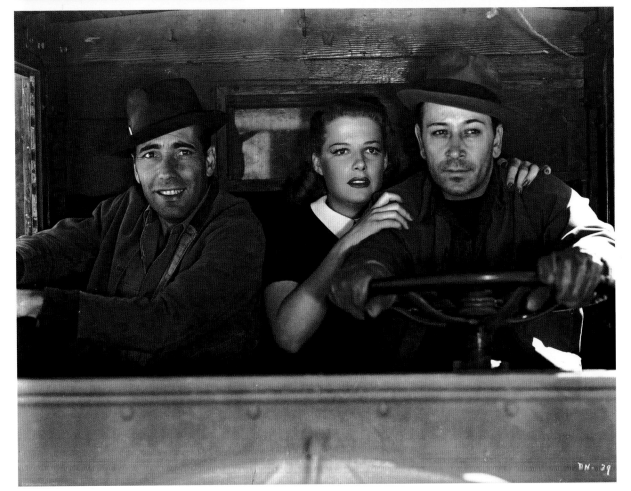

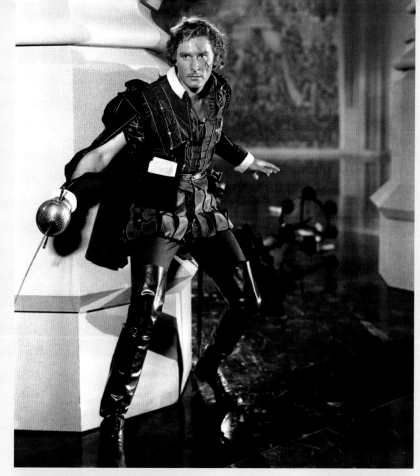

FROM TOP: Errol Flynn executes the obligatory (and enjoyable) duel in Michael Curtiz's *The Sea Hawk* (1940). • A George Hurrell photograph of Bette Davis made for Anatole Litvak's *All This, and Heaven, Too* (1940). **OPPOSITE, CLOCKWISE FROM TOP LEFT:** A portrait of Warner Bros. contract player Ronald Reagan. • Ann Sheridan, James Cagney, and Helen Vinson struck sparks in William Keighley's *Torrid Zone* (1940). • Humphrey Bogart, Ann Sheridan, and George Raft in Raoul Walsh's *They Drive by Night* (1940).

Bette Davis in the shocking first scene of William Wyler's *The Letter* (1940).

1940 ACADEMY AWARDS

WINS

Short Subject (Two-Reel):

★ *Teddy, the Rough Rider*, Warner Bros.

Special Award:

★ To Colonel Nathan Levinson for his outstanding service to the industry and the Army during the past nine years, which has made possible the present efficient mobilization of the motion picture industry facilities for the production of Army training films

Scientific or Technical Award (Class III):

★ To Warner Bros. Studio Art Department and Anton Grot for the design and perfection of the Warner Bros. water ripple and wave illusion machine

NOMINATIONS

Outstanding Production:

• *All This, and Heaven Too*, Warner Bros.

• *The Letter*, Warner Bros.

Directing:

• William Wyler for *The Letter*

Actress:

• Bette Davis in *The Letter*

Supporting Actor:

• James Stephenson in *The Letter*

Supporting Actress:

• Barbara O'Neil in *All This, and Heaven Too*

Writing (Original Screenplay):

• *Dr. Ehrlich's Magic Bullet*, Norman Burnside, Heinz Herald, and John Huston

Art Direction (Black-and-White):

• *The Sea Hawk*, Anton Grot

Cinematography (Black-and-White):

• *All This, and Heaven Too*, Ernest Haller

• *The Letter*, Gaetano Gaudio

Film Editing:

• *The Letter*, Warren Low

Music (Original Score):

• *The Letter*, Max Steiner

Music (Scoring):

• *The Sea Hawk*, Erich Wolfgang Korngold

Short Subject (Cartoon):

• *A Wild Hare*, Leon Schlesinger, Producer

Short Subject (One-Reel):

• *London Can Take It*, Warner Bros.

Short Subject (Two-Reel):

• *Service with the Colors*, Warner Bros.

Sound Recording:

• *The Sea Hawk*, Warner Bros. Studio Sound Department, Nathan Levinson, Sound Director

Special Effects:

• *The Sea Hawk*, Photographic Effects by Byron Haskin; Sound Effects by Nathan Levinson

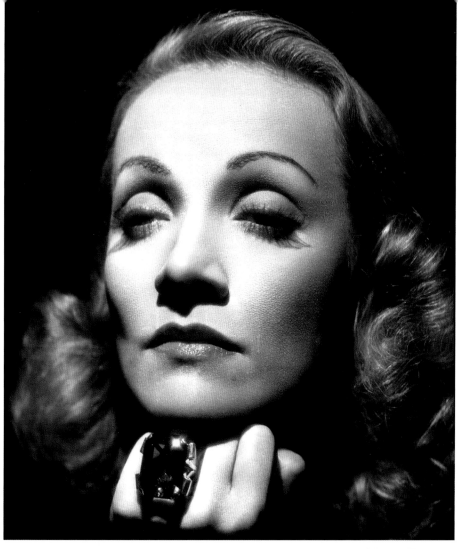

CLOCKWISE FROM TOP: A Bert Six portrait of Marlene Dietrich for Raoul Walsh's *Manpower* (1941). • A Scotty Welbourne portrait of Olivia de Havilland for *They Died with Their Boots On* (1941). • Rita Hayworth in a Scotty Welbourne portrait made for Raoul Walsh's *The Strawberry Blonde* (1941), a remake of the 1933 Paramount film *One Sunday Afternoon*, which was purchased by Warner—and buried for seventy years.

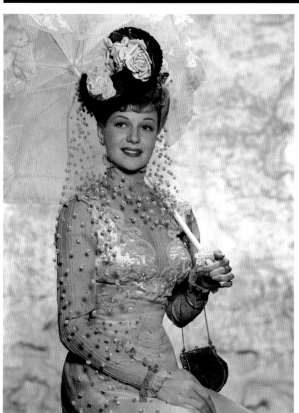

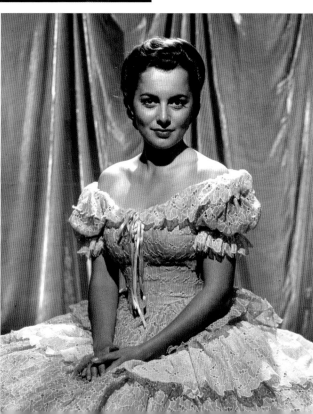

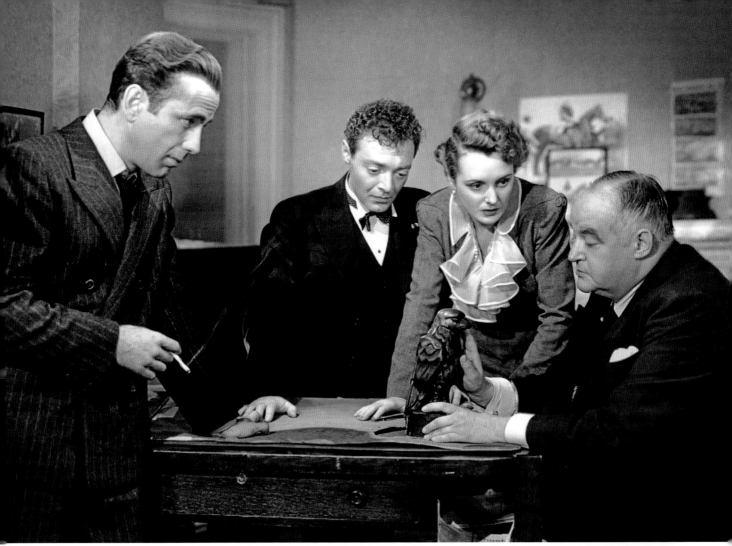

FROM TOP: Humphrey Bogart, Peter Lorre, Mary Astor, and Sydney Greenstreet in a publicity pose from John Huston's *The Maltese Falcon* (1941). This film—along with *Citizen Kane*—was noted by journalists as the beginning of a new trend called "hard-boiled," now known as film noir. • Gary Cooper helped make Howard Hawks's *Sergeant York* the blockbuster of 1941. **OPPOSITE, FROM LEFT:** Bette Davis (right), chides hungry Mary Astor in a scene from Edmund Goulding's *The Great Lie* (1941). • Moroni Olsen, Fredric March, Martha Scott, and Gene Lockhart in a scene from Irving Rapper's *One Foot in Heaven* (1941).

1941 ACADEMY AWARDS

WINS

Actor:
★ Gary Cooper in *Sergeant York*

Supporting Actress:
★ Mary Astor in *The Great Lie*

Film Editing:
★ *Sergeant York*, William Holmes

NOMINATIONS

Outstanding Motion Picture:
- *The Maltese Falcon*, Warner Bros.
- *One Foot in Heaven*, Warner Bros.
- *Sergeant York*, Warner Bros.

Directing:
- Howard Hawks for *Sergeant York*

Supporting Actor:
- Walter Brennan in *Sergeant York*
- Sydney Greenstreet in *The Maltese Falcon*

Supporting Actress:
- Margaret Wycherly in *Sergeant York*

Writing (Original Screenplay):
- *Sergeant York*, Harry Chandlee, Abem Finkel, John Huston, and Howard Koch

Writing (Original Story):
- *Meet John Doe*, Richard Connell and Robert Presnell

Writing (Screenplay):
- *The Maltese Falcon*, John Huston

Art Direction (Black-and-White):
- *Sergeant York*, Art Direction: John Hughes; Interior Decoration: Fred MacLean

Cinematography (Black-and-White):
- *Sergeant York*, Sol Polito

Cinematography (Color):
- *Dive Bomber*, Bert Glennon

Documentary (Short Subject):
- *Christmas under Fire*, British Ministry of Information

Music (Music Score of a Dramatic Picture):
- *Sergeant York*, Max Steiner

Music (Scoring of a Musical Picture):
- *The Strawberry Blonde*, Heinz Roemheld

Music (Song):
- "Blues in the Night" from *Blues in the Night*, Music by Harold Arlen; Lyrics by Johnny Mercer

Short Subject (Cartoon):
- *Hiawatha's Rabbit Hunt*, Leon Schlesinger, Producer
- *Rhapsody in Rivets*, Leon Schlesinger, Producer

Short Subject (One-Reel):
- *Forty Boys and a Song*, Warner Bros.
- *Kings of the Turf*, Warner Bros.

Short Subject (Two-Reel):
- *The Gay Parisian*, Warner Bros.
- *The Tanks Are Coming*, United States Army

Sound Recording:
- *Sergeant York*, Warner Bros. Studio Sound Department, Nathan Levinson, Sound Director

Special Effects:
- *The Sea Wolf*, Photographic Effects by Byron Haskin; Sound Effects by Nathan Levinson.

FROM TOP: Jeanne Cagney, James Cagney, Joan Leslie, Water Huston, and Rosemary DeCamp in a scene from Michael Curtiz's *Yankee Doodle Dandy*, one of the major hits of 1942.
• Ann Sheridan, Richard Travis, Bette Davis, and Monty Woolley enlivened William Keighley's *The Man Who Came to Dinner* (1942); charming cast members not pictured: Billie Burke, Grant Mitchell, Reggie Gardiner, Mary Wickes, Jimmy Durante, and a penguin.
OPPOSITE: A portrait of Humphrey Bogart made by Scotty Welbourne for Michael Curtiz's *Casablanca* (1942).

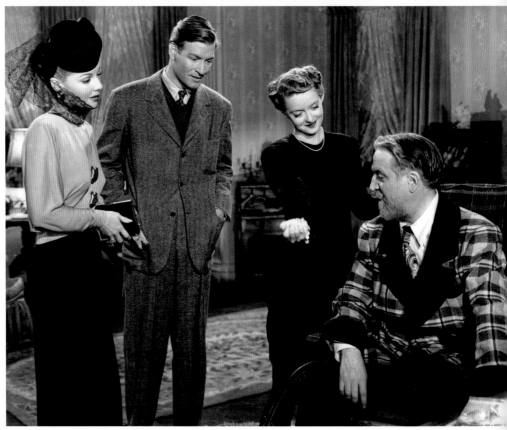

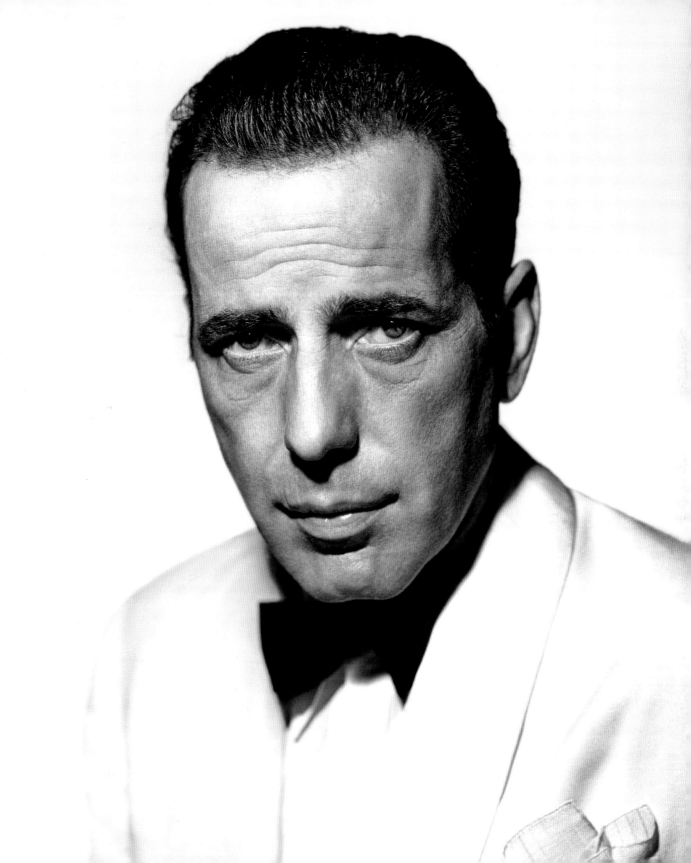

FROM TOP:
Cinematographer Arthur Edeson, Humphrey Bogart, and Ingrid Bergman on the set of *Casablanca*. • Dooley Wilson and Humphrey Bogart in a beloved scene from *Casablanca*.

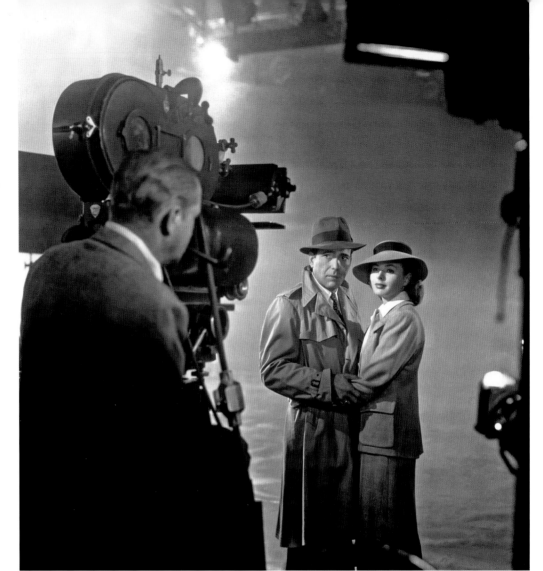

Ann Sheridan, Ronald Reagan, and Robert Cummings in a scene from Sam Wood's *Kings Row* (1942).

1942 ACADEMY AWARDS

WINS

Actor:
* ★ James Cagney in *Yankee Doodle Dandy*

Music (Music Score of a Dramatic or Comedy Picture):
* ★ *Now, Voyager*, Max Steiner

Music (Scoring of a Musical Picture):
* ★ *Yankee Doodle Dandy*, Ray Heindorf and Heinz Roemheld

Short Subject (Two-Reel):
* ★ *Beyond the Line of Duty*, Warner Bros.

Sound Recording:
* ★ *Yankee Doodle Dandy*, Warner Bros. Studio Sound Department, Nathan Levinson, Sound Director

NOMINATIONS

Outstanding Motion Picture:
* *Kings Row*, Warner Bros.
* *Yankee Doodle Dandy*, Warner Bros.

Directing:
* Michael Curtiz for *Yankee Doodle Dandy*
* Sam Wood for *Kings Row*

Actress:
* Bette Davis in *Now, Voyager*

Supporting Actor:
* Walter Huston in *Yankee Doodle Dandy*

Supporting Actress:
* Gladys Cooper in *Now, Voyager*

Writing (Original Motion Picture Story):
* *Yankee Doodle Dandy*, Robert Buckner

Art Direction (Black-and-White):
* *George Washington Slept Here*, Art Direction: Max Parker and Mark-Lee Kirk; Interior Decoration: Casey Roberts

Art Direction (Color):
* *Captains of the Clouds*, Art Direction: Ted Smith; Interior Decoration: Casey Roberts

Cinematography (Black-and-White):
* *Kings Row*, James Wong Howe

Cinematography (Color):
* *Captains of the Clouds*, Sol Polito

Documentary:
* *Little Isles of Freedom*, Victor Stoloff and Edgar Loew, Producers
* *A Ship Is Born*, United States Merchant Marine
* *Winning Your Wings*, United States Army Air Force

Film Editing:
* *Yankee Doodle Dandy*, George Amy

Music (Song):
* "Always in My Heart" from *Always in My Heart*, Music by Ernesto Lecuona; Lyrics by Kim Gannon

Short Subject (Cartoon):
* *Pigs in a Polka*, Leon Schlesinger, Producer

Short Subject (One-Reel):
* *United States Marine Band*, Warner Bros.

Special Effects:
* *Desperate Journey*, Photographic Effects by Byron Haskin; Sound Effects by Nathan Levinson

FROM TOP: Walter Huston in a publicity portrait for a controversial film, Michael Curtiz's *Mission to Moscow* (1943). • Raymond Massey and Humphrey Bogart in a combat scene from Lloyd Bacon's *Action in the North Atlantic* (1943). **RIGHT:** A publicity still showing the immense Stage 21, where Michael Curtiz was filming *This Is the Army* (1943), flanked by a freighter and a galleon.

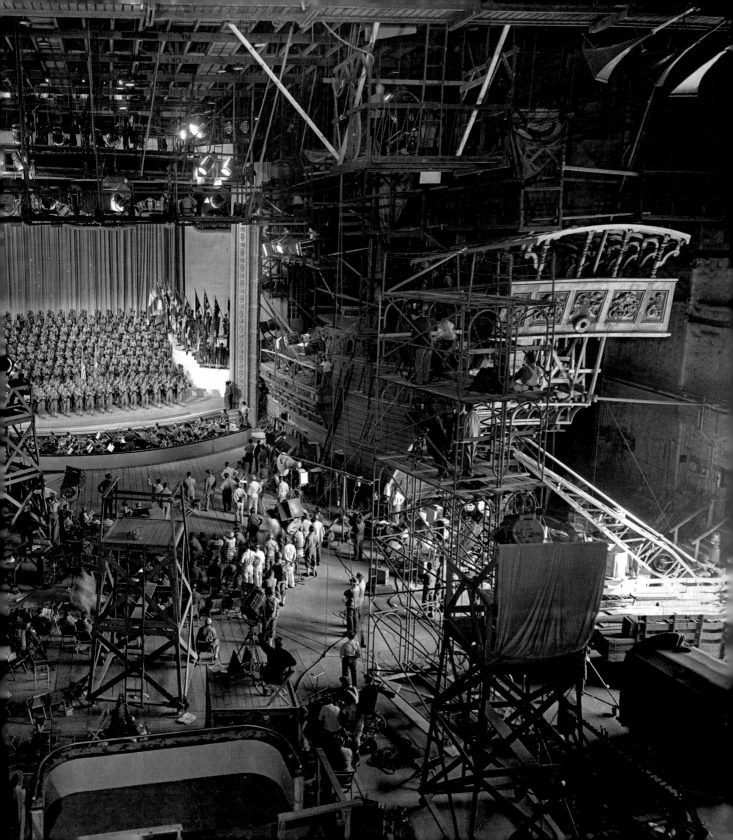

1943 ACADEMY AWARDS

WINS

Outstanding Motion Picture:
- ★ *Casablanca*, Warner Bros.

Directing:
- ★ Michael Curtiz for *Casablanca*

Actor:
- ★ Paul Lukas in *Watch on the Rhine*

Writing (Original Screenplay):
- ★ *Princess O'Rourke*, Norman Krasna

Writing (Screenplay):
- ★ *Casablanca*, Julius J. Epstein, Philip G. Epstein, and Howard Koch

Film Editing:
- ★ *Air Force*, George Amy

Music (Scoring of a Musical Picture):
- ★ *This Is the Army*, Ray Heindorf

Irving G. Thalberg Memorial Award:
- ★ Hal B. Wallis

NOMINATIONS

Outstanding Motion Picture:
- *Watch on the Rhine*, Warner Bros.

Actor:
- Humphrey Bogart in *Casablanca*

Actress:
- Joan Fontaine in *The Constant Nymph*

Supporting Actor:
- Claude Rains in *Casablanca*

Supporting Actress:
- Lucile Watson in *Watch on the Rhine*

Writing (Original Motion Picture Story):
- *Action in the North Atlantic*, Guy Gilpatric
- *Destination Tokyo*, Steve Fisher

Writing (Original Screenplay):
- *Air Force*, Dudley Nichols

Writing (Screenplay):
- *Watch on the Rhine*, Dashiell Hammett

Art Direction (Black-and-White):
- *Mission to Moscow*, Art Direction: Carl Weyl; Interior Decoration: George J. Hopkins

Art Direction (Color):
- *This is the Army*, Art Direction: John Hughes and Lt. John Koenig; Interior Decoration: George J. Hopkins

Cinematography (Black-and-White):
- *Air Force*, James Wong Howe, Elmer Dyer, and Charles Marshall
- *Casablanca*, Arthur Edeson

Film Editing:
- *Casablanca*, Owen Marks

Music (Music Score of a Dramatic or Comedy Picture):
- *Casablanca*, Max Steiner

Music (Song):
- "They're Either Too Young or Too Old," from *Thank Your Lucky Stars*, Music by Arthur Schwartz; Lyrics by Frank Loesser

Short Subject (Cartoon):
- *Greetings, Bait*, Leon Schlesinger, Producer

Short Subject (One-Reel):
- *Cavalcade of the Dance with Veloz and Yolanda*, Gordon Hollingshead, producer

Short Subject (Two-Reel):
- *Women at War,* Gordon Hollingshead, Producer

Sound Recording:
- *This Is the Army*, Warner Bros. Studio Sound Department, Nathan Levinson, Sound Director

Special Effects:
- *Air Force*, Photographic Effects by Hans Koenekamp and Rex Wimpy; Sound Effects by Nathan Levinson

OPPOSITE, FROM TOP: Bette Davis and Miriam Hopkins were directed by Vincent Sherman in *Old Acquaintance* (1943). • A publicity portrait of Bette Davis made for David Butler's *Thank Your Lucky Stars* (1943), a wartime update of the early talkie revues.

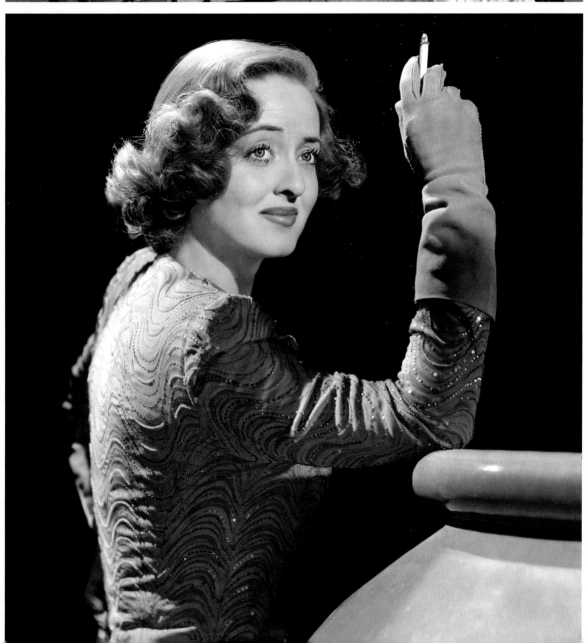

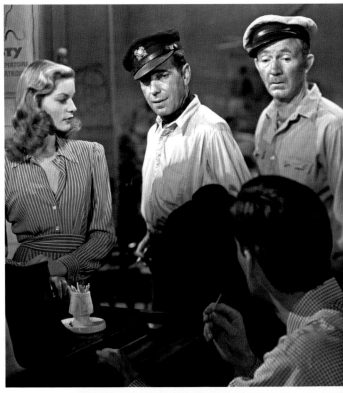

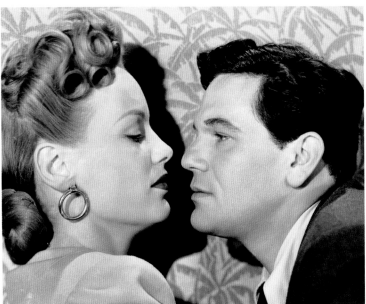

CLOCKWISE FROM TOP LEFT: Bette Davis played a vain, selfish woman in Vincent Sherman's *Mr. Skeffington* (1944). • Lauren Bacall, Humphrey Bogart, Walter Brennan, and Hoagy Carmichael (back to camera) in a scene from Howard Hawks's *To Have and Have Not* (1944). • A publicity shot of Alexis Smith for *The Constant Nymph* (1943). • Faye Emerson and John Garfield in Edward Blatt's *Between Two Worlds* (1944). **OPPOSITE:** Raymond Massey, Cary Grant, Jean Adair, and Josephine Hull in a typically madcap scene from Frank Capra's *Arsenic and Old Lace* (1944).

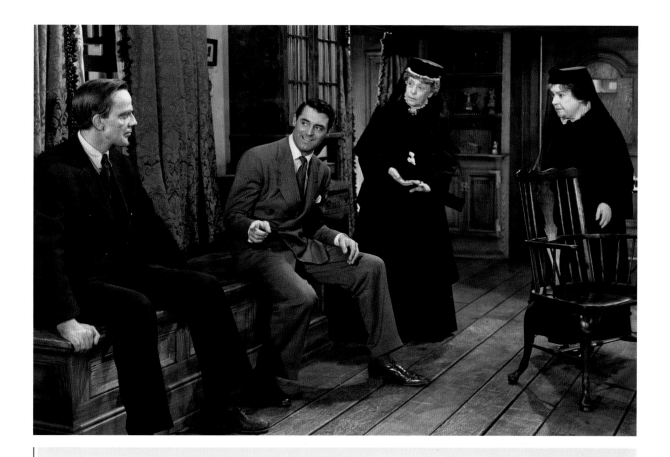

1944 ACADEMY AWARDS

WINS

Short Subject (Two-Reel):
* ★ *I Won't Play*, Gordon Hollingshead, Producer

NOMINATIONS

Actress:
* Bette Davis in *Mr. Skeffington*

Supporting Actor:
* Claude Rains in *Mr. Skeffington*

Art Direction (Black-and-White):
* *The Adventures of Mark Twain*, Art Direction: John J. Hughes; Interior Decoration: Fred MacLean

Art Direction (Color):
* *The Desert Song*, Art Direction: Charles Novi; Interior Decoration: Jack McConaghy

Film Editing:
* *Janie*, Owen Marks

Music (Music Score of a Dramatic or Comedy Picture):
* *The Adventures of Mark Twain*, Max Steiner

Music (Scoring of a Musical Picture):
* *Hollywood Canteen*, Ray Heindorf

Music (Song):
* "Sweet Dreams Sweetheart" from *Hollywood Canteen*, Music by M. K. Jerome; Lyrics by Ted Koehler

Short Subject (Cartoon):
* *Swooner Crooner*, Warner Bros.

Short Subject (One-Reel):
* *Jammin' the Blues*, Gordon Hollingshead, Producer

Sound Recording:
* *Hollywood Canteen*, Warner Bros. Studio Sound Department, Nathan Levinson, Sound Director

Special Effects:
* *The Adventures of Mark Twain*, Photographic Effects by Paul Detlefsen and John Crouse; Sound Effects by Nathan Levinson

A portrait of Ingrid Bergman made for Sam Wood's *Saratoga Trunk* (1945). **OPPOSITE, FROM TOP:** Jack Warner's faith in Joan Crawford, whose M-G-M career had stalled, revitalized her professionally and brought Warner Bros. a profitable new star. She is seen here with Zachary Scott on the set of Michael Curtiz's *Mildred Pierce* (1945). • Ann Blyth and Joan Crawford in the turning point of Michael Curtiz's *Mildred Pierce* (1945), a tremendous hit.

1945 ACADEMY AWARDS

WINS

Actress:

★ Joan Crawford in *Mildred Pierce*

Documentary (Short Subject):

★ *Hitler Lives?*, Gordon Hollingshead, Producer

Short Subject (Two-Reel):

★ *Star in the Night*, Gordon Hollingshead, Producer

NOMINATIONS

Best Motion Picture:

• *Mildred Pierce*, Warner Bros.

Supporting Actor:

• John Dall in *The Corn Is Green*

Supporting Actress:

• Eve Arden in *Mildred Pierce*

• Ann Blyth in *Mildred Pierce*

• Joan Lorring in *The Corn Is Green*

Writing (Original Motion Picture Story):

• *Objective, Burma!*, Alvah Bessie

Writing (Screenplay):

• *Mildred Pierce*, Ranald MacDougall

• *Pride of the Marines*, Albert Maltz

Art Direction (Color):

• *San Antonio*, Art Direction: Ted Smith; Interior Decoration: Jack McConaghy

Cinematography (Black-and-White):

• *Mildred Pierce*, Ernest Haller

Film Editing:

• *Objective, Burma!*, George Amy

Music (Music Score of a Dramatic or Comedy Picture):

• *Objective, Burma!*, Franz Waxman

Music (Scoring of a Musical Picture):

• *Rhapsody in Blue*, Ray Heindorf and Max Steiner

Music (Song):

• "Some Sunday Morning" from *San Antonio*, Music by Ray Heindorf and M. K. Jerome; Lyrics by Ted Koehler

Short Subject (Cartoon):

• *Life with Feathers*, Eddie Selzer, Producer

Short Subject (One-Reel):

• *Story of a Dog*, Gordon Hollingshead, Producer

Sound Recording:

• *Rhapsody in Blue*, Warner Bros. Studio Sound Department, Nathan Levinson, Sound Director

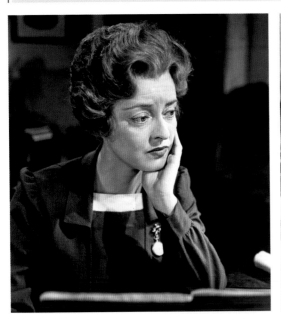

FROM LEFT: Bette Davis played a dedicated Welsh schoolteacher in Irving Rapper's *The Corn Is Green* (1945). • Robert Alda as George Gershwin in a scene from Irving Rapper's *Rhapsody in Blue* (1945).

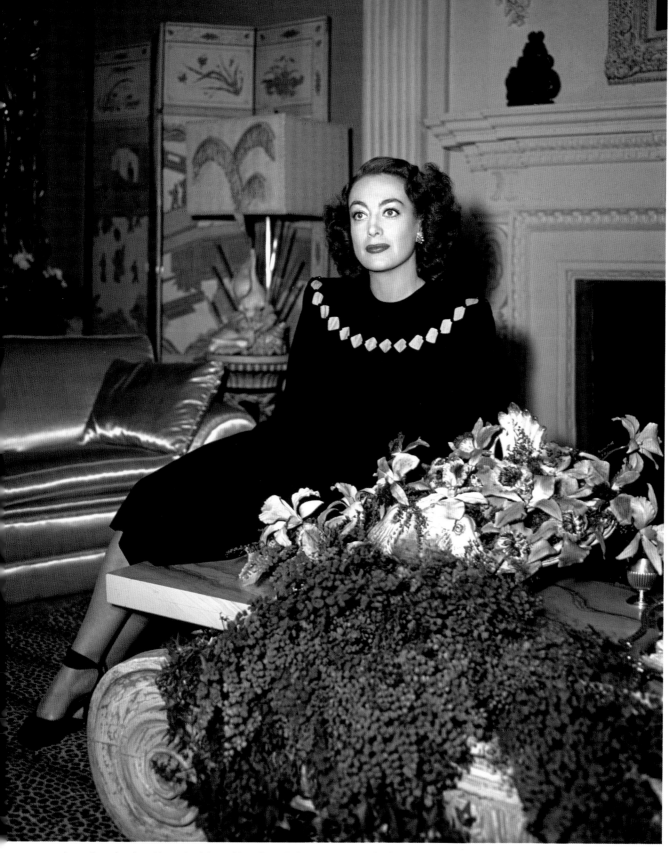

Joan Crawford on the set of Jean Negulesco's *Humoresque* (1946).

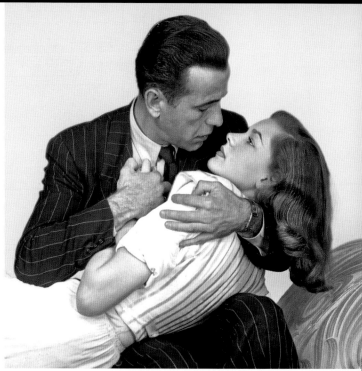

1946 ACADEMY AWARDS

WINS

Short Subject (One-Reel):

★ *Facing Your Danger*, Gordon Hollingshead, Producer

Short Subject (Two-Reel):

★ *A Boy and His Dog*, Gordon Hollingshead, Producer

Scientific or Technical Award (Class III):

★ To Burton F. Miller and the Warner Bros. Studio Sound and Electrical Departments for the design and construction of a motion picture arc lighting generator filter

★ To Burton F. Miller and the Warner Bros. Studio Sound Department for the design and application of an equalizer to eliminate relative spectral energy distortion in electronic compressors

★ To Harold Nye and the Warner Bros. Studio Electrical Department for the development of the electronically controlled fire and gaslight effect

NOMINATIONS

Supporting Actress:

• Flora Robson in *Saratoga Trunk*

Music (Music Score of a Dramatic or Comedy Picture):

• *Humoresque*, Franz Waxman

Music (Scoring of a Musical Picture):

• *Night and Day*, Ray Heindorf and Max Steiner

Short Subject (Cartoon):

• *Walky Talky Hawky*, Edward Selzer, Producer

Short Subject (One-Reel):

• *Smart as a Fox*, Gordon Hollingshead, Producer

Special Effects:

• *A Stolen Life*, Special Visual Effects by William McGann; Special Audible Effects by Nathan Levinson

FROM TOP: Barbara Stanwyck is slandered in a scene from Curtis Bernhardt's *My Reputation* (1946). • Paul Henreid, Olivia de Havilland, Ida Lupino, and Nancy Coleman in a scene from Curtis Bernhardt's *Devotion* (1946). **OPPOSITE, CLOCKWISE FROM TOP LEFT:** Glenn Ford and Bette Davis in a scene from Curtis Bernhardt's mystery film, *A Stolen Life* (1946). • A portrait of Humphrey Bogart and Lauren Bacall made for Howard Hawks's *The Big Sleep* (1946). • A publicity portrait of Cary Grant and Alexis Smith for Michael Curtiz's *Night and Day* (1946).

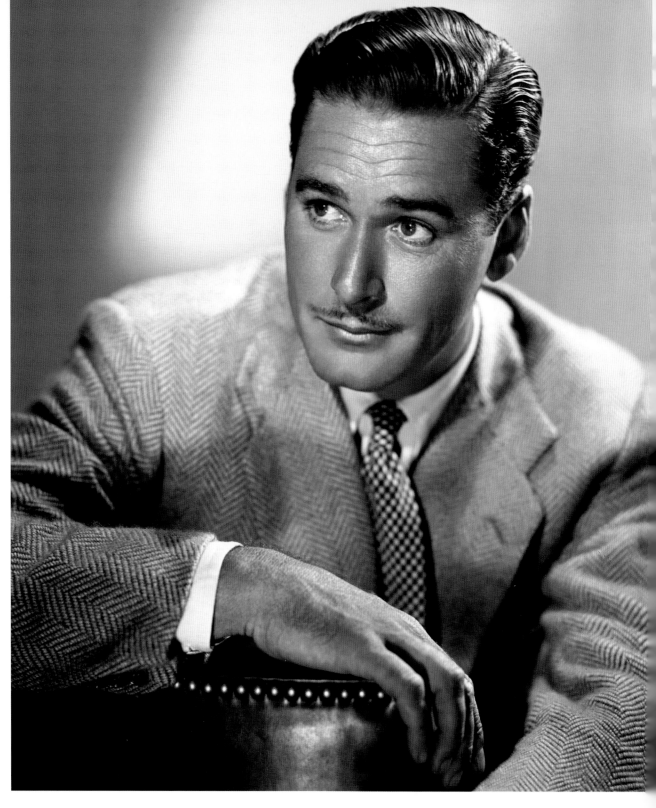

A 1942 portrait of Errol Flynn by Bert Six **OPPOSITE, FROM TOP:** (Clockwise) Irene Dunne, Jimmy Lydon, Martin Milner, Johnny Calkins, William Powell, and Derek Scott in Michael Curtiz's *Life with Father* (1947). • Ann Sheridan was popular enough to negotiate a better contract, so she stayed with Warner Bros. and made Vincent Sherman's *Nora Prentiss* (1947). • A portrait of Ida Lupino and Robert Alda made for Raoul Walsh's *The Man I Love* (1947).

Lobby card from the Merrie Melodies cartoon "Tweetie Pie" (1947).

1947 ACADEMY AWARDS

WINS

Short Subject (Cartoon):

★ *Tweetie Pie*, Edward Selzer, Producer

Scientific or Technical Award (Class III):

★ To Nathan Levinson and the Warner Bros. Studio Sound Department for the design and construction of a constant-speed sound-editing machine

★ To Fred Ponedel of Warner Bros. Studio for pioneering the fabrication and practical application to motion picture color photography of large translucent photographic backgrounds

★ To James Gibbons of Warner Bros. Studio for the development and production of large dyed plastic filters for motion picture photography

NOMINATIONS

Actor:

• William Powell in *Life with Father*

Actress:

• Joan Crawford in *Possessed*

Art Direction (Color):

• *Life with Father*, Art Direction: Robert M. Haas; Set Decoration: George James Hopkins

Cinematography (Color):

• *Life with Father*, Peverell Marley and William V. Skall

Music (Music Score of a Dramatic or Comedy Picture):

• *Life with Father*, Max Steiner

Music (Scoring of a Musical Picture):

• *My Wild Irish Rose*, Ray Heindorf and Max Steiner

Music (Song):

• "A Gal in Calico" from *The Time, The Place and the Girl*, Music by Arthur Schwartz; Lyrics by Leo Robin

Short Subject (One-Reel):

• *So You Want to Be in Pictures*, Gordon Hollingshead, Producer

FROM TOP: Bette Davis and Robert Montgomery match wits in Bretaigne Windust's *June Bride* (1948). • Errol Flynn and Ann Rutherford in a scene from Vincent Sherman's *Adventures of Don Juan* (1948).

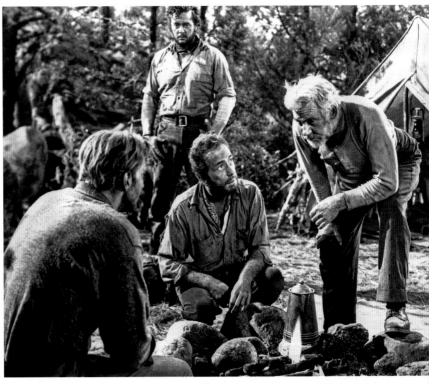

1948 ACADEMY AWARDS

WINS

Directing:

★ John Huston for *The Treasure of the Sierra Madre*

Actress:

★ Jane Wyman in *Johnny Belinda*

Supporting Actor:

★ Walter Huston in *The Treasure of the Sierra Madre*

Supporting Actress:

★ Claire Trevor in *Key Largo*

Writing (Screenplay):

★ *The Treasure of the Sierra Madre*, John Huston

Irving G. Thalberg Memorial Award:

★ Jerry Wald

Scientific or Technical Award (Class III):

★ To A. J. Moran and the Warner Bros. Studio Electrical Department for a method of remote control for shutters on motion picture arc lighting equipment

NOMINATIONS

Best Motion Picture:

• *Johnny Belinda*, Warner Bros.

• *The Treasure of the Sierra Madre*, Warner Bros.

Directing:

• Jean Negulesco for *Johnny Belinda*

Actor:

• Lew Ayres in *Johnny Belinda*

Supporting Actor:

• Charles Bickford in *Johnny Belinda*

Supporting Actress:

• Agnes Moorehead in *Johnny Belinda*

Writing (Screenplay):

• *Johnny Belinda*, Irmgard Von Cube and Allen Vincent

Art Direction (Black-and-White):

• *Johnny Belinda*, Art Direction: Robert Haas; Set Decoration: William Wallace

Cinematography (Black-and-White):

• *Johnny Belinda*, Ted McCord

Film Editing:

• *Johnny Belinda*, David Weisbart

Music (Music Score of a Dramatic or Comedy Picture):

• *Johnny Belinda*, Max Steiner

Music (Scoring of a Musical Picture):

• *Romance on the High Seas*, Ray Heindorf

Music (Song):

• "It's Magic" from *Romance on the High Seas*, Music by Jule Styne; Lyrics by Sammy Cahn

Short Subject (Cartoon):

• *Mouse Wreckers*, Edward Selzer, Producer

Short Subject (One-Reel):

• *Cinderella Horse*, Gordon Hollingshead, Producer

• *So You Want to Be on the Radio*, Gordon Hollingshead, Producer

Short Subject (Two-Reel):

• *Calgary Stampede*, Gordon Hollingshead, Producer

Sound Recording:

• *Johnny Belinda*, Warner Bros. Studio Sound Department, Col. Nathan O. Levinson, Sound Director

OPPOSITE, CLOCKWISE FROM TOP LEFT: A portrait of Jane Wyman made by Bert Six for Jean Negulesco's *Johnny Belinda* (1948). • Bruce Bennett, Tim Holt (standing), Humphrey Bogart, and Walter Huston in a scene from John Huston's *The Treasure of the Sierra Madre* (1948). • Humphrey Bogart, Harry Lewis, Lionel Barrymore, Lauren Bacall, and Edward G. Robinson in a scene from John Huston's *Key Largo* (1948), a masterly film that signaled the end of the "gangster rally." • A 1948 Harry Warnecke portrait of Doris Day.

Patricia Neal and Gary Cooper brought passion to King Vidor's *The Fountainhead* (1949). **OPPOSITE, FROM TOP:** James Cagney ended the 1940s with a fiery finale, the last scene of Raoul Walsh's *White Heat* (1949). • King Vidor's *Beyond the Forest* (1949) was Bette Davis's own fiery farewell after eighteen years at Warner Bros.

1949 ACADEMY AWARDS

WINS

Costume Design (Color):

★ *Adventures of Don Juan*, Leah Rhodes, Travilla, and Marjorie Best

Documentary (Short Subject):

★ *So Much for So Little*, Edward Selzer, Producer

Short Subject (Cartoon):

★ *For Scent-Imental Reasons*, Edward Selzer, Producer

NOMINATIONS

Actor:

• Richard Todd in *The Hasty Heart*

Writing (Motion Picture Story):

• *White Heat*, Virginia Kellogg

Art Direction (Color):

• *Adventures of Don Juan*, Art Direction: Edward Carrere; Set Decoration: Lyle Reifsnider

Music (Music Score of a Dramatic or Comedy Picture):

• *Beyond the Forest*, Max Steiner

Music (Scoring of a Musical Picture):

• *Look for the Silver Lining*, Ray Heindorf

Music (Song):

• "It's a Great Feeling" from *It's a Great Feeling*, Music by Jule Styne; Lyrics by Sammy Cahn

Short Subject (One-Reel):

• *So You Think You're Not Guilty*, Gordon Hollingshead, Producer

• *Spills and Chills*, Walton C. Ament, Producer

Short Subject (Two-Reel):

• *The Grass Is Always Greener*, Gordon Hollingshead, Producer

• *Snow Carnival*, Gordon Hollingshead, Producer

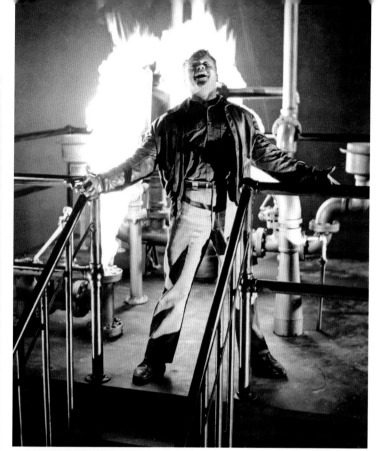

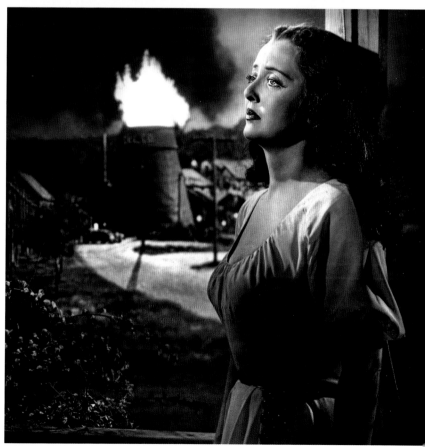

CHAPTER FOUR

THE
1950s:
GIMMICKS, EPICS, AND DESIRE

I N 1950, AS THE GROUND UNDER THE STUDIOS SHOOK AND SHIFTED, WARNER BROS. tried to keep its balance. Television ownership had soared to 15 million, roughly 30 percent of American households. By 1952, weekly movie attendance had dropped from the 1946 high of 86 million to 43 million, and the loss of Warner theater chains in 1953 pushed the already diminished profits of $10 million down to $2.9 million. Jack Warner responded by canceling long-term contracts (Joan Crawford, Errol Flynn, John Garfield), closing the story department, and laying off 6 percent of his employees. One star saved him the trouble; Kirk Douglas was so eager to leave Warner that he made *The Big Trees* without salary in exchange for release from his contract.

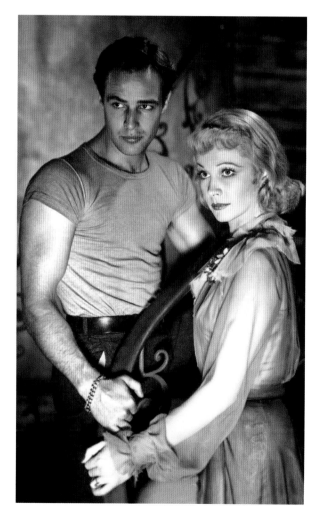

A Bert Six portrait of Vivien Leigh and Marlon Brando for Elia Kazan's *A Streetcar Named Desire* (1951). Brando's Method acting and Kazan's directing would influence the studio for the entire 1950s.

Television continued to encroach. At first there was no possibility of peaceful coexistence. The industry's only strategy was to offer what television could not. Thus followed a three-pronged defense: adult themes, epic productions, and technological gimmicks.

Television was programmed for the American living room, so it broadcast only family fare. Warner Bros. offered themes that could not play on TV. The claustrophobic *Caged*, the tortured *Young Man with a Horn*, and the agonized *Come Fill the Cup* were not family fare. Likewise, the plays of Tennessee Williams—*The Glass Menagerie* and *A Streetcar Named Desire*—were too morbid for TV, even when bound to the strictures of the Production Code Administration. Jack Warner beat his former production heads to the punch in securing these properties; Zanuck and Wallis would film other Williams plays, but these were the most desirable.

Elia Kazan, a major force in the New York theater, had directed the Broadway presentation of *A Streetcar Named Desire* in 1947. The hit play introduced Marlon Brando, so he and Karl Malden were brought to Warner for the film version. Vivien Leigh was cast as Blanche, after having triumphed on the London stage in the role. There were bitter arguments with Joseph Breen and the PCA over story elements that included rape and homosexuality. This resulted in cuts to the script before filming and to the negative before release, but *A Streetcar Named Desire* became the fourth top earner of 1951.

In addition to Brando and Malden, many so-called Method actors worked at Warner Bros., where their introspective techniques were honored. John Garfield had been the first to come from the New York stage, but Montgomery Clift, Eli Wallach, and Julie Harris would also work at Warner. Garfield starred in *The Breaking Point*, the studio's second version of Ernest Hemingway's novel *To Have and Have Not*. Sadly, this was Garfield's fifth and last outing with Michael Curtiz. Garfield was subpoenaed by the House Un-American Activities Committee in 1951, refused to name names, and was blacklisted, dying of a heart attack in 1952 at age thirty-nine.

Producer-director Alfred Hitchcock got along with Jack Warner, so he went from releasing his Transatlantic productions through Warner to producing his films under the Warner aegis. His first was *Stage Fright*, the unlikely pairing of Jane Wyman and Marlene Dietrich; then his perverse *Strangers on a Train*; his quasi-religious *I Confess*; his gruesome *Dial M for Murder*, on which he reluctantly used 3-D; and his nightmarish *The Wrong Man*.

Doris Day and Michael Curtiz continued their cheerful collaboration with a drama, *Young Man with a Horn*, and *I'll See You in My Dreams*, a biography of songwriter Gus Kahn. Doris Day and singer Gordon MacRae became a team in five pictures, including *Tea for Two*, *On Moonlight Bay*, and *By the Light of the Silvery Moon*.

Drive-in movie theaters were the rage with teenagers, and they liked science fiction. Warner produced some and picked up others. Jack Dietz had made *The Beast from 20,000 Fathoms* for his independent company Mutual, and he innocently offered the film to Jack Warner for a distribution deal. The crafty mogul offered the cash-poor Dietz $450,000 for a buyout. Eugène Lourié's film, with special effects by Ray Harryhausen, became one of the highest-grossing Warner films of 1953, earning $5 million. It was followed by an actual Warner horror production, *Them!*, where giant ants brought giant profits.

Agents had risen to power in the '40s and were helping former contract stars form production companies. Charles K. Feldman functioned as much as a producer as he did an agent, getting *Streetcar* to Warner, taking it back after its initial run, and then leasing it to Twentieth Century-Fox for a profitable reissue. John Wayne formed a production company called Wayne-Fellows Productions (later changed to Batjac Productions in 1954). Its most successful project was William Wellman's *The High and the Mighty*, and Feldman made sure that Wayne retained the rights to his Warner films. However, he could not get Jack Warner to pay Wayne all the profits he was owed; even a confrontation at a party could not get Warner to budge, so Wayne let it go.

While the studios were desperate to pull audiences from the "tube," it took time to develop new technology. Following the debuts of Cinerama and three-dimensional films in 1952, Warner in 1953 announced "the first 3-D film produced by a major studio," André de Toth's *House of Wax*. This remake of the 1933 *Mystery of the Wax Museum* starred Vincent Price as the high-strung, murderous artist. *House of Wax* was a hit,

Following the debuts of Cinerama and three-dimensional films in 1952, Warner in 1953 announced "the first 3-D film produced by a major studio."

the fourth-highest earner of the year. Curiously, the film's story dealt with a devastating fire. It was shot on the lot's New York street—which had just been rebuilt after a fire. On May 16, 1952, Burt Lancaster and Ray Bolger had run from soundstages to help firemen fight a raging blaze. Eight acres were destroyed, including a train shed, a soundstage, the French street, and numerous other "locale" streets. A recognizable façade of arches and stone steps used in *The Roaring Twenties*, *Deception*, *Mission to Moscow*, and many other films fell in a fiery roar. A second fire occurred on July 9, 1952,

and although arson was suspected, it was never proven. No Warner feature perished. The fires did not reach the vaults, but a significant number of silent features and early Technicolor talkies succumbed to nitrate decay before M-G-M made preservation a Hollywood watchword a decade later.

When Darryl Zanuck and Twentieth announced CinemaScope production in early 1953 with Henry Koster's religious epic *The Robe*, the major studios responded in different ways. Paramount developed VistaVision. Many other studios decided to matte the top and bottom of a standard square aperture, thereby creating a "wide screen" rather than spend money on an anamorphic process which Fox had patented. Eventually, MGM and later Warner Bros. signed up with Fox and paid to license the CinemaScope process and the name. Warners began production on *The Command*, starring Guy Madison and James Whitmore, with Zeiss lenses intended to be used as its own widescreen process, "WarnerScope," but by the time of release, the studio had signed a deal for CinemaScope with Fox. Warner Bros. heavily promoted the film being in CinemaScope, announcing the process in its advertising in the same size as the movie title.

One of the first Warner films to make creative use of widescreen was George Cukor's *A Star Is Born*. This film marked the return to films, after four years, of the prodigiously talented Judy Garland. When theater owners complained about the film's length, hoping to get more showings per day, the studio cut it down from 181 minutes to 154 without consulting Cukor or Garland, who were devastated by the result. Given its high cost, the film failed to break even.

The film industry was changing but still relied on genres. Most large-scale Warner projects featured adventurers, swashbucklers, or cowboys. The dynamic Burt Lancaster came to the studio with *The Flame and the Arrow*, and his Warner projects (unlike his offbeat Hal Wallis projects at Paramount) displayed his acrobatic talent, his teeth, and his torso.

Alan Ladd, who was arguably Paramount's biggest moneymaker in the forties, formed his own company, Jaguar Productions, and released several films through Warner Bros., beginning with Delmer Daves's *Drum*

The film industry was changing but still relied on genres. Most large-scale Warner projects featured adventurers, swashbucklers, or cowboys.

Beat. Ladd was a crowd-pleaser in westerns, so the arrangement was a happy one. Randolph Scott, another Paramount star, came to Warner, making a dozen good westerns. Even Doris Day got into the genre with *Calamity Jane*, mixing music and roughhousing.

Mervyn LeRoy, divorced from Harry Warner's daughter Doris in 1945, came back from nearly twenty years of distinguished producing (and directing) at M-G-M to help John Ford when the veteran director fell ill. LeRoy completed Ford's film *Mister Roberts*, which starred Henry Fonda and James Cagney, and it became the studio's number-three earner for 1955. Number four was *Battle Cry*, a Marine battalion drama, directed by veteran Raoul Walsh. LeRoy had another hit with his villainous little-girl shocker *The Bad Seed*.

While other studios lost interest in grooming stars and maintaining a stable, Warner Bros. continued to develop talent. New faces were signed every year: Natalie Wood, Tab Hunter, Dorothy Provine. If a feature role was not available, a new contract player was assigned to a Warner TV show. Some achieved fame on television first, then went to features, with James Garner, Connie Stevens, Angie Dickinson, among them.

James Dean had his first leading role in Elia Kazan's *East of Eden* and was immediately embraced by young audiences, who next experienced his star power in Nicholas Ray's *Rebel Without a Cause*. Director George Stevens then cast Dean alongside Elizabeth Taylor and Rock Hudson in his epic adaptation of the best-selling

Edna Ferber novel *Giant*. But before either *Rebel* or *Giant* could be released, Dean was killed in a highway collision. As happened with Rudolph Valentino in 1926 and Jean Harlow in 1937, death brought mythic status to James Dean. His posthumous films saw towering profits. *Giant* became number three at the box office in 1956, grossing $30 million.

By 1955, the standoff between the film industry and television had relaxed. It had to, with 17,000 theaters competing against 23 million TV sets. For Warner, détente meant two things: selling its film library and creating TV content. Its library of 850 pre-1950 features was sold for syndication to Associated Artists Productions (a.a.p.) in 1956, although it was more than a year before features such as *Mildred Pierce* were aired on *The Late Show*. The first Warner TV production, *Warner Bros. Presents*, included the first one-hour western series, *Cheyenne*. Its success spawned a school of Warner TV series, as *Maverick, 77 Sunset Strip*, and *The Roaring Twenties* generated revenue that features did not.

Kazan's *A Face in the Crowd* featured Andy Griffith in his film debut as a demagogue using television to recruit followers, which seemed like a far-fetched

By 1955, the standoff between the film industry and television had relaxed. For Warner, détente meant two things: selling its film library and creating TV content.

idea at the time. Kazan's *Baby Doll*, with Carroll Baker and Karl Malden, was an adult comedy based on a Tennessee Williams play, and it raised hackles with its little-girl sensuality.

The Searchers was the quintessential John Ford film, with John Wayne as a Civil War veteran bent on revenge, but its elegiac approach to the Old West affected its box office, which was only $4 million. John Huston's

Moby Dick did slightly better, with $5 million. Billy Wilder's *The Spirit of St. Louis* was a visual soliloquy as James Stewart retraced Charles Lindbergh's solo flight across the Atlantic, but production overruns precluded a profit.

Sayonara, starring Marlon Brando and featuring James Garner and Ricardo Montalban, was number three for 1957, even though it advocated interracial marriage, which was still outlawed in thirty states. The film was made partially on location in Tokyo and Kyoto in Technirama, a widescreen process similar to VistaVision in that the film ran past the lens horizontally instead of vertically.

In 1957, Marilyn Monroe ventured from Twentieth Century-Fox to make *The Prince and the Showgirl*. The romantic comedy co-starred Laurence Olivier, who had served as director and star of the Terence Rattigan play in London, so the film was shot entirely at Pinewood Studios. Another British-based film was *The Curse of Frankenstein*, an acquisition from Hammer Film Productions; this was Hammer's first color horror film, and the first of its Frankenstein series. The film established "Hammer Horror" as a brand of Gothic cinema, and Peter Cushing had his first lead part in this film, one of many he would make with his friend Christopher Lee.

In 1958, two more Broadway hits were brought to the screen. *Auntie Mame*, directed by Morton DaCosta and starring Rosalind Russell, who had starred in the play, became the number-two domestic earner. *No Time for Sergeants*, starring Andy Griffith, who had been in the play, was number four. Once again, great stars in great plays made great hits. This was not so with a renowned novel, *The Old Man and the Sea*. A protracted production, it started with Fred Zinnemann directing and ended with John Sturges, which ballooned the budget. Although author Ernest Hemingway was happy with the film, Spencer Tracy's performance was not enough to offset the sadness of watching a fisherman make the biggest catch of his life, only to lose it to a turn of fate. The film was a box-office disappointment.

Drive-in attendance peaked in 1958, as teenagers lined up in their cars to watch glossy depictions of teenage trauma. In *A Summer Place* (1959), Sandra Dee and Troy Donahue were indeed glossy, and Constance Ford's attacks on her daughter were traumatic for many a teen. Delmer Daves made the film one of the studio's biggest hits.

In a throwback to the studio's Errol Flynn westerns, Howard Hawks made *Rio Bravo* a robust entertainment. It starred John Wayne, Dean Martin, new contract player Angie Dickinson and, for the younger audience, teen idol Ricky Nelson.

Jack Warner was reluctant to let Fred Zinnemann direct *The Nun's Story*, opining that no one would want to watch a movie about a nun. Warner might have recalled that his Stanley Theatre chain was enriched by its Roman Catholic patrons, and although the Catholic Church looked askance at the Kathryn Hulme novel on which the film was based, Catholics would feel duty bound to see the film. The film was a smash success and Audrey Hepburn's portrait of a woman at the crossroads brought the company $12 million and eight Oscar nominations, including Best Picture.

A sad postscript to the more glamorous era was Art Napoleon's *Too Much, Too Soon*. This low-budget production purported to relate the story of Diana Barrymore's last days with her father John, the great actor who had helped Warner achieve prominence. The film starred Dorothy Malone and, of all people, Errol Flynn, who was returning to his studio for the first time in five years. In his dashing days, Flynn had been Barrymore's drinking buddy, but by this point Flynn had achieved only the same dissipation, and most critics found his impersonation of the Great Profile lacking. The film was Flynn's last for his home studio.

As the fifties ended, Warner Bros. had released 252 features, not much of a drop from the forties, although a sizable portion comprised distribution deals. Warner was known as much for its television franchises as for its feature releases; in addition, it had created Warner Bros. Records in 1958.

The studio was also known for corporate struggles. In 1956, the three Warner brothers—Albert, Harry, and Jack—decided to sell the company to an investment

It was obvious to Harry and Albert that Jack had used a side-door deal to buy back his stock and seize the presidency of the company. This news tore the Warner brothers asunder.

group headed by a shadowy figure named Serge Semenenko. The ink was barely dry on the transfer papers when the trades announced that Jack Warner was going to remain at the studio, and for the first time since 1923, he would have the title of president. It was obvious to Harry and Albert that Jack had used a side-door deal to buy back his stock and seize the presidency of the company. This news tore the Warner brothers asunder. Harry died two years later. Albert never spoke to Jack again. For a company founded on unanimity, this was the saddest postscript of all.

Kirk Douglas is obsessed with elusive Lauren Bacall in Michael Curtiz's *Young Man with a Horn* (1950). **OPPOSITE, CLOCKWISE FROM TOP LEFT:** Marlene Dietrich played a glamorous murder suspect in Alfred Hitchcock's *Stage Fright* (1950). • Jane Wyman and her only friend, a unicorn, in Irving Rapper's *The Glass Menagerie* (1950). • A Bert Six portrait of Lauren Bacall. • Ginger Rogers in a portrait made by Bert Six for Stuart Heisler's *Storm Warning* (1950), a frightening look at the Ku Klux Klan.

1950 ACADEMY AWARDS

WINS

Short Subject (One-Reel):

★ *Grandad of Races*, Gordon Hollingshead, Producer

NOMINATIONS

Actress:

- Eleanor Parker in *Caged*

Supporting Actress:

- Hope Emerson in *Caged*

Writing (Story and Screenplay):

- *Caged*, Virginia Kellogg and Bernard C. Schoenfeld

Cinematography (Color):

- *The Flame and the Arrow*, Ernest Haller

Music (Music Score of a Dramatic or Comedy Picture):

- *The Flame and the Arrow*, Max Steiner

Music (Scoring of a Musical Picture):

- *The West Point Story*, Ray Heindorf

Short Subject (One-Reel):

- *Blaze Busters*, Robert Youngson, Producer

Short Subject (Two-Reel):

- *My Country 'Tis of Thee*, Gordon Hollingshead, Producer

Patricia Neal is provocative and John Garfield is world-weary in Michael Curtiz's *The Breaking Point* (1950).

A truly candid photograph of Vivien Leigh, Tennessee Williams, and Elia Kazan on the set of *A Streetcar Named Desire* (1951).

Farley Granger and Robert Walker in Alfred Hitchcock's *Strangers on a Train* (1951).

1951 ACADEMY AWARDS

WINS

Actress:

★ Vivien Leigh in *A Streetcar Named Desire*

Supporting Actor:

★ Karl Malden in *A Streetcar Named Desire*

Supporting Actress:

★ Kim Hunter in *A Streetcar Named Desire*

Art Direction (Black-and-White):

★ *A Streetcar Named Desire*, Art Direction: Richard Day; Set Decoration: George James Hopkins

Short Subject (One-Reel):

★ *World of Kids*, Robert Youngson, Producer

Scientific or Technical Award (Class III):

★ To Fred Ponedel, Ralph Ayres, and George Brown of Warner Bros. Studio for an air-driven water motor to provide flow, wake, and white water for marine sequences in motion pictures

NOMINATIONS

Best Motion Picture:

• *A Streetcar Named Desire*, Charles K. Feldman, Producer

Directing:

• Elia Kazan for *A Streetcar Named Desire*

Actor:

• Marlon Brando in *A Streetcar Named Desire*

Supporting Actor:

• Gig Young in *Come Fill the Cup*

Writing (Screenplay):

• *A Streetcar Named Desire*, Tennessee Williams

Cinematography (Black-and-White):

• *Strangers on a Train*, Robert Burks
• *A Streetcar Named Desire*, Harry Stradling

Costume Design (Black-and-White):

• *A Streetcar Named Desire*, Lucinda Ballard

Documentary (Feature):

• *I Was a Communist for the F.B.I.*, Bryan Foy, Producer

Documentary (Short Subject):

• *The Seeing Eye*, Gordon Hollingshead, Producer

Music (Music Score of a Dramatic or Comedy Picture):

• *A Streetcar Named Desire*, Alex North

Sound Recording:

• *A Streetcar Named Desire*, Warner Bros. Studio Sound Department, Col. Nathan Levinson, Sound Director

A studio fire on May 16, 1952, destroyed this façade—recognizable from *Mission to Moscow* (1943) and *Deception* (1946)—and many studio landmarks, including the massive Stage 21.

1952 ACADEMY AWARDS

NOMINATIONS

Music (Music Score of a Dramatic or Comedy Picture):
- *The Miracle of Our Lady of Fatima*, Max Steiner

Music (Scoring of a Musical Picture):
- *The Jazz Singer*, Ray Heindorf and Max Steiner

Short Subject (One-Reel):
- *Desert Killer*, Gordon Hollingshead, Producer

Short Subject (Two-Reel):
- *Thar She Blows!* Gordon Hollingshead, Producer

FROM TOP: Burt Lancaster brought vitality to Robert Siodmak's *The Crimson Pirate* (1952). • Patrice Wymore and Kirk Douglas in a scene from Felix E. Feist's *The Big Trees* (1952), which Douglas made without salary to get out of his contract. • Susan Whitney, Sammy Ogg, and Sherry Jackson in a scene from John Brahm's *The Miracle of Our Lady of Fatima* (1952). **OPPOSITE, CLOCKWISE FROM TOP LEFT:** The *Rhedosaurus* was a species of dinosaur invented by Ray Harryhausen and a team of special effects artists for director Eugène Lourié's *The Beast from 20,000 Fathoms* (1953). • Vincent Price and 3-D made a hit of André de Toth's *House of Wax* (1953). • Montgomery Clift and Anne Baxter in a fanciful publicity portrait for Alfred Hitchcock's *I Confess* (1953).

1953 ACADEMY AWARDS

WINS

Music (Song):

★ "Secret Love" from *Calamity Jane*, Music by Sammy Fain; Lyrics by Paul Francis Webster

NOMINATIONS

Supporting Actress:

• Geraldine Page in *Hondo*

Music (Scoring of a Musical Picture):

• *Calamity Jane*, Ray Heindorf

Short Subject (Cartoon):

• *From A to Z-Z-Z-Z*, Edward Selzer, Producer

Short Subject (Two-Reel):

• *Winter Paradise*, Cedric Francis, Producer

Sound Recording:

• *Calamity Jane*, Warner Bros. Studio Sound Department, William A. Mueller, Sound Director

CLOCKWISE FROM TOP LEFT: In Fritz Lang's *The Blue Gardenia* (1953), Anne Baxter played a well-meaning woman who drank too much one night and blacked out. • Doris Day and Gordon MacRae acted and sang in David Butler's *By the Light of the Silvery Moon* (1953), which was inspired by Booth Tarkington's Penrod stories. • A Bert Six portrait of Doris Day and Howard Keel for David Butler's *Calamity Jane* (1953), a film that introduced the hit song "Secret Love."

FROM TOP: George Cukor directed Judy Garland and James Mason in the second version of *A Star Is Born* (1954), effectively reviving Garland's career. • Ray Milland and Grace Kelly starred in Alfred Hitchcock's *Dial M for Murder* (1954), which offered suspense in multiple dimensions.

FROM TOP: Joan Weldon is confronted by an ant in Gordon Douglas's *Them!* (1954). • Jim Haward, Timothy Carey, and Charles Bronson in an ugly scene from André de Toth's *Crime Wave* (1954). • **OPPOSITE:** William Campbell, Wally Brown, John Wayne, Doe Avedon, and Robert Stack in a scene from William Wellman's *The High and the Mighty* (1954).

1954 ACADEMY AWARDS

WINS

Music (Music Score of a Dramatic or Comedy Picture):

★ *The High and the Mighty*, Dimitri Tiomkin

Short Subject (One-Reel):

★ *This Mechanical Age*, Robert Youngson, Producer

NOMINATIONS

Directing:

- William Wellman for *The High and the Mighty*

Actor:

- James Mason in *A Star Is Born*

Actress:

- Judy Garland in *A Star Is Born*

Supporting Actress:

- Jan Sterling in *The High and the Mighty*
- Claire Trevor in *The High and the Mighty*

Art Direction (Color):

- *A Star Is Born*, Art Direction: Malcolm Bert, Gene Allen, Irene Sharaff; Set Decoration: George James Hopkins

Cinematography (Color):

- *The Silver Chalice*, William V. Skall

Costume Design (Color):

- *A Star Is Born*, Jean Louis, Mary Ann Nyberg, and Irene Sharaff

Film Editing:

- *The High and the Mighty*, Ralph Dawson

Music (Music Score of a Dramatic or Comedy Picture):

- *The Silver Chalice*, Franz Waxman

Music (Scoring of a Musical Picture):

- *A Star Is Born*, Ray Heindorf

Music (Song):

- "The High and the Mighty" from *The High and the Mighty*, Music by Dimitri Tiomkin; Lyrics by Ned Washington
- "The Man That Got Away" from *A Star Is Born*, Music by Harold Arlen; Lyrics by Ira Gershwin

Short Subject (Cartoon):

- *Sandy Claws*, Edward Selzer, Producer

Short Subject (Two-Reel):

- *Beauty and the Bull*, Cedric Francis, Producer

Special Effects:

- *Them!*, Warner Bros. Studio

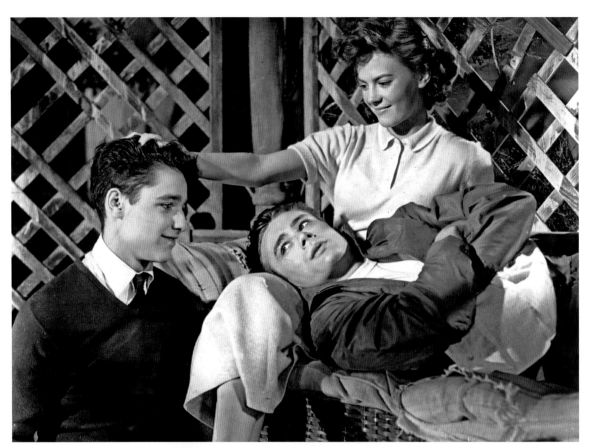

FROM TOP: Sal Mineo, James Dean, and Natalie Wood in a scene from Nicholas Ray's *Rebel Without a Cause* (1955); Dean received top billing for this, his second film, but did not live to see its premiere. • Liberace starred in Gordon Douglas's *Sincerely Yours* (1955), which was designed to tap into Liberace's TV and concert fame. **OPPOSITE:** A Bert Six portrait of Julie Harris and James Dean in Elia Kazan's *East of Eden* (1955), which made Dean an overnight star.

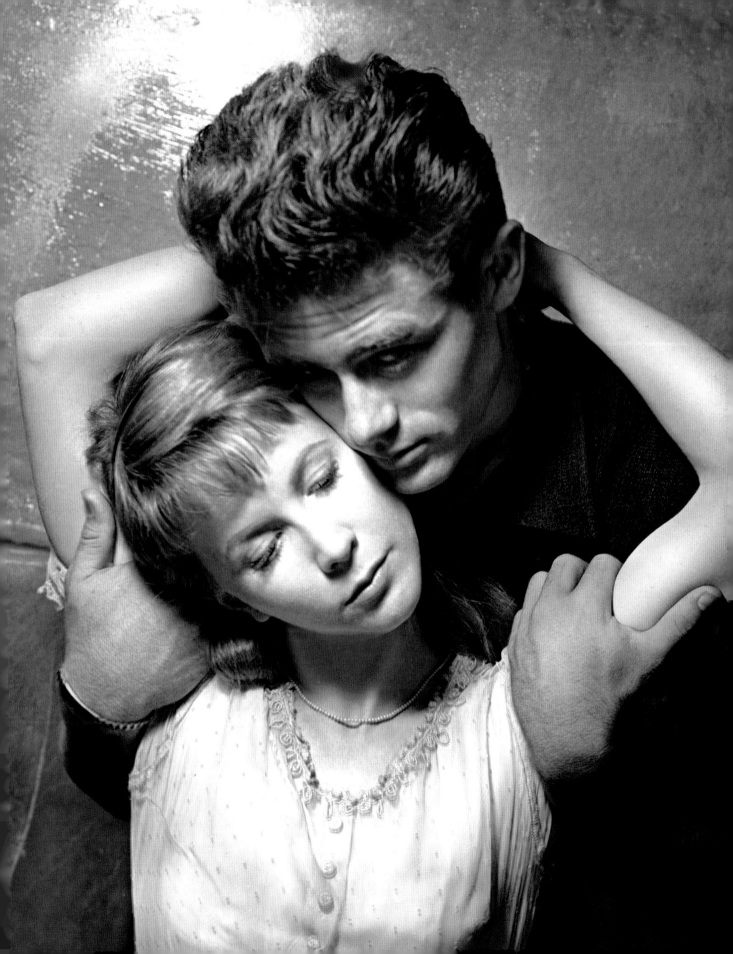

1955 ACADEMY AWARDS

WINS

Supporting Actor:

⭐ Jack Lemmon in *Mister Roberts*

Supporting Actress:

⭐ Jo Van Fleet in *East of Eden*

Short Subject (Cartoon):

⭐ *Speedy Gonzales*, Edward Selzer, Producer

NOMINATIONS

Best Motion Picture:

• *Mister Roberts*, Leland Hayward, Producer

Directing:

• Elia Kazan for *East of Eden*

Actor:

• James Dean in *East of Eden*

Supporting Actor:

• Sal Mineo in *Rebel without a Cause*

Supporting Actress:

• Peggy Lee in *Pete Kelly's Blues*
• Natalie Wood in *Rebel without a Cause*

Writing (Motion Picture Story):

• *Rebel without a Cause*, Nicholas Ray

Writing (Screenplay):

• *East of Eden*, Paul Osborn

Writing (Story and Screenplay):

• *The Court-Martial of Billy Mitchell*, Milton Sperling and Emmet Lavery

Music (Music Score of a Dramatic or Comedy Picture):

• *Battle Cry*, Max Steiner

Music (Song):

• "Unchained Melody" from *Unchained*, Music by Alex North; Lyrics by Hy Zaret

Short Subject (One-Reel):

• *Gadgets Galore*, Robert Youngson, Producer

Short Subject (Two-Reel):

• *24-Hour Alert*, Cedric Francis, Producer

Sound Recording:

• *Mister Roberts*, Warner Bros. Studio Sound Department, William A. Mueller, Sound Director

Special Effects:

• *The Dam Busters*, Associated British Picture Organization, Ltd.

William Powell, Henry Fonda, and Jack Lemmon in Mervyn LeRoy's *Mister Roberts*, one of the big hits of 1955.

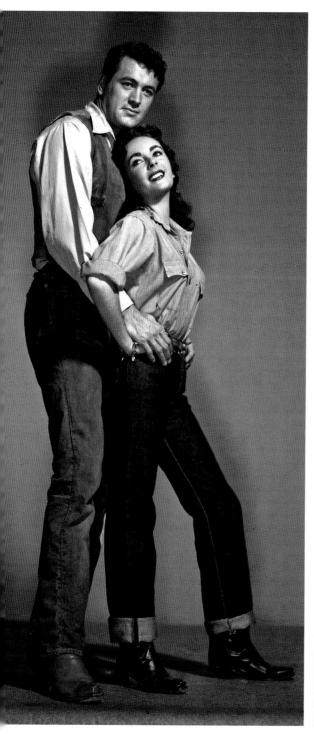

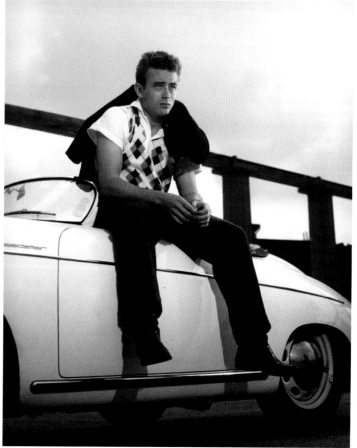

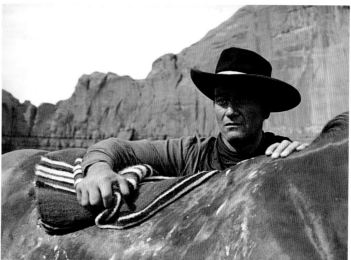

Rock Hudson and Elizabeth Taylor in a publicity portrait made for George Stevens's *Giant* (1956). • A portrait of James Dean from early 1955, when he still owned a 1955 Porsche Super Speedster. • John Wayne in a scene from John Ford's *The Searchers* (1956), a mildly successful film that has since been recognized as a masterpiece.

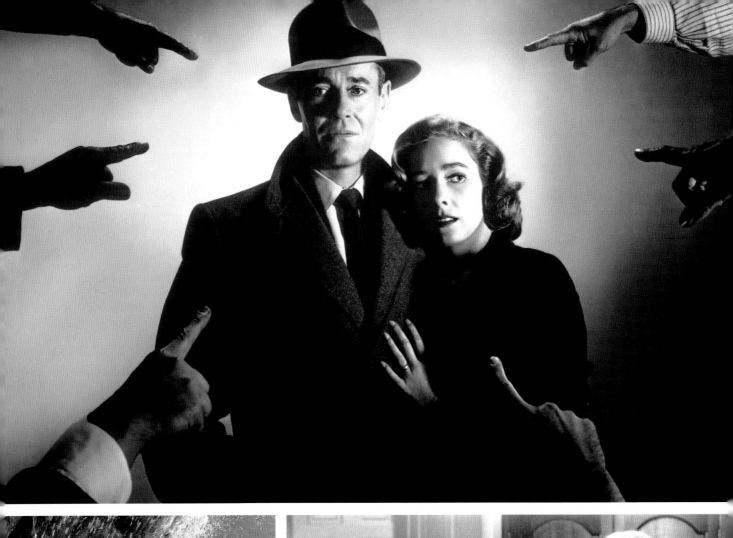

FROM TOP: Joan Fontaine, Mario Lanza, and Vincent Price in Anthony Mann's *Serenade* (1956). • *The Animal World* included a prehistoric sequence with animation by Willis O'Brien and Ray Harryhausen.

OPPOSITE, CLOCKWISE FROM TOP: A publicity portrait of Henry Fonda and Vera Miles for Alfred Hitchcock's *The Wrong Man* (1956), one of the Master's most disturbing tales. • Warner veteran Mervyn LeRoy directed Nancy Kelly and Patty McCormack in *The Bad Seed* (1956). • In 1956, Warner Bros. distributed John Huston's *Moby Dick*, which starred Gregory Peck as Captain Ahab.

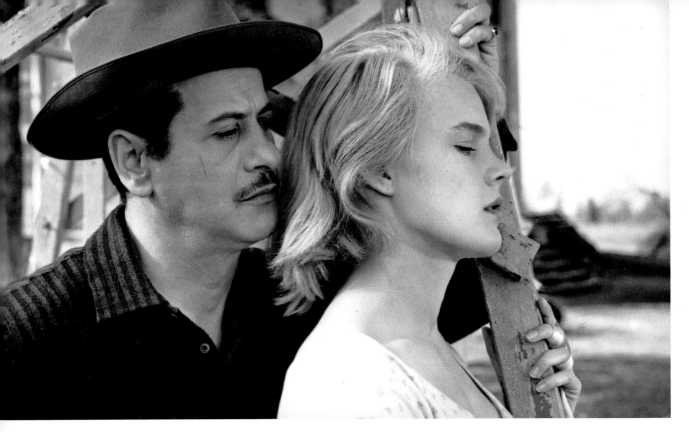

A scene of Eli Wallach and Carroll Baker in Elia Kazan's *Baby Doll* (1956), a controversial film adapted by Tennessee Williams from his play *27 Wagons Full of Cotton*.

1956 ACADEMY AWARDS

WINS

Directing:
★ George Stevens for *Giant*

Short Subject (One-Reel):
★ *Crashing the Water Barrier*, Konstantin Kalser, Producer

NOMINATIONS

Best Motion Picture:
- *Giant*, George Stevens and Henry Ginsberg, Producers

Actor:
- James Dean in *Giant*
- Rock Hudson in *Giant*

Actress:
- Carroll Baker in *Baby Doll*
- Nancy Kelly in *The Bad Seed*

Supporting Actress:
- Mildred Dunnock in *Baby Doll*
- Eileen Heckart in *The Bad Seed*
- Mercedes McCambridge in *Giant*
- Patty McCormack in *The Bad Seed*

Writing (Screenplay—Adapted):
- *Baby Doll*, Tennessee Williams
- *Giant*, Fred Guiol and Ivan Moffat

Art Direction (Color):
- *Giant*, Art Direction: Boris Leven; Set Decoration: Ralph S. Hurst

Cinematography (Black-and-White):
- *Baby Doll*, Boris Kaufman
- *The Bad Seed*, Hal Rosson

Costume Design (Color):
- *Giant*, Moss Mabry and Marjorie Best

Film Editing:
- *Giant*, William Hornbeck, Philip W. Anderson, and Fred Bohanan

Music (Music Score of a Dramatic or Comedy Picture):
- *Giant*, Dimitri Tiomkin

Short Subject (One-Reel):
- *I Never Forget a Face*, Robert Youngson, Producer
- *Time Stood Still*, Cedric Francis, Producer

CLOCKWISE FROM TOP LEFT: Andy Griffith made his screen debut as a TV demagogue in Elia Kazan's *A Face in the Crowd* (1957). • Peter Cushing starred in Terence Fisher's *The Curse of Frankenstein* (1957), a landmark film that signaled the emergence of "Hammer horror." • A publicity portrait of Doris Day and John Raitt for *The Pajama Game* (1957), which was directed by George Abbott and Stanley Donen from the hit Broadway musical.

THE 1950S: GIMMICKS, EPICS, AND DESIRE

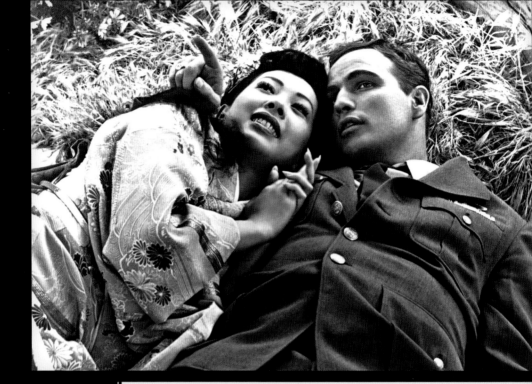

A scene of Miiko Taka and Marlon Brando in Joshua Logan's *Sayonara* (1957), one of the first films to deal with interracial marriage.

1957 ACADEMY AWARDS

WINS

Supporting Actor:
★ Red Buttons in *Sayonara*

Supporting Actress:
★ Miyoshi Umeki in *Sayonara*

Art Direction:
★ *Sayonara*, Art Direction: Ted Haworth; Set Decoration: Robert Priestley

Short Subject (Cartoon):
★ *Birds Anonymous*, Edward Selzer, Producer

Sound Recording:
★ *Sayonara*, Warner Bros. Studio Sound Department, George Groves, Sound Director

NOMINATIONS

Best Motion Picture:
• *Sayonara*, William Goetz, Producer

Directing:
• Joshua Logan for *Sayonara*

Actor:
• Marlon Brando in *Sayonara*

Writing (Screenplay):
• *Sayonara*, Paul Osborn

Cinematography:
• *Sayonara*, Ellsworth Fredericks

Film Editing:
• *Sayonara*, Arthur P. Schmidt and Philip W. Anderson

Short Subject (Cartoon):
• *Tabasco Road*, Edward Selzer, Producer

Special Effects:
• *The Spirit of St. Louis*, Visual Effects by Louis Lichtenfield

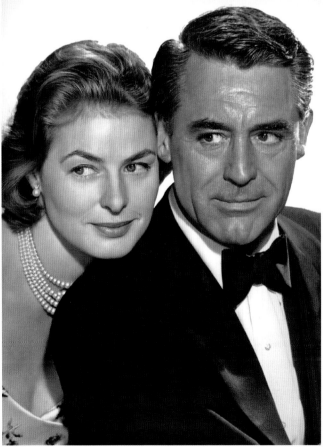

CLOCKWISE FROM TOP LEFT: Nick Adams and Andy Griffith in Mervyn LeRoy's very successful comedy *No Time for Sergeants* (1958). • A portrait of Paul Newman in Arthur Penn's *The Left-Handed Gun* (1958), Gore Vidal's analysis of Billy the Kid. • A Bert Six portrait of Ingrid Bergman and Cary Grant for Stanley Donen's *Indiscreet* (1958). • Tab Hunter and the uniquely talented Gwen Verdon in George Abbott and Stanley Donen's *Damn Yankees* (1958).

FROM LEFT: Fred Clark, Rosalind Russell, and Jan Handzlik in a tart scene from Morton DaCosta's *Auntie Mame*. • Spencer Tracy played a solitary fisherman in John Sturges's *The Old Man and the Sea* (1958).

1958 ACADEMY AWARDS

WINS

Music (Music Score of a Dramatic or Comedy Picture):

★ *The Old Man and the Sea*, Dimitri Tiomkin

Short Subject (Cartoon):

★ *Knighty Knight Bugs*, John W. Burton, Producer

Irving G. Thalberg Memorial Award:

★ Jack L. Warner

Scientific or Technical Award (Class III):

★ To Fred Ponedel, George Brown, and Conrad Boye of the Warner Bros. Special Effects Department for the design and fabrication of a new rapid-fire marble gun

NOMINATIONS

Best Motion Picture:

• *Auntie Mame*, Warner Bros.

Actor:

• Spencer Tracy in *The Old Man and the Sea*

Actress:

• Rosalind Russell in *Auntie Mame*

Supporting Actress:

• Peggy Cass in *Auntie Mame*

Art Direction:

• *Auntie Mame*, Art Direction: Malcolm Bert; Set Decoration: George James Hopkins

Cinematography (Color):

• *Auntie Mame*, Harry Stradling Sr.

• *The Old Man and the Sea*, James Wong Howe

Film Editing:

• *Auntie Mame*, William Ziegler

Music (Scoring of a Musical Picture):

• *Damn Yankees*, Ray Heindorf

Music (Song):

• "A Very Precious Love" from *Marjorie Morningstar*, Music by Sammy Fain; Lyrics by Paul Francis Webster

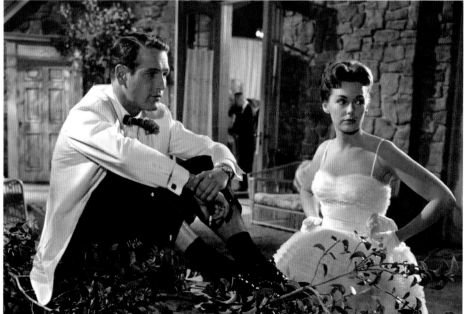

FROM TOP: Howard Hawks directed John Wayne, Dean Martin, and Ricky Nelson in *Rio Bravo* (1959), the last film co-written by the prolific and celebrated Jules Furthman.
• Paul Newman and Barbara Rush in Vincent Sherman's social drama *The Young Philadelphians* (1959).

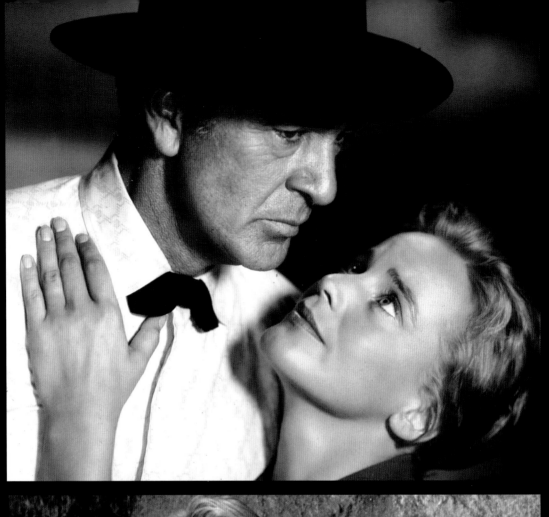
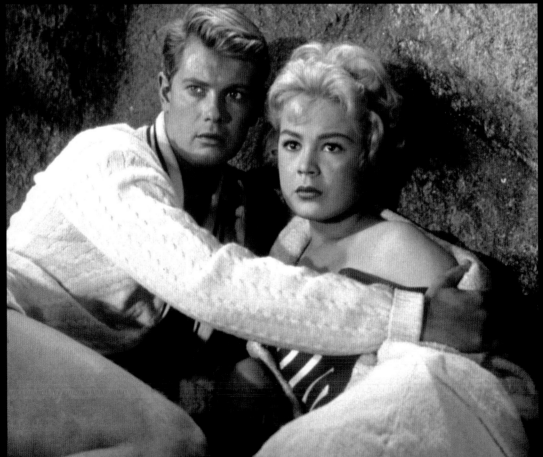

1959 ACADEMY AWARDS

NOMINATIONS

Best Motion Picture:

- *The Nun's Story*, Henry Blanke, Producer

Directing:

- Fred Zinnemann for *The Nun's Story*

Actress:

- Audrey Hepburn in *The Nun's Story*

Supporting Actor:

- Robert Vaughn in *The Young Philadelphians*

Writing (Screenplay):

- *The Nun's Story*, Robert Anderson

Cinematography (Black-and-White):

- *The Young Philadelphians*, Harry Stradling Sr.

Cinematography (Color):

- *The Nun's Story*, Franz Planer

Costume Design (Black-and-White):

- *The Young Philadelphians*, Howard Shoup

Film Editing:

- *The Nun's Story*, Walter Thompson

Music (Music Score of a Dramatic or Comedy Picture):

- *The Nun's Story*, Franz Waxman

Music (Song):

- "The Hanging Tree" from *The Hanging Tree*, Music by Jerry Livingston; Lyrics by Mack David

Short Subject (Cartoon):

- *Mexicali Shmoes*, John W. Burton, Producer

Sound:

- *The Nun's Story*, Warner Bros. Studio Sound Department, George R. Groves, Sound Director

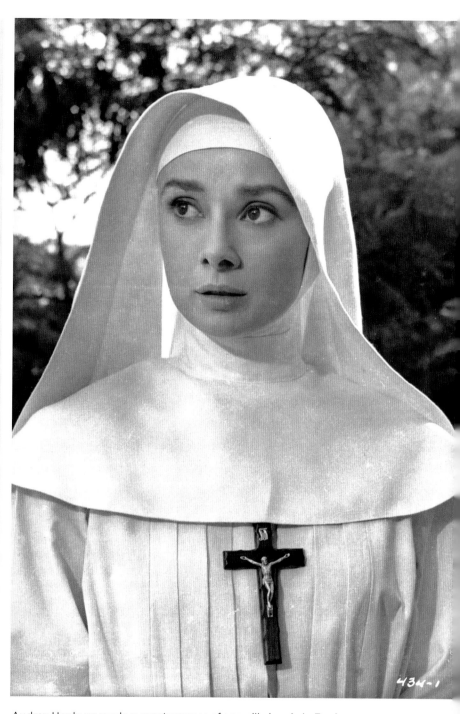

Audrey Hepburn made a great success of an unlikely role in Fred Zinnemann's *The Nun's Story* (1959). **OPPOSITE, FROM TOP:** A Bert Six portrait of Gary Cooper and Maria Schell in Delmer Daves's *The Hanging Tree* (1959), a success due to Cooper's ongoing popularity and the first film produced by Cooper's company, Baroda Productions, for Warner Bros. • A scene of Sandra Dee and Troy Donahue in Delmer Daves's popular drama, *A Summer Place* (1959).

THE 1960s:

AN ERA FADES

THE 1960S BEGAN QUIETLY, AS IF THE COMPLACENCY OF THE 1950S WOULD LAST forever. America had the highest standard of living in the world, and its citizens had gained 30 percent more purchasing power since 1950. What more could anyone want? For many, this was the American Dream come true. For others, the dream was out of reach. These were the people who didn't matter to the contented majority; they were called "dirty farmworkers," "broads," "coloreds," or "queers." For these groups, the American Dream was a tantalizing lie, like the stock-market riches of the '20s. But nothing stays the same, and by 1960, change was overdue. It would come from the young.

The 1950s had been the decade of the "Baby Boom." After American soldiers returned from the war, a million more babies were born each year, and the Boom produced more than 78 million children. Just as Warner Bros. catered to women in the 1940s, it would soon cater to Baby Boomers, whose little fists clutched disposable income. The Boomers were maturing, and it was a wise producer who knew his own children. The 1960s would be the decade of the "youth culture."

The symbiosis between Hollywood and Broadway supplied Warner with fresh content, much of it suited to Boomers. Since hero worship and political awareness went hand in hand, Warner bought *Sunrise at Campobello*, a play about Franklin Roosevelt's struggle with polio. Boomers were being vaccinated against this disease and knew Eleanor Roosevelt, so the story should have been relevant, but the well-written film was a commercial failure. The studio had misjudged young viewers; they were losing interest in "family films." Every year a higher percentage of the audience comprised young people attending without parents; by 1968, nearly 50 percent were between sixteen and twenty-four. A film had to have young people in its cast, plus music, action, and a hint of sex. Joshua Logan's *Tall Story*, which introduced Jane Fonda to movies, should have been a success. It dealt with college dating, yet there was little heat between Fonda and leading man Anthony Perkins. What made money were steamy romances like *Parrish, Susan Slade*, and *Rome Adventure*, all of which were directed by Delmer Daves and starred teen idol Troy Donahue.

Family films had to have an adult angle, as did Delbert Mann's *The Dark at the Top of the Stairs*, a successful adaptation of William Inge's play about a troubled family. It starred Dorothy McGuire and Robert Preston, but the smash hit of the early decade was Preston's exuberant

A portrait of Natalie Wood as stripper Gypsy Rose Lee in Mervyn LeRoy's *Gypsy* (1962).

turn as *The Music Man*. With songs like "Seventy-six Trombones" performed by Preston, the film endeared itself to the public. Stage success *Gypsy* also did well, once Mervyn LeRoy figured out how to make the five-foot-two Natalie Wood look like five-foot-nine Gypsy Rose Lee—he lowered the camera. Joshua Logan's *Fanny* was also based on a stage musical; the nervous director cut its songs and used them as underscoring. Nonetheless, the beloved Charles Boyer, Maurice Chevalier, and Leslie Caron made the film popular. Fred Zinnemann's *The Sundowners* was based on Jon Cleary's 1952 novel about the family of an Australian sheep herder. Although Jack Warner was not keen on location shooting, Zinnemann insisted, and he shot exteriors in Australia.

William Inge told stories of his youth to director Elia Kazan, and they became *Splendor in the Grass*, a hit that solidified Natalie Wood's stardom and made an overnight star of twenty-three-year-old Warren Beatty, who had been rejected for *Tall Story*. Kazan drew on memories of his uncle's immigration from Constantinople and wrote *America America*. His unknown players did not become stars, but the brave film did well. Meanwhile, Beatty continued his ascent, being cast with Vivien Leigh in *The Roman Spring of Mrs. Stone*, which was based on a Tennessee Williams novel.

Bette Davis was appearing on Broadway in Williams's *The Night of the Iguana* when Joan Crawford came backstage and gave her a Henry Farrell novel called *What Ever Happened to Baby Jane?* The result was a Robert Aldrich horror film that captured the imagination of viewers who were too young to have seen these stars in their Warner outings but old enough to have seen their films on local TV. Jack Warner grandly welcomed Crawford and Davis to Burbank with a photo session, but Aldrich shot the film at Occidental Studios in the Westlake District and at Producers Studios on Melrose. The equally scary—and successful—*Days of Wine and Roses* was adapted by Blake Edwards and J. P. Miller from Miller's *Playhouse 90* teleplay about a married couple's alcoholic descent into madness. Jack

Lemmon and Lee Remick each earned Oscar nominations for their riveting performances.

Frank Sinatra and the so-called Rat Pack brought their style to three Warner projects: *Ocean's 11*, *4 for Texas*, and *Robin and the 7 Hoods*. Although Sammy Davis Jr. and other African American actors were increasingly seen in Warner Bros. films, the issue of race was rarely acknowledged, much less addressed in a film. John Ford's *Sergeant Rutledge* was one of the first dramas to deal with racism and to have a Black man in a title role. John Ford cast Woody Strode, a member of his stock company, as Rutledge.

PT-109, starring Cliff Robertson as the young John F. Kennedy, was the first feature about a US president to be released while the president was in office. President Kennedy exercised approval over casting, and his first choice, Warren Beatty, turned down the role because he didn't like the script; Beatty became persona non grata at Warner for a time. After Robertson was approved, he found himself limited by changes made to Kennedy's character, even though Kennedy didn't want his character scrubbed clean. The film was released in June 1963, and no one was particularly happy with the final film. The tragic death of President Kennedy in November muted any success the film may have had.

The Incredible Mr. Limpet combined live action and animation in a goofy comedy starring the rubber-faced Don Knotts in his first lead role. Live-action sequences were directed by Arthur Lubin; animated scenes were directed by Bill Tytla, Robert McKimson, Hawley Pratt, and Gerry Chiniquy. This was the final animated feature before Warner Bros. Cartoons was shut down in 1963.

My Fair Lady was the 1956 Broadway sensation that gave America "I Could Have Danced All Night." Warner Bros. bought the film rights in 1962 for an unprecedented $5.5 million (plus 47 percent of the gross over $20 million). With sets by colorist Gene Allen, costumes and still photography by the fastidious Cecil Beaton, direction by the acclaimed George Cukor, Rex Harrison reprising his stage role, and Audrey Hepburn as Eliza Doolittle,

My Fair Lady grossed $72 million. This was fortunate, because 1963 had been a slump year. Tastes were changing, and no one in Hollywood could agree on what audiences wanted or why Americans were discontented.

Discontentment was the theme of *Inside Daisy Clover* as Natalie Wood expressed the existential frustration of a tomboy turned movie star. Wood played a more cheerful character in Blake Edwards's slapstick epic *The Great Race*, working with Jack Lemmon and Tony Curtis.

The Production Code Administration ruled that Edward Albee's play, *Who's Afraid of Virginia Woolf*, could not be filmed because of profanity, obscenity, and sexual situations. The PCA was being overseen by Jack Valenti, a newly appointed president of the Motion Picture Association of America (MPAA). (For several years before his appointment as president of the MPAA, Valenti had been special assistant to President Lyndon B. Johnson.) The negotiations between Valenti and producer Ernest Lehman and director Mike Nichols were more tortuous than those between Joseph Breen and Elia Kazan on *A Streetcar Named Desire*, but Valenti finally agreed to allow the disputed content, as long as exhibitor contracts included an "Adults Only" clause—no one under eighteen would be admitted unless accompanied by an adult. *Who's Afraid of Virginia Woolf?* became the third-highest-grossing film of 1966.

Boomers wanted films that reflected this new world: alternative spiritual practices, political dissent, feminism, rock music, recreational drugs, and sex of all stripes.

A number of stars didn't need Jack Warner or his studio to help them choose vehicles. Warren Beatty was hip enough to know that Boomers were too smart to accept hoary formulas. Civil rights unrest and the introduction of birth control pills in the mid-sixties had rocked the status quo, and a new reality had to be acknowledged. Boomers wanted films that reflected this new world: alternative spiritual practices, political dissent, feminism, rock music, recreational drugs, and sex of all stripes. Beatty's superstar status brought him the mantle of producer, so he hired Arthur Penn to direct a Depression-era fable of boy-and-girl outlaws. *Bonnie and Clyde* spoke to the new audience. For the first time since *The Public Enemy*, a Warner Bros. film had outlaws who were beautiful, volatile, and rebellious. The graphic depiction of their deaths—partly in slow motion—was criticized, yet *Bonnie and Clyde* reached number four at the box office. It also told the industry that films for young people should be made by young people. Thus was born the "New Hollywood" movement, which gave power to directors who had been schooled in low-budget filmmaking at places like American International Pictures. Filmmakers like Martin Scorsese and Peter Bogdanovich would lead this movement.

The Rain People was directed by twenty-nine-year-old Francis Ford Coppola. It was obvious to veteran crew members that the young director knew what he was doing but, more to the point, that he was making a new type of film for a new type of audience. The characters in this offbeat film were not ones who could be cast with the usual Warner players, and his performers were quirky talents like Shirley Knight and Robert Duvall.

In 1967, Paul Newman played a chain gang inmate in *Cool Hand Luke*, a martyr to brutality, and his film was tremendously popular. The next year he directed his wife, Joanne Woodward, in the title role of *Rachel, Rachel*, the story of a middle-aged woman's self-discovery. Steve McQueen chose the crime drama *Bullitt* as a showcase for his charm and driving skills. A ten-minute car chase was the talk of high-school cafeterias for months, and *Bullitt* was number four in box office for the year. Audrey Hepburn chose a tough role as a recently blinded woman in the thriller *Wait Until Dark*. In an effort to support on-screen suspense, theater owners dimmed their exit lights during the final scene.

Joshua Logan's *Camelot* was a well-meaning adaptation of the successful Broadway musical, but the production ran out of control. Jack Warner, who was personally producing the film, washed his hands of it. Yet despite overruns and in-studio fighting, the film did fairly well with audiences. The vaunted youth culture, which had splintered into a drug-beset counterculture and an antiwar movement, had no use for *The Green Berets*, a tribute to the American division fighting in the Vietnam War. The film, which John Wayne produced, co-directed, and starred in, nonetheless did well.

For years, the PCA sat in the MPAA offices above the Rexall-Owl drugstore at the corner of Beverly and La Cienega Boulevards in West Hollywood. Year after year, administrator Jack Vizzard and his beleaguered staff tried to apply the outdated Production Code to increasingly complex artistic issues. The 1966 introduction of the label "Suggested for Mature Audiences" was only a stopgap measure. In 1968, Jack Valenti replaced the Code with a system of voluntary film ratings. It was still necessary to avert wildcat censorship by fringe groups, but it was also imperative to tell parents if a film was appropriate for children. Movies would be rated, but they were at last free from the Code. This development occurred in a year that

The Learning Tree represented a milestone: It was the first feature directed by an African American for a major American studio.

saw violent antiwar protests and the advance of women's liberation, Black power, and gay liberation. The response of the filmmaking community was immediate and emphatic.

The Learning Tree was an autobiographical feature written, directed, scored, and produced by noted photographer Gordon Parks based on his own novel. The film represented a milestone: It was the first feature directed by an African American for a major American studio. There was nothing censorable in the film, but the Code had discouraged honest discussions of race.

The Code had also prohibited displays of violence. *The Wild Bunch* was a western directed by Sam Peckinpah and starring a weathered William Holden. Like a freed prisoner, the film attacked audiences with a level of violence that had never been seen before; bodies were riddled with bullets, torn, shredded, exploded.

The Damned was Luchino Visconti's thinly veiled history of the decadent Krupp dynasty. With graphic violence, abundant nudity, and depictions of pedophilia, homosexuality, rape, and incest, the film was so provocative that it was given an "X" rating by the MPAA. This rating could be misread. Pornographers had begun to apply it to their product, and the "X" rating soon came to suggest only that type of film.

By this time, Jack L. Warner had been president of Warner Bros. for more than a decade, overseeing production as he had before the sale. But *Camelot* had required him to spend more time arguing with agents than attending to creative aspects. At seventy-five, he saw a changed Hollywood landscape, and he made a firm decision. He announced that *Camelot* would be his last film for Warner Bros. In 1960, the production company Seven Arts had begun to distribute Warner Bros. films (and those of other studios) for television syndication. In late 1966, Jack Warner summarily sold his interest in the Warner Bros. corporation to Seven Arts and walked away with $32 million.

The newly combined company, Warner Bros.–Seven Arts, lasted roughly two years. In 1969, it was bought by the Kinney National Corporation, and in December it was renamed Warner Bros. Inc. with Ted Ashley as studio chief. Through various changes of names and regimes in the '60s, the company had continued to produce and release films. Its ten-year total was 167 features.

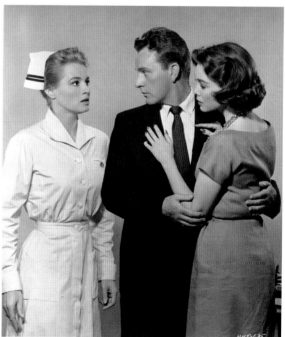

CLOCKWISE FROM TOP LEFT: Although Frank Sinatra disliked the nickname "Rat Pack," the name stuck to this group. Here are Sinatra, Dean Martin, Sammy Davis Jr., Peter Lawford, and Joey Bishop in Lewis Milestone's *Ocean's 11* (1960). • A publicity portrait of Jane Fonda and Anthony Perkins made for Joshua Logan's *Tall Story* (1960). • A publicity portrait of Angie Dickinson, Richard Burton, and Barbara Rush made for Daniel Petrie's *The Bramble Bush* (1960). • John Kerr, Joe Mantell, and Dana Andrews in a scene from Joseph Pevney's *The Crowded Sky* (1960), one of the essential airline crisis films.

1960 ACADEMY AWARDS

NOMINATIONS

Best Motion Picture:
- *The Sundowners*, Fred Zinnemann, Producer

Directing:
- Fred Zinnemann for *The Sundowners*

Actress:
- Greer Garson in *Sunrise at Campobello*
- Deborah Kerr in *The Sundowners*

Supporting Actress:
- Glynis Johns in *The Sundowners*
- Shirley Knight in *The Dark at the Top of the Stairs*

Writing (Screenplay):
- *The Sundowners*, Isobel Lennart

Art Direction (Color):
- *Sunrise at Campobello*, Art Direction: Edward Carrere; Set Decoration: George James Hopkins

Costume Design (Black-and-White):
- *The Rise and Fall of Legs Diamond*, Howard Shoup

Costume Design (Color):
- *Sunrise at Campobello*, Marjorie Best

Short Subject (Cartoon):
- *High Note*, Warner Bros.
- *Mouse and Garden*, Warner Bros.

Sound:
- *Sunrise at Campobello*, Warner Bros. Studio Sound Department, George R. Groves, Sound Director

In 1961, Jack L. Warner posed on Avenue D with his son-in-law William T. Orr and as many Warner-TV contract players as were available that day. Included are Donald May, Poncie Ponce, Connie Stevens, Peter Brown, Will Hutchins, Dorothy Provine, John Russell, Angie Dickinson, Anthony Eisley, Andrew Duggan, Richard Long, Jack Kelly, Natalie Wood, Diane McBain, Edd Byrnes, Ty Hardin, Robert Conrad, Troy Donahue, Roger Smith, Grant Williams, and Roger Moore.

1961 ACADEMY AWARDS

WINS

Writing (Story and Screenplay):

★ *Splendor in the Grass*, William Inge

Honorary Award:

★ To William Hendricks for his outstanding patriotic service in the conception, writing, and production of the Marine Corps film, *A Force in Readiness*, which has brought honor to the Academy and the motion picture industry

NOMINATIONS

Best Motion Picture:

• *Fanny*, Joshua Logan, Producer

Actor:

• Charles Boyer in *Fanny*

Actress:

• Natalie Wood in *Splendor in the Grass*

Supporting Actress:

• Lotte Lenya in *The Roman Spring of Mrs. Stone*

Cinematography (Color):

• *Fanny*, Jack Cardiff

• *A Majority of One*, Harry Stradling Sr.

Costume Design (Black-and-White):

• *Claudelle Inglish*, Howard Shoup

Film Editing:

• *Fanny*, William H. Reynolds

Music (Scoring of a Dramatic or Comedy Picture):

• *Fanny*, Morris Stoloff and Harry Sukman

Short Subject (Cartoon):

• *Beep Prepared*, Chuck Jones, Producer

• *Nelly's Folly*, Chuck Jones, Producer

• *The Pied Piper of Guadalupe*, Friz Freleng, Producer

FROM LEFT: Warner Bros. had a new star in Angie Dickinson, seen here with Roger Moore in Gordon Douglas's *The Sins of Rachel Cade* (1961). • A publicity portrait of Diane McBain made for Gordon Douglas's *Claudelle Inglish* (1961), another steamy teen hit. **OPPOSITE, CLOCKWISE FROM TOP LEFT:** A Bert Six portrait of Connie Stevens and Troy Donahue made for Delmer Daves's *Susan Slade* (1961). • Natalie Wood and Warren Beatty in a scene from Elia Kazan's *Splendor in the Grass* (1961), a film that influenced depictions of adolescent love. • Vivien Leigh and Warren Beatty in a scene from José Quintero's *The Roman Spring of Mrs. Stone* (1961).

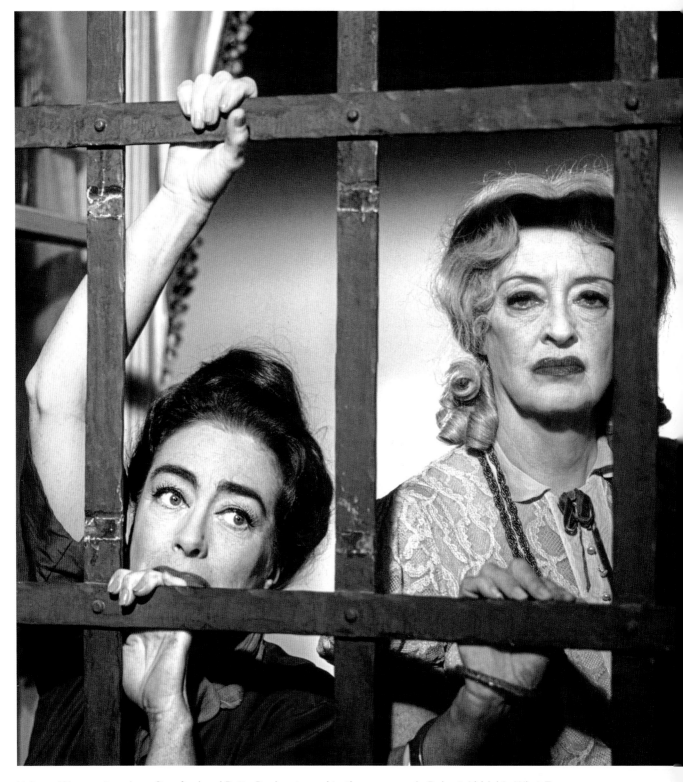

Veteran Warner stars Joan Crawford and Bette Davis returned to the company in Robert Aldrich's *What Ever Happened to Baby Jane?* (1962), a major hit with young audiences. **OPPOSITE, FROM TOP:** Judy Garland dubbed the voice of the animated character Mewsette in Abe Levitow's *Gay Purr-ee* (1962). • Jack Lemmon in a harrowing scene from Blake Edwards's *Days of Wine and Roses* (1962).

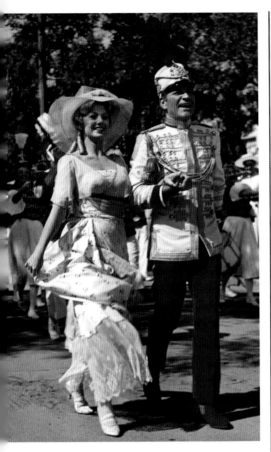

Robert Preston and Shirley Jones made a delight of Morton DaCosta's *The Music Man* (1962).

1962 ACADEMY AWARDS

WINS

Costume Design (Black-and-White):

★ *What Ever Happened to Baby Jane?*, Norma Koch

Music (Scoring of Music—Adaptation or Treatment):

★ *The Music Man*, Ray Heindorf

Music (Song):

★ "Days of Wine and Roses" from *Days of Wine and Roses*, Music by Henry Mancini; Lyrics by Johnny Mercer

NOMINATIONS

Best Picture:

• *The Music Man*, Morton DaCosta

Actor:

• Jack Lemmon in *Days of Wine and Roses*

Actress:

• Bette Davis in *What Ever Happened to Baby Jane?*

• Lee Remick in *Days of Wine and Roses*

Supporting Actor:

• Victor Buono in *What Ever Happened to Baby Jane?*

Art Direction (Black-and-White):

• *Days of Wine and Roses*, Art Direction: Joseph Wright; Set Decoration: George James Hopkins

Art Direction (Color):

• *The Music Man*, Art Direction: Paul Groesse; Set Decoration: George James Hopkins

Cinematography (Black-and-White):

• *What Ever Happened to Baby Jane?*, Ernest Haller

Cinematography (Color):

• *Gypsy*, Harry Stradling Sr.

Costume Design (Black-and-White):

• *Days of Wine and Roses*, Don Feld

Costume Design (Color):

• *Gypsy*, Orry-Kelly

• *The Music Man*, Dorothy Jeakins

Documentary (Short Subject):

• *The John Glenn Story*, William L. Hendricks, Producer

Film Editing:

• *The Music Man*, William Ziegler

Music (Scoring of Music—Adaptation or Treatment):

• *Gypsy*, Frank Perkins

Short Subject (Cartoon):

• *Now Hear This*, Warner Bros.

Sound:

• *The Music Man*, Warner Bros. Studio Sound Department, George R. Groves, Sound Director

• *What Ever Happened to Baby Jane?*, Glen Glenn Sound Department, Joseph Kelly, Sound Director

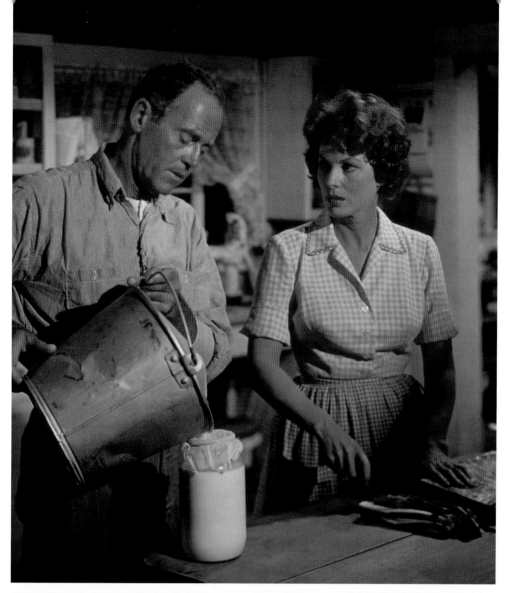

FROM TOP:
Henry Fonda and
Maureen O'Hara
starred in *Spencer's
Mountain* (1963),
which was written
and directed by
hitmaker Delmer
Daves; portrait by
Bert Six. • A scene
of Dean Martin,
Ursula Andress,
Frank Sinatra, and
Anita Ekberg in
Robert Aldrich's
4 for Texas (1963).

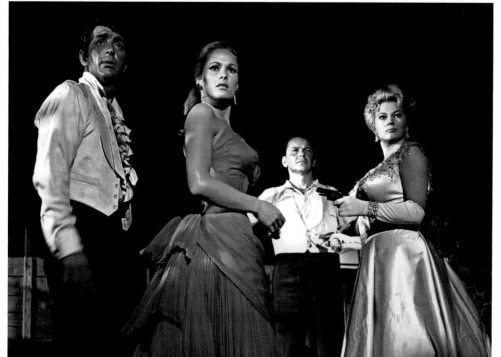

CLOCKWISE FROM TOP: Lucille Ball and Bob Hope in a publicity portrait for Don Weis's *Critic's Choice* (1963). • Stefanie Powers and Troy Donahue in a scene from Norman Taurog's *Palm Springs Weekend* (1963). • A Bert Six publicity portrait of Ty Hardin and Suzanne Pleshette for Richard Wilson's *Wall of Noise* (1963).

1963 ACADEMY AWARDS

WINS

Art Direction (Black-and-White):

★ *America America*, Gene Callahan

NOMINATIONS

Best Picture:

• *America America*, Elia Kazan, Producer

Directing:

• Elia Kazan for *America America*

Writing (Story and Screenplay):

• *America America*, Elia Kazan

FROM TOP: Stathis Giallelis personified all Greek immigrants in Elia Kazan's *America America* (1963). • Before the summer 1963 release of *PT-109,* which was directed by Leslie H. Martinson, Jack Warner hosted a reunion for President John F. Kennedy and other crew members of the World War II craft.

THE 1960S: AN ERA FADES

151

FROM TOP: Geraldine Page in a scene from Delbert Mann's *Dear Heart* (1964), a romance that underperformed at the box office but has come to be regarded as a showcase for fine performances. • Sammy Davis Jr., Richard Bakalyan, Frank Sinatra, Dean Martin, Barbara Rush and Victor Buono in a publicity pose for Gordon Douglas's *Robin and the 7 Hoods* (1964), another "Rat Pack" movie. **OPPOSITE, CLOCKWISE FROM TOP LEFT:** Carroll Baker and Dolores Del Rio in a scene from *Cheyenne Autumn* (1964), John Ford's last western and one of the few Hollywood films of the period to acknowledge the mistreatment of Native Americans. • The TV star Don Knotts dubbed the subaqueous voice of *The Incredible Mr. Limpet* (1964). • Tony Curtis and Natalie Wood publicize Richard Quine's *Sex and the Single Girl* (1964), which was based on the scandalous book by Helen Gurley Brown.

Jack Warner visits stars Audrey Hepburn, Rex Harrison, Wilfred Hyde-White, and Stanley Holloway on the set of George Cukor's *My Fair Lady* (1964), an expensive film that paid off in both box office and prestige. Director George Cukor is at far left and composer Frederick Loewe is at far right.

1964 ACADEMY AWARDS

WINS

Best Picture:
★ *My Fair Lady*, Jack L. Warner, Producer

Directing:
★ George Cukor for *My Fair Lady*

Actor:
★ Rex Harrison in *My Fair Lady*

Art Direction (Color):
★ *My Fair Lady*, Art Direction: Gene Allen and Cecil Beaton; Set Decoration: George James Hopkins

Cinematography (Color):
★ *My Fair Lady*, Harry Stradling Sr.

Costume Design (Color):
★ *My Fair Lady*, Cecil Beaton

Music (Scoring of Music—Adaptation or Treatment):
★ *My Fair Lady*, André Previn

Sound:
★ *My Fair Lady*, Warner Bros. Studio Sound Department, George R. Groves, Sound Director

NOMINATIONS

Supporting Actor:
• Stanley Holloway in *My Fair Lady*

Supporting Actress:
• Gladys Cooper in *My Fair Lady*

Writing (Screenplay):
• *My Fair Lady*, Alan Jay Lerner

Cinematography (Color):
• *Cheyenne Autumn*, William H. Clothier

Costume Design (Black-and-White):
• *Kisses for My President*, Howard Shoup

Film Editing:
• *My Fair Lady*, William Ziegler

Music (Scoring of Music—Adaptation or Treatment):
• *Robin and the 7 Hoods*, Nelson Riddle

Music (Song):
• "Dear Heart" from *Dear Heart*, Music by Henry Mancini; Lyrics by Jay Livingston and Ray Evans
• "My Kind of Town" from *Robin and the 7 Hoods*, Music by James Van Heusen; Lyrics by Sammy Cahn

FROM TOP: Frank Sinatra, Cesar Romero, and Deborah Kerr in a scene from Jack Donohue's *Marriage on the Rocks* (1965). • Maureen O'Sullivan and Paul Ford shop for maternity articles in Bud Yorkin's *Never Too Late* (1965). • Henry Fonda and Robert Ryan in a scene from Ken Annakin's *Battle of the Bulge* (1965), which was criticized for historical inaccuracies.

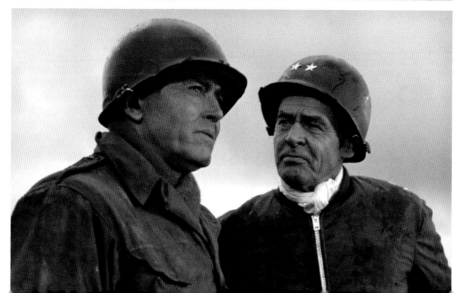

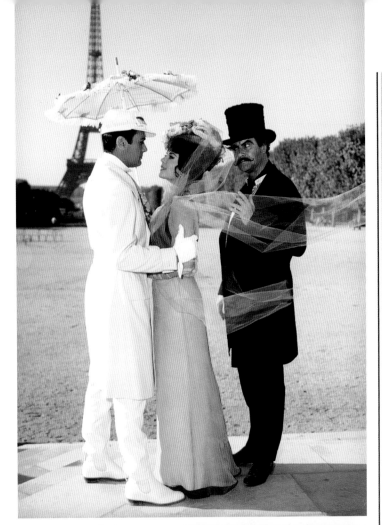

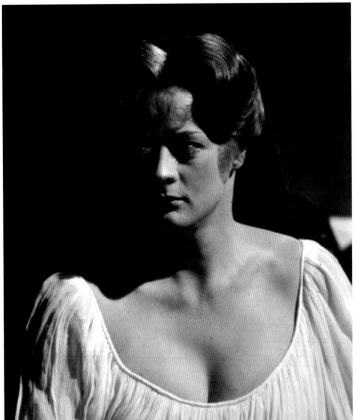

1965 ACADEMY AWARDS

WINS

Sound Effects:

★ *The Great Race*, Tregoweth Brown

NOMINATIONS

Actor:

• Laurence Olivier in *Othello*

Supporting Actor:

• Frank Finlay in *Othello*

Supporting Actress:

• Ruth Gordon in *Inside Daisy Clover*
• Joyce Redman in *Othello*
• Maggie Smith in *Othello*

Art Direction (Color):

• *Inside Daisy Clover*, Art Direction: Robert Clatworthy; Set Decoration: George James Hopkins

Cinematography (Color):

• *The Great Race*, Russell Harlan

Costume Design (Color):

• *Inside Daisy Clover*, Edith Head and Bill Thomas

Film Editing:

• *The Great Race*, Ralph E. Winters

Music (Song):

• "The Sweetheart Tree" from *The Great Race*, Music by Henry Mancini; Lyrics by Johnny Mercer

Sound:

• *The Great Race*, Warner Bros. Studio Sound Department, George R. Groves, Sound Director

FROM TOP: Blake Edwards directed Tony Curtis, Natalie Wood, and Jack Lemmon in *The Great Race* (1965), a large-scale tribute to classic Hollywood comedies.
• Maggie Smith played Desdemona in Stuart Burge's *Othello* (1965).

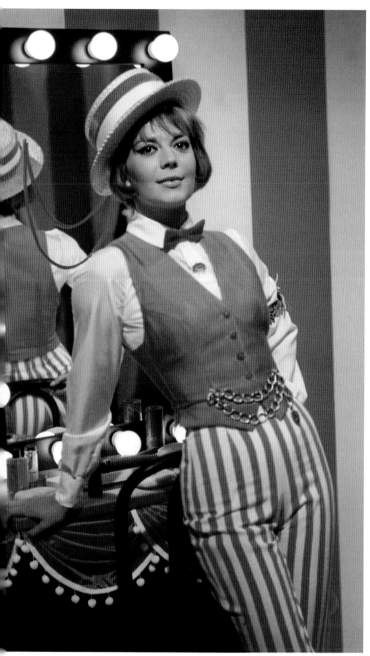

CLOCKWISE: Natalie Wood played a misfit teen who becomes an unlikely movie star in Robert Mulligan's *Inside Daisy Clover* (1965). • Joanne Woodward starred in Fielder Cook's *A Big Hand for the Little Lady* (1966). • A portrait of Sean Connery made for Irvin Kershner's *A Fine Madness* (1966).

THE 1960S: AN ERA FADES

Mike Nichols directed Richard Burton and Elizabeth Taylor in the much-talked-about *Who's Afraid of Virginia Woolf?* (1966).

1966 ACADEMY AWARDS

WINS

Actress:

★ Elizabeth Taylor in *Who's Afraid of Virginia Woolf?*

Supporting Actress:

★ Sandy Dennis in *Who's Afraid of Virginia Woolf?*

Art Direction (Black-and-White):

★ *Who's Afraid of Virginia Woolf?*, Art Direction: Richard Sylbert; Set Decoration: George James Hopkins

Cinematography (Black-and-White):

★ *Who's Afraid of Virginia Woolf?*, Haskell Wexler

Costume Design (Black-and-White):

★ *Who's Afraid of Virginia Woolf?*, Irene Sharaff

NOMINATIONS

Best Picture:

• *Who's Afraid of Virginia Woolf?*, Ernest Lehman, Producer

Directing:

• Mike Nichols for *Who's Afraid of Virginia Woolf?*

Actor:

• Richard Burton in *Who's Afraid of Virginia Woolf?*

Supporting Actor:

• George Segal in *Who's Afraid of Virginia Woolf?*

Writing (Screenplay):

• *Who's Afraid of Virginia Woolf?*, Ernest Lehman

Film Editing:

• *Who's Afraid of Virginia Woolf?*, Sam O'Steen

Music (Original Music Score):

• *Who's Afraid of Virginia Woolf?*, Alex North

Music (Scoring of Music—Adaptation or Treatment):

• *Stop the World—I Want to Get Off*, Al Ham

Music (Song):

• "A Time for Love" from *An American Dream*, Music by Johnny Mandel; Lyrics by Paul Francis Webster

Sound:

• *Who's Afraid of Virginia Woolf?*, Warner Bros. Studio Sound Department, George R. Groves, Sound Director

CLOCKWISE FROM TOP: Merle Oberon and Michael Rennie on the set of Richard Quine's *Hotel* (1967), an old-fashioned melodrama. • A scene of Sandy Dennis and Jeff Howard in Robert Mulligan's *Up the Down Staircase* (1967), a probing look at the New York public school system. • Elizabeth Taylor played a frustrated Army wife in John Huston's *Reflections in a Golden Eye* (1967).

CLOCKWISE FROM TOP LEFT: Peter Sellers as the "Blue Matador" in Robert Parrish's *The Bobo* (1967). • Richard Crenna and Audrey Hepburn in a scene from Terence Young's *Wait Until Dark* (1967), a very popular thriller that pitted a sight-impaired woman against criminals who break into her apartment. • Jack Warner holds court on the set of his last Warner Bros. production, Joshua Logan's *Camelot* (1967). Guests at the table include Franco Nero, Vanessa Redgrave, Logan, and Richard Harris. The set was designed by John Truscott. **OPPOSITE, FROM LEFT:** Faye Dunaway and Warren Beatty in Arthur Penn's blockbuster *Bonnie and Clyde* (1967), one of the first films of the "New Hollywood." • Paul Newman found a defining role in Stuart Rosenberg's *Cool Hand Luke* (1967).

1967 ACADEMY AWARDS

WINS

Supporting Actor:

★ George Kennedy in *Cool Hand Luke*

Supporting Actress:

★ Estelle Parsons in *Bonnie and Clyde*

Art Direction:

★ *Camelot*, Art Direction: John Truscott and Edward Carrere; Set Decoration: John W. Brown

Cinematography:

★ *Bonnie and Clyde*, Burnett Guffey

Costume Design:

★ *Camelot*, John Truscott

Music (Scoring of Music— Adaptation or Treatment):

★ *Camelot*, Alfred Newman and Ken Darby

NOMINATIONS

Best Picture:

• *Bonnie and Clyde*, Warren Beatty, Producer

Directing:

• Arthur Penn for *Bonnie and Clyde*

Actor:

• Warren Beatty in *Bonnie and Clyde*
• Paul Newman in *Cool Hand Luke*

Actress:

• Faye Dunaway in *Bonnie and Clyde*
• Audrey Hepburn in *Wait Until Dark*

Supporting Actor:

• Gene Hackman in *Bonnie and Clyde*
• Michael J. Pollard in *Bonnie and Clyde*

Writing (Screenplay):

• *Cool Hand Luke*, Donn Pearce and Frank R. Pierson

Writing (Story & Screenplay):

• *Bonnie and Clyde*, David Newman and Robert Benton

Cinematography:

• *Camelot*, Richard H. Kline

Costume Design:

• *Bonnie and Clyde*, Theadora Van Runkle

Music (Original Music Score):

• *Cool Hand Luke*, Lalo Schifrin

Short Subject (Live Action):

• *Sky over Holland*, John Ferno, Producer

Sound:

• *Camelot*, Warner Bros.–Seven Arts Studio Sound Department

CLOCKWISE FROM TOP LEFT: Peter Sellers and Leigh Taylor-Young in a scene from Hy Averback's *I Love You, Alice B. Toklas* (1968). • Sondra Locke and Alan Arkin in a scene from Robert Ellis Miller's *The Heart Is a Lonely Hunter* (1968), a touching adaptation of the Carson McCullers novel. • A portrait of Vanessa Redgrave for Sidney Lumet's *The Sea Gull* (1968). • **OPPOSITE, CLOCKWISE FROM TOP LEFT:** Raymond St. Jacques, John Wayne, and George Takei in a scene from Wayne and Ray Kellogg's *The Green Berets* (1968). Antiwar protestors condemned it, and critics vilified it, yet it was a commercial success. • Anne Heywood and Sandy Dennis in a scene from Mark Rydell's *The Fox* (1968), one of the first films about sexuality to benefit from that year's dismantling of the Production Code. • Don Francks, Fred Astaire, and Petula Clark in Francis Ford Coppola's *Finian's Rainbow* (1968), the last dancing film of genius Fred Astaire.

1968 ACADEMY AWARDS

WINS

Film Editing:

★ *Bullitt*, Frank P. Keller

NOMINATIONS

Best Picture:

- *Rachel, Rachel*, Paul Newman, Producer

Actor:

- Alan Arkin in *The Heart Is a Lonely Hunter*

Actress:

- Joanne Woodward in *Rachel, Rachel*

Supporting Actress:

- Sondra Locke in *The Heart Is a Lonely Hunter*
- Estelle Parsons in *Rachel, Rachel*

Writing (Screenplay):

- *Rachel, Rachel*, Stewart Stern

Music (Score of a Musical Picture):

- *Finian's Rainbow*, Adaptation Score by Ray Heindorf
- *The Young Girls of Rochefort*, Music and Adaptation Score by Michel Legrand; Lyrics by Jacques Demy

Sound:

- *Bullitt*, Warner Bros.–Seven Arts Studio Sound Department
- *Finian's Rainbow*, Warner Bros.–Seven Arts Studio Sound Department

FROM TOP: Steve McQueen's action sequences made a monster hit of Peter Yates's *Bullitt* (1968). • Paul Newman directs his wife Joanne Woodward in a scene for *Rachel, Rachel* (1968).

FROM TOP:
Photographer Gordon Parks directed Kyle Johnson and Mira Waters in his autobiographical film, *The Learning Tree* (1969). This was the first major studio feature made by an African American filmmaker.
• A cast portrait for Bryan Forbes's *The Madwoman of Chaillot* (1969); (from left) Oscar Homolka, Nanette Newman, Donald Pleasence, Charles Boyer, Paul Henreid, John Gavin, Yul Brynner, Katharine Hepburn, Danny Kaye, Giuletta Masina, Margaret Leighton, Dame Edith Evans, Claude Dauphin, and Richard Chamberlain.

CLOCKWISE FROM TOP LEFT: A portrait of Faye Dunaway for Elia Kazan's *The Arrangement* (1969). • An allosaurus and a styracosaurus were animated by Ray Harryhausen for Jim O'Connolly's *The Valley of Gwangi* (1969). • Christopher Lee in a scene from Freddie Francis's *Dracula Has Risen from the Grave* (1969), Lee's third portrayal of the undead count for Hammer, and one of the most successful in the horror series. • Robert Duvall and Shirley Knight in a scene from Francis Ford Coppola's *The Rain People* (1969), a "New Hollywood" look at ordinary people. **OPPOSITE, FROM TOP:** A portrait of Helmut Berger for Luchino Visconti's *The Damned* (1969), one of the few films to merit the newly instituted "X" rating. • A group portrait for Sam Peckinpah's *The Wild Bunch* (1969): (standing, from left) Bo Hopkins, Jaime Sanchez, Ernest Borgnine, William Holden, Rayford Barnes, Warren Oates, (kneeling from left) Tap Canutt, and Ben Johnson.

1969 ACADEMY AWARDS

NOMINATIONS

Writing (Story and Screenplay):
- *The Damned*, Story by Nicola Badalucco; Screenplay by Nicola Badalucco, Enrico Medioli, and Luchino Visconti
- *The Wild Bunch*, Story by Walon Green and Roy N. Sickner; Screenplay by Walon Green and Sam Peckinpah

Music (Original Score):
- *The Wild Bunch*, Jerry Fielding

CHAPTER SIX

THE
1970s:

THE ERA OF THE AUTEUR

WARNER BROS. ENTERED A NEW DECADE WITH THE SAME NAME, BUT BEHIND THE WB shield much was changing. The country was in turmoil. Political unrest continued with student antiwar protests, some of which turned violent and resulted in deaths. Establishment-bound studio bosses could shake their heads, but these people were now their target demographic. Roughly 70 percent of the American movie audience was under thirty and college educated. This was in contrast to the audience of the 1960s, which was middle-aged and high school educated. In 1970, movie tickets averaged $1.50, and only 18 million were sold, a drop from the 30 million of 1960. No wonder studios looked to the youth market.

With the Production Code retired since 1968, filmmakers could put practically anything on the screen that tickled their fancy, respecting, of course, the old bugaboo—community standards. Profanity, violence, and female nudity abounded, but writers stopped short of anything that would get the dreaded "X" rating. In the first years of the new freedom, though, the element of the Code that was most decisively put to rest was "compensating moral values." It was no longer necessary to punish a wicked character in the last reel. Writers argued that they were trying to portray real life, not a sanitized Hollywood version of it, so good need not triumph over evil.

As reviewers noted, audiences felt cheated, as in the case of Paramount's *Chinatown*, when a film spent two hours building an expectation that the heroine would escape the villain, only to have that expectation dashed in the last minutes of the film. That wasn't the worst of the new freedom. The ending couldn't be disappointing if there were no ending, so why write an ending? Why resolve the plot in the last minutes of the film? Taking a cue from European cinema, more American films ended ambiguously. Had the projectionist forgotten the last reel? In spite of these frustrating trends, audiences kept coming back. Moviegoing was a ritual.

Under the leadership of the esteemed Steven J. Ross (the head of Warner Bros.' parent company, Kinney/Warner Communications), Warner Bros. continued to form partnerships with star producers such as John

Wayne and Clint Eastwood, as well as directors such as Alan J. Pakula, John Boorman, Terrence Malick, Claudia Weill, and Italian-born Lina Wertmüller. Don Siegel, who had begun his career creating Warner montages in the '40s, was turning out hits, too, and he would occa-

Clint Eastwood created a sensation in Don Siegel's *Dirty Harry* (1971). The film led to more than fifty years of partnership between the producer-director-star and Warner Bros. Photograph by Bernie Abramson.

sionally answer questions at the University of Southern California, where film production was taught.

It was difficult for film students to heed the advice of instructor Dave Johnson, who warned them not to make films by simply setting images against a popular rock song. The purest form of cinema could be found in musical numbers, and one of the biggest films of 1970 was *Woodstock*. The Woodstock Music & Art Fair had taken place in August 1969 near Bethel, New York, and had been attended by 400,000 fans. *Woodstock* featured performances by, among others, Joe Cocker, Joan Baez, and Santana, yet it was not strictly a concert film; director Michael Wadleigh captured the exciting, sometimes scary experience of an oversold rock concert, editing the footage with a team that included Thelma Schoonmaker and Martin Scorsese. For a minimal expenditure, Warner made an easy $50 million.

The youth market was also key to the success of *Performance*, which presented rock star Mick Jagger as an actor. The British crime drama had been produced in 1968 and kept on the shelf because of its sadism and pansexual content—until a major re-edit and changes in studio leadership occurred. A best-selling soundtrack album sealed the deal. Britain's Hammer Film Productions offered *Taste the Blood of Dracula*, the next entry in the supernatural horror saga, the fourth to star Christopher Lee as Count Dracula, and the fifth installment in Hammer's *Dracula* series.

Warner gave a young director, George Lucas, his directorial debut with *THX 1138*, a project he developed from a student film he had made three years earlier at USC. Prepared for Warner by Lucas's producing partner Francis Ford Coppola, the film starred Robert Duvall and Donald Pleasence.

Boomers who had grown up watching John Wayne on Saturday afternoons continued to support his work. As charted by the *Motion Picture Herald*, he had been a "Top Ten Box-Office Draw" since 1949. His 1970 film *Chisum* was loosely based on the Lincoln County War of 1878, and its success warranted more Warner proj-

ects: *The Cowboys, The Train Robbers, Cahill U.S. Marshal,* and *McQ.*

Produced in the throes of a nostalgia boom occasioned by the nonstop airing of "old movies," *Summer of '42* was screenwriter Herman Raucher's reminiscence of a Nantucket Island woman whose husband had gone off to war. Striking a chord with audiences, the film yanked $25 million out of their pockets.

Aware of the civil rights movement, Warner produced a number of projects about the African American experience. *Malcolm X* was a documentary based on the activist's book *The Autobiography of Malcolm X. Come Back Charleston Blue* was a comedy shot in Harlem with Godfrey Cambridge; Warner Bros. Records benefited by its soundtrack album, which featured Donny Hathaway. *Super Fly* was directed by Gordon Parks Jr., son of the famed photographer. The film was part of a new subgenre labeled "blaxploitation," and it starred Ron O'Neal as a dealer trying to quit the drug business. The film's "funk music" soundtrack, written and produced by Curtis Mayfield, sold twelve million copies.

Aware of the civil rights movement, Warner produced a number of projects about the African American experience.

Jack Starrett gave some flair to *Cleopatra Jones*, a blaxploitation flick that featured the leggy Tamara Dobson as an undercover agent in wicked LA. The movie did well enough to merit a sequel, Charles Ball's *Cleopatra Jones and the Casino of Gold*. Perhaps in deference to women's lib (but not gay lib), both films gave Dobson a female nemesis—in the first film, Shelley Winters, and in the second, Stella Stevens, both of whom were inexplicably written as lesbians. Even more homophobic was Jerry Schatzberg's *Scarecrow*, in which a predatory bleached-blond man befriends the mentally challenged Al Pacino in order to molest him. Before anything

untoward can occur, Gene Hackman comes to the rescue, beating the blond man senseless.

The studio hit pay dirt with a number of high-profile projects. Alan J. Pakula's *Klute* starred Jane Fonda as a pragmatic prostitute who helps detective Donald Sutherland solve a missing persons case. Robert Altman directed Warren Beatty and Julie Christie in his so-called anti-western film, *McCabe & Mrs. Miller*.

Early in the decade, Warner formed alliances with two important directors. Stanley Kubrick, fresh from a series of groundbreaking hits at Columbia and MGM (formerly M-G-M), set his first Warner film, *A Clockwork Orange*, in a British society overrun with juvenile delinquents. Even by 1971 post-Code standards, the film was shocking. It received the "X" rating for its deeply disturbing violence. So did another Warner release of a British film. Ken Russell made *The Devils*, a cinematic thumbscrew, as provocative as *A Clockwork Orange*. Before granting its release, both the studio and the British Board of Film Censors demanded multiple cuts due to its mixing of religious themes with brutal sexual content.

Warner's other alliance was with Clint Eastwood, who was becoming a latter-day John Wayne (while Wayne was still active), and Eastwood could direct, too. *Dirty Harry* was an action thriller produced and directed by Eastwood's mentor Don Siegel and starring Eastwood in the career-defining title role. The film was a critical and commercial success, but it might have gone very differently. Frank Sinatra had been all set to star in *Dirty Harry* but bowed out at the last minute. Eastwood, who was the first choice to star, but was thought to be unavailable, stepped in after Sinatra's exit, and it began Eastwood's fifty-plus year relationship with Warner Bros.

Warner Bros. had been run since 1969 by Steven J. Ross and the Kinney National Company. In 1972, Kinney was reincorporated as Warner Communications, a burgeoning media empire, and in 1973, it adopted a logo designed by Saul Bass. Former agent Ted Ashley and West Coast VP Frank Wells worked with Ross and

production head John Calley to release one film each month, whether made in Burbank or abroad. In spite of an oil embargo, an energy crisis, a recession, and political travails in Washington, Warner turned out a series of hits, riding the nationwide upsurge in ticket sales during the first years of the 1970s.

Calley lured Peter Bogdanovich to Warner Bros. to make *What's Up, Doc?*, an homage to the screwball comedies of the '30s and '40s, with Barbra Streisand and Ryan O'Neal as cartoon-like characters. The title quoted Bugs Bunny's signature greeting, and the movie was the number-three domestic earner for the year.

Michael Ritchie's *The Candidate*, starring Robert Redford, was a comedy-drama written by Jeremy

> In spite of an oil embargo, an energy crisis, a recession, and political travails in Washington, Warner turned out a series of hits, riding the nationwide upsurge in ticket sales during the first years of the 1970s.

Larner, a speechwriter for Senator Eugene McCarthy's 1968 campaign. The politically active Redford was well cast, and his next hit was *Jeremiah Johnson*, the first western to be accepted at Cannes and number five at the box office.

John Boorman's *Deliverance*, a harrowing tale of survival in the Georgia wilderness, starred Jon Voight and Burt Reynolds. Its success boosted all three careers, and its "Dueling Banjos" became a hit song eighteen years after the song's release.

Enter the Dragon, the essential martial-arts film, starred the legendary Bruce Lee. It was shot on location in Hong Kong and was Lee's final completed film appearance before his untimely death in 1973 at age thirty-two.

The Last of Sheila was the only film written by actor Anthony Perkins and composer/lyricist Stephen

Sondheim. The wry whodunit was directed by Herbert Ross with a cast that included Richard Benjamin, James Mason, and Raquel Welch. Meanwhile, François Truffaut, the quintessential French auteur, directed Jacqueline Bisset—and himself—in *Day for Night*, the story of how to finish a movie on time. *Jimi Hendrix* was a "rockumentary" directed by Joe Boyd, John Head, and Gary Weis, with concert footage from the Monterey Pop Festival, the 1970 Isle of Wight Festival, and Woodstock.

Mean Streets was Martin Scorsese's personal story of New York's Little Italy as well as his first collaboration with Robert De Niro. Scorsese had worked on the project for seven years, and it refined his vision. It also made a surprising $32.6 million. After seeing the violent saga, Ellen Burstyn had her doubts that Scorsese could direct an introspective film. *Alice Doesn't Live Here Anymore* was an unlikely next subject for the New York director, but he proved that he could make a film from a woman's point of view.

Badlands was the feature debut of the deliberate Terrence Malick. With customary care, Malick directed newcomers Martin Sheen and Sissy Spacek to critical acclaim.

William Friedkin's *The Exorcist* is fondly remembered by anyone who stood in the long lines outside every theater that exhibited it. Written for the screen by William Peter Blatty from his 1971 novel, it starred Ellen Burstyn, Max von Sydow, and Lee J. Cobb, and it featured non-actor Jason Miller as a troubled young priest. Linda Blair played a teenager who suffered demonic possession. Although there were reports of fainting or vomiting in theaters, *The Exorcist* became an enormous hit.

Blazing Saddles was a western comedy with something to offend everyone. Directed by comic genius Mel Brooks and starring Cleavon Little and Gene Wilder, the film sent up everything western, from saloon singers to fistfights; its raunchy humor earned it an "R" rating, and it was a smashing success.

Sidney Poitier directed and starred in *Uptown Saturday Night*, a comedy crime film with Bill Cosby and Harry Belafonte. This was Poitier's third turn as director, and he succeeded in portraying African Americans as something more than blaxploitation stereotypes.

In 1974, a fire at the Warner Ranch destroyed eight acres of structures. As art imitates life, the studio released Irwin Allen's *The Towering Inferno* some months later. The all-star cast was led by Paul Newman and Steve McQueen, and it was the nation's highest-grossing movie of the year. Directed by John Guillermin, this co-production with Twentieth Century-Fox was the first joint venture of two Hollywood studios.

Sydney Pollack's *The Yakuza* cast Robert Mitchum as a retired detective returning to work to help find a friend's kidnapped daughter. Sidney Lumet's *Dog Day Afternoon*, with Al Pacino, was a mix of levity and drama, the true story of an unconventional bank robbery and hostage ordeal.

By 1975, the disco craze was sweeping America, turning vacant warehouses into pleasure domes and anoint-

By 1975, the disco craze was sweeping America, turning vacant warehouses into pleasure domes and anointing lucky musicians as geniuses, most of whom vanished after one dance hit.

ing lucky musicians as geniuses, most of whom vanished after one dance hit. It mattered not. This was the late twentieth century's answer to the Roaring Twenties. That era had Prohibition, speakeasies, and jazz. The '70s had recessions, quaaludes, and disco music. Writer Tom Wolfe labeled it the "'Me' Decade." It was giddy and bent on instant gratification, and, as in the films of Ken Russell, excess was not enough. Fresh from the big wow of *Tommy*, Russell wrote and directed *Lisztomania*, a deliriously overblown biography of Franz Liszt that explored the themes of idol worship and musical genius.

Coming off the success of *A Clockwork Orange*, Stanley Kubrick created an eighteenth-century comedy of manners, *Barry Lyndon*, with Ryan O'Neal, Marisa Berenson, and some grainy but pretty color cinematography. It was widely lauded.

Inspired by the history of the Supremes, *Sparkle* (preceding the play *Dreamgirls*) told the story of three sisters (Lonette McKee, Irene Cara, Dwan Smith) who crave success.

The 1974 best seller *All the President's Men* by Carl Bernstein and Bob Woodward became an Alan J. Pakula film starring Robert Redford and Dustin Hoffman as the investigative reporters. The taut political thriller was the number-five domestic earner for 1976.

The accomplished director Philip Kaufman began *The Outlaw Josey Wales*, but he was summarily replaced by Clint Eastwood due to "creative differences." Chief Dan George and Sondra Locke co-starred with Eastwood. *The Gauntlet* starred Eastwood as a policeman guarding a prostitute about to testify against the mob. In a surprising move, with 1978's *Every Which Way but Loose*, Eastwood tried his hand at comedy. He played a trucker with an orangutan sidekick named Clyde. This was the story of their misadventures with an assortment of offbeat characters, including Sondra Locke, a lost love. The choice paid off for Eastwood; it was one of his highest-grossing films.

The Song Remains the Same captured the zest of the English rock band Led Zeppelin. Filming took place in the summer of 1973 at Madison Square Garden, with additional footage shot at Shepperton Studios.

Twenty-two years after the Judy Garland version of *A Star Is Born*, Warner Bros. updated the fable, this time with a rock backdrop and Dolby Surround. Barbra Streisand and Kris Kristofferson acted the story of the ill-fated couple, directed by Frank Pierson. This second remake grossed $80 million on a $6 million budget and introduced the song "Evergreen." In yet another follow-up, John Boorman directed *Exorcist II: The Heretic*; Linda Blair was back for more punishment, along with Max von Sydow.

Playwright Neil Simon customarily adapted his plays for the screen but rarely wrote an original screenplay. *The Goodbye Girl* was the exception, a romantic comedy produced by Ray Stark. Mike Nichols was initially hired to direct Robert De Niro, but things didn't go well, so Herbert Ross took over, and Richard Dreyfuss

Twenty-two years after the Judy Garland version of *A Star Is Born*, Warner Bros. updated the fable, this time with a rock backdrop and Dolby Surround.

played the struggling actor with roommate problems. Warner Bros. and MGM partnered on the production.

Oh, God! was directed by Carl Reiner, and it starred the octogenarian George Burns as God and singer John Denver as a supermarket manager. In his big-screen debut, Denver had to convince people that he was really dealing with the Supreme Being. Claudia Weill's *Girlfriends* was the first big-studio release of an American independent film funded with grants, although private investors helped complete the film.

The year 1978 ended with a much-anticipated release, Richard Donner's *Superman*, which was based on the DC superhero. The super production starred stage actor Christopher Reeve and Margot Kidder, with a featured performance by Marlon Brando, and it was such a massive enterprise that it had to be an international co-production with the United Kingdom, Switzerland, and Panama.

In 1978, Warner Bros. signed an agreement to distribute films from the newly formed Orion Pictures Company. The first such release was George Roy Hill's *A Little Romance*, which had been shot in France and Italy, with teenagers Thelonious Bernard and Diane Lane making their film debuts in the august company of Sir Laurence Olivier.

Boulevard Nights was a story of Chicano life in 1979, directed by Michael Pressman. It starred Richard

Yniguez as an upwardly mobile professional trying to help his younger brother, Danny De La Paz, leave gang life. *Going in Style* was the story of three elderly men who rob a bank, but just for some excitement. George Burns and Art Carney were joined by Lee Strasberg, the Group Theater co-founder, in a rare film appearance. Shot in New York and Las Vegas, the picture made a stylish $30 million.

The Great Santini was a painful family drama based on a Pat Conroy novel. Written and directed by Lewis John Carlino, the film starred Robert Duvall and was shot on location in Beaufort, South Carolina. The studio had international rights only to *Mad Max*, an Australian action film directed by George Miller and produced by Byron Kennedy. The film starred Australian newcomer Mel Gibson as a vigilante in a futuristic world, and it earned more than $100 million.

10 was a comedy written, produced, and directed by Blake Edwards and starring Dudley Moore, Julie

The decade ended with the fortieth anniversary of everyone's favorite cartoon rabbit, Bugs Bunny, so Warner produced *The Bugs Bunny/ Road Runner Movie* (1979).

Andrews, and Bo Derek. The tale of a dumpy, fortyish man infatuated with a sublimely beautiful young woman was one of the year's biggest hits. The studio was doing well.

The decade ended with the fortieth anniversary of everyone's favorite cartoon rabbit, Bugs Bunny, so

Warner produced *The Bugs Bunny/Road Runner Movie* (1979). Directed by the beloved animator Chuck Jones, it was a compilation of *Looney Tunes* and *Merrie Melodies*, with newly animated sequences hosted by Bugs at his home.

In all, the 1970s saw 185 feature films released by Warner Communications. For the industry, the average ticket price rose from $1.65 in 1971 to $2.50 in 1978. It was generally agreed that the landscape had been radically altered by the success of, first, Steven Spielberg's *Jaws* in 1975, and then George Lucas's *Star Wars* in 1977. With their overwhelming attendance, merchandising tie-ins, and cultural ubiquity, these two films showed Hollywood that an "event picture" could carry an entire studio. No more sweating over little films? Maybe, maybe not. If a huge film like *Hello, Dolly!* flopped, it could close a studio, which had almost happened at Twentieth Century-Fox. Even so, United Artists gave the headstrong Michael Cimino a "green light" for a promised event picture, *Heaven's Gate*, and then watched the budget creep upward. At Warner, meanwhile, the respected team of Ashley, Ross, and Calley proceeded with caution, happy to have a *Superman* sequel in post-production.

As a new decade approached, the American economy was shifting. Inflation was spiraling upward. The cost of the average film jumped from $5 million (in 1976) to $10 million (in 1979). As a result, production slowed. Another oil embargo put cars back in lines at gas stations, and the 1980s threatened a repeat of the 1974 recession. As if this weren't bad enough, studios felt the nagging fear of both cable TV and videocassette recorders. Was Hollywood ready for the '80s?

CLOCKWISE FROM TOP LEFT: Peter Cushing is a very cold scientist in Terence Fisher's *Frankenstein Must Be Destroyed* (1970), the fifth Hammer film in the Frankenstein vein and a moneymaker for both Hammer and Warner. • Andrew V. McLaglen's *Chisum* (1970) was a John Wayne vehicle enlivened by the presence of popular television actress Lynda Day George. • Nicholas Roeg and Donald Cammell created a psychedelic, pansexual nightmare for Mick Jagger (here with Anita Pallenberg) in *Performance* (1970).

FROM TOP: Kirk Douglas and Henry Fonda were 1970s-style antiheroes in Joseph L. Mankiewicz's *There Was a Crooked Man* (1970). • Kathleen Freeman and Steve Franken were comic relief in Jerry Lewis's *Which Way to the Front* (1970).

1970 ACADEMY AWARDS

WINS

Documentary (Feature):

★ *Woodstock,* Bob Maurice, Producer

NOMINATIONS

Film Editing:

• *Woodstock,* Thelma Schoonmaker

Sound:

• *Woodstock,* Dan Wallin and Larry Johnson

CLOCKWISE FROM TOP LEFT: Silvana Mangano and Björn Andrésen in a scene from Luchino Visconti's *Death in Venice* (1971), which was based on the Thomas Mann novella about an intellectual's descent into obsession. • Maggie McOmie and Robert Duvall in a scene from George Lucas's *THX 1138* (1971), a warning against a society in which emotions are controlled by the government. • A publicity portrait of Donald Sutherland and Jane Fonda made for Alan J. Pakula's *Klute* (1971). • Charlton Heston is a plague survivor in Boris Sagal's *The Omega Man* (1971).

1971 ACADEMY AWARDS

WINS

Actress:

★ Jane Fonda in *Klute*

Music (Original Dramatic Score):

★ *Summer of '42*, Michel Legrand

NOMINATIONS

Best Picture:

• *A Clockwork Orange*, Stanley Kubrick, Producer

Directing:

• Stanley Kubrick for *A Clockwork Orange*

Actress:

• Julie Christie in *McCabe & Mrs. Miller*

Writing (Screenplay):

• *A Clockwork Orange*, Stanley Kubrick

Writing (Story and Screenplay):

• *Klute*, Andy Lewis and Dave Lewis

• *Summer of '42*, Herman Raucher

Cinematography:

• *Summer of '42*, Robert Surtees

Costume Design:

• *Death in Venice*, Piero Tosi

Documentary (Short Subject):

• *Art Is . . .* , Julian Krainin and DeWitt L. Sage Jr., Producers

Film Editing:

• *A Clockwork Orange*, Bill Butler

• *Summer of '42*, Folmar Blangsted

Foreign Language Film:

• *The Emigrants* (Sweden)

Special Visual Effects:

• *When Dinosaurs Ruled the Earth*, Jim Danforth and Roger Dicken

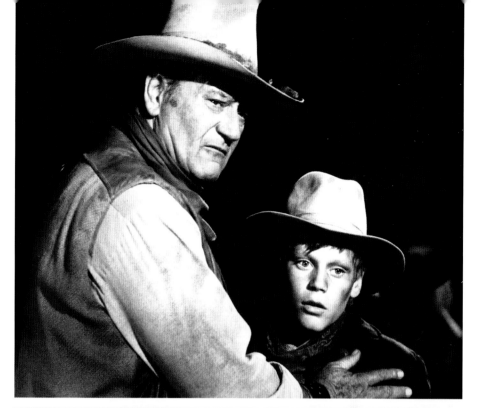

FROM TOP: John Wayne is a mentor to Norman Howell in Mark Rydell's *The Cowboys* (1972). • Ryan O'Neal and Barbra Streisand in a scene from Peter Bogdanovich's *What's Up, Doc?* (1972), an affectionate satire of screwball comedies. OPPOSITE, FROM TOP: Jennifer O'Neill and Gary Grimes in a scene from Robert Mulligan's *Summer of '42* (1971), a wistful recollection of a first love. • Malcolm McDowell in a scene from Stanley Kubrick's *A Clockwork Orange* (1971), a nightmarish odyssey through a society beset with sexual violence. • Julie Christie and Warren Beatty in a scene from Robert Altman's "anti-western" *McCabe & Mrs. Miller* (1971).

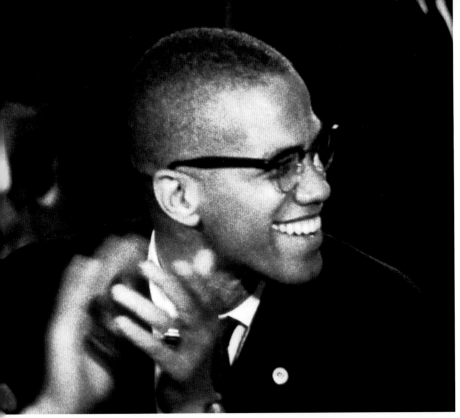

1972 ACADEMY AWARDS

WINS

Writing (Story and Screenplay):
★ *The Candidate*, Jeremy Larner

NOMINATIONS

Best Picture:
- *Deliverance*, John Boorman, Producer
- *The Emigrants*, Bengt Forslund, Producer

Directing:
- John Boorman for *Deliverance*
- Jan Troell for *The Emigrants*

Actress:
- Liv Ullmann in *The Emigrants*

Writing (Screenplay):
- *The Emigrants*, Jan Troell and Bengt Forslund

Documentary (Feature):
- *Malcolm X*, Marvin Worth and Arnold Perl, Producers

Film Editing:
- *Deliverance*, Tom Priestley

Foreign Language Film:
- *The New Land* (Sweden)

Sound:
- *The Candidate*, Richard Portman and Gene Cantamessa

FROM TOP: A scene from Arnold Perl's *Malcolm X* (1972).• A publicity portrait of Ron O'Neal and Sheila Frazier made for *Super Fly* (1972), which was directed by Gordon Parks Jr.

CLOCKWISE FROM TOP LEFT: Robert Redford played an inexperienced politician in Michael Ritchie's *The Candidate* (1972). • Burt Reynolds uses his wits to survive a wilderness ordeal in John Boorman's monstrously popular *Deliverance* (1972). • Liv Ullmann in a scene from Jan Troell's *The Emigrants* (1971), a much-praised saga about the journey of poor Swedish farmers to Minnesota in the mid-nineteenth century.

CLOCKWISE FROM TOP LEFT: A publicity portrait of Tamara Dobson, made for Jack Starrett's *Cleopatra Jones* (1973). • Bruce Lee starred in *Enter the Dragon* (1973). The massively profitable, legendary film was directed by Robert Clouse. • Jane Fonda in a scene from Alan Myerson's *Steelyard Blues* (1973), a hip crime film shot in Hayward, California. • David Proval and Robert De Niro in Martin Scorsese's *Mean Streets* (1973). The film made Scorsese an American auteur.

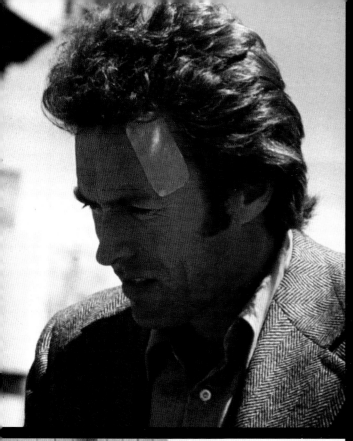

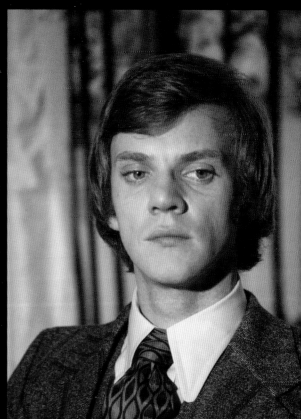

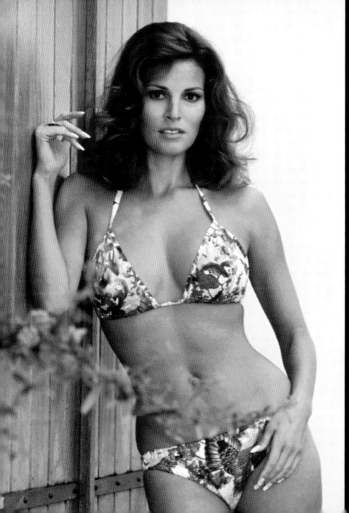

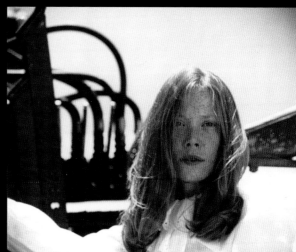

CLOCOKWISE FROM TOP LEFT: Clint Eastwood played Detective Harry Callahan for the second time in Ted Post's *Magnum Force* (1973). • Malcolm McDowell in a scene from Lindsay Anderson's *O Lucky Man* (1973). • A portrait of Sissy Spacek made for Terrence Malick's *Badlands* (1973), which was loosely based on the murder spree of Charles Starkweather and his girlfriend Caril Ann Fugate. • Raquel Welch played a murder suspect in Herbert Ross's *The Last of Sheila* (1973).

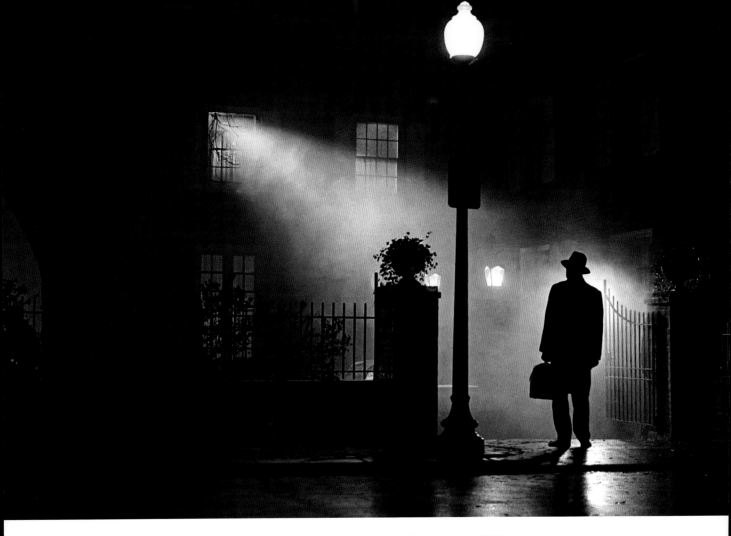

The ominous image that publicized William Friedkin's blockbuster, *The Exorcist* (1973).

1973 ACADEMY AWARDS

WINS

Writing (Screenplay):

★ *The Exorcist,* William Peter Blatty

Sound:

★ *The Exorcist,* Robert Knudson and Chris Newman

Foreign Language Film:

★ *Day for Night* (France)

NOMINATIONS

Best Picture:

• *The Exorcist*, William Peter Blatty, Producer

Directing:

• William Friedkin for *The Exorcist*

Actress:

• Ellen Burstyn in *The Exorcist*

Supporting Actor:

• Jason Miller in *The Exorcist*

Supporting Actress:

• Linda Blair in *The Exorcist*

Art Direction:

• *The Exorcist*, Art Direction: Bill Malley; Set Decoration: Jerry Wunderlich

Cinematography:

• *The Exorcist*, Owen Roizman

Film Editing:

• *The Exorcist*, Jordan Leondopoulos, Bud Smith, Evan Lottman, and Norman Gay

CLOCKWISE FROM TOP LEFT: A portrait of Lucille Ball made for Gene Saks's *Mame* (1974); Ball was television's most successful star, so there was excitement in her taking the role made legendary by Rosalind Russell on film and by Angela Lansbury onstage; no one expected this to be Ball's last theatrical feature. • Sidney Poitier in a scene from Richard Wesley's *Uptown Saturday Night* (1974). • Alan Arkin and James Caan in a scene from Richard Rush's frenetic *Freebie and the Bean* (1974).

CLOCKWISE FROM TOP LEFT:
Madeline Kahn and Harvey Korman in
a scene from Mel Brooks's outrageous
satire *Blazing Saddles* (1974).
• Ellen Burstyn played a widow
crossing the country with her young
son in Martin Scorsese's *Alice Doesn't
Live Here Anymore* (1974). • John
Sturges directed John Wayne, seen
here with Diana Muldaur, in another
action spree, *McQ* (1974). **OPPOSITE:**
The all-star cast of John Guillermin's
The Towering Inferno (1974): (from
left) Robert Wagner, Fred Astaire,
Richard Chamberlain, Paul Newman,
William Holden, Faye Dunaway,
Steve McQueen, Jennifer Jones, O. J.
Simpson, and Robert Vaughn.

1974 ACADEMY AWARDS

WINS

Actress:
⭑ Ellen Burstyn in *Alice Doesn't Live Here Anymore*

Cinematography:
⭑ *The Towering Inferno*, Fred Koenekamp and Joseph Biroc

Film Editing:
⭑ *The Towering Inferno*, Harold F. Kress and Carl Kress

Music (Song):
⭑ "We May Never Love Like This Again" from *The Towering Inferno*, Music and Lyrics by Al Kasha and Joel Hirschhorn

Scientific or Technical Award (Class II):
⭑ To The Burbank Studios Sound Department for the design of new audio control consoles, engineered and constructed by the Quad-Eight Sound Corporation

NOMINATIONS

Best Picture:
• *The Towering Inferno*, Irwin Allen, Producer

Directing:
• François Truffaut for *Day for Night*

Supporting Actor:
• Fred Astaire in *The Towering Inferno*

Supporting Actress:
• Valentina Cortese in *Day for Night*
• Madeline Kahn in *Blazing Saddles*
• Diane Ladd in *Alice Doesn't Live Here Anymore*

Writing (Original Screenplay):
• *Alice Doesn't Live Here Anymore*, Robert Getchell
• *Day for Night*, François Truffaut, Jean-Louis Richard, and Suzanne Schiffman

Art Direction:
• *The Towering Inferno*, Art Direction: William Creber and Ward Preston; Set Decoration: Raphael Bretton

Film Editing:
• *Blazing Saddles*, John C. Howard and Danford Greene

Music (Original Dramatic Score):
• *The Towering Inferno*, John Williams

Music (Song):
• "Blazing Saddles" from *Blazing Saddles*, Music by John Morris; Lyrics by Mel Brooks

Sound:
• *The Towering Inferno*, Theodore Soderberg and Herman Lewis

1975 ACADEMY AWARDS

WINS

Writing (Original Screenplay):

★ *Dog Day Afternoon*, Frank Pierson

Art Direction:

★ *Barry Lyndon*, Art Direction: Ken Adam and Roy Walker; Set Decoration: Vernon Dixon

Cinematography:

★ *Barry Lyndon*, John Alcott

Music (Scoring: Original Song Score and/or Adaptation):

★ *Barry Lyndon*, Adapted Score by Leonard Rosenman

Costume Design:

★ *Barry Lyndon*, Ulla-Britt Soderlund and Milena Canonero

NOMINATIONS

Best Picture:

• *Barry Lyndon*, Stanley Kubrick, Producer

• *Dog Day Afternoon*, Martin Bregman and Martin Elfand, Producers

Directing:

• Stanley Kubrick for *Barry Lyndon*

• Sidney Lumet for *Dog Day Afternoon*

Actor:

• Al Pacino in *Dog Day Afternoon*

Supporting Actor:

• Chris Sarandon in *Dog Day Afternoon*

Writing (Adapted Screenplay):

• *Barry Lyndon*, Stanley Kubrick

Film Editing:

• *Dog Day Afternoon*, Dede Allen

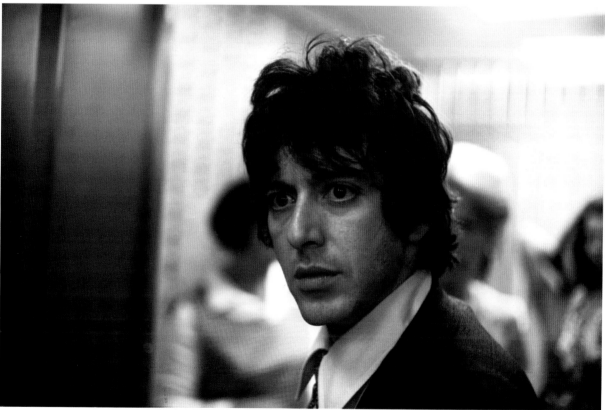

FROM TOP: A scene still of Ryan O'Neal and Marisa Berenson in Stanley Kubrick's *Barry Lyndon* (1975), the tale of an Irish rogue who marries a rich widow. • Al Pacino in a scene from Sidney Lumet's hugely profitable *Dog Day Afternoon* (1975). **OPPOSITE, FROM TOP:** Anne Bancroft in a scene from Melvin Frank's *The Prisoner of Second Avenue* (1975). • Paul Newman in a scene from Stuart Rosenberg's *The Drowning Pool* (1975), another 1970s tribute to film noir and a sequel to 1966's *Harper*, an American Zoetrope co-production with Warner Bros. • A portrait of Susan Clark from Arthur Penn's *Night Moves* (1975), a detective film set in Hollywood.

CLOCKWISE FROM TOP LEFT: Irene Cara and Philip Michael Thomas in Sam O'Steen's *Sparkle* (1976), which introduced "Something He Can Feel," a song composed by Curtis Mayfield and sung by Aretha Franklin. • A portrait of Kris Kristofferson and Barbra Streisand made for Frank Pierson's *A Star Is Born* (1976). • Rita Moreno and Treat Williams in a scene from Richard Lester's manic comedy *The Ritz* (1976). **OPPOSITE, CLOCKWISE FROM LEFT:** The excitement of Robert Plant and a Led Zeppelin concert were captured in *The Song Remains the Same* (1976), a documentary directed by Peter Clifton and Joe Massot. • Clint Eastwood starred in James Fargo's *The Enforcer* (1976), the third of the Dirty Harry films. • Robby Benson played a misunderstood youth in Max Baer Jr.'s *Ode to Billy Joe* (1976). • Clint Eastwood starred in *The Outlaw Josey Wales* (1976), his fifth film as a director.

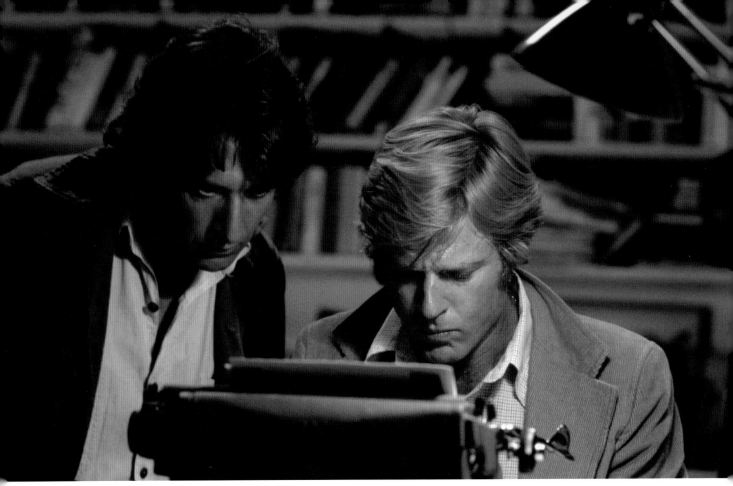

Dustin Hoffman and Robert Redford in a scene from *All the President's Men* (1976), which was directed by Alan J. Pakula.

1976 ACADEMY AWARDS

WINS

Supporting Actor:

★ Jason Robards in *All the President's Men*

Writing (Adapted Screenplay):

★ *All the President's Men*, William Goldman

Art Direction:

★ *All the President's Men*, Art Direction: George Jenkins; Set Decoration: George Gaines

Music (Original Song):

★ "Evergreen (Love Theme from *A Star Is Born*)" from *A Star Is Born*, Music by Barbra Streisand, Lyrics by Paul Williams

Sound:

★ *All the President's Men*, Arthur Piantadosi, Les Fresholtz, Dick Alexander, and Jim Webb

NOMINATIONS

Best Picture:

• *All the President's Men*, Walter Coblenz, Producer

Directing:

• Alan J. Pakula for *All the President's Men*

Supporting Actress:

• Jane Alexander in *All the President's Men*

Cinematography:

• *A Star Is Born*, Robert Surtees

Film Editing:

• *All the President's Men*, Robert L. Wolfe

Music (Original Score):

• *The Outlaw Josey Wales*, Jerry Fielding

Music (Original Song Score and Its Adaptation or Adaptation Score):

• *A Star Is Born*, Adaptation Score by Roger Kellaway

Sound:

• *A Star Is Born*, Robert Knudson, Dan Wallln, Robert J. Glass, and Tom Overton

FROMT TOP: Pam Grier and Richard Pryor starred in Michael Schultz's *Greased Lightning* (1977), a biography of the first African American NASCAR race winner, Wendell Scott. • A scene of Vonetta McGee in Arthur Barron's *Brothers* (1977), which may have been inspired by the life of activist Angela Davis. • Clint Eastwood and Sondra Locke starred in Eastwood's film *The Gauntlet* (1977), a hero's journey if there ever was one.

FROM TOP: A scene still of Richard Dreyfuss and Marsha Mason in Herbert Ross's *The Goodbye Girl* (1977), a story written for the screen by Neil Simon. • John Denver and George Burns in a scene from Carl Reiner's *Oh, God!* (1977), which struck lightning as one of 1977's top ten movies.

1977 ACADEMY AWARDS

WINS

Actor:

* ☆ Richard Dreyfuss in *The Goodbye Girl*

NOMINATIONS

Best Picture:

* *The Goodbye Girl*, Ray Stark, Producer

Actress:

* Marsha Mason in *The Goodbye Girl*

Supporting Actress:

* Quinn Cummings in *The Goodbye Girl*

Writing (Adapted Screenplay):

* *Oh, God!*, Larry Gelbart

Writing (Original Screenplay):

* *The Goodbye Girl*, Neil Simon
* *The Late Show*, Robert Benton

FROM TOP:
Burt Reynolds
in a scene from
Hal Needham's
Hooper (1978), a
very popular film
about a Hollywood
stunt man. •
Clint Eastwood
and Clyde the
orangutan in a
scene from
Eastwood's terrific
comedy, *Every
Which Way But
Loose* (1978).

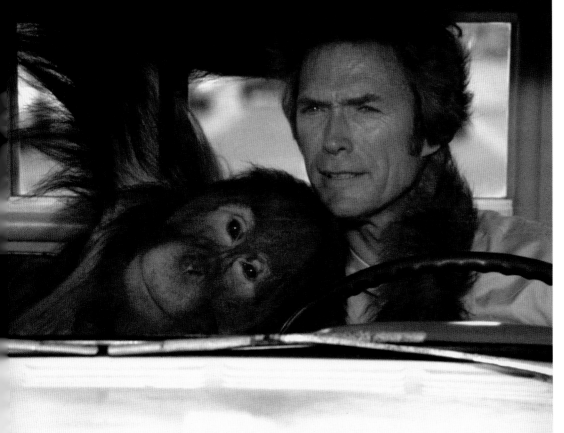

1978 ACADEMY AWARDS

WINS

Special Achievement Award (Visual Effects):

* ★ *Superman*, Les Bowie, Colin Chilvers, Denys Coop, Roy Field, Derek Meddings, and Zoran Perisic

NOMINATIONS

Writing (Adapted Screenplay):

* • *Bloodbrothers*, Walter Newman

Costume Design:

* • *The Swarm*, Paul Zastupnevich

Film Editing:

* • *Superman*, Stuart Baird

Music (Original Score):

* • *Superman*, John Williams

Sound:

* • *Hooper*, Robert Knudson, Robert J. Glass, Don MacDougall, and Jack Solomon
* • *Superman*, Gordon K. McCallum, Graham Hartstone, Nicholas Le Messurier, and Roy Charman

A portrait of Christopher Reeve made for Richard Donner's *Superman* (1978), which became a super-hit because it was seen by everyone—everywhere. **OPPOSITE, CLOCKWISE FROM TOP LEFT:** A portrait of Olivia de Havilland made for Irwin Allen's *The Swarm* (1978), a disaster film about bees. • Steve McQueen in his pet project, George Schaefer's *An Enemy of the People* (1978). • Gary Busey, Jan-Michael Vincent, and William Katt in John Milius's *Big Wednesday* (1978), an autobiographical film about surf culture.

CLOCKWISE FROM TOP LEFT: A portrait of Mel Gibson made for George Miller's *Mad Max* (1979), the Australian film that launched a franchise. • Jonathan Kaplan's *Over the Edge* (1979), a look at aimless middle-class youth with (clockwise from top right) Matt Dillon, Michael Kramer, Pamela Ludwig, and Tiger Thompson. • Danny De La Paz and Richard Yniguez in a scene from Michael Pressman's *Boulevard Nights* (1979), which was filmed in East Los Angeles, with gang members serving as both consultants and actors. • A portrait of Sir Laurence Olivier for George Roy Hill's *A Little Romance* (1979).

FROM TOP: George Burns, Lee Strasberg, and Art Carney plan a crime in Martin Brest's *Going in Style* (1979). • Poster art of Bugs Bunny for Chuck Jones's *The Bugs Bunny/Road Runner Movie* (1979). • A scene still of Barbra Streisand and Ryan O'Neal from Howard Zieff's *The Main Event* (1979), a very successful romantic comedy.

THE 1980s:

HIGH CONCEPT, BOTTOM LINE

AS THE 1980S ARRIVED, THE OUTLOOK MOMENTARILY BRIGHTENED. GASOLINE WAS plentiful and the economy stable, in spite of an ongoing hostage crisis in Iran. But nothing was stable in Hollywood. Because of inflation, average ticket prices were creeping upward from $2.69, and the cost of publicizing a film had risen to $6 million. What kind of film would justify such a marketing expenditure? The average film already cost $15 million.

Under the supportive guidance of CEO Steven J. Ross, Warner Bros. was a director-friendly environment. Throughout the 1980s, the studio continued to show faith in Stanley Kubrick, giving the renowned perfectionist time to craft his distinctive films. Moreover, Warner had relationships with filmmakers such as Clint Eastwood, Sidney Lumet, and Richard Lester.

The first of two Eastwood films released in 1980 was *Bronco Billy*, a quickly made, feel-good parable that grossed five times its cost. His 1978 foray into comedy, *Every Which Way but Loose*, had spun box-office gold, so in 1980 he made a sequel, *Any Which Way You Can*, with the welcome return of Ruth Gordon, Sondra Locke, and the orangutan Clyde. Audiences approved, and the film grossed $70 million, making it the number-five earner of the year.

Sidney Lumet had a modest success with *Just Tell Me What You Want*, a New York comedy of manners, which would be the last film for '30s superstar Myrna Loy, who had started at Warner Bros. in the '20s, and the last theatrical release for '70s superstar Ali MacGraw.

Superman II brought back Christopher Reeve, Margot Kidder, and Gene Hackman. Selected premiere engagements were presented in bass-enhancing Megasound, and *Superman II* shot to number two for the year's domestic take.

Stanley Kubrick was shown the galleys of a Stephen King novel called *The Shining* and thereupon decided to do a horror film. Not believing in an afterlife, Kubrick was unwilling to make a conventional ghost story; instead, he concentrated on the element of evil that he believed was inherent in each human being. After acting in 127 takes of a terrifying scene, Shelley Duvall was

perhaps ready to accept Kubrick's premise. Jack Nicholson also starred in this story of a family beset by madness in an isolated hotel. Warner Bros. was hoping for another *Exorcist*, but once more, a drawn-out shoot obviated a profit. Nevertheless, in the decades since its release, *The Shining* has gained almost mythic status and is widely respected as a classic of the genre.

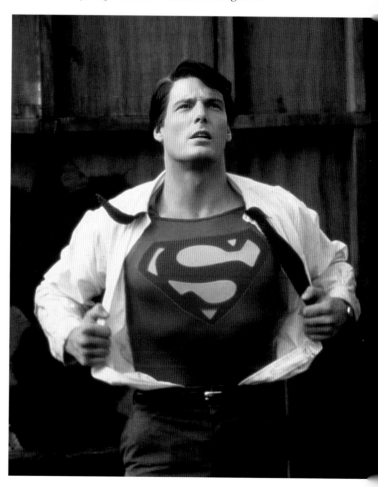

Christopher Reeve in a publicity portrait for Richard Lester's *Superman III* (1983).

Although studies were wary in the wake of '70s extravagance, Warner rolled the dice with independent filmmakers on small-scale movies, many of which

> **Although studios were wary in the wake of '70s extravagance, Warner rolled the dice with independent filmmakers on small-scale movies, many of which would do big box office; in particular, the company had luck with comedies.**

would do big box office; in particular, the company had luck with comedies. When no one else in town wanted *Private Benjamin*, a feminist comedy, Warner gave star-producer Goldie Hawn and producer Nancy Meyers a chance to film the story of a spoiled widow who joins the Army. *Private Benjamin* kicked off the '80s with a bang, grossing a total of $70 million.

Saturday Night Live alumni Chevy Chase and Bill Murray joined comedian Rodney Dangerfield in first-time director Harold Ramis's *Caddyshack*, an R-rated golf comedy based on anecdotes related by Murray's brother. George Burns, star of *Oh, God!*, returned to Warner for a sequel, *Oh, God! Book II*. In *Divine Madness*, Bette Midler performs her bawdy stand-up comedy plus sixteen songs with her backup singers, the Harlettes, in concerts filmed at the Pasadena Civic Auditorium. The Midler film resulted from Warner's partnership with the Ladd Company, an upstart production unit founded in 1979 by former Fox executives Alan Ladd Jr., Jay Kanter, and Gareth Wigan.

Veteran playwright Paddy Chayefsky wrote *Altered States*, but it was directed by Ken Russell without Chayefsky's approval; creative differences struck again. In his film debut, William Hurt played a psychopathologist who uses hallucinogenic agents to better determine the nature of schizophrenia, eventually taking his experiments to a sensory deprivation tank to explore the horizons of consciousness and, indeed, existence.

In July 1980, angered by the industry's refusal to share revenues from the home-video market, actors went on strike, shutting down production for months. In October, negotiations resulted in contracts that included a 32 percent wage increase and an increase of over 30 percent in residuals, plus better health, welfare, and pension benefits. In November, the acting profession was once again in the spotlight—as was Warner: Ronald Reagan, who had signed with the studio as a contract player in April 1937, was elected the fortieth president of the United States.

A new age of corporate power was dawning, and Hollywood studios increasingly fell under the sway of profit-driven CEOs and billion-dollar takeover bids. In December 1980, Ted Ashley retired as studio head and was replaced by Robert Daly, who in January 1982 installed Terry Semel as president and chief operating officer. The new team would oversee the production of traditional dramas, comedies, and thrillers, with an eye open for the magic property that would yield a blockbuster.

Excalibur was produced, directed, and co-written by John Boorman, and it revisited the legend of King Arthur. It grossed nearly $35 million, boosting the careers of Liam Neeson, Patrick Stewart, and Gabriel Byrne. George Miller's Australian production of *Mad Max 2* (released as *The Road Warrior* in the United States) brought Mel Gibson back as the post-apocalyptic fighter.

The studio's partnership with the Ladd Company yielded Hugh Hudson's *Chariots of Fire*, an engrossing film based on the story of two British athletes competing in the 1924 Olympics. Ian Charleson played Eric Liddell, a Christian Scot running for God, and Ben Cross played Harold Abrahams, a Jewish Britisher running to overcome bigotry. The film was very popular, vastly outgrossing its cost, and won the Best Picture Oscar. The Ladd Company also presented Ridley Scott's *Blade Runner*, a visually stunning glimpse of the future, starring Harrison Ford and Sean Young. The film was set in 2019 Los Angeles, where synthetic human beings called

"replicants" start to rebel. Ford was a "blade runner," authorized to find replicants and "retire" them.

The term *film noir* was relatively unknown in 1981, but a few directors were emulating the 1940s style that had previously been called "hard-boiled" or "crime

> **The term *film noir* was relatively unknown in 1981, but a few directors were emulating the 1940s style that had previously been called "hard-boiled" or "crime mystery."**

mystery." Inspired by Billy Wilder's *Double Indemnity*, Lawrence Kasdan made his directorial debut with the Ladd Company's *Body Heat*. It starred William Hurt, in his third screen appearance, and introduced sizzling Kathleen Turner. George Lucas executive-produced, and its $9 million budget led to $24 million at the domestic box office. Actor Burt Reynolds was in the director's chair for the third time with Orion's *Sharky's Machine*, the story of a detective investigating a drug ring; the neo-noir was influenced by Otto Preminger's classic *Laura*, which happened to be a Reynolds favorite. Sidney Lumet co-wrote and directed Orion's *Prince of the City*, a crime drama in which Treat Williams played a character based on the NYPD narcotics detective Robert Leuci.

Through its partnership with Orion Pictures, Warner struck gold a few times, most notably with *Arthur*, a comedy written and directed by Steve Gordon. Dudley Moore played a rich dipso, bound to a fortune-saving marriage, who nevertheless falls for the working-class gal played by Liza Minnelli. It was the only film directed by Gordon, who died of a heart attack at age forty-four in 1982.

This Is Elvis, written and directed by Andrew Solt and Malcolm Leo, was a documentary about the life of singer Elvis Presley. It combined archival footage with reenactments.

Oliver Stone, in his second directing effort, gave audiences *The Hand* (1981), a psychological horror film based on Marc Brandel's novel *The Lizard's Tail*. Michael Caine played a comic book artist who loses his hand, which then gains a life of its own. In *Outland*, a Peter Hyams science-fiction film, Sean Connery played a federal marshal who pursues drug dealers on one of Jupiter's moons.

Warner Bros. paid more than $1 million to acquire the motion picture rights to the 1978 Ira Levin play *Deathtrap*. This marked the most expensive purchase of non-musical play rights at the time. The film was co-written by Levin and Jay Presson Allen, directed by Sidney Lumet, and starred Michael Caine, Dyan Cannon, and Christopher Reeve.

John Irving's best seller *The World According to Garp* was translated to film by screenwriter Steve Tesich and director George Roy Hill, with talented actors such as John Lithgow, Glenn Close, and, in the title role, Robin Williams. *Night Shift* was actor Ron Howard's second turn as director. This comedy of morgue workers who also run a prostitution ring starred Henry Winkler and introduced Michael Keaton. George A. Romero's *Creepshow* was a horror-comedy anthology inspired by the EC comic book series, scripted by Stephen King, and enlivened by Hal Holbrook, Adrienne Barbeau, and Leslie Nielsen. The cartoon compilations released in the '80s included *The Looney Looney Looney Bugs Bunny Movie* and *Bugs Bunny's 3rd Movie: 1001 Rabbit Tales*.

Clint Eastwood produced, directed, and starred in two 1982 features: *Firefox*, an action techno-thriller, and *Honkytonk Man*, a Depression-era drama that included his son Kyle. In 1983, Eastwood made *Sudden Impact*, his fourth Dirty Harry entry, his last film with Sondra Locke, and the only film in the series that he directed.

The 1967 S. E. Hinton novel *The Outsiders* became a moody coming-of-age drama directed by Francis Ford Coppola. The film was shot in Tulsa, Oklahoma, with a cast that included youngsters Rob Lowe, Emilio

Estevez, Matt Dillon, Tom Cruise, Patrick Swayze, and Ralph Macchio.

Harold Ramis directed *National Lampoon's Vacation* from a screenplay by filmmaker John Hughes, which was, in turn, based on his short story for the *National Lampoon*. Starring Chevy Chase, Beverly D'Angelo, and Imogene Coca, the film was a critical and commercial success.

What could possibly go wrong when a Chicago teenager was left alone for a week? Tom Cruise showed his big-screen charisma in Paul Brickman's *Risky Business*, a Geffen Pictures production released through Warner Bros. that was a critical success and provided Cruise with his breakthrough role.

Tom Wolfe's best seller *The Right Stuff* became a distinguished Philip Kaufman, film produced by the Ladd Company. The film's story began in 1947 with pioneering test pilot Chuck Yeager and showed the military pilots who were groomed for outer space travel. Yeager served as a technical consultant on the film.

Police Academy, Hugh Wilson's directorial debut, followed the misadventures of police department recruits as they try to graduate. With Steve Guttenberg, Kim Cattrall, and former pro football player Bubba Smith, the film grossed $149 million worldwide. The Ladd Company turned this into a successful franchise and greatly benefited Warner Bros. as its distributor.

Superman III was released in 1983, with Richard Lester directing Christopher Reeve and Margot Kidder. It reached number five for the year, but overall revenues were down, and Warner had slipped behind the competition. Coincidentally, on July 27 Robert Shapiro resigned as production head. Mark Rosenberg was named new president, and at thirty-five, he was one of the youngest to head a major studio's production division.

Ticket prices were rising steadily. By 1984, the average admission was $3.45. More suburban multiplexes were being built, more people were seeing movies, and the industry's total revenue jumped to $3 billion annually.

More suburban multiplexes were being built, more people were seeing movies, and the industry's total revenue jumped to $3 billion annually.

Clint Eastwood had two releases in 1984. *City Heat*, directed by Richard Benjamin, was a buddy-crime comedy starring Eastwood and Burt Reynolds; *Tightrope* was a crime drama with Genevieve Bujold, filmed in New Orleans. Both films were well attended.

The mythic character of Tarzan returned to the big screen in 1984 with *Greystoke: The Legend of Tarzan, Lord of the Apes*. Based on Edgar Rice Burroughs's 1912 novel *Tarzan of the Apes* and directed by Hugh Hudson, *Greystoke* starred French actor Christopher Lambert in his first English-speaking role and Andie MacDowell, whose Southern-accented voice was dubbed by Glenn Close.

Roland Joffé's *The Killing Fields* told the story of two real-life journalists. Dith Pran was played by Haing S. Ngor, and Sydney Schanberg was played by Sam Waterston. Ngor was himself a survivor of the Khmer Rouge prison camps and a non-actor who gave an acclaimed, Oscar-winning performance.

The rock star Prince appeared on the big screen for the first time in the loosely autobiographical musical *Purple Rain*, which he also scored. The film was directed by Albert Magnoli, later Prince's manager, and filmed mostly in Prince's hometown of Minneapolis.

Steven Spielberg executive-produced *Gremlins*, Joe Dante's fable of small-town life upended by an invasion of little creatures, some mischievous and some malevolent. According to *The Hollywood Reporter*, *Gremlins* set a Warner Bros. record by taking in $100 million faster than any of the studio's previous blockbusters. Spielberg returned as an executive producer for *The Goonies*, an adventure comedy co-produced and directed by Richard Donner about young teens who discover a treasure map. The cast included Sean Astin, Josh Brolin,

and Martha Plimpton. It was filmed in Oregon, and its story of friendship and adventure sold tickets.

Pee-wee's Big Adventure was a comedy directed by Tim Burton in his feature-film debut. Future television star Pee-wee Herman was, of course, played by Paul Reubens, who co-wrote the screenplay with comedian Phil Hartman, among others, making Pee-wee's search for a stolen bicycle into a hero's journey worthy of Joseph Campbell. The second film in the *National Lampoon* series was *European Vacation*, directed by Amy Heckerling, with Chevy Chase and Beverly D'Angelo on hand for the further misadventures of the Griswold family. Martin Scorsese directed *After Hours*, a comedy thriller about "average guy" Griffin Dunne, which in the '80s meant a computer programmer.

Although auteurs such as Scorsese were given ample room to play, "high-concept" pictures were increasingly sought to pay overhead and fund smaller films. A high-concept film could be summarized in one or two sentences, something like "Bambi meets Godzilla, who wants to eat Bambi, but Bambi's mar-

> **Although auteurs such as Scorsese were given ample room to play, "high-concept" pictures were increasingly sought to pay overhead and fund smaller films.**

tial-arts training defeats Godzilla." High-concept films were simpler to write (if not to make) and easier to advertise.

The Australian Mad Max films were not exactly high concept, but the images they used in advertising were bold and intriguing. The third film in the series was George Miller and George Ogilvie's *Mad Max Beyond Thunderdome*, which had ads showing the visually arresting Tina Turner as Aunty Entity.

After shattering all previous box-office records in 1982 with Universal's *E.T. The Extra-Terrestrial*, Hol-

lywood's most in-demand director, Steven Spielberg, made a deal with Warner Bros. for a departure from his usual subject matter. He chose to adapt Alice Walker's Pulitzer Prize–winning novel *The Color Purple*. Spielberg's ensemble of actors included Whoopi Goldberg, Danny Glover, and Oprah Winfrey; Quincy Jones, who also produced, composed the score. With *The Color Purple,* Spielberg gave Warner that rare commodity: a critically acclaimed commercial success.

In 1986, Clint Eastwood produced, directed, and starred in *Heartbreak Ridge*, which centered on a Marine who delays his retirement to get a platoon of undisciplined recruits into shape to fight in Grenada. Goldie Hawn produced the Michael Ritchie film *Wildcats*, in which she played the coach of a high school football team that included Wesley Snipes and Woody Harrelson.

Some films proved to be too limited in their appeal. *The Mission* was a weighty drama about the experiences of a Jesuit missionary in eighteenth-century South America. Directed by Roland Joffé, the much-praised film starred Robert De Niro and Jeremy Irons; it earned Academy recognition, if not huge profits. *Little Shop of Horrors*, a dark comedy musical directed by puppeteer Frank Oz, was an adaptation of the 1982 off-Broadway play by composer Alan Menken and lyricist Howard Ashman, which was itself an adaptation of the 1960 Roger Corman cult film *The Little Shop of Horrors*. The 1986 version underperformed at the box office but later became a huge hit on home video.

In 1987, Richard Donner directed and co-produced *Lethal Weapon*, with Mel Gibson as an LAPD detective who is a former Green Beret and a grieving widower, and Danny Glover as a methodical, patient veteran. The mismatched team members, of course, have to overcome their differences. *Lethal Weapon*'s high concept grossed $120 million.

Every Stanley Kubrick outing was an event. His 1987 war movie *Full Metal Jacket* was no exception. Named for the bullet used in combat, the film followed 1960s Marines from training at Parris Island to street fighting

in Vietnam. Kubrick's film grossed an impressive $120 million, yet the director would not make another film for twelve years.

Empire of the Sun was an epic coming-of-age film, directed by Steven Spielberg, written by Tom Stoppard, and based on J. G. Ballard's semi-autobiographical 1984 novel. The film told the story of a boy, played by Christian Bale, who is torn from his affluent British family in Shanghai and ends up in a Japanese internment camp. Spielberg served as executive producer on *Innerspace*, Joe Dante's science-fiction comedy about a miniaturization experiment that mistakenly injects a tiny man into a human body. It starred Dennis Quaid, Martin Short, and Meg Ryan, with veteran Kevin McCarthy in support.

In Joel Schumacher's *The Lost Boys*, two brothers stumble onto a community of vampires. The young cast included Kiefer Sutherland, Jamie Gertz, Jason Patric, Corey Haim, and Corey Feldman.

Nuts was directed by Martin Ritt from Tom Topor's adaptation of his own play. Barbra Streisand starred as a woman whose stepfather is trying to commit her to a mental institution. It was the final feature role for both Karl Malden and Robert Webber.

Christopher Reeve contributed to the script of *Superman IV: The Quest for Peace*, which was directed by Sidney J. Furie. The film starred Reeve, Margot Kidder, Gene Hackman, Jackie Cooper, and Mariel Hemingway. It was Reeve's last appearance as the superhero.

In 1988, Clint Eastwood starred in *The Dead Pool*, the fifth and last installment in the Dirty Harry series. Then Eastwood's enthusiasm for jazz led him to produce and direct *Bird*, a biography of jazz saxophonist Charlie "Bird" Parker; Forest Whitaker gave a fine performance.

In *The Accidental Tourist*, William Hurt, Kathleen Turner, and director Lawrence Kasdan were reunited for an adaptation of the Anne Tyler novel about a conflicted middle-aged writer.

Tim Burton's second film as director was *Beetlejuice*, a fantastical comedy. With Michael Keaton, Winona Ryder, Alec Baldwin, and Geena Davis, *Beetlejuice* made $74 million.

Sidney Lumet's last film of the '80s was *Running on Empty*, made for Lorimar Films, which had signed a distribution deal with Warner in 1988. Inspired by true events, it told the story of a husband and wife hiding from the FBI and how their son, played by River Phoenix, escapes their fugitive existence. Susan Sandler's play about a Manhattan single who meets a man through her Jewish grandmother's matchmaker became Joan Micklin Silver's *Crossing Delancey*, a romantic comedy with Amy Irving, Peter Riegert, and Sylvia Miles. The film was produced by Lorimar Film Entertainment, and released by Warner Bros. as the studio was in the process of finalizing their outright purchase of Lorimar.

Stand and Deliver, directed by Ramón Menéndez, was based on the true story of Jaime Escalante, an East Los Angeles high school teacher who taught students calculus to prepare them for success outside the barrio. Edward James Olmos gave a superb performance as the inspiring educator.

Imagine: John Lennon was Andrew Solt's documentary about former Beatle John Lennon, whose interviews narrate the film. It was released in October 1988, two days before what would have been Lennon's forty-eighth birthday and almost eight years after his untimely death.

Lethal Weapon 2 was produced and directed by Richard Donner and starred Mel Gibson and Danny Glover. The film made number three at the box office in 1989. John G. Avildsen's *Lean on Me* starred Morgan Freeman as Joe Louis Clark, the inner-city principal who motivated his students to improve their scores on the New Jersey Minimum Basic Skills Test.

Driving Miss Daisy was a drama about a wealthy Jewish woman and her African American chauffeur in the American South that won the Best Picture Oscar. Directed by Australian Bruce Beresford and based on Alfred Uhry's play, the film starred Jessica Tandy and Morgan Freeman, who reprised his 1987 Off Broadway role.

Dead Calm was filmed over a six-month period in Australia by Phillip Noyce and featured young actors Sam Neill, Nicole Kidman, and Billy Zane. With an unusual plot about a married couple at sea in a powerboat picking up a man from a sinking schooner, the film was not a hit, but its actors soon found favor.

Roger & Me was the debut documentary of producer-director-writer Michael Moore, and it showed the damage done when General Motors CEO Roger Smith closed auto plants in Flint, Michigan. Made by Moore's production company for a tiny budget, the film grossed $7 million for Warner Bros., which had acquired the film after its premiere at the 1989 Toronto International Film Festival.

Clint Eastwood's last action film was Buddy Van Horn's *Pink Cadillac*, a comedy about a bounty hunter chasing an innocent woman who is driving her husband's prized auto. Eastwood had the vivacious Bernadette Peters as his leading lady.

Warner Bros. released a total of 232 features in the 1980s. Its steady output of quality entertainment generated profits, but by 1989, Warner had not had a major hit in years. The studio needed a superhero to fly to the rescue, just as *Superman* had done in 1978. Enter *Batman*. As produced by Jon Peters and Peter Guber, and directed by the innovative Tim Burton, *Batman* provided the summer blockbuster for which Warner had hoped. The film grossed $251 million domestically and $411 million worldwide. Starring Michael Keaton and Jack Nicholson, *Batman* became the third-highest-grossing film of the 1980s and was the fifth-highest-grossing film in history at the time of its release. It spawned a

Warner Bros. released a total of 232 features in the 1980s. Its steady output of quality entertainment generated profits, but by 1989, Warner had not had a major hit in years. Enter *Batman*.

franchise, reintroduced the practice of adapting comic books to films, and created a merchandising bonanza of *Batman*-related paraphernalia.

The decade's end brought major developments. In 1989, Warner Bros. fully acquired Lorimar-Telepictures, which encompassed both the old MGM lot in Culver City and the Columbia lot in Hollywood. On March 4, 1989, the company announced the proposed merger of Warner Communications with Time Inc. If this took place, the extent of Warner's reach could only be guessed at.

As contracts were being drawn up and a stock swap was in the works, Paramount Communications made a bid of $10.7 billion for Time, Inc. This hostile takeover attempt forced Time to offer cash for Warner, a sum of $14 billion. Paramount then filed a challenge to block the merger, but on July 24, 1989, the Delaware Supreme Court ruled in Time's favor and the merger formally began.

CLOCKWISE FROM TOP LEFT: Bette Midler's special brand of humor was on full display in Michael Ritchie's *Divine Madness* (1980). • Willie Nelson and Dyan Cannon were charming in Jerry Schatzberg's *Honeysuckle Rose* (1980). • Chevy Chase, Ted Knight, and Rodney Dangerfield enlivened the antics of Harold Ramis's *Caddyshack* (1980).

FROM TOP: Shelley Duvall endured a gruesome siege in Stanley Kubrick's *The Shining* (1980). • Clint Eastwood's *Any Which Way You Can* (1980) was a welcome sequel to his *Every Which Way But Loose.* Seen here: Geoffrey Lewis, Ruth Gordon, and Clint Eastwood.

1980 ACADEMY AWARDS

NOMINATIONS

Actor:

• Robert Duvall in *The Great Santini*

Actress:

• Goldie Hawn in *Private Benjamin*

Supporting Actor:

• Michael O'Keefe in *The Great Santini*

Supporting Actress:

• Eileen Brennan in *Private Benjamin*

Writing (Original Screenplay):

• *Private Benjamin*, Nancy Meyers, Charles Shyer, and Harvey Miller

Costume Design:

• *When Time Ran Out*, Paul Zastupnevich

Music (Original Score):

• *Altered States*, John Corigliano

Music (Original Song):

• "On the Road Again" from *Honeysuckle Rose*, Music and Lyrics by Willie Nelson

Sound:

• *Altered States*, Arthur Piantadosi, Les Fresholtz, Michael Minkler, and Willie D. Burton

FROM TOP: Goldie Hawn struck gold with her production of Howard Zieff's *Private Benjamin* (1980). • William Hurt made his film debut in Ken Russell's *Altered States* (1980).

CLOCKWISE FROM TOP: William Hurt and Kathleen Turner raised temperatures in Lawrence Kasdan's *Body Heat* (1981). • *This Is Elvis* (1981) was written and directed by Andrew Solt and Malcolm Leo as a posthumous tribute. • Burt Reynolds directed Rachel Ward and himself in *Sharky's Machine* (1981).

Dudley Moore and Liza Minnelli in a scene from Steve Gordon's *Arthur* (1981), which came in at number four for 1981.
OPPOSITE, FROM TOP: Nigel Havers, Daniel Gerroll, Ian Charleson, Nicolas Farrell, and Ben Cross in Hugh Hudson's *Chariots of Fire* (1981). • Sean Connery visited Jupiter for Peter Hyams's *Outland* (1981).

1981 ACADEMY AWARDS

WINS

Best Picture:
★ *Chariots of Fire*, David Puttnam, Producer

Supporting Actor:
★ John Gielgud in *Arthur*

Writing (Original Screenplay):
★ *Chariots of Fire*, Colin Welland

Costume Design:
★ *Chariots of Fire*, Milena Canonero

Music (Original Score):
★ *Chariots of Fire*, Vangelis

Music (Original Song):
★ "Arthur's Theme (Best That You Can Do)," *Arthur*, Music and Lyrics by Burt Bacharach, Carole Bayer Sager, Christopher Cross, and Peter Allen

Technical Achievement Award:
★ To Hal Landaker for the concept and Alan D. Landaker for the engineering of the Burbank Studios' Production Sound Department 24-frame color video system

NOMINATIONS

Directing:
• Hugh Hudson for *Chariots of Fire*

Actor:
• Dudley Moore in *Arthur*

Supporting Actor:
• Ian Holm in *Chariots of Fire*

Writing (Adapted Screenplay):
• *Prince of the City*, Jay Presson Allen and Sidney Lumet

Writing (Original Screenplay):
• *Arthur*, Steve Gordon

Cinematography:
• *Excalibur*, Alex Thomson

Film Editing:
• *Chariots of Fire*, Terry Rawlings

Sound:
• *Outland*, John K. Wilkinson, Robert W. Glass Jr., Robert M. Thirlwell, and Robin Gregory

CLOCKWISE FROM LEFT: Sean Young in a futuristic scene from Ridley Scott's *Blade Runner* (1982). • Clint Eastwood took on the Cold War in *Firefox* (1982).• Mariel Hemingway was a stressed athlete in Robert Towne's *Personal Best* (1982). **OPPOSITE, FROM TOP:** Glenn Close and Robin Williams brought John Irving's quirky characters to life in George Roy Hill's *The World According to Garp* (1982). • Burt Reynolds and Goldie Hawn in a scene from Norman Jewison's *Best Friends* (1982).

1982 ACADEMY AWARDS

NOMINATIONS

Supporting Actor:

- John Lithgow in *The World According to Garp*

Supporting Actress:

- Glenn Close in *The World According to Garp*

Art Direction:

- *Blade Runner,* Art Direction: Lawrence G. Paull, David L. Snyder; Set Decoration: Linda DeScenna

Music (Original Song):

- "How Do You Keep the Music Playing?" from *Best Friends*, Music by Michel Legrand; Lyrics by Alan Bergman and Marilyn Bergman

Visual Effects:

- *Blade Runner*, Douglas Trumbull, Richard Yuricich, and David Dryer

FROM TOP: Chevy Chase, Beverly D'Angelo, Dana Barron, and Anthony Michael Hall in a portrait made for Harold Ramis's *National Lampoon's Vacation* (1983). • Rebecca de Mornay and Tom Cruise in *Risky Business* (1983), the highly profitable high school film, written and directed by Paul Brickman. • Future stars Patrick Swayze and Rob Lowe in Francis Ford Coppola's *The Outsiders* (1983). **OPPOSITE:** Fred Ward, Dennis Quaid, Scott Paulin, Ed Harris, Charles Frank, Scott Glenn, and Lance Henriksen in a scene from Philip Kaufman's *The Right Stuff* (1983).

1983 ACADEMY AWARDS

WINS

Film Editing:

★ *The Right Stuff*, Glenn Farr, Lisa Fruchtman, Stephen A. Rotter, Douglas Stewart, and Tom Rolf

Music (Original Score):

★ *The Right Stuff*, Bill Conti

Sound:

★ *The Right Stuff*, Mark Berger, Tom Scott, Randy Thom, and David MacMillan

Sound Effects Editing:

★ *The Right Stuff*, Jay Boekelheide

NOMINATIONS

Best Picture:

• *The Right Stuff*, Irwin Winkler and Robert Chartoff, Producers

Supporting Actor:

• Sam Shepard in *The Right Stuff*

Art Direction:

• *The Right Stuff*, Art Direction: Geoffrey Kirkland, Richard J. Lawrence, W. Stewart Campbell, and Peter Romero; Set Decoration: Pat Pending and George R. Nelson

Cinematography:

• *The Right Stuff*, Caleb Deschanel

• *Zelig*, Gordon Willis

Costume Design:

• *Zelig*, Santo Loquasto

CLOCKWISE FROM TOP: One of the less friendly creatures in Joe Dante's *Gremlins* (1984). • Steve Guttenberg in a scene from Hugh Wilson's grossly successful *Police Academy* (1984). It was no surprise when six sequels followed, sustaining the series through 1989. • A publicity portrait of Richard Romanus and Goldie Hawn made for Herbert Ross's *Protocol* (1984).

OPPOSITE: Prince and Apollonia in a scene from Albert Magnoli's *Purple Rain* (1984), a successful debut for the pop star.

Haing S. Ngor and Sam Waterston in Roland Joffé's *The Killing Fields* (1984), a drama set during Cambodia's Khmer Rouge regime.

1984 ACADEMY AWARDS

WINS

Supporting Actor:

★ Haing S. Ngor in *The Killing Fields*

Cinematography:

★ *The Killing Fields*, Chris Menges

Film Editing:

★ *The Killing Fields*, Jim Clark

Music (Original Song Score):

★ *Purple Rain*, Prince

NOMINATIONS

Best Picture:

• *The Killing Fields*, David Puttnam, Producer

Directing:

• Roland Joffé for *The Killing Fields*

Actor:

• Sam Waterston in *The Killing Fields*

Supporting Actor:

• Ralph Richardson in *Greystoke: The Legend of Tarzan, Lord of the Apes*

Supporting Actress:

• Christine Lahti in *Swing Shift*

Writing (Adapted Screenplay):

• *Greystoke: The Legend of Tarzan, Lord of the Apes*, P. H. Vasak and Michael Austin

• *The Killing Fields*, Bruce Robinson

Makeup:

• *Greystoke: The Legend of Tarzan, Lord of the Apes*, Rick Baker and Paul Engelen

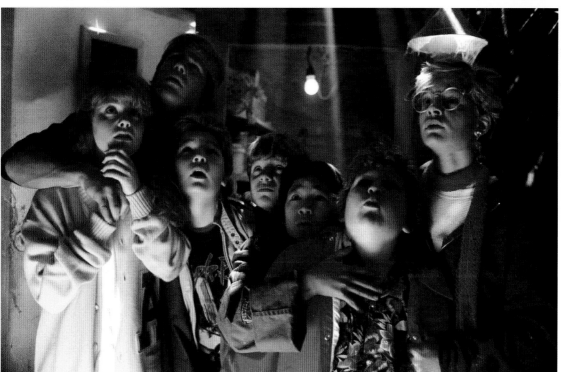

FROM TOP: Michelle Pfeiffer in a portrait made for Richard Donner's *Ladyhawke* (1985), a medieval fantasy film. • Kerri Green, Josh Brolin, Corey Feldman, Sean Astin, Ke Huy Quan, Jeff Cohen, and Martha Plimpton in a scene from Richard Donner's *The Goonies* (1985).

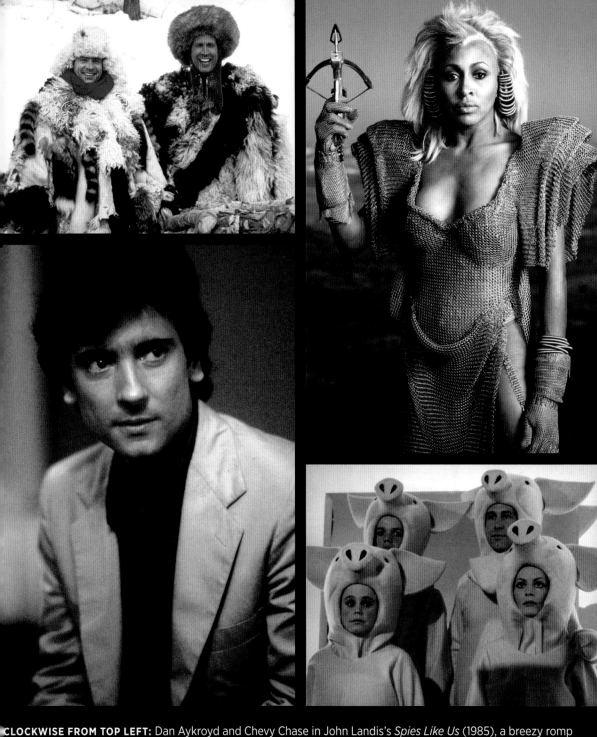

CLOCKWISE FROM TOP LEFT: Dan Aykroyd and Chevy Chase in John Landis's *Spies Like Us* (1985), a breezy romp through hostile climes. • A portrait of Tina Turner as Aunty Entity made for George Miller and George Ogilvie's *Mad Max Beyond Thunderdome* (1985). • Jason Lively, Dana Hill, Chevy Chase, and Beverly D'Angelo in a scene from Amy Heckerling's *National Lampoon's European Vacation* (1985). • Griffin Dunne in a scene from Martin Scorsese's *After Hours* (1985), which followed the misadventures of a computer programmer. **OPPOSITE:** Whoopi Goldberg in a scene

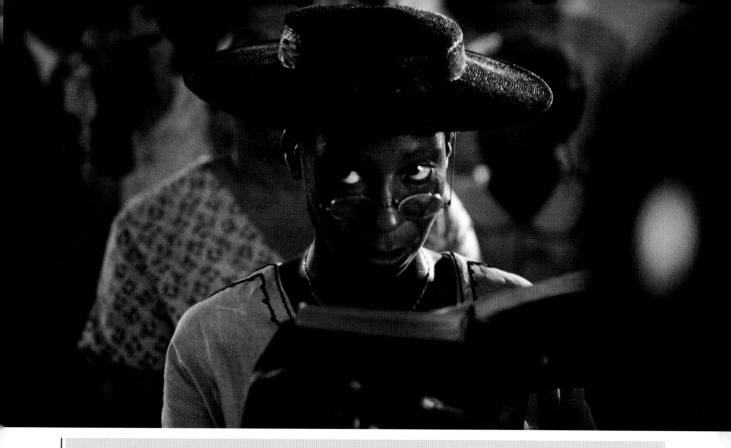

1985 ACADEMY AWARDS

WINS

Technical Achievement Award:

★ To Alan Landaker of The Burbank Studios for the Mark III Camera Drive for motion picture photography

NOMINATIONS

Best Picture:

• *The Color Purple*, Steven Spielberg, Kathleen Kennedy, Frank Marshall, and Quincy Jones, Producers

Actress:

• Whoopi Goldberg in *The Color Purple*

Supporting Actress:

• Margaret Avery in *The Color Purple*
• Oprah Winfrey in *The Color Purple*

Writing (Adapted Screenplay):

• *The Color Purple*, Menno Meyjes

Art Direction:

• *The Color Purple*, Art Direction: J. Michael Riva and Robert W. Welch; Set Decoration: Linda DeScenna

Cinematography:

• *The Color Purple*, Allen Daviau

Costume Design:

• *The Color Purple*, Aggie Guerard Rodgers

Makeup:

• *The Color Purple*, Ken Chase

Music (Original Song):

• "Miss Celie's Blues (Sister)" from *The Color Purple*, Music by Quincy Jones and Rod Temperton; Lyrics by Quincy Jones, Rod Temperton, and Lionel Richie

Music (Original Score):

• *The Color Purple*, Quincy Jones, Jeremy Lubbock, Rod Temperton, Caiphus Samenya, Andrae Crouch, Chris Boardman, Jorge Calandrelli, Joel Rosenbaum, Fred Steiner, Jack Hayes, Jerry Hey, and Randy Kerber

Sound:

• *Ladyhawke*, Les Fresholtz, Dick Alexander, Vern Poore, and Bud Alper

Sound Effects Editing:

• *Ladyhawke*, Bob Henderson and Alan Murray

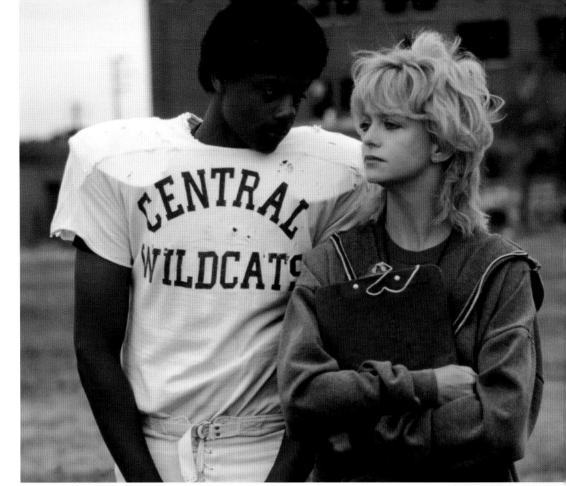

FROM TOP: A scene of Mykelti Williamson and football coach Goldie Hawn in Michael Ritchie's *Wildcats* (1986).
• Clint Eastwood played a Marine with a recalcitrant platoon in his film *Heartbreak Ridge* (1986).

CLOCKWISE FROM TOP: Rick Moranis makes a grisly discovery in Frank Oz's *Little Shop of Horrors* (1986). • David Byrne in a scene from his film *True Stories* (1986). • A portrait of Sylvester Stallone in George P. Cosmatos's *Cobra* (1986), an action film that has become a cult movie.

FROM LEFT: Dexter Gordon and Lonette McKee in a scene from Bertrand Tavernier's *Round Midnight* (1986). • Jeremy Irons and Robert De Niro in a scene from Roland Joffé's *The Mission* (1986).

1986 ACADEMY AWARDS

WINS

Cinematography:

★ *The Mission*, Chris Menges

Music (Original Score):

★ *Round Midnight*, Herbie Hancock

Technical Achievement Award:

★ To Carl Holmes of Carl E. Holmes Co. and Alexander Bryce of the Burbank Studios for the development of a mobile DC power supply unit for motion picture production photography

★ To Hal Landaker and Alan Landaker of the Burbank Studios for the development of the Beat System low-frequency cue track for motion picture production sound recording

NOMINATIONS

Best Picture:

• *The Mission*, Fernando Ghia and David Puttnam, Producers

Directing:

• Roland Joffé for *The Mission*

Actor:

• Dexter Gordon in *Round Midnight*

Art Direction:

• *The Mission*, Art Direction: Stuart Craig; Set Decoration: Jack Stephens

Costume Design:

• *The Mission*, Enrico Sabbatini

Film Editing:

• *The Mission*, Jim Clark

Makeup:

• *The Clan of the Cave Bear*, Michael G. Westmore and Michèle Burke

Music (Original Score):

• *The Mission*, Ennio Morricone

Music (Original Song):

• "Mean Green Mother from Outer Space" from *Little Shop of Horrors*, Music by Alan Menken; Lyrics by Howard Ashman

Sound:

• *Heartbreak Ridge*, Les Fresholtz, Dick Alexander, Vern Poore, and William Nelson

Visual Effects:

• *Little Shop of Horrors*, Lyle Conway, Bran Ferren, and Martin Gutteridge

FROM TOP: Richard
Dreyfuss and Barbra
Streisand in Martin Ritt's
Nuts (1987). • Christopher
Reeve and Margot Kidder
starred in Sidney J.
Furie's *Superman IV: The
Quest for Peace* (1987),
which was co-written by
Reeve. • Danny Glover
and Mel Gibson in a scene
from Richard Donner's
Lethal Weapon (1987),
a high-concept film that
grossed $120 million.

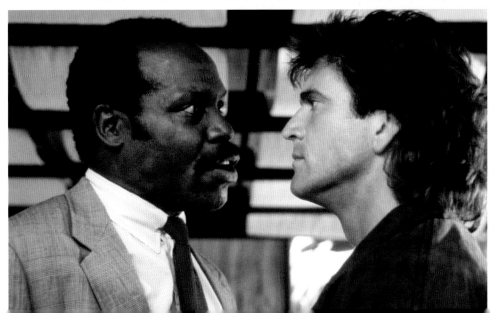

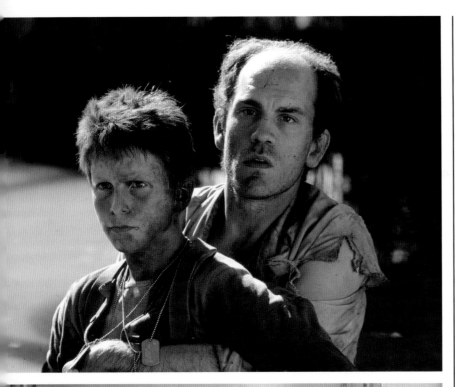

1987 ACADEMY AWARDS

WINS

Visual Effects:

★ *Innerspace*, Dennis Muren, William George, Harley Jessup, and Kenneth Smith

NOMINATIONS

Writing (Adapted Screenplay):

• *Full Metal Jacket*, Stanley Kubrick, Michael Herr, and Gustav Hasford

Art Direction:

• *Empire of the Sun*, Art Direction: Norman Reynolds; Set Decoration: Harry Cordwell

Cinematography:

• *Empire of the Sun*, Allen Daviau

Costume Design:

• *Empire of the Sun*, Bob Ringwood

Film Editing:

• *Empire of the Sun*, Michael Kahn

Music (Original Score):

• *Empire of the Sun*, John Williams

• *The Witches of Eastwick*, John Williams

Sound:

• *Empire of the Sun*, Robert Knudson, Don Digirolamo, John Boyd, and Tony Dawe

• *Lethal Weapon*, Les Fresholtz, Dick Alexander, Vern Poore, and Bill Nelson

• *The Witches of Eastwick*, Wayne Artman, Tom Beckert, Tom Dahl, and Art Rochester

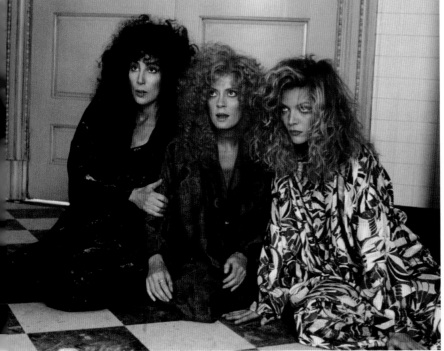

FROM TOP: Christian Bale and John Malkovich starred in Steven Spielberg's *Empire of the Sun* (1987), an epic of survival in wartime. • Cher, Susan Sarandon, and Michelle Pfeiffer starred in George Miller's *The Witches of Eastwick* (1987).

CLOCKWISE FROM TOP: Edward James Olmos in Ramón Menéndez's *Stand and Deliver* (1988), the true story of a courageous inner-city teacher. • Forest Whitaker in Clint Eastwood's *Bird* (1988), a biography of Charlie Parker. • Mel Gibson exercised his star power in Robert Towne's *Tequila Sunrise* (1988).

CLOCKWISE FROM TOP: Geena Davis and William Hurt, who is constantly required to make difficult decisions, in Lawrence Kasdan's *The Accidental Tourist* (1988). • Clint Eastwood and Patricia Clarkson in a scene from Buddy Van Horn's *The Dead Pool* (1988), the last Dirty Harry film. • Meryl Streep and Sam Neill in Fred Schepisi's *A Cry in the Dark* (1988), which was based on the true story of a miscarriage of justice and the irresponsible behavior of the media. **OPPOSITE FROM TOP:** A portrait of Glenn Close made for Stephen Frears's *Dangerous Liaisons* (1988). • In Tim Burton's *Beetlejuice* (1988), a deceased husband and wife enlist Michael Keaton and Winona Ryder to scare the new owners out of their former home.

Sigourney Weaver in a scene from Michael Apted's *Gorillas in the Mist* (1988). The co-production with Universal was a biography of naturalist Dian Fossey.

1988 ACADEMY AWARDS

WINS

Supporting Actress:
★ Geena Davis in *The Accidental Tourist*

Writing (Adapted Screenplay):
★ *Dangerous Liaisons*, Christopher Hampton

Art Direction:
★ *Dangerous Liaisons*, Art Direction: Stuart Craig; Set Decoration: Gerard James

Costume Design:
★ *Dangerous Liaisons*, James Acheson

Makeup:
★ *Beetlejuice*, Ve Neill, Steve La Porte, and Robert Short

Sound:
★ *Bird*, Les Fresholtz, Dick Alexander, Vern Poore, and Willie D. Burton

NOMINATIONS

Best Picture:
• *The Accidental Tourist*, Lawrence Kasdan, Charles Okun, and Michael Grillo, Producers
• *Dangerous Liaisons*, Norma Heyman and Hank Moonjean, Producers

Actor:
• Edward James Olmos in *Stand and Deliver*

Actress:
• Glenn Close in *Dangerous Liaisons*
• Meryl Streep in *A Cry in the Dark*
• Sigourney Weaver in *Gorillas in the Mist* (WB/Universal)

Supporting Actor:
• River Phoenix in *Running on Empty*

Supporting Actress:
• Michelle Pfeiffer in *Dangerous Liaisons*

Writing (Adapted Screenplay):
• *The Accidental Tourist*, Frank Galati and Lawrence Kasdan
• *Gorillas in the Mist,* Screenplay by Anna Hamilton Phelan; Story by Anna Hamilton Phelan and Tab Murphy

Writing (Original Screenplay):
• *Running on Empty*, Naomi Foner

Cinematography:
• *Tequila Sunrise*, Conrad L. Hall

Film Editing:
• *Gorillas in the Mist*, Stuart Baird

Music (Original Score):
• *The Accidental Tourist*, John Williams
• *Dangerous Liaisons*, George Fenton
• *Gorillas in the Mist*, Maurice Jarre

Sound:
• *Gorillas in the Mist*, Andy Nelson, Brian Saunders, and Peter Handford

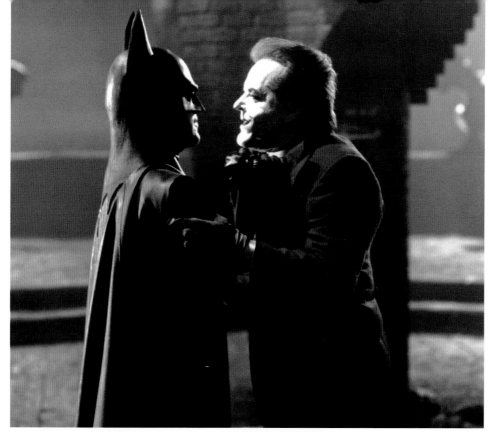

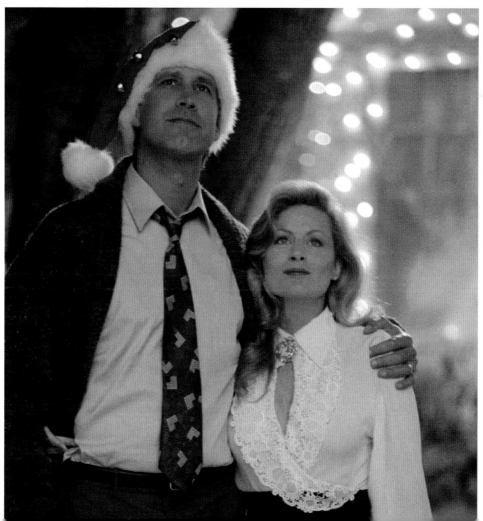

FROM TOP: Michael Keaton and Jack Nicholson starred in Tim Burton's *Batman* (1989), a $411 million hit. • Chevy Chase and Beverly D'Angelo in Jeremiah S. Chechik's *National Lampoon's Christmas Vacation* (1989).

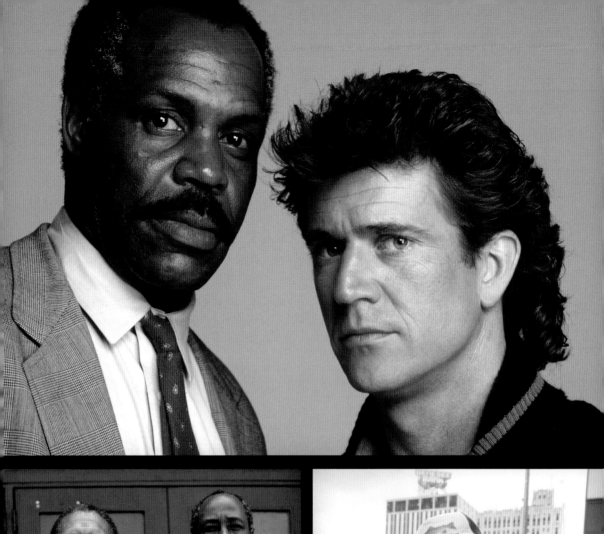

1989 ACADEMY AWARDS

WINS

Best Picture:

★ *Driving Miss Daisy*, Richard D. Zanuck and Lili Fini Zanuck, Producers

Actress:

★ Jessica Tandy in *Driving Miss Daisy*

Writing (Adapted Screenplay):

★ *Driving Miss Daisy*, Alfred Uhry

Art Direction:

★ *Batman*, Art Direction: Anton Furst; Set Decoration: Peter Young

Makeup:

★ *Driving Miss Daisy*, Manlio Rocchetti, Lynn Barber, and Kevin Haney

NOMINATIONS

Actor:

• Morgan Freeman in *Driving Miss Daisy*

Supporting Actor:

• Dan Aykroyd in *Driving Miss Daisy*

Art Direction:

• *Driving Miss Daisy*, Art Direction: Bruno Rubeo; Set Decoration: Crispian Sallis

Costume Design:

• *Driving Miss Daisy*, Elizabeth McBride

Film Editing:

• *Driving Miss Daisy*, Mark Warner

Sound Effects Editing:

• *Lethal Weapon 2*, Robert Henderson and Alan Robert Murray

Morgan Freeman and Jessica Tandy in Bruce Beresford's *Driving Miss Daisy* (1989), a modestly made movie that grossed $145 million.
OPPOSITE, CLOCKWISE FROM TOP: A portrait of Danny Glover and Mel Gibson made for Richard Donner's *Lethal Weapon 2*, the number-three box-office earner of 1989. • Michael Moore directs his confrontational documentary *Roger & Me* (1989). • Morgan Freeman with the real-life Joe Clark on the set of John G. Avildsen's *Lean on Me* (1989), another true-life story about a resourceful educator.

THE 1990s:

MERGING, EMERGING, AND SURGING

NINETEEN NINETY ARRIVED WITH MORE THAN THE USUAL "NEW YEAR–NEW DECADE" excitement for Warner Bros. Among other reasons to celebrate, it had regained full control of its historic studio lot in Burbank, which had been shared with Columbia for more than a decade. As part of a deal with Sony, Columbia's parent company, *Batman* producers Peter Guber and Jon Peters were released from their contract to become heads of the rival studio, which relinquished its share of the lot. The water tower was repainted with the WB shield, and a gala celebration followed.

Time Warner Inc. was more than a film studio. It was an entertainment conglomerate, comprising film, television, home video, music, and print media. But it was also rich with studio properties. Nearly a hundred years after the invention of cinema, Americans were hungry for movies. Construction of multiplexes continued, and the total number of movie screens would increase from 23,000 in 1990 to 35,600 by the end of the new decade. Drive-ins, though, were becoming a thing of the past; there were only 900 screens left in the country. The reason was obvious: Cable TV offered hundreds of channels, and videotape was even more prominent. Seventy percent of all households used a VCR, whether to rent or to buy VHS tapes of feature films. Consumers were building private movie libraries, formerly the perquisite of industry heads.

In the 1990s, old television became a source for new screenplays, features, and franchises. *Maverick, Dennis the Menace,* and *The Fugitive* were some of the shows mined for story elements. Classic films were also remade, and in one clever twist, a classic film production inspired a Warner Bros. stalwart. Clint Eastwood adapted Peter Viertel's novel, *White Hunter Black Heart* to recount John Huston's robust antics during the making of *The African Queen*. Not inclined to take a break, Eastwood then directed and starred in *The Rookie*, playing a veteran policeman who investigates a crime ring while saddled with rookie Charlie Sheen. Another 1990 release with a classic-film connection was *Dreams*, the first film in forty-five years written solely by the fabled Japanese filmmaker Akira Kurosawa. *Dreams* contained eight vignettes inspired by his recurring dreams.

Following Paul Brickman's 1983 hit *Risky Business* was his comedy-drama *Men Don't Leave*, which starred Jessica Lange as a widow alongside Chris O'Donnell, Joan Cusack, and Kathy Bates. *Joe Versus the Volcano* was a fantasy-comedy, written and directed by John Patrick Shanley. It presented the team of Tom Hanks and Meg Ryan, making their first movie together, a screwball comedy that arrived decades late. Its wacky plot would have served Henry Fonda and Binnie Barnes

Denzel Washington as a *Washington Herald* reporter in Alan J. Pakula's *The Pelican Brief* (1993).

in their finest moments. Seemingly on time was Joe Dante's *Gremlins 2: The New Batch*. It avoided the overt violence of its predecessor and relied on wit, but its cleverness went unappreciated by audiences, and its box office did not match its predecessor's.

Films based on actual events were not huge Warner moneymakers in 1990. *Memphis Belle* focused on the twenty-fifth and last mission of *Memphis Belle*, a B-17 bomber in World War II. Barbet Schroeder's *Reversal of Fortune* was another drama based on true events, in this case the Sunny von Bülow murder trial. The film starred Glenn Close as Sunny, Jeremy Irons as her husband, Claus, and Ron Silver as Alan Dershowitz, the law professor who successfully challenged Claus's conviction. Robert De Niro and Martin Scorsese reunited for *Goodfellas*, an adaptation of the Nicholas Pileggi book *Wiseguy*, which traced the criminal career of mobster Henry Hill. *Goodfellas* grossed a decent $47 million, but found a bigger market with video rentals and film students. Bernardo Bertolucci based *The Sheltering Sky* on the 1949 Paul Bowles novel about the

The film industry was experiencing a renaissance, thanks to home video, international distribution, and suburban sprawl.

aimless life of American expatriates in Morocco. The film starred John Malkovich and Debra Winger, whose characters endured much and gained nothing.

In a year dominated by other studios' hits (*Home Alone*, *Ghost*, and *Pretty Woman*), Warner's top earner of 1990 was Alan J. Pakula's *Presumed Innocent*. Based on the 1987 novel by lawyer Scott Turow, the legal thriller starred Harrison Ford as a man caught in a tangled web he has inadvertently woven. *Presumed Innocent* grossed $221.4 million.

By 1991, video rentals and sales had surpassed box-office totals. The film industry was experiencing a

renaissance, thanks to home video, international distribution, and suburban sprawl. Theater admissions were around $4, and attendance dipped slightly in 1991 because of a minor recession but picked up by 1993 and remained stable thereafter through the decade.

Oliver Stone directed Kevin Costner in *JFK*, a political thriller that used the trial of New Orleans businessman Clay Shaw to further investigate the assassination of President John F. Kennedy. The film was a critical and commercial success, with a gross of $200 million.

Another hit came from Mario Van Peebles, the son of filmmaker Melvin Van Peebles. Mario made his directorial debut with and starred in *New Jack City* with Wesley Snipes, Ice-T, and Judd Nelson. The crime film grossed $47 million. *Robin Hood: Prince of Thieves* was an adventure based on English folklore. Kevin Costner starred as the man in tights, with Mary Elizabeth Mastrantonio as Maid Marian. The film was a major hit, earning more than $390 million worldwide and coming in at number two for 1991.

In 1992, Spike Lee directed and co-wrote the feature *Malcolm X*, with Denzel Washington in the title role, supported by Angela Bassett, Al Freeman Jr., and Delroy Lindo, and with cameo appearances by the Reverend Al Sharpton and future South African president Nelson Mandela. The singer Whitney Houston made her acting debut in Mick Jackson's *The Bodyguard*, a romantic thriller written by Lawrence Kasdan and starring Kevin Costner as a Secret Service agent turned bodyguard. Kasdan had written his screenplay in the 1970s for Steve McQueen and Diana Ross.

Richard Donner's *Lethal Weapon 3* continued the popular franchise, bringing back Mel Gibson and Danny Glover. The film found its way to number four in 1992. The number-three earner was Tim Burton's fourth film for the studio, *Batman Returns*, once again starring Michael Keaton as Batman, with Danny DeVito as the Penguin and Michelle Pfeiffer as Catwoman. It was the cinema's first Dolby Digital film, and it grossed $262 million. Clint Eastwood returned to westerns with

Unforgiven, directing and playing a retired outlaw who agrees to take on one more job. The film co-starred Gene Hackman, Morgan Freeman, and Richard Harris. *Unforgiven* grossed $159 million and won several Oscars.

In 1992, Warner Bros. Family Entertainment was launched, adopting rascally rabbit Bugs Bunny as the star of its main-title logo. The cartoon character was bringing in $8–$10 million annually, which made him one of the

In 1992, Warner Bros. Family Entertainment was launched, adopting rascally rabbit Bugs Bunny as the star of its main-title logo.

studio's all-time biggest stars. The following year, Time Warner completed the $70 million purchase of all Six Flags amusement parks, which had featured Bugs and his Looney Tunes cohorts as mascots since 1984.

In Joel Schumacher's *Falling Down,* Michael Douglas is a divorced and unemployed engineer. As he tries to reach his daughter's birthday party at his estranged ex-wife's home, he is confronted by one situation after another that triggers his pent-up rage. Moviegoers were intrigued by TV spots showing Douglas being maddened by a fly in his car in a traffic jam, so *Falling Down* made four times its cost. A live whale named Keiko was the star of *Free Willy,* a hit family film directed by Simon Wincer. The orca was discovered at a Mexican amusement park, and his role in the film led Warner Bros. to place him in a better home.

Dennis the Menace, a TV series that ran from 1959 to 1963, itself based on a comic strip, inspired Nick Castle's 1993 comedy about a five-year-old boy named Dennis who is a walking disaster area. Mason Gamble won the role of Dennis over the auditions of 20,000 other children. Likewise, *The Fugitive,* a 1960s TV series, set the stage for the tense and intelligent Harrison Ford thriller, directed by Andrew Davis, that made number three for the year.

Grumpy Old Men cast longtime friends Jack Lemmon and Walter Matthau as feuding neighbors, alongside Ann-Margret. Also joining forces were Clint Eastwood and Kevin Costner for the critically acclaimed *A Perfect World.* Eastwood directed and played a Texas Ranger in pursuit of Costner, an escaped convict who takes a boy hostage.

Alan J. Pakula's last Warner Bros. film before his death in an auto accident was *The Pelican Brief,* which was based on the best-selling novel by Mississippi lawyer John Grisham. Julia Roberts played a law student and Denzel Washington played a *Washington Herald* reporter. Another Grisham book was the basis for Joel Schumacher's *The Client,* which starred Susan Sarandon, Tommy Lee Jones, and Mary-Louise Parker.

Oliver Stone's *Natural Born Killers* starred Woody Harrelson and Juliette Lewis as young lovers, both trauma survivors, who become killers. In spite of (or perhaps because of) its graphic content, the film was a box-office success. Neil Jordan's *Interview with the Vampire* was a gothic horror film based on Anne Rice's 1976 novel, which had been developed for John Travolta in the early '80s and then shut down when his fiancée, actress Diana Hyland, died. Tom Cruise and Brad Pitt played the dapper vamps.

Amblin Entertainment, Steven Spielberg's production company, bought *The Bridges of Madison County* before it was published, and then Clint Eastwood produced, directed, and starred in the property with Meryl Streep. Glenn Gordon Caron's *Love Affair* was a remake of the 1939 romance, which in turn had inspired the 1957 *An Affair to Remember.* The 1994 version starred real-life husband and wife Warren Beatty and Annette Bening. In her final screen role, Katharine Hepburn played a friend who counsels the smitten couple.

Jim Carrey's star was on the rise with *Ace Ventura: Pet Detective* and its sequel, *Ace Ventura: When Nature Calls,* which shot to number five in 1995. *Free Willy 2: The Adventure Home* brought back young actor Jason James Richter but not Keiko; a robot double created by

Edge Innovations played the whale. Another follow-up arrived with *Grumpier Old Men*, which starred Jack Lemmon, Walter Matthau, Ann-Margret, and Sophia Loren.

Batman Forever was directed by Joel Schumacher, and Val Kilmer replaced Michael Keaton as Batman. Also added were Tommy Lee Jones as Two-Face and Jim Carrey as the Riddler. The casting changes made little difference to audiences, and the film quickly went to number one for 1995, earning $184 million domestically.

As the industry raked in billions, the more bloated each Hollywood film became, and the more difficult it was for artists to break into the system. In response, novice auteurs rented cameras and shot no-frills films on shoestring budgets. Quentin Tarantino funded his first film, *Reservoir Dogs*, with the sale of his script for *True Romance*, which was directed by Tony Scott and distributed by Warner Bros. The studio continued the trend by green-lighting smaller films with Arnon Milchan's New Regency Productions. Meanwhile, Daly and Semel tapped

The development and launch of the DVD format was led by Warner Bros., who brokered deals with similar technologies at other studios to engineer a unified industry initiative, leading to the most successful launch of a consumer electronics product in history.

Warner Music vice presidents Lorenzo di Bonaventura and William Gerber for film production; this would lead to the *Matrix* and Harry Potter franchises.

More changes were afoot in 1997, namely the debut of the digital video disc, or DVD. The development and launch of the DVD format was led by Warner Bros., who brokered deals with similar technologies at other studios to engineer a unified industry initiative, leading to the most successful launch of a consumer electronics product in history. Home viewing surged.

In 1996, Time Warner acquired Turner Broadcasting System and Ted Turner's massive library of classic films. Turner had been harshly criticized for colorizing some black-and-white films of the Golden Era, though the process did not harm the original films. After the outcry subsided, classic film fans came to realize that Turner's care, preservation, and sharing of the films in his library had made available more than four thousand titles, including the pre-1950s Warner Bros. catalog. After four decades in other hands, the purchase of Turner Broadcasting brought the entire studio library under one roof. Warner Bros. would mark its seventy-fifth anniversary in 1998 by releasing over 350 popular titles on video and DVD, ranging from *Casablanca* to *Batman*.

Unlike many studios in the high stakes '90s, Warner Bros. maintained a family environment that patriarch Benjamin Warner would have appreciated. Co-chairmen Bob Daly and Terry Semel preferred to promote within their ranks. They favored long-term relationships and took their time nurturing quality entertainment, keeping two hundred projects on the development list, while Universal, Paramount, and Fox typically had a hundred in development. Producers such as Peter Guber, Lee Rich, and Joel Silver held Warner contracts for years, as did James G. Robinson's Morgan Creek Productions.

Family atmosphere or not, the company was under pressure to spawn monster hits. Just as Steven Spielberg's *Jaws* had set the tone for the '70s, his *Jurassic Park* set the tone for the '90s: monsters created by computer graphics, an equally monstrous budget, and a merchandising budget as large as the film itself. When all this effort dropped a billion at the box office, it was clear what would pull potatoes from couches: special-effects extravaganzas. They were the moneymakers, but there was a catch: They could lose big money, too. Tim Burton's big-budget *Mars Attacks!* had a cast that included Jack Nicholson, Glenn Close, Pierce Brosnan, Annette Bening, and Michael J. Fox. Despite all these and Martians, too, the film failed to crack $10

million on its opening weekend. Studios became cautious, tailoring big-ticket ventures to please everyone. Stars and monsters were clearly not enough for a hit. Did there need to be car chases, automatic weapons, quotable one-liners?

Joel Schumacher's *A Time to Kill* was another legal drama based on a Grisham novel. The film starred Matthew McConaughey, Sandra Bullock, and Samuel L. Jackson, and it grossed $152 million worldwide. Joe Pytka's *Space Jam* was a sports comedy with animation sequences, the first release from Warner Bros. Feature Animation. The film featured NBA superstar Michael Jordan as a fictional version of himself helping Looney Tunes characters in a basketball match against aliens. *Twister* was a latter-day disaster film, co-produced with Universal and directed by Jan de Bont, from a screenplay co-written by best-selling author Michael Crichton. The film starred Helen Hunt and Bill Paxton as storm chasers during a severe tornado outbreak in Oklahoma. *Twister* was the number-two box-office earner for 1996, grossing a breezy $241 million.

Jennifer Lopez had a starring role in Gregory Nava's *Selena*, the biography of Tejano music star Selena Quintanilla Pérez. John Singleton's *Rosewood* starred Ving Rhames, Don Cheadle, and Jon Voight in a re-creation of the 1923 Rosewood massacre in which a race riot destroyed an African American community. Clint Eastwood's *Midnight in the Garden of Good and Evil* (1997) was a mystery starring John Cusack and Kevin Spacey. Based on John Berendt's 1994 novel, it followed the story of a Savannah antiques dealer accused of murdering a male prostitute.

Spacey also starred in Curtis Hanson's *L.A. Confidential* (a Regency production distributed by Warner Bros.), a neo-noir co-written by Hanson and Brian Helgeland, opposite Russell Crowe, Guy Pearce, and Danny DeVito. James Cromwell stole his scenes with a laconic malevolence, and Kim Basinger, who was presented as a double for Veronica Lake, won critical acclaim and an Academy Award.

The internet was making an impact on America and on American culture. Thus, *The Shop Around the Corner*, Ernst Lubitsch's 1940 classic about pen pals, was updated to give Tom Hanks and Meg Ryan a vehicle called *You've Got Mail*, a nod to the cheery robotic prompt heard daily by AOL users. The reunion of the two stars and writer-director Nora Ephron proved irresistible to audiences, who brought the film $250 million worldwide.

Warner needed no prompt to remind them that 1997 was time for another *Batman* film. Joel Schumacher directed *Batman & Robin*, which had George Clooney as Batman, Chris O'Donnell as Robin, Alicia Silverstone as Batgirl, Arnold Schwarzenegger as Ice Man, and Uma Thurman as Poison Ivy. Art direction and special effects were impressive, adding to the film's enormous budget, but its worldwide gross was only $238 million.

By 1998, the average budget for major releases was almost $53 million. If star salaries were added, the cost could top $100 million. A film had to target a known demographic, and focus groups were increasingly used to determine a film's potential earning power. The emphasis on remakes, franchises, and TV series–derived films was a result of the increasing pressure to reap huge profits.

Richard Donner's *Lethal Weapon 4* starred Mel Gibson, Danny Glover, Joe Pesci, and Rene Russo. It was Donner's last film in the series, which had no further theatrical releases. *A Perfect Murder* was Andrew Davis's remake of Alfred Hitchcock's 1954 Warner release *Dial M for Murder*. This film, unlike Hitchcock's, was not shot in 3-D, but it did have Michael Douglas, Gwyneth Paltrow, and Viggo Mortensen.

The last year of the century, and of the millennium, began with suspense involving the latest film by the legendary Stanley Kubrick. For five years he had been adapting an Arthur Schnitzler novella *Traumnovelle* (*Dream Story*). Kubrick had kept this under wraps, just as he demanded strict secrecy for his production of the resulting film, *Eyes Wide Shut*. All that was known were

the high-profile talent—married stars Tom Cruise and Nicole Kidman—and that the film included an orgy sequence that promised to go to the limit. In March 1999, Kubrick screened the film for Cruise and Kidman. Six days later, the great director died, which only added to the film's hype. To avoid an NC-17 rating, which would have severely limited its market reach, Warner Bros. digitally altered some of its more gratuitous shots and cut others before its domestic release in July. *Eyes Wide Shut* caused the polarization that only a Kubrick film could; it was proclaimed either a masterpiece or a mess. The box office was healthy but not huge, driven by a curious public, and decades later it remains revered by film buffs.

The parade of remakes continued with the loud marketing noise made for *Wild Wild West*, a big-budget western, co-produced and directed by Barry Sonnenfeld. Loosely adapted from a 1960s TV series, it starred Will Smith and Kevin Kline and saw its Old West settings mixed with a dose of science fiction. William Castle's 1959 *House on Haunted Hill* was remade by director William Malone with stars Geoffrey Rush and Taye Diggs. Produced by Robert Zemeckis and Joel Silver, this *House on Haunted Hill* followed a group of people who come to an empty sanitarium with the promise of big money for braving spooky doings.

Pokémon: The First Movie—Mewtwo Strikes Back was a Japanese film directed by Kunihiko Yuyama, the chief director of the Pokémon television series. It was the first theatrical release in the Pokémon franchise, grossing $172 million worldwide. Brad Bird's *The Iron Giant* was an animated film about a boy and his robot keeping warm during the Cold War. Featuring the voices of Jennifer Aniston, Vin Diesel, and Cloris Leachman, the film found its audience mostly after theatrical engagement and went on to become a cult classic.

Robert De Niro satirized his image in Harold Ramis's *Analyze This*, playing a mobster who seeks the help of psychiatrist Billy Crystal. The goofy film grossed $176 million. David O. Russell's critically acclaimed *Three Kings* starred George Clooney, Mark Wahlberg, Ice Cube, and Spike Jonze as soldiers in the Gulf War. Frank Darabont's *The Green Mile* drew on Stephen King's novel for its tale of unearthly happenings on Death Row. Star Tom Hanks helped make the film a success, as it grossed $286 million.

The Matrix was something new in 1999—cyberpunk science fiction. It was written and directed by the Wachowski siblings—Lana and Lilly. Starring Keanu Reeves, Laurence Fishburne, Hugo Weaving, and Carrie-Anne Moss in a story of simulated reality, *The Matrix* brought Warner Bros. an end-of-decade blockbuster in the tradition of *Superman* and *Batman*. *The Matrix* grossed $460 million worldwide and became the number-five domestic earner for the year.

While Hollywood enjoyed a corner on the entertainment market, competition was looming. The newly ubiquitous internet hosted the first "live-streaming" broadcast of a baseball game in 1995, and Netflix began shipping DVDs across America in 1998. At this high

The Matrix brought Warner Bros. an end-of-decade blockbuster in the tradition of *Superman* and *Batman*.

point, Bob Daly and Terry Semel retired. They were replaced by Alan F. Horn and Barry Meyer, who would run the studio as their predecessors did. At the close of the twentieth century, Time Warner stood strong as the world's largest media company, while Warner Bros. covered all the bases, producing lucrative series like *Friends* and *ER* for its television division and partnering with the Tribune Company to form the youth-oriented WB Network. But features were still the mainstay, and Warner had released 263 in the '90s.

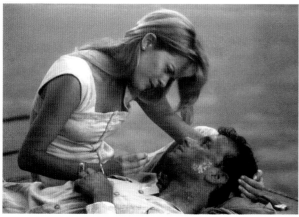

CLOCKWISE FROM TOP: Ray Liotta, Robert De Niro, Paul Sorvino, and Joe Pesci in a publicity portrait from Martin Scorsese's *Goodfellas* (1990). • Harrison Ford in a scene from Alan J. Pakula's *Presumed Innocent* (1990), Warner's top earner of 1990. • Meg Ryan and Tom Hanks in John Patrick Shanley's *Joe Versus the Volcano* (1990), a throwback to the screwball comedies of the '30s.

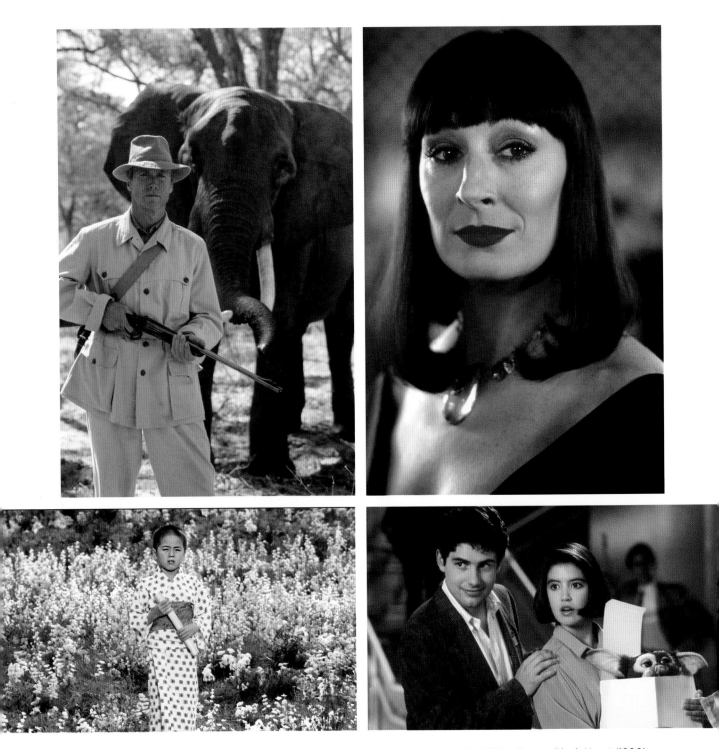

CLOCKWISE FROM TOP LEFT: Clint Eastwood produced, directed, and starred in *White Hunter Black Heart* (1990), a roman à clef about director John Huston's production of *The African Queen* forty years earlier. • Anjelica Huston in a scene from Nicolas Roeg's *The Witches* (1990), which was produced by Jim Henson. • Zach Galligan and Phoebe Cates in Joe Dante's *Gremlins 2: The New Batch* (1990), the witty sequel to his 1984 hit *Gremlins*. • A scene from Akira Kurosawa's *Dreams* (1990), the veteran filmmaker's meditation on his subconscious. **OPPOSITE:** Jeremy Irons as Claus von Bülow and Glenn Close as socialite Sunny von Bülow in Barbet Schroeder's *Reversal of Fortune* (1990).

1990 ACADEMY AWARDS

WINS

Actor:

★ Jeremy Irons in *Reversal of Fortune*

Supporting Actor:

★ Joe Pesci in *Goodfellas*

NOMINATIONS

Best Picture:

• *Goodfellas*, Irwin Winkler, Producer

Directing:

• Barbet Schroeder for *Reversal of Fortune*
• Martin Scorsese for *Goodfellas*

Supporting Actress:

• Lorraine Bracco in *Goodfellas*

Writing (Adapted Screenplay):

• *Goodfellas*, Nicholas Pileggi and Martin Scorsese
• *Reversal of Fortune*, Nicholas Kazan

Art Direction:

• *Hamlet*, Art Direction: Dante Ferretti; Set Decoration: Francesca Lo Schiavo

Costume Design:

• *Hamlet*, Maurizio Millenotti

Film Editing:

• *Goodfellas*, Thelma Schoonmaker

FROM TOP: Michael J. Fox and Julie Warner in a scene from the surprise hit *Doc Hollywood* (1991). • Damon Wayans and Bruce Willis in a scene from Tony Scott's *The Last Boy Scout* (1991), one of the first films to benefit from subsequent success in the home video market. • Buck Henry and Albert Brooks in a touching scene from his film *Defending Your Life* (1991).

OPPOSITE, CLOCKWISE FROM TOP: Robert De Niro and Annette Bening in the Irwin Winkler Hollywood blacklist drama, *Guilty by Suspicion* (1991). • Wesley Snipes in a scene from *New Jack City* (1991), the directorial debut of Mario Van Peebles. • Kevin Costner struck gold in *Robin Hood: Prince of Thieves* (1991).

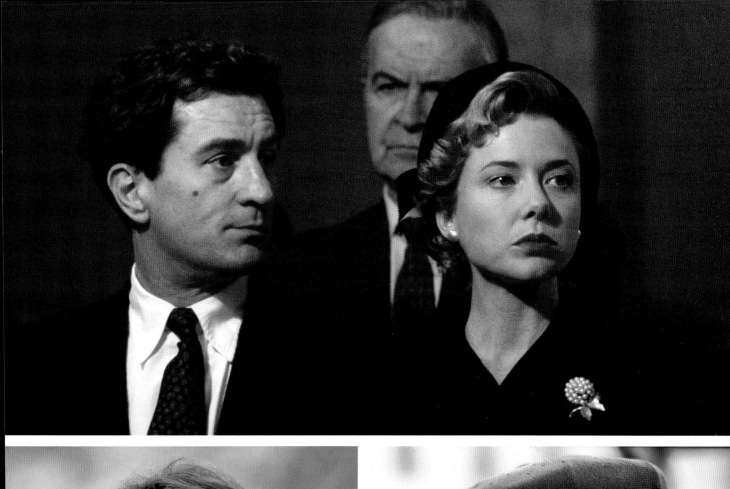

Kevin Costner played New Orleans district attorney Jim Garrison in Oliver Stone's *JFK* (1991).

1991 ACADEMY AWARDS

WINS

Cinematography:

★ *JFK*, Robert Richardson

Film Editing:

★ *JFK*, Joe Hutshing and Pietro Scalia

NOMINATIONS

Best Picture:

- *JFK*, A. Kitman Ho and Oliver Stone, Producers

Directing:

- Oliver Stone for *JFK*

Supporting Actor:

- Tommy Lee Jones in *JFK*

Writing (Adapted Screenplay):

- *JFK*, Oliver Stone and Zachary Sklar

Music (Original Score):

- *JFK*, John Williams

Music (Original Song):

- "(Everything I Do) I Do It for You" from *Robin Hood: Prince of Thieves*, Music by Michael Kamen; Lyrics by Bryan Adams and Robert John Lange

Sound:

- *JFK*, Michael Minkler, Gregg Landaker, and Tod A. Maitland

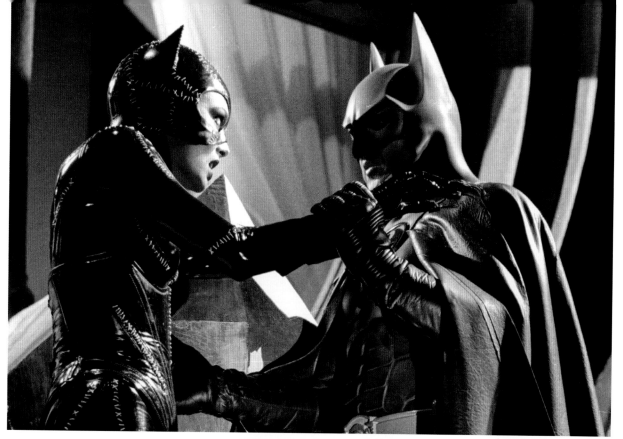

CLOCKWISE FROM TOP: Michelle Pfeiffer and Michael Keaton in a scene from Tim Burton's smash hit *Batman Returns* (1992). • Whitney Houston in a scene from the suspenseful Lawrence Kasdan film *The Bodyguard* (1992). • In 1992, beloved cartoon star Bugs Bunny became the mascot of Warner Bros. Family Entertainment.

CLOCKWISE FROM TOP LEFT: Denzel Washington in the title role of Spike Lee's *Malcolm X* (1992). • Bridget Fonda in a scene from Cameron Crowe's grunge romance *Singles* (1992). • Country singer George Strait made his acting debut in Christopher Cain's *Pure Country* (1992), written by Rex McGee, who was a Texas native and a protégé of writer-director Billy Wilder. **OPPOSITE:** Morgan Freeman and Clint Eastwood in a scene from Eastwood's successful *Unforgiven* (1992).

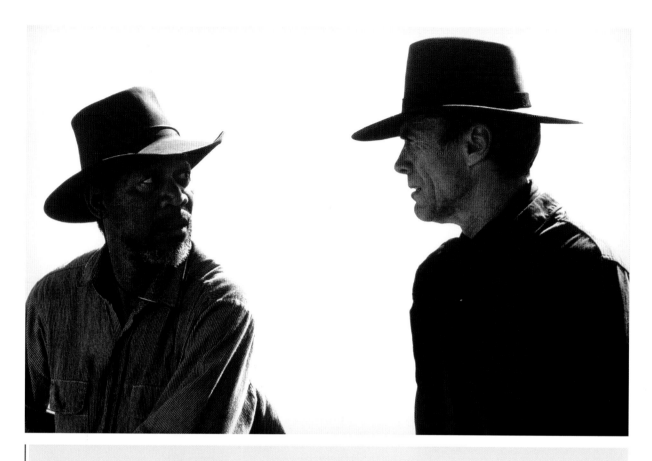

1992 ACADEMY AWARDS

WINS

Best Picture:

★ *Unforgiven*, Clint Eastwood

Directing:

★ Clint Eastwood for *Unforgiven*

Supporting Actor:

★ Gene Hackman in *Unforgiven*

Film Editing:

★ *Unforgiven*, Joel Cox

NOMINATIONS

Actor:

• Clint Eastwood in *Unforgiven*

• Denzel Washington in *Malcolm X*

Writing (Original Screenplay):

• *Unforgiven*, David Webb Peoples

Art Direction:

• *Unforgiven*, Art Direction: Henry Bumstead; Set Decoration: Janice Blackie-Goodine

Cinematography:

• *Unforgiven*, Jack N. Green

Costume Design:

• *Malcolm X*, Ruth Carter

Makeup:

• *Batman Returns*, Ve Neill, Ronnie Specter, and Stan Winston

Music (Original Song):

• "Beautiful Maria of My Soul" from *The Mambo Kings*, Music by Robert Kraft; Lyrics by Arne Glimcher

• "I Have Nothing" from *The Bodyguard*, Music by David Foster; Lyrics by Linda Thompson

• "Run to You" from *The Bodyguard*, Music by Jud Friedman; Lyrics by Allan Rich

Sound:

• *Under Siege*, Don Mitchell, Frank A. Montaño, Rick Hart, and Scott Smith

• *Unforgiven*, Les Fresholtz, Vern Poore, Dick Alexander, and Rob Young

Sound Effects Editing:

• *Under Siege*, John Leveque and Bruce Stambler

Visual Effects:

• *Batman Returns*, Michael Fink, Craig Barron, John Bruno, and Dennis Skotak

FROM TOP: Jack Lemmon, and Walter Matthau in a portrait made for Donald Petrie's *Grumpy Old Men* (1993). • Michael Douglas has the proverbial meltdown in Joel Schumacher's *Falling Down* (1993). **OPPOSITE, CLOCKWISE FROM TOP:** Sylvester Stallone in a scene from visual artist Marco Brambilla's hit film *Demolition Man* (1993). • Clint Eastwood directed Kevin Costner and T. J. Lowther in the crime hit *A Perfect World* (1993). • Leonardo DiCaprio in Michael Caton-Jones's *This Boy's Life* (1993). • In the tradition of numerous Warner Bros. films, a whale was the star of Simon Wincer's *Free Willy* (1993), but unlike Moby Dick, Keiko the orca did not attack his co-star Jason James Richter.

1993 ACADEMY AWARDS

WINS

Supporting Actor:

★ Tommy Lee Jones in *The Fugitive*

NOMINATIONS

Best Picture:

• *The Fugitive*, Arnold Kopelson, Producer

Supporting Actress:

• Rosie Perez in *Fearless*

Writing (Original Screenplay):

• *Dave*, Gary Ross

Cinematography:

• *The Fugitive*, Michael Chapman

Film Editing:

• *The Fugitive*, Dennis Virkler, David Finfer, Dean Goodhill, Don Brochu, Richard Nord, and Dov Hoenig

Music (Original Score):

• *The Fugitive*, James Newton Howard

Sound:

• *The Fugitive*, Donald O. Mitchell, Michael Herbick, Frank A. Montaño, and Scott D. Smith

Sound Effects Editing:

• *The Fugitive*, John Leveque and Bruce Stambler

FROM TOP: Harrison Ford is captured (in a photograph) in Andrew Davis's very successful action thriller *The Fugitive* (1993). • Sigourney Weaver and Kevin Kline in a scene from Ivan Reitman's political comedy *Dave* (1993).

CLOCKWISE FROM TOP LEFT: A portrait of Juliette Lewis and Woody Harrelson made for Oliver Stone's violent, controversial *Natural Born Killers* (1994). • Tim Robbins in a scene from the Coen Brothers' comedy *The Hudsucker Proxy* (1994). • Macaulay Culkin and Jonathan Hyde in a portrait made for Donald Petrie's *Richie Rich* (1994). • Katharine Hepburn, Warren Beatty, and Annette Bening in Glenn Gordon Caron's *Love Affair* (1994), a throwback to the romance films of an earlier era.

1994 ACADEMY AWARDS

NOMINATIONS

Actress:
- Susan Sarandon in *The Client*

Art Direction:
- *Interview with the Vampire*, Art Direction: Dante Ferretti; Set Decoration: Francesca Lo Schiavo

Cinematography:
- *Wyatt Earp*, Owen Roizman

Costume Design:
- *Maverick*, April Ferry

Music (Original Score):
- *Interview with the Vampire*, Elliot Goldenthal

CLOCKWISE FROM TOP LEFT: A portrait of Jodie Foster made for Richard Donner's *Maverick* (1994). • Tom Cruise and Brad Pitt in Neil Jordan's *Interview with the Vampire* (1994). • Susan Sarandon and Brad Renfro in a scene from Joel Schumacher's successful *The Client* (1994).

FROM TOP: Kyra Sedgwick in a scene from Lasse Hallström's *Something to Talk About* (1995). • Cuba Gooding Jr. and Dustin Hoffman in a scene from Wolfgang Petersen's *Outbreak* (1995). • Al Pacino and Robert De Niro in a scene from Michael Mann's *Heat* (1995), a Regency Production distributed by Warner Bros.

FROM TOP: Jim Carrey as The Riddler in Joel Schumacher's *Batman Forever*, the number-one film of 1995. • A portrait of Liesel Matthews made for Alfonso Cuarón's *A Little Princess* (1995).
OPPOSITE, FROM TOP: Meryl Streep and Clint Eastwood in a scene from Eastwood's *The Bridges of Madison County* (1995). • Walter Matthau and Jack Lemmon in a scene from Howard Deutch's *Grumpier Old Men* (1995).

FROM TOP: Bugs Bunny, Bill Murray, Michael Jordan, and Lola Bunny in Joe Pytka's *Space Jam* (1996), a sports comedy with animated sequences directed by Tony Cervone and Bruce W. Smith. • Kurt Russell and Halle Berry in a scene from Stuart Baird's *Executive Decision* (1996).

CLOCKWISE FROM TOP LEFT: A scene with Rene Russo and Kevin Costner in Ron Shelton's *Tin Cup* (1996). • A portrait of Sandra Bullock and Matthew McConaughey made for Joel Schumacher's *A Time to Kill* (1996). • Arnold Schwarzenegger and Vanessa Williams in a scene from Chuck Russell's *Eraser* (1996).

THE 1990S: MERGING, EMERGING, AND SURGING

FROM TOP:
Aidan Quinn and
Liam Neeson in a
scene from Neil
Jordan's *Michael
Collins* (1996).
• Helen Hunt
and Bill Paxton
in a scene from
Jan de Bont's
hit disaster film
Twister (1996).

1996 ACADEMY AWARDS

NOMINATIONS

Cinematography:

• *Michael Collins*, Chris Menges

Music (Original Dramatic Score):

• *Michael Collins*, Elliot Goldenthal
• *Sleepers*, John Williams

Sound:

• *Twister*, Steve Maslow, Gregg
Landaker, Kevin O'Connell, and
Geoffrey Patterson

Sound Effects Editing:

• *Eraser*, Alan Robert Murray and
Bub Asman

Visual Effects:

• *Twister*, Stefan Fangmeier, John
Frazier, Habib Zargarpour, and
Henry La Bounta

FROM TOP LEFT:
George Clooney and
Chris O'Donnell in
a scene from Joel
Schumacher's *Batman
and Robin* (1997). •
Ethan Embry, Marisol
Nichols, Beverly
D'Angelo, and Chevy
Chase in a scene from
Stephen Kessler's
Vegas Vacation (1997).

1997 ACADEMY AWARDS

WINS

Supporting Actress:

★ Kim Basinger in *L.A. Confidential*

Writing (Adapted Screenplay):

★ *L.A. Confidential*, Brian Helgeland and Curtis Hanson

NOMINATIONS

Best Picture:

- *L.A. Confidential*, Arnon Milchan, Curtis Hanson, and Michael Nathanson, Producers

Directing:

- Curtis Hanson for *L.A. Confidential*

Art Direction:

- *L.A. Confidential*, Art Direction: Jeannine Oppewall; Set Decoration: Jay R. Hart

Cinematography:

- *L.A. Confidential*, Dante Spinotti

Film Editing:

- *L.A. Confidential*, Peter Honess

Music (Original Dramatic Score):

- *L.A. Confidential*, Jerry Goldsmith

Sound:

- *Contact*, Randy Thom, Tom Johnson, Dennis Sands, and William B. Kaplan
- *L.A. Confidential*, Andy Nelson, Anna Behlmer, and Kirk Francis

FROM TOP: Matthew McConaughey and Jodie Foster in a scene from Robert Zemeckis's *Contact* (1997). • A portrait of Jennifer Lopez as Tejano music star Selena Quintanilla Pérez, made for Gregory Nava's *Selena* (1997).

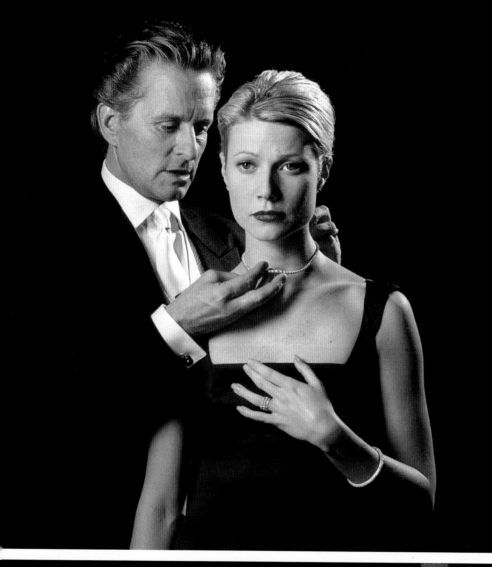

FROM TOP: A portrait of Michael Douglas and Gwyneth Paltrow made for Andrew Davis's *A Perfect Murder* (1998). • Nicole Kidman, Goran Visnjic, and Sandra Bullock in a ghoulish scene from Griffin Dunne's *Practical Magic* (1998).

CLOCKWISE FROM TOP LEFT: Tommy Lee Jones in a scene from Stuart Baird's *U.S. Marshals* (1998), a sequel to *The Fugitive.* • Danny Glover and Mel Gibson in a scene from Richard Donner's *Lethal Weapon 4* (1998). • Tom Hanks and Meg Ryan in a scene from Nora Ephron's romantic comedy *You've Got Mail* (1998).

1998 ACADEMY AWARDS

NOMINATION

Music (Original Song):
- "The Prayer" from *Quest for Camelot*, Music by Carole Bayer Sager and David Foster; Lyrics by Carole Bayer Sager, David Foster, Tony Renis, and Alberto Testa

CLOCKWISE FROM TOP: Ice Cube, George Clooney, and Mark Wahlberg in a scene from David O. Russell's critically praised *Three Kings* (1999). • Robert De Niro and Billy Crystal in a scene from Harold Ramis's comedy *Analyze This* (1999). • Nicole Kidman and Tom Cruise in a scene from Stanley Kubrick's last film, the much-anticipated and -discussed *Eyes Wide Shut* (1999).

1999 ACADEMY AWARDS

WINS

Film Editing:

★ *The Matrix*, Zach Staenberg

Sound:

★ *The Matrix*, John Reitz, Gregg Rudloff, David Campbell, and David Lee

Sound Effects Editing:

★ *The Matrix*, Dane A. Davis

Visual Effects:

★ *The Matrix*, John Gaeta, Janek Sirrs, Steve Courtley, and Jon Thum

NOMINATIONS

Best Picture:

• *The Green Mile*, David Valdes and Frank Darabont, Producers

Supporting Actor:

• Michael Clarke Duncan in *The Green Mile*

Writing (Adapted Screenplay):

• *The Green Mile*, Frank Darabont

Sound:

• *The Green Mile*, Robert J. Litt, Elliot Tyson, Michael Herbick, and Willie D. Burton

LEFT: A portrait of Keanu Reeves made for the Wachowskis' big hit of the decade, *The Matrix* (1999). **OPPOSITE, FROM TOP:** Tom Hanks and Michael Clarke Duncan in a scene from Frank Darabont's mystical *The Green Mile* (1999). • A scene of the characters Pikachu and Ash from Kunihiko Yuyama's *Pokémon: The First Movie— Mewtwo Strikes Back* (1998).

THE 2000s:

MEDIA FOR THE MILLENNIUM

AS A NEW MILLENNIUM DAWNED, OPTIMISM WAS IN THE AIR. THE WORLD WIDE WEB was connecting the globe in a digital revolution. With its sights on the future, Time Warner took a bold step. In early 2000, in a staggering $350 billion deal, the company merged with America Online, the nation's top internet provider. The new entity was AOL Time Warner, the world's first fully integrated multimedia and communications giant.

At the Warner Bros. lot in Burbank, business proceeded as usual. Second assistants loaded thousand-foot film magazines as they had done in Hollywood since 1913. Regardless of changes in format, dimension, and color, certain things hadn't changed. There had always been film and cans to put it in.

The year began with Jay Russell's *My Dog Skip*, a gentle comedy about the effect of a Jack Russell terrier on the life of a child, engagingly played by Frankie Muniz. Next up was first-time director Andrzej Bartkowiak's *Romeo Must Die*, an action film produced by Joel Silver for Jet Li in the style of a Hong Kong fight fest.

Wolfgang Petersen's *The Perfect Storm* was based on the Sebastian Junger book about a commercial fishing vessel and its doomed crew. It was a risky bet for a summer movie, given its tragic story, but it grossed $328 million worldwide. Its success bolstered both George Clooney's bankability and his relationship with Warner. Like Clint Eastwood, Clooney would be with the studio as a star, producer, and director on multiple projects. Eastwood directed and produced *Space Cowboys*, a feeltough movie about veteran test pilots repairing an old Soviet satellite in space.

Into the Arms of Strangers: Stories of the Kindertransport was a documentary written and directed by Mark Jonathan Harris and produced by Deborah Oppenheimer. Made with the cooperation of the United States Holocaust Memorial Museum, it recounted an operation that saved 10,000 Jewish children from the Nazis. With narration by Judi Dench and numerous interviews with those who were rescued, this moving film won the Academy Award for Best Documentary Feature.

Best in Show was a mockumentary of dog shows, co-written by Eugene Levy and Christopher Guest, who also directed. Stephen Kay's *Get Carter* was a

A portrait of Daniel Radcliffe as Harry Potter in Mike Newell's *Harry Potter and the Goblet of Fire* (2005).

remake of the 1971 British thriller that starred Michael Caine. This version brought Caine to star with Sylvester Stallone, Miranda Richardson, and Alan Cumming. Caine was also featured in Donald Petrie's *Miss Congeniality*, a Sandra Bullock FBI caper set in the midst of a beauty pageant.

In 2001, two years after Stanley Kubrick's passing, his influence was still being felt. A co-production with Dreamworks, *A.I. Artificial Intelligence* was a hit film about a robot child programmed to feel love. Directed by Steven Spielberg, its provenance could be traced to a Brian Aldiss short story, which Kubrick had been developing unsuccessfully for decades before handing the rights to Spielberg in the mid-'90s. Lawrence Guterman's *Cats & Dogs* was a spy comedy about the ongoing war between the two species, who are more intelligent than can be ascertained with current technology. The film starred Jeff Goldblum and Elizabeth Perkins, but the performing animals declined to record dialogue, so they were dubbed by Alec Baldwin, Susan Sarandon, and Charlton Heston. Antoine Fuqua's *Training Day* had Denzel Washington as a narcotics officer and Ethan Hawke as a recruit.

Steven Soderbergh's *Ocean's Eleven* was inspired by the 1960 Rat Pack heist classic. On board were George Clooney, Brad Pitt, Matt Damon, Andy García, Bernie Mac, and Julia Roberts. This story of friends who plan

Wall Street and Hollywood were sailing into the new millennium when the unthinkable happened. The dot-com bubble burst.

to steal from a casino was the number-five film of 2001, with a worldwide take of $450 million.

Wall Street and Hollywood were sailing into the new millennium when the unthinkable happened. The dot-com bubble burst. In a matter of months, most internet stocks had declined to a quarter of their value.

Total losses were estimated at $1.755 trillion. For the average citizen, this was not as bad as the 1929 crash, but Hollywood was seriously affected. By 2002, AOL Time Warner had lost a seismic $98 billion, As a result, the AOL deal soured, executives resigned, and Time Warner dropped AOL from its name.

In the midst of this tumult, a success story was beginning. In 1998, Warner Bros. had bought the rights to a series of children's books by British author J. K. Rowling. Only two of the books had been published, but it was a wise move. In 2001, Chris Columbus directed *Harry Potter and the Sorcerer's Stone* with Daniel Radcliffe as Harry, Rupert Grint as Ron Weasley, and Emma Watson as Hermione Granger. The spellbinding film followed eleven-year-old Harry to Hogwarts School of Witchcraft and Wizardry, where the novice wizard is trained in magic. *Harry Potter* reached number one in domestic earnings for 2001.

Simon Wells, great-grandson of the author H. G. Wells, directed Guy Pearce, Samantha Mumba, and Jeremy Irons in a new film version of his grandfather's classic, *The Time Machine*, a co-production with DreamWorks. George Clooney executive-produced his second feature—Christopher Nolan's *Insomnia* (2002), a psychological thriller starring Al Pacino as a Los Angeles homicide detective investigating Robin Williams in Alaska. *Blood Work* was an FBI thriller produced by, directed by, and starring Clint Eastwood.

Callie Khouri directed and co-wrote *Divine Secrets of the Ya-Ya Sisterhood*, a comedy-drama based on Rebecca Wells's 1996 novel. Raja Gosnell's *Scooby-Doo* blended live action and computer creatures from the long-running Hanna-Barbera animated television series. Freddie Prinze Jr. and Sarah Michelle Gellar provided voices for the lively mystery, which was shot in Queensland, Australia. This was the last film produced by the beloved animator William Hanna before his death on March 22, 2001. Another cartoon came to the screen with Craig McCracken's *The Powerpuff Girls Movie*, an animated superhero feature.

Harry Potter and the Chamber of Secrets was directed by Chris Columbus, and the three young film stars returned, enacting Harry's second year at Hogwarts. The film was highly successful.

In 2003, Warner released two sequels to its 1999 hit, *The Matrix*. Written and directed by the Wachowskis, with Keanu Reeves, Laurence Fishburne, Carrie-Anne Moss, Hugo Weaving, and Gloria Foster, and filmed concurrently, *The Matrix Reloaded* and *The Matrix Revolutions* were visually stunning and hugely successful.

Increasingly, major studios like Warner stuck to remakes (*House of Wax, Ocean's Eleven, Friday the 13th*) and big-screen versions of TV series (*The Dukes of Hazzard, Starsky and Hutch, Get Smart*), yet moderately budgeted "niche" films could still find an audience. In

Increasingly, major studios like Warner stuck to remakes (*House of Wax, Ocean's Eleven, Friday the 13th*) and big-screen versions of TV series (*The Dukes of Hazzard, Starsky and Hutch, Get Smart*), yet moderately budgeted "niche" films could still find an audience.

2004, the studio formed Warner Independent Pictures (WIP) to develop indie projects. Richard Linklater's *Before Sunset*—itself a sequel to the 1995 indie *Before Sunrise*—was the division's first release.

Remakes and sequels continued. Jonathan Mostow's *Terminator 3: Rise of the Machines* (2003) was the third installment in the Terminator franchise, with Arnold Schwarzenegger on the trail of a nasty cyborg. Joe Dante's *Looney Tunes: Back in Action* was, as the title implies, a hybrid of live action and animation comedy, with Daffy Duck and Bugs Bunny as stars, along with Jenna Elfman, Brendan Fraser, and Steve Martin.

The tireless Clint Eastwood directed and co-produced *Mystic River*. Sean Penn, Tim Robbins, and Kevin Bacon starred in the film, which was both criti-

cally praised and successful, grossing $156 million. *A Mighty Wind* was another of Christopher Guest's trademark mockumentaries, this one about 1960s folk groups reuniting for a television concert.

Wolfgang Petersen's *Troy* fared better and featured an ensemble cast led by Brad Pitt and Orlando Bloom. Equally mythic was Mark Rosman's teen comedy *A Cinderella Story*, which starred Hilary Duff and Chad Michael Murray in a clever update of the classic fairy tale. In this fanciful version, two internet correspondents make a date for their high school dance.

Robert Zemeckis's *The Polar Express* was a musical fantasy—totally computer-animated—about a boy who sees a mysterious train stop outside his window on Christmas Eve. The Harry Potter franchise continued to earn immense sums for Warner with its inventive third installment, Alfonso Cuarón's *Harry Potter and the Prisoner of Azkaban*.

Two esteemed Warner Bros. directors made films that departed from their previous hits, and with gratifying results. Clint Eastwood directed, co-produced, and scored *Million Dollar Baby*. It co-starred Hilary Swank as an aspiring pugilist, training with a veteran boxer who becomes a father figure. Martin Scorsese's *The Aviator* starred Leonardo DiCaprio as the enigmatic Howard Hughes, Cate Blanchett as Katharine Hepburn, and Kate Beckinsale as Ava Gardner. The two films won a combined nine Oscars.

In 2002, *Star Wars: Episode II—Attack of the Clones* became the first major feature to be captured entirely on digital video. It had to be transferred to 35mm film for most exhibitors, but just as theaters had to be wired for sound in 1928, exhibitors began buying digital projectors, even though the price tag could be $100,000. In 2005, digital still photography had nearly eclipsed traditional, film-based photography. Industry giant Agfa was bankrupt, and Kodak was imperiled. In the same year, total revenue from DVD sales reached a phenomenal $16.3 billion, almost double the $8.8 billion earned at the box office that year. The cash flow from home viewing led

studios to end a film's theatrical run sooner so it could be available on disc, often only two months after its release.

Ken Kwapis's *The Sisterhood of the Traveling Pants* (2005) featured America Ferrera, Amber Tamblyn, Blake Lively, and Alexis Bledel as four friends who share

The cash flow from home viewing led studios to end a film's theatrical run sooner so it could be available on disc, often only two months after its release.

a pair of pants that fits each of them despite their differing sizes. Shane Black's *Kiss Kiss Bang Bang* was a detective comedy with Robert Downey Jr., Val Kilmer, and Corbin Bernsen. Stephen Gaghan's *Syriana* was a political suspense film starring Matt Damon, George Clooney, and William Hurt.

For every original film idea, there were two that reworked old movies or TV series. Jay Chandrasekhar's *The Dukes of Hazzard* was based on the 1970s CBS series about three Georgia cousins and a corrupt sheriff. However, Tim Burton's *Charlie and the Chocolate Factory* was based on the 1964 novel by Roald Dahl—not on the 1971 film *Willy Wonka and the Chocolate Factory*. With Johnny Depp and chocolate practically oozing out of the screen, theater concessions did well, not to mention the studio. Burton co-directed *Corpse Bride* with Mike Johnson as a Victorian-era romance using the voices of Johnny Depp and Helena Bonham Carter.

A worthy first entry in the *Dark Knight* trilogy, Christopher Nolan's *Batman Begins* starred Christian Bale as the title superhero. The number-two earner of 2005 was Mike Newell's *Harry Potter and the Goblet of Fire*, the story of Harry's fourth year at Hogwarts.

Martin Scorsese's *The Departed* adapted the 2002 Hong Kong crime drama *Infernal Affairs* to portray rival moles in both the Irish American mob and the Boston Police Department. The film starred Jack Nicholson, Matt Damon, Leonardo DiCaprio, and Mark Wahlberg.

The film did nicely and won Scorsese his long-awaited Academy Award.

George Miller's *Happy Feet* was a computer-animated musical with penguins speaking like Robin Williams and Nicole Kidman, thanks to the animation studio Animal Logic. Andrew Fleming's *Nancy Drew* was a sprightly teen detective played by Emma Roberts. Rob Reiner's *The Bucket List* was a comedy starring Jack Nicholson and Morgan Freeman as incurably ill friends on a journey of final fulfillment.

Tony Gilroy's *Michael Clayton* starred George Clooney as a lawyer who stumbles onto a corporate cover-up. Paul Haggis's *In the Valley of Elah* was inspired by the true story of a man who searches a military base for his son's killers. Also based on actual events was Andrew Dominik's *The Assassination of Jesse James by the Coward Robert Ford*, which starred Brad Pitt as Jesse James and Casey Affleck as Robert Ford.

David Yates's *Harry Potter and the Order of the Phoenix* returned with Harry to a darker, more politically charged Hogwarts.

The burgeoning field of "new media" led to a Writers Guild of America strike in late 2007, which ended with screenwriters securing a fair royalty agreement for online content. Despite this setback, Time Warner was recovering handsomely from the ill-fated AOL merger. The company not only owned *Time*, *People*, and *Sports Illustrated* magazines but also Time Warner Cable, HBO, CNN, Turner Classic Movies, and other networks, not to mention the Warner Bros. studio. Under studio president Alan F. Horn and head of production Kevin McCormick, profits climbed steadily.

The first fully animated film in the Star Wars franchise was Dave Filoni's *Star Wars: The Clone Wars*, in which the heroic Jedi Knights attempt to restore peace. Roland Emmerich's *10,000 BC* was a film about prehistoric mammoth hunters, a demo often neglected by Hollywood.

The top earner of 2008 was Christopher Nolan's *The Dark Knight* (2008), starring Christian Bale. After giving a memorable performance as the Joker, Heath

Ledger suffered a fatal overdose of medication six months before the film's release. The credits carried a dedication to him, audiences poured in to see the critically acclaimed sequel, and Ledger won a posthumous Oscar for his work.

Much as they had taken the leap into sound technology in the 1920s, Warner Bros. plunged into digital technology in the 2000s. Breaking new ground with dazzling computer-generated visuals in the *Matrix* franchise and pioneering motion-capture computer animation in *The Polar Express*, the studio embraced films shot on

Breaking new ground with dazzling computer-generated visuals in the *Matrix* franchise and pioneering motion-capture computer animation in *The Polar Express*, Warner Bros. embraced films shot on digital video cameras, which could not yet replace celluloid film, but were fast encroaching.

digital video cameras, which could not yet replace celluloid film, but were fast encroaching.

Zack Snyder's *Watchmen,* a co-production with Paramount, was based on the 1986 DC limited series and set in an imaginary Cold War, where a coterie of veteran superheroes closes ranks to find a friend's killer. Spike Jonze's *Where the Wild Things Are* brought Maurice Sendak's beloved 1963 picture book to life

with performers in costumes, animatronics, and computer-generated imagery. One of the year's highest-grossing films was Todd Phillips's uninhibited comedy *The Hangover*, the story of a Las Vegas bachelor party spoiled by epic intemperance.

Guy Ritchie's *Sherlock Holmes* was the latest of dozens of films based on Sir Arthur Conan Doyle's immortal character. Holmes was portrayed by Robert Downey Jr. and Dr. Watson by Jude Law.

The last Harry Potter entry for the decade was David Yates's *Harry Potter and the Half-Blood Prince*. In less than a decade, the eight David Heyman–produced Harry Potter films had become the highest-grossing franchise in history, out-earning even James Bond. Between Batman and Harry Potter, Warner was setting the standard for entertainment in the new century: impeccably made, hero-centered, good-versus-evil franchises that generated both installments and merchandise.

Releasing a grand total of 287 films in the first decade of the 2000s—more than any other major studio—Warner repeatedly struck box-office gold as average ticket prices shot up from $5.39 in 2000 to $7.50 by 2009.

Despite an upswing in Warner Bros.' profit, to the tune of $3.3 billion in 2009, a decline in print media drove profits down at its parent company. With an ever-changing entertainment landscape and only one book left in the Harry Potter franchise, could the studio continue to make magic in the coming years?

CLOCKWISE FROM TOP LEFT: Jet Li and Aaliyah in a scene from Andrzej Bartkowiak's *Romeo Must Die* (2000). • Patrick Cranshaw and Jennifer Coolidge in Christopher Guest's mockumentary *Best in Show* (2000). • Animated characters James, Meowth, and Jessie in Kunihiko Yuyama's *Pokémon the Movie 2000: The Power of One* (2000). • FBI agent Sandra Bullock goes undercover to prevent a murder in Donald Petrie's *Miss Congeniality* (2000). **OPPOSITE, CLOCKWISE FROM TOP LEFT:** James Garner, Tommy Lee Jones, Donald Sutherland, and Clint Eastwood in Eastwood's *Space Cowboys* (2000). • A poster for Mark Jonathan Harris's moving documentary *Into the Arms of Strangers: Stories of the Kindertransport* (2000).

2000 ACADEMY AWARDS

WINS

Documentary (Feature):

★ *Into the Arms of Strangers: Stories of the Kindertransport*, Mark Jonathan Harris and Deborah Oppenheimer

NOMINATIONS

Sound:

• *The Perfect Storm*, John Reitz, Gregg Rudloff, David Campbell, and Keith A. Wester

Sound Editing:

• *Space Cowboys*, Alan Robert Murray and Bub Asman

Visual Effects:

• *The Perfect Storm*, Stefen Fangmeier, Habib Zargarpour, John Frazier, and Walt Conti

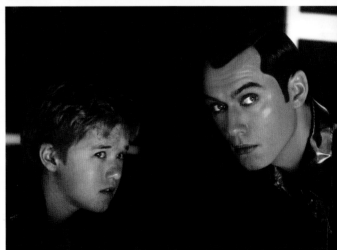

CLOCKWISE FROM TOP: Denzel Washington and Ethan Hawke cruise the Westlake District of Los Angeles in *Training Day* (2001). • Haley Joel Osment and Jude Law in a scene from Steven Spielberg's *A.I. Artificial Intelligence* (2001), a project that originated with, of all people, Stanley Kubrick. • A scene of George Clooney and Brad Pitt in *Ocean's Eleven* (2001), a remake of the 1960 Rat Pack comedy.

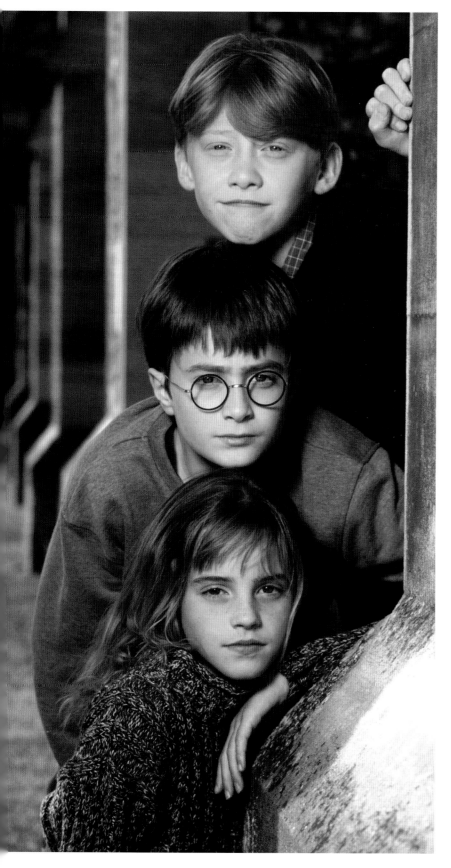

2001 ACADEMY AWARDS

WINS

Actor:

⋆ Denzel Washington in *Training Day*

NOMINATIONS

Supporting Actor:

• Ethan Hawke in *Training Day*

Art Direction:

• *Harry Potter and the Sorcerer's Stone*, Art Direction: Stuart Craig; Set Decoration: Stephenie McMillan

Costume Design:

• *The Affair of the Necklace*, Milena Canonero

• *Harry Potter and the Sorcerer's Stone*, Judianna Makovsky

Music (Original Score):

• *A.I. Artificial Intelligence*, John Williams

• *Harry Potter and the Sorcerer's Stone*, John Williams

Visual Effects:

• *A.I. Artificial intelligence*, Dennis Muren, Scott Farrar, Stan Winston, and Michael Lantieri

LEFT: A portrait of Rupert Grint as Ron Weasley, Daniel Radcliffe as Harry Potter, and Emma Watson as Hermione Granger in Chris Columbus's *Harry Potter and the Sorcerer's Stone* (2001). *Harry Potter* made $90.3 million during its first weekend, breaking the record for highest-opening weekend of all time (previously held by *The Lost World: Jurassic Park*).

FROM TOP LEFT: Clint Eastwood and Anjelica Huston in a scene from Eastwood's *Blood Work* (2002), the story of an FBI officer who is asked to help with a case while recovering from heart surgery. • A poster art portrait of Billy Crystal and Robert De Niro for Harold Ramis's *Analyze That* (2002). • Robin Williams and Al Pacino in a scene from Christopher Nolan's *Insomnia* (2002), a gripping detective drama.

2002 ACADEMY AWARDS

NOMINATIONS

Makeup:

- *The Time Machine*, John M. Elliott, Jr. and Barbara Lorenz

FROM TOP: Emma Watson in a scene from Chris Columbus's *Harry Potter and the Chamber of Secrets* (2002), which earned the number-three spot for the year. • Sarah Michelle Gellar, Linda Cardellini, Matthew Lillard, Freddie Prinze Jr., and Scooby-Doo in Raja Gosnell's *Scooby-Doo* (2002).

FROM TOP: Keanu Reeves in a scene from the Wachowskis' *The Matrix Reloaded* (2003), the highest-grossing R-rated film up to that time. • In Jonathan Mostow's *Terminator 3: Rise of the Machines* (2003), Arnold Schwarzenegger tracks a cyborg that was sent back in time to kill humans.**OPPOSITE, FROM TOP:** Eugene Levy and Catherine O'Hara in a scene from Christopher Guest's mockumentary *A Mighty Wind* (2003). • Jenna Elfman and Brendan Fraser in a scene from Joe Dante's *Looney Tunes: Back in Action* (2003), the last film produced by Warner Bros. Feature Animation.

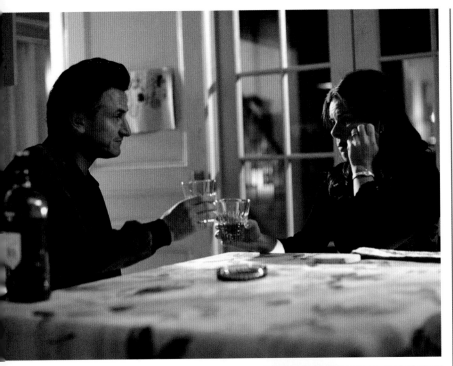

FROM TOP: Sean Penn and Marcia Gay Harden in Clint Eastwood's *Mystic River* (2003), an intense psychological drama written by Brian Helgeland.
• Edward Zwick's sweeping production of *The Last Samurai* (2003) starred Tom Cruise as a United States Cavalry soldier in conflicts with samurai in 1877 Japan.

2003 ACADEMY AWARDS

WINS

Actor:
★ Sean Penn in *Mystic River*

Supporting Actor:
★ Tim Robbins in *Mystic River*

NOMINATIONS

Best Picture:
• *Mystic River*, Clint Eastwood, Judie Hoyt, and Robert Lorenz, Producers

Directing:
• Clint Eastwood for *Mystic River*

Supporting Actor:
• Ken Watanabe in *The Last Samurai*

Supporting Actress:
• Marcia Gay Harden in *Mystic River*

Writing (Adapted Screenplay):
• *Mystic River*, Brian Helgeland

Art Direction:
• *The Last Samurai*, Art Direction: Lilly Kilvert; Set Decoration: Gretchen Rau

Costume Design:
• *The Last Samurai*, Ngila Dickson

Music (Original Song):
• "A Kiss at the End of the Rainbow" from *A Mighty Wind*, Music and Lyrics by Michael McKean and Annette O'Toole

Sound Mixing:
• *The Last Samurai*, Andy Nelson, Anna Behlmer, Jeff Wexler

FROM TOP: Hilary Duff and Chad Michael Murray in Mark Rosman's *A Cinderella Story* (2004). • Brad Pitt in a scene from Wolfgang Petersen's *Troy* (2004), a grand-scale production based on Homer's ever-popular *Iliad*.

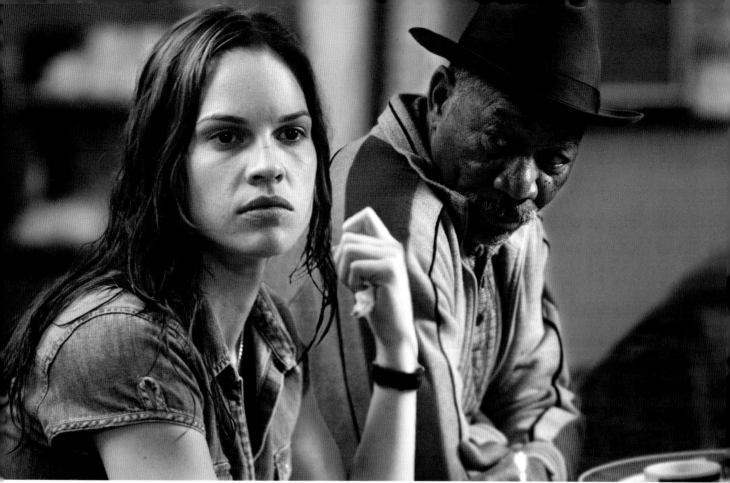

FROM TOP: Hilary Swank and Morgan Freeman in a scene from Clint Eastwood's *Million Dollar Baby* (2004). One of Eastwood's most respected works, the film grossed $216 million and won four Oscars. • Leonardo DiCaprio and Cate Blanchett in a scene from Martin Scorsese's *The Aviator* (2004). **OPPOSITE, FROM TOP:** Daniel Radcliffe as Harry Potter and Buckbeak the Hippogriff in *Harry Potter and the Prisoner of Azkaban*. • Tom Hanks provides the voice for Santa Claus and Daryl Sabara is the young hero's voice for Robert Zemeckis's *The Polar Express* (2004).

2004 ACADEMY AWARDS

WINS

Best Picture:
- ★ *Million Dollar Baby*, Clint Eastwood, Albert S. Ruddy, and Tom Rosenberg, Producers

Directing:
- ★ Clint Eastwood for *Million Dollar Baby*

Actress:
- ★ Hilary Swank in *Million Dollar Baby*

Supporting Actor:
- ★ Morgan Freeman in *Million Dollar Baby*

Supporting Actress:
- ★ Cate Blanchett in *The Aviator*

Art Direction:
- ★ *The Aviator*, Art Direction: Dante Ferretti; Set Decoration: Francesca Lo Schiavo

Cinematography:
- ★ *The Aviator*, Robert Richardson

Costume Design:
- ★ *The Aviator*, Sandy Powell

Film Editing:
- ★ *The Aviator*, Thelma Schoonmaker

NOMINATIONS

Best Picture:
- *The Aviator*, Michael Mann and Graham King, Producers

Directing:
- Martin Scorsese for *The Aviator*

Actor:
- Leonardo DiCaprio in *The Aviator*
- Clint Eastwood in *Million Dollar Baby*

Supporting Actor:
- Alan Alda in *The Aviator*

Writing (Adapted Screenplay):
- *Before Sunset*, Screenplay by Richard Linklater, Julie Delpy, and Ethan Hawke; Story by Richard Linklater and Kim Krizan
- *Million Dollar Baby*, Screenplay by Paul Haggis

Writing (Original Screenplay):
- *The Aviator*, John Logan

Art Direction:
- *The Phantom of the Opera*, Art Direction: Anthony Pratt; Set Decoration: Celia Bobak
- *A Very Long Engagement*, Art Direction; Aline Bonetto

Cinematography:
- *The Phantom of the Opera*, John Mathieson
- *A Very Long Engagement*, Bruno Delbonnel

Costume Design:
- *Troy*, Bob Ringwood

Film Editing:
- *Million Dollar Baby*, Joel Cox

Music (Original Score):
- *Harry Potter and the Prisoner of Azkaban*, John Williams

Music (Original Song):
- "Believe" from *The Polar Express*, Music and Lyrics by Glen Ballard and Alan Silvestri
- "Learn to Be Lonely" from *The Phantom of the Opera*, Music by Andrew Lloyd Webber; Lyrics by Charles Hart

Sound Editing:
- *The Polar Express*, Randy Thom and Dennis Leonard

Sound Mixing:
- *The Aviator*, Tom Fleischman and Petur Hliddal
- *The Polar Express*, Randy Thom, Tom Johnson, Dennis Sands, and William B. Kaplan

Visual Effects:
- *Harry Potter and the Prisoner of Azkaban*, Roger Guyett, Tim Burke, John Richardson, and Bill George

FROM TOP: A portrait of Johnny Depp for Tim Burton's *Charlie and the Chocolate Factory* (2005), a sweet film. • Val Kilmer and Robert Downey Jr. in a scene from Shane Black's *Kiss Kiss Bang Bang* (2005).

2005 ACADEMY AWARDS

WINS

Supporting Actor:
- ★ George Clooney in *Syriana*

Documentary (Feature):
- ★ *March of the Penguins*, Luc Jacquet and Yves Darondeau

NOMINATIONS

Best Picture:
- *Good Night, and Good Luck*, Grant Heslov, Producer

Directing:
- George Clooney for *Good Night, and Good Luck*

Actor:
- David Strathairn in *Good Night, and Good Luck*

Actress:
- Charlize Theron in *North Country*

Supporting Actress:
- Frances McDormand in *North Country*

Writing (Original Screenplay):
- *Good Night, and Good Luck*, George Clooney and Grant Heslov
- *Syriana*, Stephen Gaghan

Animated Feature Film:
- *Corpse Bride*, Tim Burton and Mike Johnson

Art Direction:
- *Good Night, and Good Luck*, Art Direction: Jim Bissell; Set Decoration: Jan Pascale
- *Harry Potter and the Goblet of Fire*, Art Direction: Stuart Craig; Set Decoration: Stephenie McMillan

Cinematography:
- *Batman Begins*, Wally Pfister
- *Good Night, and Good Luck*, Robert Elswit

Costume Design:
- *Charlie and the Chocolate Factory*, Gabriella Pescucci

Foreign Language Film:
- *Paradise Now* (Palestine)

ABOVE, FROM LEFT: Blake Lively, America Ferrera, Amber Tamblyn, and Alexis Bledel in a portrait made for Ken Kwapis's *The Sisterhood of the Traveling Pants* (2005). • Emily, the bride voiced by Helena Bonham Carter in Mike Johnson and Tim Burton's *Corpse Bride* (2005), a stop-motion animation feature. **OPPOSITE, FROM TOP:** David Strathairn played the extraordinary TV journalist Edward R. Murrow in George Clooney's *Good Night, and Good Luck* (2005). • Matt Damon, George Clooney, and Alexander Siddig in a scene from Stephen Gaghan's political thriller *Syriana* (2005).

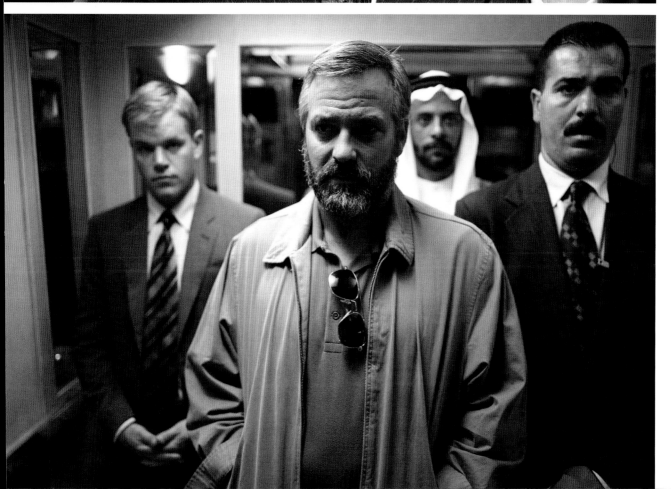

FROM TOP:
Leonardo DiCaprio and Djimon Hounsou in a scene from Edward Zwick's *Blood Diamond* (2006), which was set in the 1990s Sierra Leone civil war.

• Hugo Weaving and Natalie Portman in a scene from James McTeigue's *V for Vendetta* (2006). The Wachowskis based their screenplay on the 1988 DC Vertigo Comics' limited series about a masked freedom fighter who seeds sedition in a ruined English society.

2006 ACADEMY AWARDS

WINS

Best Picture:

★ *The Departed*, Graham King, Producer

Directing:

★ Martin Scorsese for *The Departed*

Writing (Adapted Screenplay):

★ *The Departed*, William Monahan

Animated Feature Film:

★ *Happy Feet*, George Miller

Film Editing:

★ *The Departed*, Thelma Schoonmaker

Sound Editing:

★ *Letters from Iwo Jima*, Alan Robert Murray and Bub Asman

NOMINATIONS

Best Picture:

• *Letters from Iwo Jima*, Clint Eastwood, Steven Spielberg, and Robert Lorenz, Producers

Directing:

• Clint Eastwood for *Letters from Iwo Jima*

Actor:

• Leonardo DiCaprio in *Blood Diamond*

Supporting Actor:

• Djimon Hounsou in *Blood Diamond*

• Mark Wahlberg in *The Departed*

Writing (Original Screenplay):

• *Letters from Iwo Jima*, Screenplay by Iris Yamashita; Story by Iris Yamashita and Paul Haggis

Art Direction:

• *The Prestige*, Art Direction: Nathan Crowley; Set Decoration: Julie Ochipinti

Cinematography:

• *The Prestige*, Wally Pfister

Film Editing:

• *Blood Diamond*, Steven Rosenblum

Music (Original Score):

• *The Good German*, Thomas Newman

Sound Editing:

• *Blood Diamond*, Lon Bender

• *Flags of Our Fathers*, Alan Robert Murray and Bub Asman

Sound Mixing:

• *Blood Diamond*, Andy Nelson, Anna Behlmer, and Ivan Sharrock

• *Flags of Our Fathers*, John Reitz, Dave Campbell, Gregg Rudloff, and Walt Martin

Visual Effects:

• *Poseidon*, Boyd Shermis, Kim Libreri, Chas Jarrett, and John Frazier

• *Superman Returns*, Mark Stetson, Neil Corbould, Richard R. Hoover, and Jon Thum

FROM TOP: Ken Watanabe in a scene from Clint Eastwood's *Letters from Iwo Jima* (2006). • A portrait of Brandon Routh in Bryan Singer's *Superman Returns* (2006), the sixth installment of the original Superman series and the number-five earner for 2006.

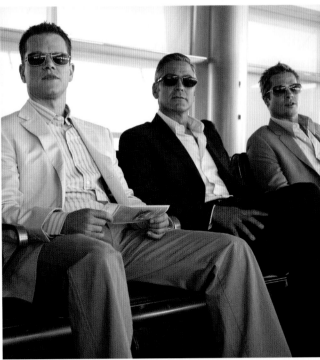

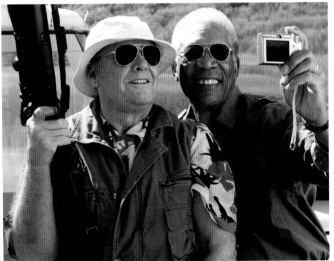

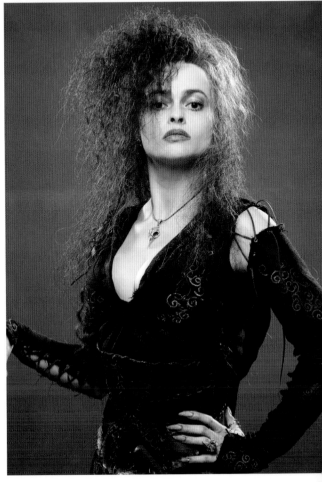

CLOCKWISE FROM TOP LEFT: Hilary Swank and Gerard Butler in a scene from Richard LaGravenese's *P. S. I Love You* (2007). • Matt Damon, George Clooney, and Brad Pitt in Steven Soderbergh's *Ocean's Thirteen* (2007). • A portrait of Helena Bonham Carter in David Yates's *Harry Potter and the Order of the Phoenix*, the fifth top earner for 2007. • Jack Nicholson and Morgan Freeman in a scene from Rob Reiner's *The Bucket List* (2007). **OPPOSITE:** Gerard Butler in a scene from Zack Snyder's *300* (2006), a digital re-creation of the Battle of Thermopylae in the Persian Wars.

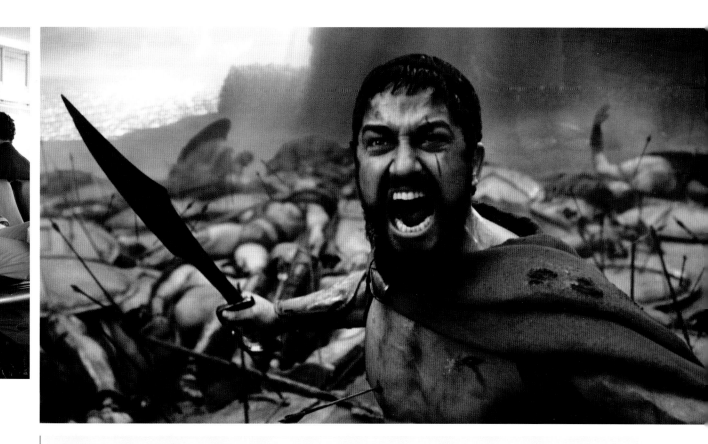

2007 ACADEMY AWARDS

WINS

Supporting Actress:

★ Tilda Swinton in *Michael Clayton*

Art Direction:

★ *Sweeney Todd: The Demon Barber of Fleet Street*, Art Direction: Dante Ferretti; Set Decoration: Francesca Lo Schiavo

NOMINATIONS

Best Picture:

• *Michael Clayton*, Sydney Pollack, Jennifer Fox, and Kerry Orent, Producers

Directing:

• Tony Gilroy for *Michael Clayton*

Actor:

• George Clooney in *Michael Clayton*
• Johnny Depp in *Sweeney Todd: The Demon Barber of Fleet Street*
• Tommy Lee Jones in *In the Valley of Elah*

Supporting Actor:

• Casey Affleck in *The Assassination of Jesse James by the Coward Robert Ford*
• Tom Wilkinson in *Michael Clayton*

Writing (Original Screenplay):

• *Michael Clayton*, Written by Tony Gilroy

Cinematography:

• *The Assassination of Jesse James by the Coward Robert Ford*, Roger Deakins

Costume Design:

• *Sweeney Todd: The Demon Barber of Fleet Street*, Colleen Atwood

Music (Original Score):

• *Michael Clayton*, James Newton Howard

Music (Original Song):

• "Raise It Up" from *August Rush*, Music and Lyrics by Jamal Joseph, Charles Mack, and Tevin Thomas

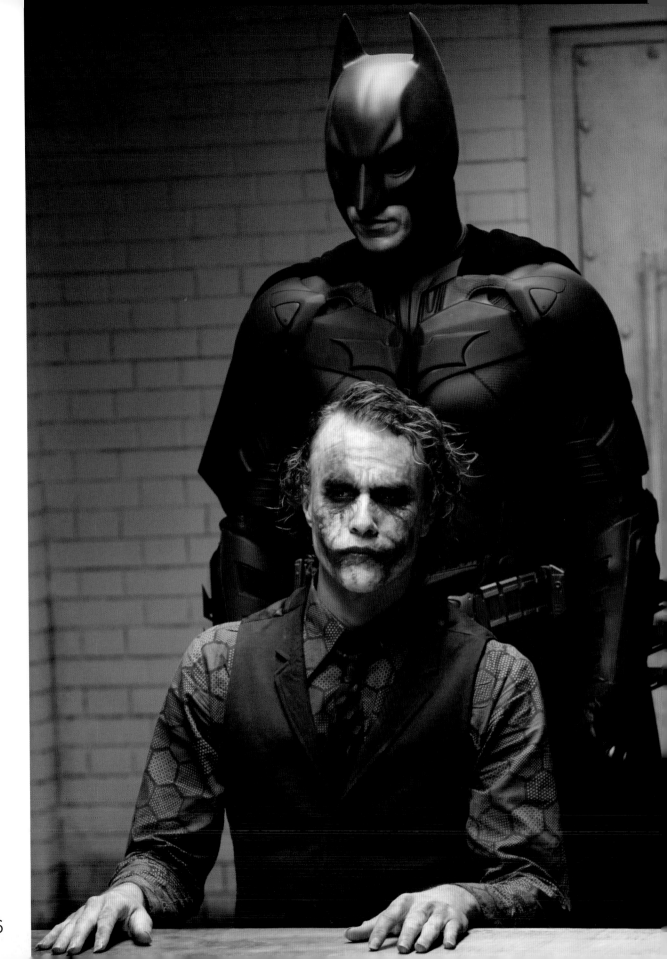

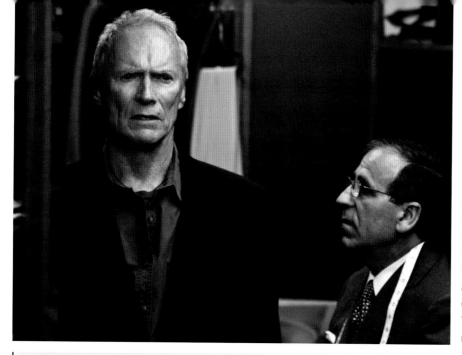

LEFT: Clint Eastwood and Vincent Bonasso in a scene from Eastwood's *Gran Torino* (2008), a drama about a reclusive older American adjusting to an influx of Laotian refugees in his neighborhood. **OPPOSITE:** Christian Bale and Heath Ledger in a scene from Christopher Nolan's *The Dark Knight* (2008). Surpassing every hit in the history of Warner Bros., the film *netted* more than $1 billion worldwide.

2008 ACADEMY AWARDS

WINS

Supporting Actor:
- ★ Heath Ledger in *The Dark Knight*

Art Direction:
- ★ *The Curious Case of Benjamin Button*, Art Direction: Donald Graham Burt; Set Decoration: Victor J. Zolfo

Makeup:
- ★ *The Curious Case of Benjamin Button*, Greg Cannom

Sound Editing:
- ★ *The Dark Knight*, Richard King

Visual Effects:
- ★ *The Curious Case of Benjamin Button*, Eric Barba, Steve Preeg, Burt Dalton, and Craig Barron

NOMINATIONS

Best Picture:
- *The Curious Case of Benjamin Button*, Kathleen Kennedy, Frank Marshall, and Ceán Chaffin, Producers

Directing:
- David Fincher for *The Curious Case of Benjamin Button*

Actor:
- Brad Pitt in *The Curious Case of Benjamin Button*

Supporting Actress:
- Taraji P. Henson in *The Curious Case of Benjamin Button*

Writing (Adapted Screenplay):
- *The Curious Case of Benjamin Button*, Screenplay by Eric Roth; Screen Story by Eric Roth and Robin Swicord

Art Direction:
- *The Dark Knight*, Art Direction: Nathan Crowley; Set Decoration: Peter Lando

Cinematography:
- *The Curious Case of Benjamin Button*, Claudio Miranda
- *The Dark Knight*, Wally Pfister

Costume Design:
- *The Curious Case of Benjamin Button*, Jacqueline West

Film Editing:
- *The Curious Case of Benjamin Button*, Kirk Baxter and Angus Wall
- *The Dark Knight*, Lee Smith

Makeup:
- *The Dark Knight*, John Caglione Jr. and Conor O'Sullivan

Music (Original Score):
- *The Curious Case of Benjamin Button*, Alexandre Desplat

Sound Mixing:
- *The Curious Case of Benjamin Button*, David Parker, Michael Semanick, Ren Klyce, and Mark Weingarten
- *The Dark Knight*, Lora Hirschberg, Gary Rizzo, and Ed Novick

Visual Effects:
- *The Dark Knight*, Nick Davis, Chris Corbould, Tim Webber, and Paul Franklin

2009 ACADEMY AWARDS

WINS

Actress:

★ Sandra Bullock in *The Blind Side*

NOMINATIONS

Picture:

• *The Blind Side*, Gil Netter, Andrew Kosove, and Broderick Johnson

Actor:

• Morgan Freeman in *Invictus*

Supporting Actor:

• Matt Damon in *Invictus*

Cinematography:

• *Harry Potter and the Half-Blood Prince*, Bruno Delbonnel

Set Decoration:

• *Sherlock Holmes*, Sarah Greenwood and Katie Spencer

Score:

• *Sherlock Homes*, Hans Zimmer

FROM TOP: Zach Galifianakis, Bradley Cooper, and Ed Helms starred in Todd Phillips's *The Hangover* (2009), a sobering look at a bachelor party spoiled by intemperance. The unflinchingly graphic comedy was one of the year's top earners. • Max Records in a scene from Spike Jonze's *Where the Wild Things Are* (2009), the story of a lonely preteen who finds "Wild Things" on a distant island. **OPPOSITE, FROM TOP:** Jae Head, Quinton Aaron, and Sandra Bullock in John Lee Hancock's *The Blind Side* (2009), the story of adoptive parents who help their underprivileged son achieve the nearly impossible goal of playing in the National Football League. • Robert Downey Jr. and Jude Law in a scene from Guy Ritchie's *Sherlock Holmes* (2009), which grossed $524 million. •

THE 2010s:

IT'S A DIGITAL WORLD, AFTER ALL

BY LATE 2009, TIME WARNER HAD COMPLETELY SHED AOL AND SPUN ITS CABLE carrier services to Roadrunner. Cutting losses, the parent company confirmed entertainment as the priority of the new decade, ready to invest funds and resources in Warner Bros. film production. Beginning in 2010, a reordering of personnel transformed the Burbank lot. Time Warner CEO Jeff Bewkes established a triumvirate: Jeff Robinov, Bruce Rosenblum, and Kevin Tsujihara. By 2013, Tsujihara had replaced Barry Meyer as studio chair, Robinov was out, and a new team, including Sue Kroll and Greg Silverman, was in, overseeing film production and distribution. More changes lay ahead. Corporate shifts, technology-driven fluctuations, and societal upheavals made for an unpredictable era in Hollywood.

As in the early '50s, when competition from TV caused a panicked rush to gimmicks, studios turned to 3-D, which was better suited to theater screens than to TV. Curiously, large screens were increasingly the home entertainment choice. Consumers trashed their Trinitrons and bought flat-screen TVs, which could connect to the internet and stream unlimited content. Warner Bros. experimented with technology such as video on demand (VOD). Faced with the proliferation of cell phones and the reality that consumers were watching feature films on these dinky devices, Warner Bros. looked into releasing films via Facebook and iPhone apps.

Whereas studios traditionally hoped for a few "tentpole" films each year to carry the weight of the smaller projects, the studios were growing so dependent on tentpoles that other types of films were denied a green

> **The crowd-pleasing blockbusters were elbowing smaller films out of the arena. More frequently, the studio favored a franchise sequel or a major event picture, expecting it to coax patrons into theaters.**

light. The crowd-pleasing blockbusters were elbowing smaller films out of the arena. More frequently, the studio favored a franchise sequel or a major event picture, expecting it to coax patrons into theaters. Intimate

A portrait of Gal Gadot from Patty Jenkins's *Wonder Woman* (2017).

dramas and romantic comedies were facing extinction. Instead, there were hybrid genres with mutations of style and setting in place of original content.

David Yates directed the seventh entry in the wildly popular Harry Potter series, and *Harry Potter and the Deathly Hallows—Part 1* hit number seven in 2010. Louis Leterrier's *Clash of the Titans* brought back Medusa and the gang in a remake of the star-studded 1981 film, this one boasting Liam Neeson and Ralph Fiennes. The next best thing to Greek gods were characters from 1960s TV shows. Eric Brevig's *Yogi Bear* was based on the animated series created by William Hanna and Joseph Barbera but added live action and 3-D. A different kind of folk hero could be found in Samuel Bayer's *A Nightmare on Elm Street*, a remake of the 1984 Wes Craven hit that gave the culture Freddy Krueger.

Albert and Allen Hughes, who were known as the Hughes brothers, created a post-apocalyptic western, *The Book of Eli*, that starred Denzel Washington, Gary Oldman, and Jennifer Beals. *Legend of the Guardians: The Owls of Ga'Hoole* was a computer-animated fantasy directed by Zack Snyder in 3-D.

DVD sales slowed and then declined, due to consumer fatigue, said some, and due to lack of shelf space, said others.

Happily, there were still character-driven films. *The Town* was a gambit flick co-written by, directed by, and starring Ben Affleck. Veteran Garry Marshall directed an ensemble cast in a nice romantic comedy called *Valentine's Day*. With a cast that included Jessica Alba, Bradley Cooper, Patrick Dempsey, Jamie Foxx, Jennifer Garner, Anne Hathaway, Ashton Kutcher, Queen Latifah, George Lopez, Shirley MacLaine, and Julia Roberts, the film had to be a hit. Well, it was.

Clint Eastwood brought Warner another mid-range success with an offbeat film. In *Hereafter* he explored the ways in which the death of a loved one affects different individuals. Eastwood also directed Leonardo DiCaprio in the title role of *J. Edgar*, a life story of FBI director Hoover, the cast of which included Armie Hammer, Naomi Watts, and Judi Dench. It made a fair amount of money. Christopher Nolan's wildly popular *Inception* presented DiCaprio as a thief who enters subconscious minds, and it grossed $836 million worldwide.

DVD sales slowed and then declined, due to consumer fatigue, said some, and due to lack of shelf space, said others. If you owned a Betamax copy of *Casablanca*, plus a laserdisc, a VHS, and a special edition VHS, where would you fit the DVD or Blu-ray? There were other reasons for the drop in sales. Netflix was in town. In 2010, to avoid infringing on box office and DVD sales, Warner had made a deal to delay the availability of its new films on the streaming service for twenty-eight days, and other studios followed suit. But streaming was clearly the way of the future. Sure enough, Netflix would gain 151.5 million annual subscribers by 2019, a 142 percent jump from 2015.

For conventional comedies, one had only to look at the latest sequel to *The Hangover* or to Seth Gordon's *Horrible Bosses*, which showed abused employees adopting extreme measures to improve working conditions. Guy Ritchie's *Sherlock Holmes: A Game of Shadows*, the 2011 sequel to the 2009 Sherlock Holmes, did well, as did *Dolphin Tale*, a family film about a bottlenose dolphin rescued from a crab trap off the Florida coast and rehabilitated by caring humans.

The tentpole of 2011 arrived in the summer when the final film in the Harry Potter series, *Harry Potter and the Deathly Hallows—Part 2*, raked in $1.3 *billion* worldwide. This broke the record set by *The Dark Knight* in 2008.

Tim Burton and Johnny Depp made their eighth film together with 2012's *Dark Shadows*, which was based on the 1960s afternoon serial. Burton's cast included Michelle Pfeiffer, Helena Bonham Carter, and Christopher Lee.

The final installment in Christopher Nolan's *Dark Knight* trilogy was *The Dark Knight Rises*. Christian Bale returned as Batman, and the movie reached number two in domestic box-office grosses, earning $1 billion worldwide.

Peter Jackson's *The Hobbit: An Unexpected Journey* was the first of a new Middle Earth–set film trilogy, based on J. R. R. Tolkien's 1937 novel. Ben Affleck's *Argo* (2012) had him as the CIA operative Tony Mendez pretending to make a science-fiction film during the Iran hostage crisis, but actually rescuing diplomats from Tehran. The film starred Affleck as Mendez and featured Bryan Cranston, Alan Arkin, and John Goodman.

> **Digital technology had already wiped out still photography of the celluloid persuasion. Digital cinematography was deemed cheaper and quicker, so it took over.**

After years of streaming other companies' content, Netflix, Amazon, and Hulu decided to do what the Warner brothers had done seventy years earlier. Rather than continuing to solely license, they would create their own content. And that's what Netflix and the new kids did. In 2012, Netflix initiated content production with its original series, *Lilyhammer*. No comment came from the major studios as Netflix's gamble began to pay off handsomely.

At Warner, Brian Helgeland wrote and directed *42*, a biography of baseball great Jackie Robinson, the black athlete who integrated Major League Baseball. Chadwick Boseman played Robinson. *The Great Gatsby* was Baz Luhrmann's appropriation of F. Scott Fitzgerald's beloved 1925 novel, and Leonardo DiCaprio helped make the film a success.

James Wan's *The Conjuring* inaugurated the Conjuring Universe franchise, with Patrick Wilson and Vera Farmiga as paranormal investigators. Spike

Jonze's *Her* posited the possibility of a relationship with an "artificially intelligent virtual assistant with a female voice." Alfonso Cuarón's *Gravity* left Sandra Bullock and George Clooney stranded in orbit after their space shuttle collides with debris. The film won seven Academy Awards; more than any other Warner Bros. film save *My Fair Lady*.

The number-four top earner of 2013 was Zack Snyder's *Man of Steel*. The visual spectacle starred Henry Cavill as Superman, with Amy Adams, Michael Shannon, and Kevin Costner.

A profound change in motion picture production occurred in 2013. For the first time since the birth of motion pictures, shooting on film was not the industry standard. Digital technology had already wiped out still photography of the celluloid persuasion. Digital cinematography was deemed cheaper and quicker, so it took over. A handful of filmmakers, Quentin Tarantino and Christopher Nolan among them, kept Kodak in business by refusing to switch to digital cameras. They preferred the rich tones, the subtle textures, the "human" feel of filmed images.

The Lego Movie was a computer-animated adventure, written and directed by Phil Lord and Christopher Miller. In it, a Lego mini-figure goes up against a tyrannical tycoon; because this was a movie, the mini-figure won. *300: Rise of an Empire* was directed by Noam Murro and written and produced by Zack Snyder.

Twenty-nine Godzilla films mandated a thirtieth, and it arrived in 2014 with Gareth Edwards's *Godzilla*. Its cast included Ken Watanabe, Juliette Binoche, and Bryan Cranston. Not surprisingly, there would be more Godzilla films. There would also be more *Annabelle* films, since a doll possessed by spirits can return at will.

In the early '60s, the Four Seasons had hits like "Big Girls Don't Cry." Clint Eastwood adapted the Broadway musical *Jersey Boys* to let the big screen tell the singing group's story. The film's producers included group members Frankie Valli and Bob Gaudio.

Eastwood made *American Sniper* a top box-office earner by recounting the story of the deadliest marksman in US military history. At the other end of the professional spectrum was Paul Thomas Anderson's *Inherent Vice*, the story of a slothful sleuth in 1970 Los Angeles. *Mad Max: Fury Road* starred Charlize Theron in the fourth and most popular installment of George Miller's *Mad Max* franchise.

Ryan Coogler's *Creed* was a sequel to and spin-off of the Rocky franchise. Sylvester Stallone reprised the role of Rocky, and Michael B. Jordan played Adonis "Donnie" Johnson Creed, Apollo Creed's son. David Yates's *The Legend of Tarzan* cast Alexander Skarsgård as the character created by Edgar Rice Burroughs, and it was fairly well attended.

The big-money movies were dropping like golden goose eggs. Zack Snyder's *Batman v Superman: Dawn*

The big-money movies were dropping like golden goose eggs.

of Justice followed *Man of Steel* and was the second installment in the DC Universe. It made $873 million. David Ayer's *Suicide Squad* featured the DC supervillain team, starring Will Smith, Jared Leto, and Margot Robbie.

Longtime Warner presence Clint Eastwood did not need a superhero to make a super-hit; he chose a real-life hero. *Sully* re-created the heroic piloting of Chesley "Sully" Sullenberger in the 2009 emergency landing of a US Airways flight on the Hudson River in New York City, with Tom Hanks in the lead role.

The Disney company gave Warner stiff competition in the 2010s with its family-friendly animated fare, rights to Marvel comics, and control of the Star Wars universe. Warner Bros. rose to the challenge with spin-offs of J. K. Rowling's Wizarding World and entries in the Middle Earth saga, which had been acquired in the New Line Cinema merger.

David Yates's *Fantastic Beasts and Where to Find Them* represented a spin-off of and a prequel to the Harry Potter film series, taking its cue from Rowling's guidebook—and it made $814 million worldwide.

In 2017, Warner tapped into its DC reserves to finally craft a Wonder Woman feature worthy of the classic superheroine. Directed by Patty Jenkins, *Wonder Woman* starred Gal Gadot and was a blockbuster, earning $822 million.

Chris McKay's *The Lego Batman Movie* was a co-production of the United States, Australia, and Denmark that made $312 million. Not every *Lego* series entry was as successful. *The Lego Ninjago Movie* made a mere $123 million. Zack Snyder's *Justice League* was based on the DC superhero team. With a cast that included Ben Affleck, Henry Cavill, Amy Adams, and Gal Gadot, the film made $657 million.

For fans of clowns, antiheroes, and Stephen King nightmares, there was Andy Muschietti's *It* in 2017, followed by *It Chapter Two* the next year. Fans of Ridley Scott's *Blade Runner* had to wait thirty-five years for a sequel. Luckily, Harrison Ford and Edward James Olmos were able to reprise their 1982 roles for Denis Villeneuve's *Blade Runner 2049* in 2017. The new film starred Ryan Gosling as this generation's replicant hunter.

Jon M. Chu's *Crazy Rich Asians* (2018) was a rare studio release with an all-Asian main cast. Audiences were enthusiastic, and the romantic comedy grossed $238 million. Gary Ross's *Ocean's Eight* was a female-driven caper that had Sandra Bullock, Cate Blanchett, and Helena Bonham Carter plundering the Met Gala.

A Star Is Born was filmed for the fourth time in 2018, with Lady Gaga in the lead role and a soundtrack full of hits like "Shallow," which won the Original Song Oscar. The Bradley Cooper film succeeded admirably, earning $438 million. Equally profitable was David Yates's *Fantastic Beasts: The Crimes of Grindelwald*, the second entry in the Harry Potter spinoff series.

The Mule was a quirky drama produced and directed by Clint Eastwood, who also played the lead.

The screenplay, by Nick Schenk, told the story of Leo Sharp, a World War II veteran who, in his eighties, became a drug courier for the Sinaloa cartel.

The sixth film in the DC Universe franchise was *Aquaman*, directed by James Wan and starring Jason Momoa as the half–man, half–sea creature who is the reluctant heir to the kingdom of Atlantis. It became the biggest DC hit so far and one of the most successful films in Warner Bros. history with worldwide grosses of $1.148 billion.

The sequels and follow-ups and franchise entries kept on coming with *The Lego Movie 2: The Second Part*, *Godzilla: King of the Monsters*, and *Annabelle Comes Home*. Then there was *Joker*, which gave the DC villain a starring role, complete with contemporary concerns of inequality, alienation, and vigilantism and told with a nuance rarely seen in comic book–based films. Director Todd Phillips gave the film a dose of '70s New Hollywood style, and Joaquin Phoenix's performance was universally praised and Oscar winning.

Clint Eastwood's last film of the 2010s was *Richard Jewell* (2019), which related the true story of the 1996 Olympics security guard who discovered a bomb and was then accused of having placed it.

With two-thirds of the adult population using social media in the 2010s, online movements could generate significant societal change almost overnight. In 2015, #OscarsSoWhite held the Academy of Motion Picture Arts and Sciences accountable for the dearth of people of color on the nominations list, as well as in their membership. In 2017, the #MeToo movement exposed a culture of sexual harassment in Hollywood and beyond.

A series of scandalous revelations followed, and prominent figures like Harvey Weinstein were accused both in the press and in court. When accusations of assault and cruelty were verified, careers were summarily ended. Calls for equity and inclusion were beginning to challenge an industry long dominated by white men.

> When accusations of assault and cruelty were verified, careers were summarily ended. Calls for equity and inclusion were beginning to challenge an industry long dominated by white men.

There was more drama at Warner Bros. in 2018, when an $85 billion deal was inked to sell Time Warner and all its assets to the world's largest telecommunications company, AT&T. Over the next few years, Warner's various entertainment divisions would be broken up, dissolved, or incorporated as elements of WarnerMedia.

A new era began on June 14, 2018, when AT&T formally acquired Time Warner. The next year, Warner Bros. unveiled a new logo, a blue revamp of the venerable WB shield. WarnerMedia announced plans for its own streaming service, HBO Max, featuring 10,000 hours of premium entertainment from the vaults of Warner, the Turner networks, and the original programming of HBO. As 2019 drew to a close, the future looked limitless. The industry was ready to take a deep breath and expand, paying no heed to scattered news stories of a virus outbreak in China.

FROM TOP: Mila Kunis and Denzel Washington try to deliver a mysterious book in the Hughes brothers' *The Book of Eli* (2010). • A portrait of Sam Worthington in Louis Leterrier's *Clash of the Titans* (2010), a remake of the 1981 film about Greek mythology.
OPPOSITE, FROM TOP: A portrait of Daniel Radcliffe made for *Harry Potter and the Deathly Hallows—Part 1*. • Michelle Fairley, Emma Watson, and Ian Kelly in a scene from David Yates's *Harry Potter and the Deathly Hallows—Part 1* (2010).

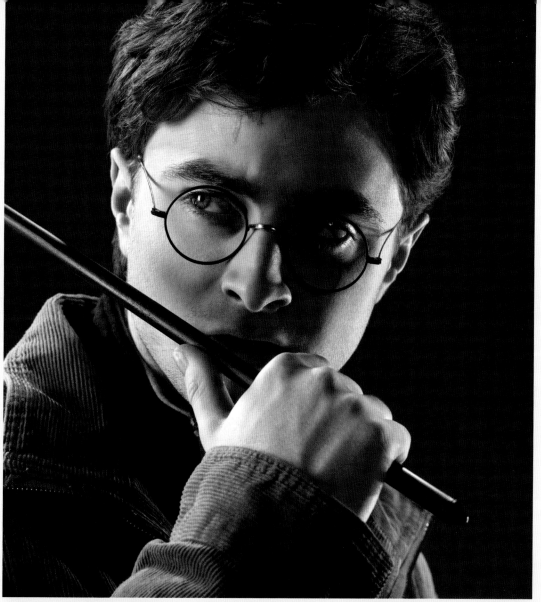

Marion Cotillard and Leonardo DiCaprio in a scene from Christopher Nolan's *Inception* (2010), the tale of a thief who enters subconscious minds in order to steal information—a plausible concept in the internet era.

2010 ACADEMY AWARDS

WINS

Cinematography:
* ★ *Inception*, Wally Pfister

Sound Editing:
* ★ *Inception*, Richard King

Sound Mixing:
* ★ *Inception*, Lora Hirschberg, Gary A. Rizzo, and Ed Novick

Visual Effects:
* ★ *Inception*, Paul Franklin, Chris Corbould, Andrew Lockley, and Peter Bebb

NOMINATIONS

Best Picture:
* *Inception*, Emma Thomas and Christopher Nolan, Producers

Supporting Actor:
* Jeremy Renner in *The Town*

Writing (Original Screenplay):
* *Inception*, Christopher Nolan

Art Direction:
* *Harry Potter and the Deathly Hallows—Part 1*, Production Design: Stuart Craig; Set Decoration: Stephenie McMillan
* *Inception*, Production Design: Guy Hendrix Dyas; Set Decoration: Larry Dias and Doug Mowat

Music (Original Score):
* *Inception*, Hans Zimmer

Visual Effects:
* *Harry Potter and the Deathly Hallows—Part 1*, Tim Burke, John Richardson, Christian Manz, and Nicolas Aithadi
* *Hereafter*, Michael Owens, Bryan Grill, Stephan Trojansky, and Joe Farrell

FROM TOP: Robert Downey Jr. and Jude Law in Guy Ritchie's *Sherlock Holmes: A Game of Shadows* (2011). • Matt Damon in Steven Soderbergh's *Contagion* (2011), a frighteningly prescient film.

FROM TOP: Jamie Chung and old Warner Bros. posters in a scene from Zack Snyder's *Sucker Punch* (2011). • Ed Helms, Bradley Cooper, and Zach Galifianakis see the result of more intemperance in Todd Phillips's *The Hangover Part II* (2011). • Nathan Gamble and Harry Connick Jr. help rehabilitate Winter the dolphin in Charles Martin Smith's *Dolphin Tale* (2011). **OPPOSITE, FROM TOP:** Ryan Reynolds in Martin Campbell's *Green Lantern* (2011). • A breezy scene from George Miller's *Happy Feet Two* (2011).

Daniel Radcliffe, Emma Watson, and Rupert Grint in David Yates's *Harry Potter and the Deathly Hallows—Part 2* (2011). This "tentpole" release grossed $1.3 billion worldwide, breaking the record set by *The Dark Knight* in 2008 and reaching number fourteen for all-time highest-grossing films.

2011 ACADEMY AWARDS

NOMINATIONS

Best Picture:

- *Extremely Loud & Incredibly Close*, Scott Rudin, Producer

Supporting Actor:

- Max von Sydow in *Extremely Loud & Incredibly Close*

Art Direction:

- *Harry Potter and the Deathly Hallows—Part 2*, Production Design: Stuart Craig; Set Decoration: Stephenie McMillan

Makeup:

- *Harry Potter and the Deathly Hallows—Part 2*, Nick Dudman, Amanda Knight, and Lisa Tomblin

Visual Effects:

- *Harry Potter and the Deathly Hallows—Part 2*, Tim Burke, David Vickery, Greg Butler, and John Richardson

FROM TOP: Dwayne Johnson, Josh Hutcherson, Luis Guzmán, and Vanessa Hudgens in Brad Peyton's *Journey 2: The Mysterious Island* (2012). • Queen Latifah and Dolly Parton in Todd Graff's *Joyful Noise* (2012), a parable of contentious choir members. • Channing Tatum shows his shape in Steven Soderbergh's *Magic Mike* (2012).

CLOCKWISE FROM TOP LEFT: Halle Berry in a scene from *Cloud Atlas* (2012), a film by sisters Lana and Lilly Wachowski. • Christian Bale and Anne Hathaway in a scene from Christopher Nolan's *The Dark Knight Rises* (2012), which, at $1.08 billion, was another Warner success story. • A portrait of Johnny Depp in his film *Dark Shadows* (2012), which was based on the 1960s TV serial. • Rosamund Pike in a mythical scene from Jonathan Liebesman's *Wrath of the Titans* (2012). • Zach Galifianakis and Will Ferrell wax political in Jay Roach's *The Campaign* (2012).

2012 ACADEMY AWARDS

WINS

Best Picture:

★ *Argo*, Grant Heslov, Ben Affleck, and George Clooney, Producers

Writing (Adapted Screenplay):

★ *Argo*, Chris Terrio

Film Editing:

★ *Argo,* William Goldenberg

NOMINATIONS

Supporting Actor:

• Alan Arkin in *Argo*

Makeup and Hairstyling:

• *The Hobbit: An Unexpected Journey*, Peter Swords King, Rick Findlater, and Tami Lane

Music (Original Score):

• *Argo*, Alexandre Desplat

Production Design:

• *The Hobbit: An Unexpected Journey*, Production Design: Dan Hennah; Set Decoration: Ra Vincent and Simon Bright

Sound Editing:

• *Argo*, Erik Aadahl and Ethan Van der Ryn

Sound Mixing:

• *Argo*, John Reitz, Gregg Rudloff, and Jose Antonio Garcia

Visual Effects:

• *The Hobbit: An Unexpected Journey*, Joe Letteri, Eric Saindon, David Clayton, and R. Christopher White

FROM TOP: Ben Affleck based his espionage thriller *Argo* (2012) on a book by CIA operative Tony Mendez.
• Ian McKellen in Peter Jackson's *The Hobbit: An Unexpected Journey* (2012), the first of a new fantasy film trilogy.

CLOCKWISE FROM TOP LEFT: Leonardo DiCaprio and Carey Mulligan in a scene from Baz Luhrmann's *The Great Gatsby* (2013). • Joaquin Phoenix in a scene from Spike Jonze's *Her* (2013), a story of love in the age of A.I. • Vera Farmiga in James Wan's *The Conjuring* (2013). • A portrait of Henry Cavill in Zack Snyder's *Man of Steel* (2013), which was based on *Superman*, which began the DC Universe franchise. **OPPOSITE, FROM TOP:** Chadwick Boseman as the courageous Jackie Robinson in a scene from Brian Helgeland's *42* (2013). • Martin Freeman in a scene from Peter Jackson's *The Hobbit: The Desolation of Smaug*, the fourth-highest-grossing film of 2013.

Sandra Bullock in a terrifying scene from Alfonso Cuarón's *Gravity* (2013). The film's effects were shown to good advantage in 3-D and IMAX.

2013 ACADEMY AWARDS

WINS

Directing:

★ Alfonso Cuarón for *Gravity*

Writing (Original Screenplay):

★ *Her*, Spike Jonze

Cinematography:

★ *Gravity*, Emmanuel Lubezki

Costume Design:

★ *The Great Gatsby*, Catherine Martin

Film Editing:

★ *Gravity*, Alfonso Cuarón and Mark Sanger

Music (Original Score):

★ *Gravity*, Steven Price

Production Design:

★ *The Great Gatsby*, Production Design: Catherine Martin; Set Decoration: Beverley Dunn

Sound Editing:

★ *Gravity*, Glenn Freemantle

Sound Mixing:

★ *Gravity*, Skip Lievsay, Niv Adiri, Christopher Benstead, and Chris Munro

Visual Effects:

★ *Gravity*, Tim Webber, Chris Lawrence, David Shirk, and Neil Corbould

NOMINATIONS

Best Picture:

• *Gravity*, Alfonso Cuarón and David Heyman, Producers

• *Her*, Megan Ellison, Spike Jonze, and Vincent Landay, Producers

Actress:

• Sandra Bullock in *Gravity*

Cinematography:

• *Prisoners*, Roger A. Deakins

Music (Original Score):

• *Her*, William Butler and Owen Pallett

Music (Original Song):

• "The Moon Song" from *Her*, Music by Karen O; Lyrics by Karen O and Spike Jonze

Production Design:

• *Gravity*, Production Design: Andy Nicholson; Set Decoration: Rosie Goodwin and Joanne Woollard

• *Her*, Production Design: K. K. Barrett; Set Decoration: Gene Serdena

Sound Editing:

• *The Hobbit: The Desolation of Smaug*, Brent Burge and Chris Ward

Sound Mixing:

• *The Hobbit: The Desolation of Smaug,* Christopher Boyes, Michael Hedges, Michael Semanick, and Tony Johnson

Visual Effects:

• *The Hobbit: The Desolation of Smaug*, Joe Letteri, Eric Saindon, David Clayton, and Eric Reynolds

FROM TOP: Godzilla acts out in Gareth Edwards's *Godzilla* (2014), which was only the second Godzilla film made totally by a Hollywood studio. • A portrait of Rodrigo Santoro in Noam Murro's *300: Rise of an Empire* (2014), a semi-prequel to the 2007 film *300*. Its story took place before, during, and after the events of the previous epic. • Luke Evans and Orlando Bloom in a scene from Peter Jackson's *The Hobbit: The Battle of the Five Armies* (2014), which grossed nearly a billion dollars.

FROM TOP: Emily Blunt and Tom Cruise in Doug Liman's *Edge of Tomorrow* (2014), a thriller involving so-called time loops. • Joaquin Phoenix played an easily distracted detective in Paul Thomas Anderson's *Inherent Vice* (2014).
OPPOSITE: Bradley Cooper and Luke Grimes in a scene from Clint Eastwood's *American Sniper* (2014), another Eastwood success.

2014 ACADEMY AWARDS

WINS

Sound Editing:

★ *American Sniper*, Alan Robert Murray and Bub Asman

Visual Effects:

★ *Interstellar*, Paul Franklin, Andrew Lockley, Ian Hunter, and Scott Fisher

NOMINATIONS

Best Picture:

• *American Sniper*, Clint Eastwood, Robert Lorenz, Andrew Lazar, Bradley Cooper, and Peter Morgan, Producers

Actor:

• Bradley Cooper in *American Sniper*

Supporting Actor:

• Robert Duvall in *The Judge*

Writing (Adapted Screenplay):

• *American Sniper*, Jason Hall
• *Inherent Vice*, Paul Thomas Anderson

Costume Design:

• *Inherent Vice*, Mark Bridges

Film Editing:

• *American Sniper*, Joel Cox and Gary D. Roach

Music (Original Score):

• *Interstellar*, Hans Zimmer

Music (Original Song):

• "Everything Is Awesome," *The Lego Movie*, Music and Lyrics by Shawn Patterson

Production Design:

• *Interstellar*, Production Design: Nathan Crowley; Set Decoration: Gary Fettis

Sound Editing:

• *The Hobbit: The Battle of the Five Armies*, Brent Burge and Jason Canovas
• *Interstellar*, Richard King

Sound Mixing:

• *American Sniper*, John Reitz, Gregg Rudloff, and Walt Martin
• *Interstellar*, Gary A. Rizzo, Gregg Landaker, and Mark Weingarten

Charlize Theron in a scene from George Miller's *Mad Max: Fury Road* (2015), the highest-grossing Mad Max film to date.
OPPOSITE, FROM TOP: A portrait of Mila Kunis in Lana and Lilly Wachowski's *Jupiter Ascending* (2015). • Michael B. Jordan and Sylvester Stallone in a scene from Ryan Coogler's *Creed* (2015), the seventh installment of the series and a sequel to 2006's *Rocky Balboa*. • Margot Robbie and BD Wong in a conspiratorial scene from Glenn Ficarra and John Requa's *Focus* (2015).

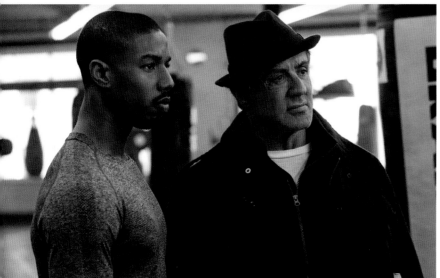

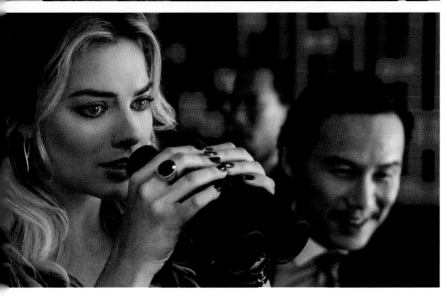

WINS

Costume Design:

⋆ *Mad Max: Fury Road*, Jenny Beavan

Film Editing:

⋆ *Mad Max: Fury Road*, Margaret Sixel

Makeup and Hairstyling:

⋆ *Mad Max: Fury Road*, Lesley Vanderwalt, Elka Wardega, and Damian Martin

Production Design:

⋆ *Mad Max: Fury Road*, Production Design: Colin Gibson; Set Decoration: Lisa Thompson

Sound Editing:

⋆ *Mad Max: Fury Road*, Mark Mangini and David White

Sound Mixing:

⋆ *Mad Max: Fury Road*, Chris Jenkins, Gregg Rudloff, and Ben Osmo

NOMINATIONS

Best Picture:

• *Mad Max: Fury Road*, Doug Mitchell and George Miller, Producers

Directing:

• George Miller for *Mad Max: Fury Road*

Supporting Actor:

• Sylvester Stallone in *Creed*

Cinematography:

• *Mad Max: Fury Road*, John Seale

Visual Effects:

• *Mad Max: Fury Road*, Andrew Jackson, Tom Wood, Dan Oliver, and Andy Williams

THE 2010S: IT'S A DIGITAL WORLD, AFTER ALL

CLOCKWISE FROM TOP: Ben Affleck and Henry Cavill in a scene from Zack Snyder's *Batman v Superman: Dawn of Justice* (2016), the first live-action film to feature these superheroes together, as well as the first to include Wonder Woman. • Margot Robbie and Alexander Skarsgård in David Yates's *The Legend of Tarzan* (2016). In this film, Tarzan, after moving to London, is persuaded to return to the jungle and fight the slave trade. • Patrick Wilson in a scene from James Wan's The Conjuring 2 (2016). **OPPOSITE, FROM TOP:** Eddie Redmayne in a scene from David Yates's *Fantastic Beasts and Where to Find Them* (2016), the ninth entry in the Wizarding World franchise. • Common, Jared Leto, and Margot Robbie in a scene from David Ayer's *Suicide Squad* (2016), a supervillain exercise that earned $746 million.

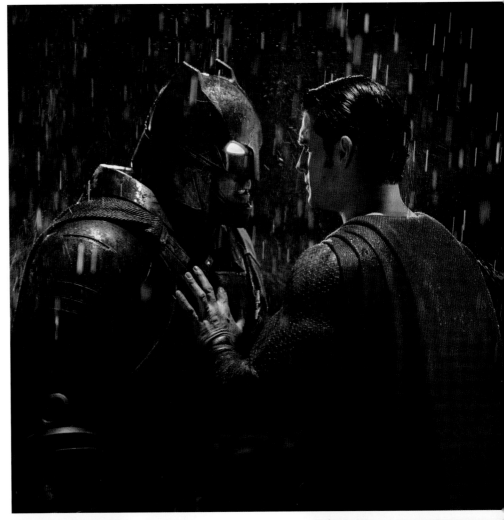

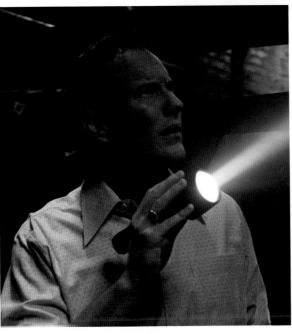

2016 ACADEMY AWARDS

WINS

Costume Design:

★ *Fantastic Beasts and Where to Find Them*, Colleen Atwood

Makeup and Hairstyling:

★ *Suicide Squad*, Alessandro Bertolazzi, Giorgio Gregorini, and Christopher Nelson

NOMINATIONS

Production Design:

• *Fantastic Beasts and Where to Find Them*, Production Design: Stuart Craig; Set Decoration: Anna Pinnock

Sound Editing:

• *Sully*, Alan Robert Murray and Bub Asman

CLOCKWISE FROM TOP: *Blade Runner 2049* (2017). • Pennywise in *It* (2017) . • Gal Gadot in a scene from Patty Jenkins's *Wonder Woman* (2017), a massive hit released in 4-DX, RealD 3-D, and IMAX 3-D. **OPPOSITE:** A scene from Christopher Nolan's *Dunkirk* (2017) a skilled and respectful recreation of the heroic evacuation of World War II.

2017 ACADEMY AWARDS

WINS

Cinematography:

★ *Blade Runner 2049*, Roger A. Deakins

Film Editing:

★ *Dunkirk*, Lee Smith

Sound Editing:

★ *Dunkirk*, Richard King and Alex Gibson

Sound Mixing:

★ *Dunkirk*, Gregg Landaker, Gary A. Rizzo, and Mark Weingarten

Visual Effects:

★ *Blade Runner 2049*, John Nelson, Gerd Nefzer, Paul Lambert, and Richard R. Hoover

NOMINATIONS

Best Picture:

• *Dunkirk*, Emma Thomas and Christopher Nolan, Producers

Directing:

• Christopher Nolan for *Dunkirk*

Cinematography:

• *Dunkirk*, Hoyte van Hoytema

Music (Original Score):

• *Dunkirk*, Hans Zimmer

Production Design:

• *Blade Runner 2049*, Production Design: Dennis Gassner; Set Decoration: Alessandra Querzola

• *Dunkirk*, Production Design: Nathan Crowley; Set Decoration: Gary Fettis

Sound Editing:

• *Blade Runner 2049*, Mark Mangini and Theo Green

Sound Mixing:

• *Blade Runner 2049*, Ron Bartlett, Doug Hemphill, and Mac Ruth

Visual Effects:

• *Kong: Skull Island*, Stephen Rosenbaum, Jeff White, Scott Benza, and Mike Meinardus

A portrait of Jason Momoa in James Wan's *Aquaman* (2018), a motion picture that grossed $1.134 *billion*.

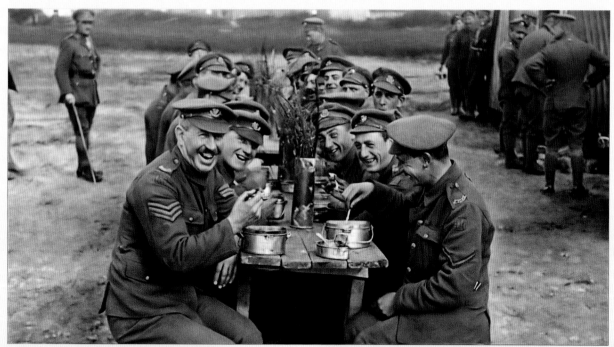

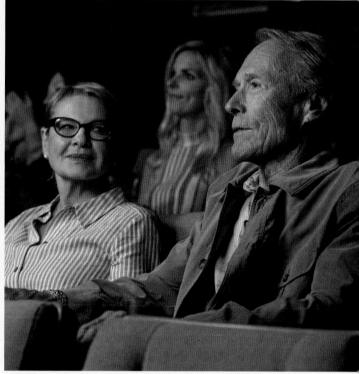

CLOCKWISE FROM TOP: An image capture from Peter Jackson's *They Shall Not Grow Old* (2018), a documentary created from digitally enhanced newsreel footage of World War I. • Dianne Wiest and Clint Eastwood in a scene from Eastwood's *The Mule* (2018), the true story of an octogenarian drug courier. • Constance Wu and Henry Golding in a scene from Jon M. Chu's *Crazy Rich Asians* (2018), which was not part of a series or franchise but tapped the growing Asian market with its nearly all-Asian cast—the first since *The Joy Luck Club*—and its astutely observed comedy.

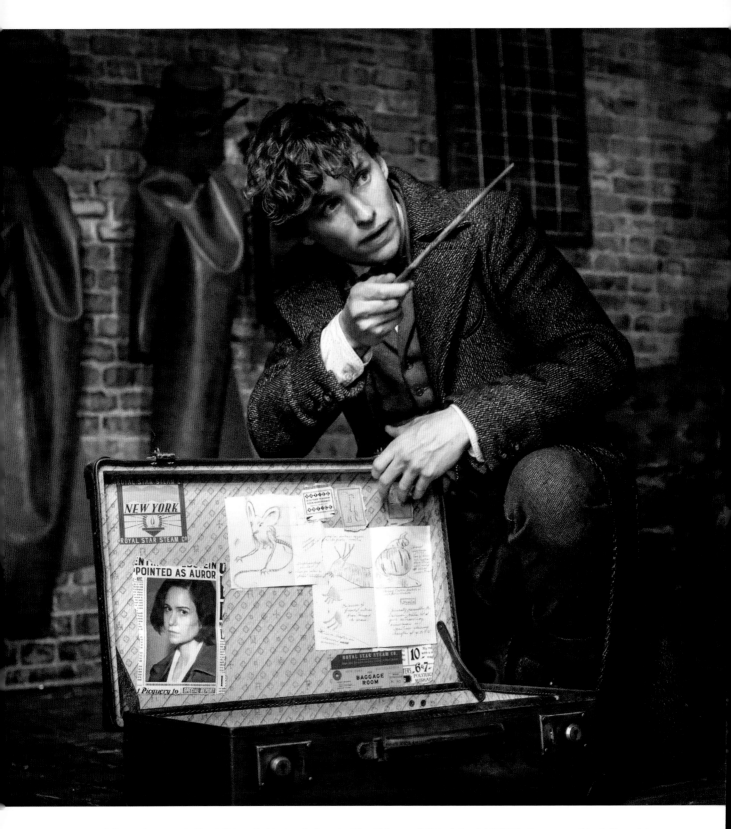

Eddie Redmayne in David Yates's *Fantastic Beasts: The Crimes of Grindelwald* (2018), the second installment in the Fantastic Beasts film series, and the tenth overall in the Wizarding World franchise.

2018 ACADEMY AWARDS

WINS

Music (Original Song):

* "Shallow" from *A Star Is Born*, Music and Lyrics by Lady Gaga, Mark Ronson, Anthony Rossomando, and Andrew Wyatt

NOMINATIONS

Best Picture:

* *A Star Is Born*, Bill Gerber, Bradley Cooper, and Lynette Howell Taylor, Producers

Actor:

* Bradley Cooper in *A Star Is Born*

Actress:

* Lady Gaga in *A Star Is Born*

Supporting Actor:

* Sam Elliott in *A Star Is Born*

Writing (Adapted Screenplay):

* *A Star Is Born*, Eric Roth, Bradley Cooper, and Will Fetters

Cinematography:

* *A Star Is Born*, Matthew Libatique

Sound Mixing:

* *A Star Is Born*, Tom Ozanich, Dean Zupancic, Jason Ruder, and Steve Morrow

Visual Effects:

* *Ready Player One*, Roger Guyett, Grady Cofer, Matthew E. Butler, and David Shirk

The durable plot of *A Star Is Born* was filmed—again—with Lady Gaga as the Hollywood hopeful and Bradley Cooper as the fading star. Cooper also directed, and the film made nearly half a billion dollars.

THE 2010S: IT'S A DIGITAL WORLD, AFTER ALL

FROM TOP: Isaiah Mustafa, Bill Hader, James McAvoy, Jessica Chastain, and Jay Ryan in *It Chapter Two* (2019). • Justice Smith in Rob Letterman's *Pokémon Detective Pikachu* (2019), the first live-action Pokémon film and the first live-action film based on a Nintendo game property since *Super Mario Bros.* (1993). • Batman, Queen Watevra Wa'nabi and Wyldstyle in *The Lego Movie 2: The Second Part* (2019). **OPPOSITE, FROM TOP:** Joaquin Phoenix in Todd Phillips's *Joker* (2019), a billion-dollar hit. • Michael Jordan and Jamie Foxx in Destin Daniel Cretton's *Just Mercy* (2019). • A monstrous scene from Michael Dougherty's *Godzilla: King of the Monsters* (2019).

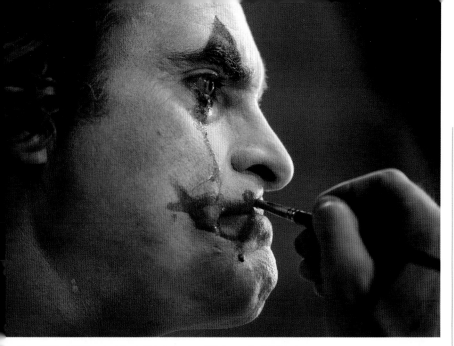

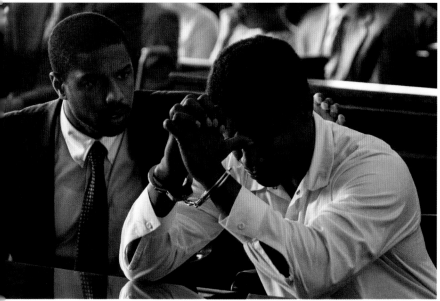

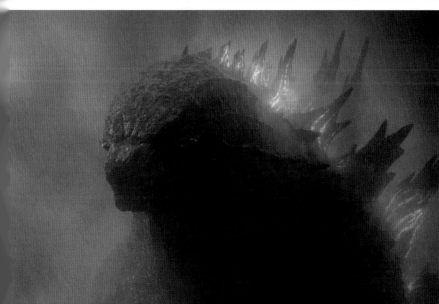

2019 ACADEMY AWARDS

WINS

Actor:

★ Joaquin Phoenix in *Joker*

Music (Original Score):

★ *Joker*, Hildur Guðnadóttir

NOMINATIONS

Best Picture:

• *Joker*, Todd Phillips, Bradley Cooper, and Emma Tillinger Koskoff, Producers

Directing:

• Todd Phillips for *Joker*

Supporting Actress:

• Kathy Bates in *Richard Jewell*

Writing (Adapted Screenplay):

• *Joker*, Todd Phillips and Scott Silver

Cinematography:

• *Joker*, Lawrence Sher

Costume Design:

• *Joker*, Mark Bridges

Film Editing:

• *Joker,* Jeff Groth

Makeup and Hairstyling:

• *Joker*, Nicki Ledermann and Kay Georgiou

Sound Editing:

• *Joker*, Alan Robert Murray

Sound Mixing:

• *Joker*, Tom Ozanich, Dean Zupancic, and Tod Maitland

THE 2020s:

STILL WARNER BROS. AFTER ALL THESE YEARS

BY THE YEAR 2020, THE WARNER FAMILY STUDIO HAD COME A LONG WAY. IT WAS among the most prestigious media empires in the world. Even with a boom in home viewing, box-office returns had continued to rise in 2019. They were still rising in early 2020, with movie tickets averaging nearly $10 each. No one in the business—or outside of it—foresaw a looming catastrophe, a force majeure that would affect the entire planet and nearly destroy the motion picture industry.

The first release of the new decade was Cathy Yan's *Birds of Prey (and the Fantabulous Emancipation of One Harley Quinn)*, which flew into theaters on February 7. Before it could fully play its engagements, theaters started to close, forced by state mandates. Not since the influenza virus of 1918 had a crisis like this been seen. The country was under siege, and emergency measures of all kinds were imposed to slow the spread of the virus. The Los Angeles lockdown took effect on March 16.

Movie theaters were among the most transmissible indoor locations. Most theater managers were told that they would be shut down for three months; many remained closed for a year, and some shuttered their doors permanently. While *Birds of Prey* failed to make a profit, more Warner films sat in wait for audiences to return.

From a high of $11.4 billion in 2019, ticket sales dropped to $2.28 billion, the lowest number since the dismal '70s. As the virus continued to wreak havoc, posts were cut, employees were laid off, and plans were

> **Most theater managers were told that they would be shut down for three months; many remained closed for a year, and some shuttered their doors permanently.**

put on hold. Jason Kilar was named chief of Warner-Media in April 2020, and he immediately restructured the mammoth studio, placing an emphasis on streaming. WarnerMedia launched its HBO Max premium streaming service in May, offering Warner's vast library

of feature films, plus top TV series like *Friends*, *The Big Bang Theory*, and *Game of Thrones*. Filmmakers such as J. J. Abrams, Ridley Scott, and Baz Luhrmann were signed to create original content.

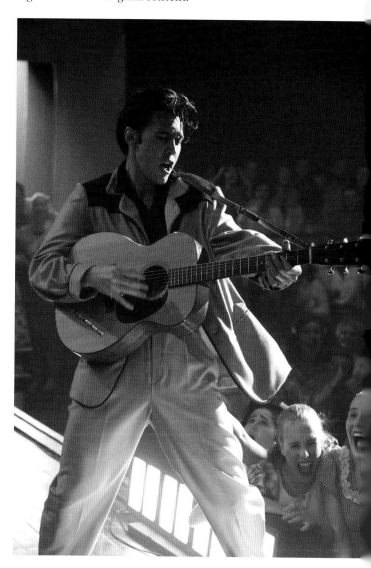

Austin Butler in a scene from Baz Luhrmann's *Elvis* (2022).

There was a silver lining to the dark cloud of coronavirus. With much of the country locked inside and online, streaming surged higher than ever, with a total number of worldwide subscribers hitting 1.1 billion in 2020. The catch? Staying competitive. The streaming business was more expensive in the long run, as it could only keep viewers interested by offering newly created content.

Studios began releasing movies to theaters and streaming sites simultaneously. Controversy raged as actors and directors accused studios of failing to honor their contractual commitments. In truth, theatrical runs had already been shrinking. Offering features to streaming sooner made sense, as most titles earned the bulk of their grosses on their first three weekends in movie theaters. Still, theaters could not survive without exclusive rights to exhibit films before they were made available online. The quandary was hotly debated.

Warner had twelve releases planned for 2020, now suspended in space by the lockdown. The most highly anticipated of these, Christopher Nolan's *Tenet*, starred John David Washington as a CIA agent who can warp time to evade attacks. The film's theatrical release had been postponed three times because of the lockdown, and while its September opening was tentative by any standards, it did make $363 million—welcome income in a grim and uncertain time. After several delayed openings, Robert Zemeckis's *The Witches* was released directly on HBO Max in time for Halloween. It got a theatrical release in some markets a week later, but it made a low $26 million. Patty Jenkins's *Wonder Woman 1984* took a different approach: It was released in December simultaneously in theaters and on HBO Max, where subscribers could view it for one month.

As most theaters remained closed, Warner Bros. announced that their entire 2021 slate of films—seventeen domestic releases in all—would debut on HBO Max the same day as their theatrical opening. The announcement of this strategy, designed in part to attract more viewers to the streaming service, sent shock waves through Hollywood.

Out came the movies, many of high quality but—predictably—soft performance at the box office. Shaka King's *Judas and the Black Messiah* recounted the FBI's murder of Illinois Black Panther chairman Fred Hampton, a worthy topic told with panache and starring Daniel Kaluuya and LaKeith Stanfield. It performed well with critics and won two Oscars at the postponed Academy Awards ceremony. Tim Story's *Tom & Jerry: The Movie*, a reboot of the classic cartoon characters, opened strong in those theaters that were braving coronavirus variants. The scene was brightening by June, when Michael Chaves's *The Conjuring: The Devil Made Me Do It* was released; the film made $202 million. Also released in June, after waiting almost a year, was Jon M. Chu's *In the Heights*, an adaptation of Lin-Manuel Miranda's first Tony Award–winning musical set among the Dominican American community of upper Manhattan. Malcolm D. Lee's *Space Jam: A New Legacy* and James Gunn's

As most theaters remained closed, Warner Bros. announced that their entire 2021 slate of films—seventeen domestic releases in all—would debut on HBO Max the same day as their theatrical opening.

The Suicide Squad would normally have been strong summer tentpole releases, but both had to content themselves with at-home audiences. The newest version of Frank Herbert's cult science-fiction novel, directed by Denis Villeneuve, had many hoping for a definitive interpretation, not to mention a hit. *Dune* did well, spurred by strong word-of-mouth that convinced many to see it on as big a screen as possible. An artfully crafted epic, it starred Timothée Chalamet, Rebecca Ferguson, Oscar Isaac, and Josh Brolin, and it

won six Oscars the following year. Will Smith also took home an Oscar for his performance in *King Richard* as the determined father of tennis superstars Venus and Serena Williams. Rounding out 2021 was Lana Wachowski's *The Matrix Resurrections*, the fourth film in the popular franchise.

> **David Zaslav, an aficionado of classic Hollywood, vowed to restore Warner Bros. to its full glory by focusing on quality theatrical films in a world struggling to recover.**

In 2021, WarnerMedia announced that it would spin off from its parent company and merge with Discovery, Inc. After the $43 billion merger was complete, AT&T planned to quietly exit the entertainment business and stick to telecommunications. When the two companies were combined into Warner Bros. Discovery in 2022, Jason Kilar stepped aside to allow longtime Discovery CEO David Zaslav to run the show. More staff departed, including Ann Sarnoff, who had made history in 2019 as the first woman ever to head Warner Bros.

Zaslav, an aficionado of classic Hollywood, vowed to restore Warner Bros. to its full glory by focusing on quality theatrical films in a world struggling to recover. The time-honored experience of watching movies on a giant screen in a dark theater would continue. As of June 2022, America was tentatively rebounding, with year-to-date US box-office receipts totaling $4.42 bil-

lion, poised to surpass those of China, which were $2.6 billion. Meanwhile, the growth of Netflix slowed and even declined as streaming sources mushroomed and as Americans left their homes to seek entertainment for the first time in two years.

In March, Matt Reeves's *The Batman* became the much-needed tentpole, grossing $770 million worldwide. Amid the era's many cultural and societal changes, some elements remained constant. The Harry Potter, Batman, and Matrix franchises remained crucial to Warner's identity. Legions of multigenerational fans were hungry for new installments. The enduring Looney Tunes characters were still raising mayhem on Cartoon Network and HBO Max. The ageless gray rabbit turned eighty in 2020, and two years later, Warner celebrated Tweety's eightieth birthday by commissioning artists across the world to paint eighty original murals of the sassy yellow canary.

The company founded by Harry, Sam, Albert, and Jack Warner has, with every incarnation, expanded and become more far-reaching while remaining true to its original watchwords: entertainment, enlightenment, storytelling. From Warner Bros. in 1923 to Warner Bros. Discovery in 2023, the family business has grown. What was once a motion picture manufacturer is now a global entertainment leader. HBO Max served nearly 50 million domestic subscribers by early 2022, and 2023 will see HBO Max and Discovery+ combined into one streaming service with millions more.

As Warner Bros. embarks on its second century, it would do well to remember Benjamin Warner's exhortation of more than a century ago: "All for one, one for all."

FROM TOP: John David Washington played a CIA agent who can warp time in Christopher Nolan's *Tenet* (2020). • In Patty Jenkins's *Wonder Woman 1984* (2020), Gal Gadot played the super-heroine in the era in which many fans first encountered her. • Anne Hathaway and her coven advance toward the camera in Robert Zemeckis's *The Witches* (2020), which was based on the 1983 children's novel by Roald Dahl. **OPPOSITE, FROM TOP:** Margot Robbie is a formidable super-heroine in Cathy Yan's *Birds of Prey* (2020). This film was the first DC Universe production to be rated "R" by the Motion Picture Association of America and the second DC Films production following *Joker* (2019) to earn that rating. • These are the lovable characters in Tony Cervone's *Scoob!* (2020), their third feature film.

2020 ACADEMY AWARDS

WINS

Supporting Actor:

★ Daniel Kaluuya in *Judas and the Black Messiah*

Music (Original Song):

★ "Fight for You" from *Judas and the Black Messiah*, Music by H.E.R. and Dernst Emile II; Lyrics by H.E.R. and Tiara Thomas

Visual Effects:

★ *Tenet*, Andrew Jackson, David Lee, Andrew Lockley, and Scott Fisher

NOMINATIONS

Best Picture:

• *Judas and the Black Messiah*, Shaka King, Charles D. King, and Ryan Coogler, Producers

Supporting Actor:

• LaKeith Stanfield in *Judas and the Black Messiah*

Writing (Original Screenplay):

• *Judas and the Black Messiah*, Will Berson and Shaka King; Story by Will Berson, Shaka King, Kenny Lucas, and Keith Lucas

Cinematography:

• *Judas and the Black Messiah*, Sean Bobbit

Production Design:

• *Tenet*, Production Design: Nathan Crowley; Set Decoration: Kathy Lucas

In Shaka King's *Judas and the Black Messiah* (2021), Daniel Kaluuya portrayed Black Panther leader Fred Hampton, whose work was stopped by the FBI. **OPPOSITE, CLOCKWISE FROM TOP LEFT:** Vera Farmiga and Patrick Wilson are paranormal investigators once again in Michael Chaves's *The Conjuring: The Devil Made Me Do It* (2021). • Flanked by cartoon entities, basketball player LeBron James plays a cinematic version of himself in Malcolm D. Lee's *Space Jam: A New Legacy* (2021). • Anthony Ramos and Melissa Barrera in Jon M. Chu's *In the Heights* (2021), a bouncy musical based on the stage play by Quiara Alegría Hudes and Lin-Manuel Miranda.

341

FROM LEFT: Zendaya and Timothée Chalamet in Denis Villeneuve's *Dune* (2021), an impressive adaptation of the 1965 Frank Herbert novel. • Demi Singleton, Saniyya Sidney, and Will Smith in a scene from Reinaldo Marcus Green's *King Richard* (2021), a film biography of Richard Williams, who was dedicated to launching his daughters, Venus and Serena Williams, into professional tennis.

2021 ACADEMY AWARDS

WINS

Actor:

★ Will Smith in *King Richard*

Cinematography:

★ *Dune*, Greig Fraser

Film Editing:

★ *Dune*, Joe Walker

Music (Original Score):

★ *Dune*, Hans Zimmer

Production Design:

★ *Dune*, Production Design: Patrice Vermette; Set Decoration: Zsuzsanna Sipos

Sound:

★ *Dune*, Mac Ruth, Mark Mangini, Theo Green, Doug Hemphill, and Ron Bartlett

Visual Effects:

★ *Dune*, Paul Lambert, Tristan Myles, Brian Connor, and Gerd Nefzer

NOMINATIONS

Best Picture:

• *Dune*, Mary Parent, Denis Villeneuve, and Cale Boyter, Producers

• *King Richard*, Tim White, Trevor White, and Will Smith, Producers

Supporting Actress:

• Aunjanue Ellis in *King Richard*

Writing (Adapted Screenplay):

• *Dune*, Jon Spaihts, Denis Villeneuve, and Eric Roth

Writing (Original Screenplay):

• *King Richard*, Zach Baylin

Costume Design:

• *Dune*, Jacqueline West and Robert Morgan

Film Editing:

• *King Richard*, Pamela Martin

Makeup and Hairstyling:

• *Dune*, Donald Mowat, Love Larson, and Eva von Bahr

Music (Original Song):

• "Be Alive" from *King Richard*, Music and Lyrics by DIXSON and Beyoncé Knowles-Carter

FROM TOP: Austin Butler and Tom Hanks in a scene from Baz Luhrmann's *Elvis* (2022), a film dedicated to the late executive Alan Ladd Jr. • Dwayne Johnson in Jaume Collet-Serra's *Black Adam* (2022), which is based on the DC character.

FROM TOP: Animated characters in Jared Stern's *DC League of Super-Pets* (2022), a 3-D computer-animated comedy. Its voice cast includes Dwayne Johnson, Kevin Hart, and John Krasinski. • Zoë Kravitz and Robert Pattinson starred in Matt Reeves's *The Batman* (2022), a happily profitable film that signaled the beginning of the country's recovery.

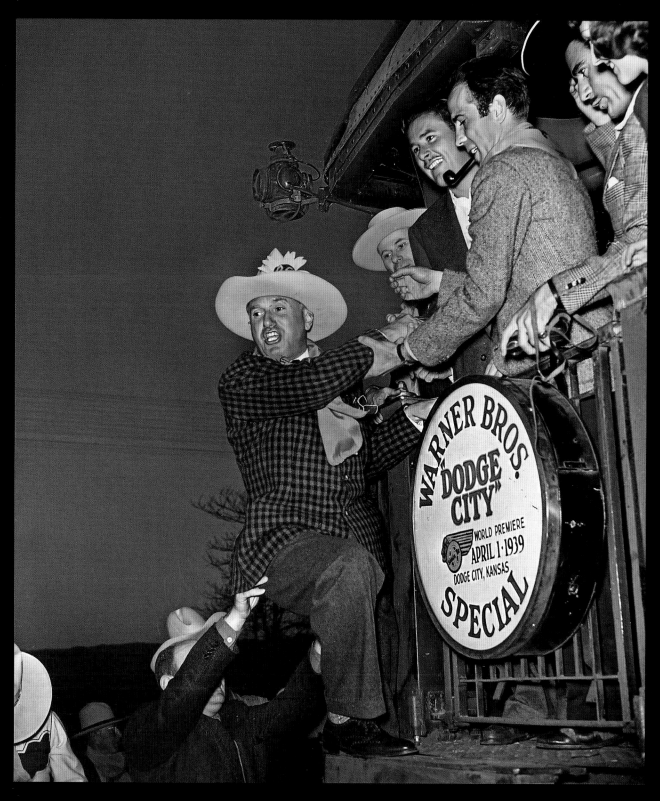

Recalling the Warner patriarch's favorite quote, "All for one, one for all,"
this candid photograph shows studio founder Jack Warner being lifted onto a
train by two of his biggest stars, Errol Flynn and Humphrey Bogart.

ACKNOWLEDGMENTS

I thank my editor, Cindy Sipala, for initiating, guiding, and managing this project, which is to honor a distinguished American corporation.

I thank individuals at Warner Bros. for help with research: Jeff Briggs, George Feltenstein, Victoria Selover, and Ashlea Green. At Running Press, I thank designer Susan Van Horn, Seta Zink, Randall Lotowycz, and Jess Riordan.

I also thank individuals at Turner Entertainment Corporation for their contributions: Eileen Flanagan; Pola Changnon; Genevieve McGillicuddy; Heather Margolis; John Malahy; Taryn Jacobs; Wendy Gardner; Justin Gottlieb; Diana Bosch; Aaron Spiegeland; and Charles Tabesh.

I thank these friends for photographs: John McElwee and Greenbriar Picture Shows; Robert Cosenza; Bill Nelson; Garrett Mahoney; Tom Conroy; Kenton Bymaster; Marc Wanamaker of Bison Archives; and Rob McKay. For specialized research, I thank John Morrissey and Sloan De Forest. I am deeply grateful to Lou Valentino for the loan of vintage Kodachrome transparencies.

I wish to thank David W. Packard and the Packard Humanities Institute.

I acknowledge the education I received from my teachers at St. Joseph High School: Anthony Aiello; Robert Sickenger, Stanley Murakami; and Patrick McCormick. My undergraduate film education derives from the inestimable filmmaker and educator, Robert L. Hillmann.

Many individuals have contributed to this long-awaited project: Albert Agate, Kevin Anderson, Leonardo Baricala, Darin Barnes, Matias Bombal, Anthony Carrillo, Alfred Chico, Francis Coiro, Jon Davison, David Del Valle, Damon Devine, Kathleene Labby, Deon Lambrecht, James Leggio, Mary Mallory, William Martin III, Joseph Ornelas, Eddie Muller, Alan K. Rode, Darrell Rooney, Leonard Stanley, Victor Varela, and Leonel Way.

For generous assistance and support, I am deeply grateful to: Mike Chambless; Helen Cohen; John Connolly; Janine Faelz; Janice Findley; Paul Hansen; Keith Hill; Eugene La Pietra; Garrett Mahoney; Howard Mandelbaum; Ann Meine; Andrew Montealegre; William Nelson; Bruce Paddock; Bronni Stein; the Deacon's Fund of First Congregational Church of Los Angeles, and P.R. Tooke.

I acknowledge the assistance of a recently departed friend from First Church, Eugene Kenourgios. I acknowledge fifty years of counsel and assistance from my recently departed friend, Frank Tingley. I acknowledge the two decades of support I received from my recently departed assistant, Jonathan G. Quiej.

I thank Suzanne McCormick; Pat Tooke; Robert E. Brown; Jann Hoffman; Ruben Alvarez, MD; and Rev. Michael Lehman, Senior Associate Minister of First Congregational Church of Los Angeles.

I thank Deborah Warren of East-West Literary for her steadfast, resourceful work on my behalf.

I thank Alexa Foreman for research. I thank Sloan De Forest for research and contextual advice.

I thank Antonio Marroquin for a smoothly functioning studio and for care of the pets who sit by me as I write.

I thank Cecilia de Mille Presley for her patronage. For guidance and counsel, I thank Helen Cohen of the De Mille Office.

For ongoing encouragement, I thank my family: Jan Callender; Sue Costa; Julie Chambless; Michael and Cindy Chambless; Lenore Griego; Matthew Griffiths; John and Julie Vieira; Guy and Shannon Vieira; and Steve and Janine Faelz.

Lastly, I wish to acknowledge my parents for sending me to the University of Southern California Cinema Department in 1973, where I learned Warner Bros. history by listening to Rudi Fehr, Vincent Sherman, Delmer Daves, Jack Warner, and Bette Davis. I studied Warner Bros. films by making frame enlargements from nitrate prints of *Mystery of the Wax Museum* and *Mildred Pierce*.

SELECTED BIBLIOGRAPHY
Books

Behlmer, Rudy. *Inside Warner Bros. (1935-1951)*. New York: Viking Penguin, Inc., 1985.

Bingen, Steven, with Marc Wanamaker. *Warner Bros.: Hollywood's Ultimate Backlot*. Lanham, MD: Taylor Trade Publishing, 2014.

Biskind, Peter. *Easy Riders, Raging Bulls: How the Sex-Drugs-and-Rock 'n' Roll Generation Saved Hollywood*. New York: Simon and Schuster, 1998.

Buford, Kate. *Burt Lancaster: An American Life*. New York: Alfred A. Knopf, 2013.

Cagney, James. *Cagney by Cagney*. New York: Doubleday, 1976.

Custen, George. *Twentieth Century's Fox: Darryl F. Zanuck and the Culture of Hollywood*. New York: Basic Books, 1997.

_____, and Whitney Stine. *Mother Goddam: The Story of the Career of Bette Davis*. New York: Hawthorn Books, 1974.

Davis, Ronald L. *The Glamour Factory*. Dallas: Southern Methodist University Press, 1993.

Eyman, Scott. *Ernst Lubitsch: Laughter in Paradise*. New York: Simon and Schuster, 1993.

Finler, Joel. *The Hollywood Story*. New York: Crown Publishers, 1988.

Florczak, Robert. *Errol Flynn*. New York: Lyons Press, 2022.

Flynn, Errol. *My Wicked, Wicked Ways*. New York: Cooper Square Press, 2002.

Gabler, Neal. *An Empire of Their Own: How the Jews Invented Hollywood*. New York: Anchor Books, 1989.

Gallagher, John Andrew, and Frank Thompson. *Nothing Sacred: The Cinema of William Wellman*. Asheville, North Carolina: Men with Wings Press, 2018.

Grobel, Lawrence. *The Hustons*. New York: Charles Scribner's Sons, 1989.

Greenberg, Joel, and Charles Higham. *The Celluloid Muse*. New York: Signet, 1972.

Gussow, Mel. *Don't Say Yes Until I Finish Talking*. New York: Doubleday and Company, 1971.

Harmetz, Aljean. *Round Up the Usual Suspects: The Making of* Casablanca: *Bogart, Bergman, and World War II*. New York: Hyperion, 1992.

Hirschhorn, Clive. *The Warner Bros. Story*. New York: Crown Publishers, 1979.

Howard, James. *Stanley Kubrick Companion*. London: B. T. Batsford, Ltd., 1999.

Kotsilibas-Davis, James. *The Barrymores: The Royal Family in Hollywood*. New York: Crown Publishers, 1981.

Lambert, Gavin. *On Cukor*. New York: G. P. Putnam and Sons, 1972.

Lawrence, Jerome. *Actor: The Life and Times of Paul Muni*. New York: G. P. Putnam's Sons, 1974.

Lax, Eric, and Ann Sperber. *Humphrey Bogart*. New York: It Books, 2011.

Madsen, Axel. *Stanwyck*. New York: HarperCollins, 1994.

McCarthy, Todd. *Howard Hawks*. New York: Grove Press, 1997.

Miller, Arnold. *The Films and Career of Robert Aldrich*. Knoxville: University of Tennessee Press, 1986.

Mosley, Leonard. *Zanuck: The Rise and Fall of Hollywood's Last Tycoon*. Boston: Little, Brown, 1984.

Negulesco, Jean. *The Things I Did and the Things I Think I Did*. New York: Linden Press/Simon and Schuster, 1984.

Niven, David. *Bring On the Empty Horses*. New York: Dell Publishing Co., Inc., 1976.

Robinson, Edward G. *All My Yesterdays: An Autobiography*. New York: Hawthorn Books, 1973.

Schatz, Thomas. *The Genius of the System: Hollywood Filmmaking in the Studio Era*. New York: Pantheon Books, 1988.

Schickel, Richard, and George Perry. *You Must Remember This*. Philadelphia: Running Press, 2008.

Sennett, Ted. *Warner Brothers Presents*. New York: Arlington House, 1971.

Server, Lee. *Baby, I Don't Care*. New York: St. Martin's Press, 2001.

Sherman, Vincent. *Studio Affairs: My Life as a Film Director*. Lexington, Kentucky: University of Kentucky Press, 1996.

Shorris, Sylvia, and Marion Abbott Bundy. *Talking Pictures*. New York: The New Press, 1994.

Silke, James R. *Here's Looking at You, Kid*. Boston: Little, Brown, and Company, 1976.

Smith, Steven C. *Music by Max Steiner*. New York: Oxford University Press, 2020.

Sperling, Cass Warner, and Jack Warner Jr. *The Brothers Warner*. Los Angeles: CreateSpace, 2014.

Spoto, Donald. *The Dark Side of Genius: The Life of Alfred Hitchcock*. New York: Da Capo Press, 1999.

Thomas, Tony. *The Busby Berkeley Book*. Greenwich, Connecticut: New Tork Graphic Society, 1973.

Thomson, David. *Warner Bros: The Making of an American Movie Studio*. Yale University Press, 2019.

Thrasher, Frederick. *Okay for Sound*. New York: Duell, Sloan, and Pearce, 1946.

Walker, Alexander. *Joan Crawford, The Ultimate Star*. New York: Harper and Row, 1983.

Wallis, Hal. *Starmaker*. New York: Macmillan, 1980.

Wanamaker, Marc, and E. J. Stephens. Early Warner Bros. Studios. Los Angeles: Arcadia Publishing, 2010.

Warner, Jack Leonard. *My First Hundred Years in Hollywood*. New York: Random House, 1965.

Signed Articles

Atkinson, Claire. "Warner Brothers Shakeup." *New York Times*, September 23, 2010.

Barnes, Brooks. "New Era Begins at Warner Bros., Tinged with Nostalgia." *New York Times*, April 10, 2022.

Cieply, Michael. "Can Batman Help Warner?" *Los Angeles Times*, June 23, 1989.

Frater, Patrick. "North America Set to Beat China as the Global Box Office's Biggest Market."

Maltby, Richard. "*Baby Face,* or How Joe Breen Made Barbara Stanwyck Atone for Causing the Wall Street Crash." *Screen* 27, no. 2 (March/April 1986), pp. 22-45.

Slavitt, David. "Whistling in the Dark" *Newsweek,* February 1, 1965, p. 76.

Sontag, Susan. "The Decay of Cinema." *New York Times Magazine*, February 25, 1996, pp. 59-62, 84.

Surmelian, Leon. "Studio Photographer Confesses." *Motion Picture* 56, no. 6 (January 1939), pp. 38-39, 53.

Whitten, Sarah. "This chart shows 2020 had a chance to break box office records, but Covid caused lowest haul in decades." CNBC.com. December 29, 2020. Accessed May 28, 2020.

Anonymous Articles

"China Box-Office Recovery." Variety.com. May 23, 2022. https://variety.com/2022/biz/asia/north-america-china-global-box-office-recovery-1235275084/.

"Not 1 Chicago Censor Cut in 4 Weeks." *Variety*, September 24, 1934, p. 5.

"*Public Enemy.*" *Time* 17, no. 18 (May 4, 1931), p. 44.

Mediavillage.com. "History's Moment in Media: AOL Time Warner Merger." January 14, 2019. Accessed May 18, 2022. https://www.mediavillage.com/article/historys-moment-in-media-aol-time-warner-merger/.

THR Staff. "It's Official: Jeff Robinov Out at Warner Bros." Hollywoodreporter.com. June 24, 2013. Accessed May 24, 2022. https://www.hollywoodreporter.com/news/general-news/official-jeff-robinov-at-warner-574090/.

https://www.cnbc.com/2020/12/29/box-office-2020-sales-plummeted-80percent-the-lowest-haul-in-decades.html.

Documentary Films

The Adventures of Errol Flynn. Turner Broadcasting, 2002.

You Must Remember This: The Warner Bros. Story. Warner Home Video, 2008.

INDEX

Page numbers in *italics* refer to photographs or their captions.

A

Aadahl, Erik, 315
Aaliyah, 276
Aaron, Quinton, 298–299
Abbott, George, 129, 131
Abrams, J. J., 335
Abramson, Bernie, 169
Accidental Tourist, The, 206, 231–232
Ace Ventura: Pet Detective, 239
Ace Ventura: When Nature Calls, 239
Across the Pacific, 68
Action in the North Atlantic, 68, 84, 86
Adair, Jean, 88–89
Adams, Amy, 303–304
Adams, Nick, 131
Adolfi, John, 29
Adventures of Don Juan, 99, 103
Adventures of Robin Hood, The, 34, 58–60
Affair to Remember, An, 239
Affleck, Ben, 302–304, 315, 324
Affleck, Casey, 274, 295
African Queen, The, 237, 244
After Hours, 205, 222
A.I. Artificial Intelligence, 272, 278–279
Air Force, 68, 86
Aithadi, Nicolas, 308
Alba, Jessica, 302
Albee, Edward, 139
Alda, Robert, 71, 92, 96–97
Aldiss, Brian, 272
Aldrich, Robert, 138, 146, 149
Alexander, Dick, 192, 223, 226, 228, 232, 251
Alexander Hamilton, 31
Alice Doesn't Live Here Anymore, 172, 185, 187
All the President's Men, 173, 192
All This, and Heaven Too, 67, 75–76
All Through the Night, 68
Allen, Gene, 121, 138, 154
Allen, Irwin, 172, 187, 196–197
Allen, Jay Presson, 203, 213
Allen, Levin, 203
Altered States, 202, 210
Altman, Robert, 171, 178–179
Amblin Entertainment, 239
America America, 138, 151
America Online, 271
American International Pictures, 139
American Sniper, 304, 320–321
Analyze This, 242, 267, 280
Anderson, Lindsay, 183

Anderson, Paul Thomas, 304, 320
Andrésen, Björn, 177
Andress, Ursula, 149
Andrews, Dana, 141
Andrews, Julie, 174
Andrews Sisters, 71
Angels with Dirty Faces, 57, 60
Animal Logic, 274
Animal World, 127
animation studio, 33
Aniston, Jennifer, 242
Annabelle, 303
Annabelle Comes Home, 305
Annakin, Ken, 155
Ann-Margret, 239–240
Anthony Adverse, 33, 51–52
Any Which Way You Can, 201, 209
AOL Time Warner, 271–272, 274
Apollonia, 218–219
Apted, Michael, 232
Aquaman, 305, 328
Argo, 303, 315
Arkin, Alan, 162, 164, 185, 303, 315
Arliss, George, 28–29, 31
Arrangement, The, 166
Arsenic and Old Lace, 70, 88–89
Arthur, 203, 213
Ashley, Ted, 140, 171, 174, 202
Ashman, Howard, 205, 226
Assassination of Jesse James by the Coward Robert Ford, The, 274, 295
Associated Artists Productions, 108
Astaire, Fred, 162–163, 186–187
Astin, Sean, 204, 221
Astor, Mary, 69, 78–79
Atwill, Lionel, 43
Auntie Mame, 108, 132
Austin, Michael, 220
Avedon, Doe, 120–121
Averback, Hy, 162
Avery, "Tex," 33
Aviator, The, 273, 287–288
Avildsen, John G., 206, 234–235
Ayer, David, 304, 324–325
Aykroyd, Dan, 222, 235
Ayres, Lew, 101

B

Babbitt, 14
Baby Doll, 108, 128
Baby Face, 32, 42–43
Bacall, Lauren, 71, 88, 94–95, 100–101, 110–111
Bacon, Kevin, 273
Bacon, Lloyd, 44–45, 53, 84
Bad Seed, The, 107, 126–128
Badlands, 172, 183
Baer, Max, Jr., 190–191

Baez, Joan, 170
Bainter, Fay, 59–60
Baird, Stuart, 197, 232, 260, 266
Bakalyan, Richard, 152
Baker, Carroll, 108, 128, 152–153
Baker, Rick, 220
Baker, Sam, 18
Baldwin, Alec, 206, 272
Bale, Christian, 206, 228, 274, 296–297, 303, 314
Ball, Charles, 170
Ball, Lucille, 150, 185
Ballard, J. G., 206
Bambi, 69
Bancroft, Anne, 188–189
Barbeau, Adrienne, 203
Barbera, Joseph, 302
Barnes, Rayford, 166–167
Baroda Productions, 135
Barrat, Robert, 42–43
Barrera, Melissa, 340–341
Barron, Arthur, 193
Barron, Dana, 216
Barry, Wesley, 7
Barry Lyndon, 173, 188–189
Barrymore, Diana, 109
Barrymore, John, 7–8, 14, 17–18, 20, 29, 31, 34–35, 39, 69, 109
Barrymore, Lionel, 100–101
Barthelmess, Richard, 22, 36–37
Bartkowiak, Andrzej, 271, 276
Basinger, Kim, 241, 264
Bass, Saul, 171
Bassett, Angela, 238
Bates, Kathy, 237, 333
Batjac, 106
Batman, 1, 207, 233, 235, 237, 240
Batman, The, 337, 344
Batman & Robin, 241, 263
Batman Begins, 274, 290
Batman Forever, 240, 259
Batman Returns, 238–239, 249, 251
Batman v Superman: Dawn of Justice, 304, 324
Battle Cry, 107, 124
Battle of the Bulge, 155
Baxter, Anne, 116–118
Bayer, Samuel, 302
Beals, Jennifer, 302
Beast from 20,000 Fathoms, The, 106, 116–117
Beaton, Cecil, 138, 154
Beatty, Warren, 138–139, 144–145, 160–161, 171, 178–179, 239, 255
Beau Brummel, 8, 14, 69
Beaumont, Harry, 10–11, 14
Bebb, Peter, 308
Beckinsale, Kate, 273

Beesemeyer, William, 5
Beetlejuice, 206, 230–232
Before Sunrise, 273, 288
Before Sunset, 273
Belafonte, Harry, 172
Bell, Monta, 14
Bell Laboratories, 8
Bening, Annette, 239–240, 246–247, 255
Benjamin, Richard, 172, 204
Bennett, Bruce, 100–101
Bennett, Joan, 28–29
Benny, Jack, 71
Benson, Robby, 190–191
Benton, Robert, 161, 194
Berendt, John, 241
Berenson, Marisa, 173, 189
Beresford, Bruce, 206, 235
Berger, Helmut, 166–167
Bergman, Ingrid, 69, 82, 90, 131
Berkeley, Busby, 32, 44–46, 50, 52, 56
Berlin, Irving, 70
Bernard, Thelonious, 173
Bernhardt, Curtis, 94–95
Bernhardt, Sarah, 8
Bernsen, Corbin, 274
Bernstein, Carl, 173
Berry, Halle, 260, 314
Bertolucci, Bernardo, 238
Best Friends, 214–215
Best in Show, 271, 276
Better 'Ole, The, 17
Between Two Worlds, 88
Bewke, Jeff, 301
Beyond the Forest, 73, 102–103
Big Bang Theory, The, 335
Big Hand for the Little Lady, A, 157
Big Sleep, The, 71, 94–95
Big Trees, The, 105, 116
Big Wednesday, 196–197
Binoche, Juliette, 303
Bird, 206, 229, 232
Bird, Brad, 242
Birds of Prey, 335, 338–339
Bishop, Joey, 141
Bisset, Jacqueline, 172
Black, Shane, 274, 289
Black Adam, 343
Blade Runner, 202–203, 214–215, 304
Blade Runner 2049, 304, 326–327
Blair, Linda, 172–173, 184
Blanchett, Cate, 273, 287–288, 304
Blanke, Henry, 32, 73, 135
Blatt, Edward, 88
Blatty, William Peter, 172, 184

Blazing Saddles, 172, 186–187
Bledel, Alexis, 274, 290
Blessed Event, 41
Blind Side, The, 298–299
Blondell, Joan, 1, 41–43
Blood Diamond, 292–293
Blood Work, 272, 280
Bloom, Orlando, 273, 319
Blue Gardenia, The, 118
Blunt, Emily, 320
Blyth, Ann, 90–92
Bobo, The, 160
Body Heat, 203, 211
Bodyguard, The, 238, 249, 251
Bogart, Humphrey, 1, 51, 62, 64–65, 68–69, 71–72, 74–75, 78, 80–82, 84, 86, 88, 94–95, 100–101, 345
Bogdanovich, Peter, 139, 171, 179
Bolger, Ray, 106
Bonasso, Vincent, 297
Bonnie and Clyde, 139, 160–161
Book of Eli, The, 302, 306
Boorman, John, 169, 171, 173, 180–181, 202
Borgnine, Ernest, 166–167
Boseman, Chadwick, 303, 316–317
Bostock Jungle and Film Company, 4–5
Boulevard Nights, 173–174, 198
Bowles, Paul, 238
Boyd, Joe, 172
Boyer, Charles, 70, 138, 145, 165
Brahm, John, 116
Brambilla, Marco, 252–253
Bramble Bush, The, 141
Brandel, Marc, 203
Brando, Marlon, 105, 108, 114, 130, 173
Brass, 12
Breaking Point, The, 106, 112
Breen, Joseph, 105, 139
Brennan, Eileen, 210
Brennan, Walter, 88
Brest, Martin, 199
Brevig, Eric, 302
Brickman, Paul, 204, 216, 237
Bridges of Madison County, The, 239, 258–259
Bright, Simon, 315
Brisbane, Arthur, 4
British Board of Film Censors, 171
British Censor Board, 46
Broadway After Dark, 14
Brolin, Josh, 204, 221, 336
Bronco Billy, 201
Bronson, Charles, 120
Brooks, Albert, 246
Brooks, Louise, 27
Brooks, Mel, 172, 186–187
Brosnan, Pierce, 240
Brothers, 193
Brown, Helen Gurley, 152–153
Brown, Peter, 142–143
Brown, Wally, 120–121

Bryce, Alexander, 226
Brynner, Yul, 165
Bucket List, The, 274, 294
Bugs Bunny, 33, 171, 174, 199, 239, 249, 260, 273, 337
Bugs Bunny/Road Runner Movie, The, 174, 199
Bugs Bunny's 3rd Movie: 1001 Rabbit Tales, 203
Bujold, Genevieve, 204
Bullitt, 139, 164
Bullock, Sandra, 241, 261, 265, 272, 276, 298–299, 303–304, 318
Buono, Victor, 152
Burge, Stuart, 156
Burke, Billie, 80
Burke, Michèle, 226
Burke, Tim, 288, 308, 312
Burns, George, 173–174, 194, 199, 202
Burroughs, Edgar Rice, 204, 304
Burstyn, Ellen, 172, 184–185, 187
Burton, Richard, 141, 158
Burton, Tim, 205–207, 230–231, 233, 238, 240, 249, 274, 289–290, 302
Burton, Willie D., 210, 232, 269
Busey, Gary, 196–197
Butler, Austin, 335, 343
Butler, David, 86–87, 118
Butler, Gerard, 294–295
Butler, Greg, 312
By the Light of the Silvery Moon, 106, 118
Byrne, David, 225
Byrne, Gabriel, 202
Byrnes, Edd, 142–143

C

Caan, James, 185
Caddyshack, 202, 208
Caged, 105, 112
Cagney, James, 1, 31, 38–39, 41, 57, 60, 64–65, 68–69, 73–75, 80, 83, 102–103, 107
Cagney, Jeanne, 80
Cahill U.S. Marshal, 170
Cain, Christopher, 250
Caine, Michael, 203, 272
Calamity Jane, 107, 118
Calkins, Johnny, 96–97
Calley, John, 171, 174
Cambridge, Godfrey, 170
Camelot, 140, 160–161
Cammell, Donald, 175
Campaign, The, 314
Campbell, Martin, 310–311
Campbell, William, 120–121
Candidate, The, 171, 180–181
Cannon, Dyan, 203, 208
Cantor, Eddie, 9
Canutt, Tap, 166–167
Capra, Frank, 88–89
Captain Blood, 33, 49–50
Cara, Irene, 173, 190

Cardellini, Linda, 281
Carey, Timothy, 120
Carlino, Lewis John, 174
Carmichael, Hoagy, 88
Carney, Art, 174, 199
Caron, Glenn Gordon, 239, 255
Caron, Leslie, 138
Carrey, Jim, 239–240, 259
Carter, Helena Bonham, 274, 290, 294, 302, 304
Casablanca, 1, 69–70, 80–82, 86, 240
Cascade theater, 3
Castle, Nick, 239
Castle, William, 242
Catchings, Waddell, 7
Cates, Phoebe, 244
Caton-Jones, Michael, 252–253
Cats & Dogs, 272
Cattrall, Kim, 204
Cavill, Henry, 303–304, 317, 324
Cervone, Tony, 260, 338–339
Chalamet, Timothée, 336, 342
Chamberlain, Richard, 165, 186–187
Chandler, Raymond, 71
Chandrasekhar, Jay, 274
Chaplin, Charles, 17
Chaplin, Sydney, 17
Charge of the Light Brigade, The, 52
Chariots of Fire, 202, 212–213
Charleson, Ian, 202, 212–213
Charlie and the Chocolate Factory, 274, 289–290
Chase, Chevy, 202, 204–205, 208, 216, 222, 233, 263
Chastain, Jessica, 332
Chatterton, Ruth, 32
Chaves, Michael, 336, 340–341
Cheadle, Don, 241
Chechik, Jeremiah S., 233
Cher, 228
Chevalier, Maurice, 138
Cheyefsky, Paddy, 202
Cheyenne, 108
Cheyenne Autumn, 152–154
Chinatown, 169
Chiniquy, Gerry, 138
Chisum, 170, 175
Christensen, Benjamin, 26–27
Christie, Julie, 171, 178–179
Christmas in Connecticut, 71
Chu, Jon M., 304, 329, 336, 340–341
Chung, Jamie, 310
Cimino, Michael, 174
Cinderella Story, A, 273, 285
CinemaScope, 107
Citizen Kane, 71, 78
City for Conquest, 68
City Heat, 204
Clampett, Bob, 33
Clan of the Cave Bear, The, 226
Clark, Fred, 132
Clark, Jim, 220, 226
Clark, Joe, 234–235

Clark, Petula, 162–163
Clark, Susan, 188–189
Clarke, Mae, 38–39
Clarkson, Patricia, 231
Clash of the Titans, 302, 306
Clash of the Wolves, 15
Claudelle Inglish, 145
Clayton, David, 315, 318
Cleary, Jon, 138
Cleopatra Jones, 170, 182
Cleopatra Jones and the Casino of Gold, 170
Client, The, 239, 256
Clift, Montgomery, 106, 116–117
Clifton, Peter, 190–191
Clockwork Orange, A, 171, 173, 178–179
Clooney, George, 241–242, 263, 267, 271–272, 274, 278, 290–291, 294, 303, 315
Close, Glenn, 203–204, 214–215, 230–232, 238, 240, 244–245
Cloud Atlas, 314
Clouse, Robert, 182
Clyde, 173, 195, 201
Cobb, Lee J., 172
Cobra, 225
Coca, Imogene, 204
Cocker, Joe, 170
Coen brothers, 255
Cohan, George M., 69
Cohen, Jeff, 221
Coleman, Nancy, 95
Collet-Serra, Jaume, 343
Colman, Ronald, 15
Color Purple, The, 205, 222–223
Columbus, Chris, 272–273, 279, 281
Come Back Charleston Blue, 170
Come Fill the Cup, 105, 114
Command, The, 107
Committee for the First Amendment, 72
Common, 324–325
Confessions of a Nazi Spy, 34, 61
Conjuring, The, 303, 317
Conjuring 2, The, 324
Conjuring: The Devil Made Me Do It, The, 336, 340–341
Connery, Sean, 157, 203, 212–213
Connick, Harry, Jr., 310
Connolly, Walter, 53
Conrad, Robert, 142–143
Conroy, Pat, 174
Constant Nymph, The, 70, 86, 88
Contact, 264
Convention City, 32, 42–43
Conway, Lyle, 226
Coogler, Ryan, 304, 322–323, 339
Cook, Fielder, 157
Cool Hand Luke, 139, 160–161
Coolidge, Jennifer, 276
Coonan, Dorothy, 43
Cooper, Bradley, 298, 302, 304, 310, 320–321, 331, 333

Cooper, Gary, 68, 77, 79, 102, 134–135
Cooper, Gladys, 83, 154
Cooper, Jackie, 206
Coppola, Francis Ford, 139, 162–163, 166, 170, 203, 216
Corbould, Chris, 297, 308
Corigliano, John, 210
Corman, Roger, 205
Corn Is Green, The, 92
Corpse Bride, 274, 290
Cosby, Bill, 172
Cosmatos, George P., 225
Costello, Dolores, 20, 23
Costner, Kevin, 238–239, 246–248, 252–253, 261, 303
Cotillard, Marion, 308
Cotten, Joseph, 73
Cowboys, The, 170, 179
Craig, Stuart, 226, 232, 279, 290, 308, 312, 325
Cranshaw, Paul, 276
Cranston, Bryan, 303
Craven, Wes, 302
Crawford, Joan, 71, 73, 90–93, 98, 105, 138, 146
Crazy Rich Asians, 304, 329
Creed, 304, 322–323
Creepshow, 203
Crenna, Richard, 160
Cretton, Destin Daniel, 332–333
Crichton, Michael, 241
Crime Wave, 120
Crimson Pirate, The, 116
Critic's Choice, 150
Cromwell, James, 241
Crosland, Alan, 20–21, 23, 27, 34–35
Cross, Ben, 202, 212–213
Crossing Delancey, 206
Crowded Sky, The, 141
Crowe, Cameron, 250
Crowe, Russell, 241
Cruise, Tom, 204, 216, 239, 242, 256, 267, 284, 320
Cry in the Dark, A, 231–232
Cry Wolf, 71
Crystal, Billy, 242, 267, 280
Cuarón, Alfonso, 259, 273, 303, 318
Cukor, George, 107, 119, 138, 154
Culkin, Macaulay, 255
Cumming, Alan, 272
Cummings, Robert, 83
Curse of Frankenstein, The, 108, 129
Curtis, Tony, 139, 152–153, 156
Curtiz, Michael, 24–25, 33, 39, 41, 43, 52, 57–61, 68–71, 75, 80–81, 83–86, 90–91, 94–95, 106, 111–112
Cusack, Joan, 237
Cusack, John, 241
Cushing, Peter, 108, 129, 175

D

DaCosta, Morton, 108, 132, 148
Daffy Duck, 33, 273
Dahl, Roald, 274, 338

Daly, Robert, 202, 240, 242
Dames, 46
Damn Yankees, 131–132
Damned, The, 140, 166–167
Damon, Matt, 272, 274, 290–291, 294, 298
D'Angelo, Beverly, 204–205, 216, 222, 233, 263
Dangerfield, Rodney, 202, 208
Dangerous, 33, 48, 50
Dangerous Liaisons, 230–232
Dante, Joe, 204, 206, 219, 238, 244, 273, 282–283
Darabont, Frank, 242, 268–269
Dark at the Top of the Stairs, The, 137, 142
Dark Knight Rises, The, 303, 314
Dark Knight, The, 274–275, 296–297, 302, 312
Dark Knight trilogy, 274
Dark Shadows, 302, 314
Dark Victory, 33–34, 65, 70
Darro, Frankie, 43
Dauphin, Claude, 165
Dave, 254
Daves, Delmer, 107, 109, 134–135, 137, 144–145, 149
Davies, Joseph E., 70
Davis, Andrew, 239, 241, 254, 265
Davis, Angela, 193
Davis, Bette, 1, 33–34, 41, 48, 50–51, 53, 57, 59–60, 64–65, 67, 69, 71, 73, 75–76, 78–79, 83, 86–89, 92, 94–95, 99, 102–103, 138, 146, 148
Davis, Geena, 206, 231–232
Davis, Sammy, Jr., 138, 141, 152
Dawn Patrol, The, 36–37, 39, 59
Day, Doris, 71, 100–101, 106–107, 118, 129
Day for Night, 172, 184, 187
Days of Wine and Roses, 138, 146–148
DC League of Super-Pets, 344
de Bont, Jan, 241, 262
De Havilland Law, 68
de Havilland, Olivia, 33–34, 62, 68, 77, 95, 196–197
De La Paz, Danny, 174, 198
de Mornay, Rebecca, 216
De Niro, Robert, 172–173, 182, 205, 224, 238, 242–243, 246–247, 257, 267, 280
de Toth, André, 106, 116–117, 120
Dead Calm, 207
Dead Pool, The, 206, 231
Dean, James, 107–108, 122–125, 128
Dear Heart, 152, 154
Death in Venice, 177–178
Deathtrap, 203
DeCamp, Rosemary, 80
Deception, 73, 106, 115
Dee, Sandra, 109, 134–135
Deep Valley, 72
Defending Your Life, 246

Del Rio, Dolores, 46, 152–153
del Ruth, Roy, 28–29, 41
Deliverance, 171, 180–181
DeMille, Cecil B., 8, 68
Demolition Man, 252–253
Dempsey, Patrick, 302
Dench, Judi, 271, 302
Dennis, Sandy, 158–159, 162–163
Dennis the Menace, 237, 239
Denver, John, 173, 194
Departed, The, 274, 293
Depp, Johnny, 274, 289, 295, 302, 314
Derek, Bo, 174
Dershowitz, Alan, 238
Desert Song, The, 89
Desplat, Alexandre, 297, 315
Destination Tokyo, 68, 86
Deutch, Howard, 258–259
Devils, The, 171
DeVito, Danny, 238, 241
Devotion, 95
di Bonaventura, Lorenzo, 240
Dial M for Murder, 106, 119, 241
Dias, Larry, 308
DiCaprio, Leonardo, 252–253, 273–274, 287–288, 292, 302–303, 308, 317
Dickinson, Angie, 107, 109, 141–143, 145
Diesel, Vin, 242
Dieterle, William, 32, 46, 48, 51, 54–56, 64–65, 67
Dietrich, Marlene, 77, 106, 110–111
Dietz, Jack, 106
Diggs, Taye, 242
Dillon, Matt, 198, 204
Dirty Harry, 169, 171
Disney company, 304
Disraeli, 28–29
Divine Lady, The, 23–24
Divine Madness, 202, 208
Divine Secrets of the Ya-Ya Sisterhood, 272
Dobson, Tamara, 170, 182
Doc Hollywood, 246
Dodge City, 34, 62
Dog Day Afternoon, 172, 188–189
Dolphin Tale, 302, 310
Dominik, Andrew, 274
Don Juan, 8, 17
Donahue, Troy, 109, 134–135, 137, 142–145, 150
Donat, Robert, 33
Donen, Stanley, 129, 131
Donner, Richard, 173, 197, 204–206, 221, 227, 234–235, 238, 241, 256, 266
Donohue, Jack, 155
Doorway to Hell, The, 39
Dorsey, Jimmy, 71
Double Indemnity, 71, 203
Dougherty, Michael, 332–333
Douglas, Gordon, 120, 122, 145, 152

Douglas, Kirk, 105, 111, 116, 176
Douglas, Michael, 239, 241, 252, 265
Downey, Robert, Jr., 274–275, 289, 298–299, 309
Dr. Ehrlich's Magic Bullet, 67, 76
Dracula Has Risen from the Grave, 166
Dreamgirls, 173
Dreams, 237, 244
Dreamworks, 272
Dreyfuss, Richard, 173, 194, 227
Driving Miss Daisy, 206, 235
Drowning Pool, The, 188–189
Drum Beat, 107
Dubin, Al, 44–45, 50, 56
Dudman, Nick, 312
Duel in the Sun, 73
Duff, Hilary, 273, 285
Duggan, Andrew, 142–143
Dukes of Hazzard, The, 273–274
Dunaway, Faye, 160–161, 166, 186–187
Duncan, Michael Clarke, 268–269
Dune, 336–337, 342
Dunkirk, 326–327
Dunne, Griffin, 205, 222, 265
Dunne, Irene, 96–97
Duquesne Amusement Supply Co., 3
Durante, Jimmy, 80
Duvall, Robert, 139, 166, 170, 174, 177, 210, 321
Duvall, Shelley, 201, 209
Dvorak, Ann, 41, 46
Dyas, Guy Hendrix, 308

E

Eagels, Jeanne, 67
East of Eden, 107, 122–124
Eastwood, Clint, 1, 169, 171, 173, 183, 190–191, 193, 195, 201, 203–207, 209, 214, 224, 229, 231, 237–239, 241, 244, 250–253, 258–259, 271–273, 276–277, 280, 284, 287–288, 293, 297, 302–305, 320–321, 329
Eastwood, Kyle, 203
Edelman, Lou, 73
Edeson, Arthur, 82, 86
Edge of Darkness, 68
Edge of Tomorrow, 320
Edison, Thomas A., 3
Edison Kinetoscope, 2–3
Edwards, Blake, 138–139, 146–147, 156, 174
Edwards, Gareth, 303, 319
Eichelbaum, Pearl, 2
Eisenhower, Dwight D., 68
Eisley, Anthony, 142–143
Ekberg, Anita, 149
Elfman, Jenna, 273, 282–283
Elvis, 335, 343
Embry, Ethan, 263
Emerson, Faye, 88
Emigrants, The, 178, 180–181

Emmerich, Roland, 274
Empire of the Sun, 206, 228
Enemy of the People, An, 196–197
Enforcer, The, 190–191
Engelen, Paul, 220
Enright, Ray, 46
Enter the Dragon, 171, 182
Ephron, Nora, 241, 266
ER, 242
Eraser, 261–262
Escalante, Jaime, 206
Estevez, Emilio, 203–204
E.T. the Extra-Terrestrial, 205
Evans, Dame Edith, 165
Evans, Luke, 319
Every Which Way but Loose, 173, 195, 201
Excalibur, 202, 213
Executive Decision, 260
Exorcist, The, 1, 172, 184, 201
Exorcist II: The Heretic, 173
Extremely Loud & Incredibly Close, 312
Eyes Wide Shut, 241–242, 267

F

Face in the Crowd, A., 108, 129
Fairbanks, Douglas, Jr., 36–39
Fairley, Michelle, 306–307
Falling Down, 239, 252
Fanny, 138, 145
Fantastic Beasts and Where to Find Them, 304, 324–325
Fantastic Beasts: The Crimes of Grindelwald, 304, 330
Fargo, James, 190–191
Farmiga, Vera, 303, 317, 340–341
Farrell, Charles, 15
Farrell, Henry, 138
Farrell, Joe, 308
Farrell, Nicolas, 212–213
Fazenda, Louise, 10–11
Feist, Felix E., 116
Feldman, Charles K., 106, 114
Feldman, Corey, 206, 221
Female, 32
Ferber, Edna, 67, 108
Ferguson, Rebecca, 336
Ferrell, Will, 314
Ferren, Brian, 226
Ferrera, America, 274, 290
Ficarra, Glenn, 322–323
Field, Rachel, 67
Fiennes, Ralph, 302
Fifty Million Frenchmen, 32
Film Daily, 10–11
Filoni, Dave, 274
Findlater, Rick, 315
Fine Madness, A, 157
Finian's Rainbow, 162–164
Firefox, 203, 214
First Lady, 53
First National, 4, 8, 10, 28–29, 41, 47, 50, 60, 65
Fishburne, Laurence, 242, 273

Fisher, Terence, 129, 175
Fitzgerald, F. Scott, 303
Five Star Final, 33, 39, 41
Flags of Our Fathers, 293
Flame and the Arrow, The, 107, 112
Fleming, Andrew, 274
Flint, Motley, 7
Florey, Robert, 71
Flowers and Trees, 34
Flynn, Errol, 33–34, 49, 52, 57–62, 64, 68, 71, 75, 96, 99, 105, 109, 345
Focus, 322–323
Foghorn Leghorn, 69
Fonda, Bridget, 250
Fonda, Henry, 107, 124, 126–127, 149, 155, 176
Fonda, Jane, 137, 141, 171, 177–178, 182
Fontaine, Joan, 70, 86, 127
Footlight Parade, 1, 32, 45
Foran, Dick, 51
Forbes, Bryan, 165
Ford, Constance, 109
Ford, Glenn, 94–95
Ford, Harrison, 202, 238–239, 243, 254, 304
Ford, John, 107–108, 125, 138, 152–153
Ford, Paul, 155
42nd Street, 32, 44–45
42, 303, 316–317
Fossey, Dian, 232
Foster, Gloria, 273
Foster, Jodie, 256, 264
Fountainhead, the, 102
Four Daughters, 59–60
4 for Texas, 138, 149
Fox, Michael J., 241, 246
Fox, The, 162–163
Fox, William, 4, 9
Fox Film Corporation, 31–32, 45
Foxx, Jamie, 302, 332–333
Foy, Bryan, 23, 114
Francis, Freddie, 166
Francis, Kay, 1, 32–33, 47, 53, 55, 69
Francis, Noel, 40
Francks, Don, 162–163
Frank, Charles, 216–217
Frank, Melvin, 188–189
Franken, Steve, 176
Frankenstein Must Be Destroyed, 175
Franklin, Aretha, 190
Franklin, Chester, 12–13
Franklin, Paul, 297, 308, 321
Fraser, Brendan, 273, 282–283
Frazier, Sheila, 180
Frear, Stephen, 230–231
Free Willy, 239, 252–253
Free Willy 2: The Adventure Home, 239–240
Freebie and the Bean, 185
Freeman, Al, Jr., 238

Freeman, Kathleen, 176
Freeman, Martin, 316–317
Freeman, Morgan, 206, 234–235, 239, 250–251, 274, 287–288, 294, 298
Freleng, Friz, 33, 48, 145
Fresholtz, Les, 192, 210, 223, 226, 228, 232, 251
Friday the 13th, 273
Friedkin, William, 172, 184
Friends, 242, 335
Frisco Jenny, 32
Fugitive, The, 1, 237, 239, 254
Full Metal Jacket, 205–206, 228
Fuqua, Antoine, 272
Furie, Sidney J., 206, 227
Furthman, Jules, 133

G

Gadot, Gal, 301, 304, 326, 338
Gaghan, Stephen, 274, 290–291
Galifianakis, Zach, 298, 310, 314
Galligan, Zach, 244
Gamble, Mason, 239
Gamble, Nathan, 310
Game of Thrones, 335
García, Andy, 272
Garcia, Jose Antonio, 315
Gardiner, Reggie, 80
Gardner, Ava, 273
Garfield, John, 59–60, 71, 88, 105–106, 112
Garland, Judy, 107, 119, 121, 146–147
Garner, James, 107–108, 276–277
Garner, Jennifer, 302
Gaudio, Bob, 303
Gauntlet, The, 173, 193
Gavin, John, 165
Gay Purr-ee, 146–147
Gellar, Sarah Michelle, 272, 281
General Crack, 34–35
General Film, 3
George, Dan, 173
George, Lynda Day, 175
Gerard, James W., 4
Gerber, William, 240
Gerroll, Daniel, 212–213
Gershwin, George, 10, 71
Gertz, Jamie, 206
Get Carter, 271–272
Get Smart, 273
Ghia, Fernando, 226
Ghost, 238
Giallelis, Stathis, 151
Giant, 108, 125, 128
Gibson, Mel, 174, 198, 202, 205–206, 227, 229, 234–235, 238, 241, 266
Gilroy, Tony, 274, 295
Girlfriends, 173
Glass Menagerie, The, 105, 110–111
Glenn, Scott, 216–217
Glorious Betsy, 22–23
Glover, Danny, 205–206, 227, 234–235, 238, 241, 266
G-Men, 33

God Is My Co-Pilot, 71
God's Country and the Woman, 34, 55
Godzilla, 303, 319
Godzilla: King of the Monsters, 305, 332–333
Going in Style, 174, 199
Gold Diggers of 1933, 33, 44–45, 50
Gold Diggers of 1937, 52
Gold Diggers of Broadway, 28–29
Goldberg, Whoopi, 205, 222–223
Goldblum, Jeff, 272
Goldenberg, William, 315
Golding, Henry, 329
Gone with the Wind, 69
Good Night, and Good Luck, 290–291
Goodbye Girl, The, 173, 194
Goodfellas, 238, 243, 245
Gooding, Cuba, Jr., 257
Goodman, John, 303
Goonies, The, 204–205, 221
Gordon, Dexter, 226
Gordon, Ruth, 156, 201, 209
Gordon, Seth, 302
Gordon, Steve, 203, 213
Gordon Street Studio, 5
Gorillas in the Mist, 232
Gosling, Ryan, 304
Gosnell, Raja, 272, 281
Goulding, Edmund, 59, 70, 78–79
Graff, Todd, 313
Gran Torino, 297
Granger, Farley, 114
Grant, Cary, 71, 88–89, 94–95, 131
Gravity, 303, 318
Greased Lightning, 193
Great Depression, 31
Great Gatsby, The, 303, 317–318
Great Lie, The, 69, 78–79
Great Race, The, 139, 156
Great Santini, The, 174, 210
Great Train Robbery, The, 3
Green, Alfred E., 28–29, 42–43, 48
Green, Kerri, 221
Green, Reinaldo Marcus, 342
Green Berets, The, 140, 162–163
Green Goddess, The, 29
Green Lantern, 310–311
Green Mile, The, 242, 268–269
Greenstreet, Sydney, 69, 78–79
Gremlins, 204, 219
Gremlins 2: The New Batch, 238, 244
Greystoke: The Legend of Tarzan, Lord of the Apes, 204, 220
Grier, Pam, 193
Griffith, Andy, 108, 129, 131
Griffith, Corinne, 24, 36
Griffith, D.W., 8
Grill, Bryan, 308
Grimes, Gary, 178–179
Grimes, Luke, 320–321
Grint, Rupert, 272, 279, 312

Grisham, John, 239, 241
Grumpier Old Men, 240, 258–259
Grumpy Old Men, 239, 252
Guber, Peter, 207, 237, 240
Guest, Christopher, 271, 273, 276, 282–283
Guillermin, John, 172, 186–187
Guilty by Suspicion, 246–247
Gunn, James, 336
Guterman, Lawrence, 272
Guttenberg, Steve, 204, 219
Gutteridge, Martin, 226
Guzmán, Luis, 313
Gypsy, 137–138, 148

H

Hackman, Gene, 161, 171, 201, 206, 239, 251
Hader, Bill, 332
Haggis, Paul, 274, 288, 293
Haim, Corey, 206
Hale, Alan, 10–11
Hall, Anthony Michael, 216
Haller, Ernest, 60, 76, 92, 112, 148
Hallström, Lasse, 257
Hamilton, Neil, 28–29
Hamlet, 8, 245
Hammer, Armie, 302
Hammer Film, 108, 170, 175
Hammett, Dashiell, 69, 86
Hampton, Fred, 336, 340
Hancock, Herbie, 226
Hancock, John Lee, 298–299
Hand, The, 203
Handzlik, Jan, 132
Hanging Tree, The, 134–135
Hangover, The, 275, 298, 302
Hangover Part II, The, 310
Hanks, Tom, 237, 241–243, 266, 268–269, 287, 304, 343
Hanna, William, 272, 302
Hanna-Barbera, 272
Hanson, Curtis, 241, 264
Happy Feet, 274, 293
Happy Feet Two, 310–311
Harden, Marcia Gay, 284
Hardin, Ty, 142–143, 150
Harlow, Jean, 108
Harman, Hugh, 33
Harms Inc., 10
Harper, 188–189
Harrelson, Woody, 205, 239, 255
Harris, Ed, 216–217
Harris, Julie, 106, 122–123
Harris, Mark Jonathan, 271, 276–277
Harris, Richard, 160, 239
Harrison, Rex, 138, 154
Harry Potter and the Chamber of Secrets, 273, 281
Harry Potter and the Deathly Hallows: Part 1, 302, 306–308
Harry Potter and the Deathly Hallows: Part 2, 302, 312
Harry Potter and the Goblet of Fire, 271, 274, 290

Harry Potter and the Half-Blood Prince, 275, 298
Harry Potter and the Order of the Phoenix, 274, 294
Harry Potter and the Prisoner of Azkaban, 273, 287–288
Harry Potter and the Sorcerer's Stone, 272, 279
Harry Potter franchise, 1, 240, 272, 337
Harryhausen, Ray, 106, 116–117, 127, 166
Hart, Kevin, 344
Hartman, Phil, 205
Hathaway, Anne, 302, 314, 338
Hathaway, Donny, 170
Havers, Nigel, 212–213
Haward, Jim, 120
Hawke, Ethan, 272, 278–279, 288
Hawks, Howard, 36–37, 68, 71, 77, 79, 88, 94–95, 109, 133
Hawn, Goldie, 202, 205, 210, 214–215, 219, 224
Hayworth, Rita, 77
Head, Jae, 298–299
Head, John, 172
Heart Is a Lonely Hunter, The, 162, 164
Heartbreak Ridge, 205, 224, 226
Heat, 257
Heat Lightning, 46
Heaven's Gate, 174
Heckerling, Amy, 205, 222
Heisler, Stuart, 110–111
Helgeland, Brian, 241, 264, 284, 303, 316–317
Hellinger, Mark, 71
Hello, Dolly! 174
Helms, Ed, 298, 310
Hemingway, Ernest, 67, 106, 108
Hemingway, Mariel, 206, 214
Hendrix, Jimi, 172
Hennah, Dan, 315
Henreid, Paul, 95, 165
Henriksen, Lance, 216–217
Henry, Buck, 246
Henry VI, Part III, 29
Henson, Jim, 244
Hepburn, Audrey, 109, 135, 138–139, 154, 160–161
Hepburn, Katharine, 165, 239, 255, 273
Her, 303, 317–318
Herbert, Frank, 336, 342
Hereafter, 302, 308
Herman, Pee-wee, 205
Heslov, Grant, 290, 315
Heston, Charlton, 177, 272
Heyman, David, 275, 318
Heywood, Anne, 162–163
High and the Mighty, The, 106, 120–121
High Sierra, 69
Hill, Dana, 222

Hill, George Roy, 173–174, 198, 203, 214–215
Hill, Henry, 238
Hinton, S. E., 203
Hirschberg, Lora, 297, 308
Hitchcock, Alfred, 72–73, 106, 110–111, 114, 116–117, 119, 126–127, 241
Hobbit: An Unexpected Journey, The, 303, 315
Hobbit: The Battle of the Five Armies, The, 319, 321
Hobbit: The Desolation of Smaug, The, 316–318
Hoffman, Dustin, 173, 192, 257
Holbrook, Hal, 203
Holden, William, 140, 166–167, 186–187
Holloway, Stanley, 154
Hollywood Canteen, 71, 89
Holmes, Carl, 226
Holt, Tim, 100–101
Home Alone, 238
Homolka, Oscar, 165
Honeysuckle Rose, 208, 210
Honkytonk Man, 203
Hooper, 195, 197
Hope, Bob, 150
Hopkins, Bo, 166–167
Hopkins, Miriam, 69, 86–87
Horn, Alan F., 242, 274
Horrible Bosses, 302
Horsely, David, 4–5
Hotel, 159
Hounsou, Djimon, 292–293
House of Wax, 106, 116–117, 273
House on Haunted Hill, 242
House Un-American Activities Committee (HUAC), 72, 106
Houston, Whitney, 238, 249
Howard, Jeff, 159
Howard, Leslie, 51
Howard, Ron, 203
Howell, Norman, 179
Hudes, Quiara Alegría, 340–341
Hudgens, Vanessa, 313
Hudson, Hugh, 202, 204, 212–213
Hudson, Rock, 107, 125, 128
Hudsucker Proxy, The, 255
Hughes, Albert and Allen, 302, 306
Hughes, Howard, 273
Hughes, John, 204
Hull, Josephine, 88–89
Hulme, Kathryn, 109
Humoresque, 72, 93
Hunt, Helen, 241, 262
Hunt, Marsha, 72
Hunter, Tab, 107, 131
Hurrell, George, 59, 62–65, 68, 75
Hurt, William, 202–203, 206, 210–211, 231, 274
Huston, Anjelica, 244, 280
Huston, John, 67–69, 72, 76, 78–79, 100–101, 108, 126–127, 159, 237, 244

Huston, Walter, 72, 80, 83–84, 100–101
Hutcherson, Josh, 313
Hutchins, Will, 142–143
Hyams, Peter, 203, 212–213
Hyde, Jonathan, 255
Hyde-White, Wilfred, 154
Hyland, Diana, 239

I

I Am a Fugitive from a Chain Gang, 31, 33, 40, 45
I Confess, 106, 116–117
I Haven't Got a Hat, 33, 48
I Love You, Alice B. Toklas, 162
Ice Cube, 242, 267
Ice-T, 238
I'll See You in My Dreams, 106
Illicit, 32
Imagine: John Lennon, 206
In the Heights, 336, 340–341
In the Valley of Elah, 274, 295
Inception, 302, 308
Incredible Mr. Limpet, The, 138, 152–153
Independent Moving Picture Company (IMP), 3
Indiscreet, 131
Infernal Affairs, 274
Inge, William, 137–138, 145
Inherent Vice, 304, 320
Innerspace, 206, 228
Inside Daisy Clover, 139, 156–157
Insomnia, 272, 280
Interstellar, 321
Interview with the Vampire, 239, 256
Into the Arms of Strangers: Stories of the Kindertransport, 271, 276–277
Invictus, 298
Iron Giant, The, 242
Irons, Jeremy, 205, 224, 238, 244–245, 272
Irving, Amy, 206
Irving, John, 203, 214–215
Isaac, Oscar, 336
Ising, Rudolf, 33
It, 304, 326
It Chapter Two, 304, 332

J

J. Edgar, 302
Jackson, Mick, 238
Jackson, Peter, 303, 315–317, 319, 329
Jackson, Samuel L., 241
Jackson, Sherry, 116
Jagger, Mick, 170, 175
Jaguar Productions, 107
James, LeBron, 340–341
Jaws, 174, 240
Jazz Singer, The, 9, 21–22, 116
Jenkins, Patty, 301, 304, 326, 336, 338

Jeremiah Johnson, 171
Jersey Boys, 303
Jessel, George, 9
Jewison, Norman, 214–215
Jezebel, 33, 59–60
JFK, 238, 248
Jimi Hendrix, 172
Joe Versus the Volcano, 237–238, 243
Joffé, Roland, 204–205, 220, 224, 226
Johnny Belinda, 72, 100–101
Johns, Glynis, 142
Johnson, Ben, 166–167
Johnson, Dave, 170
Johnson, Dwayne, 313, 343–344
Johnson, Kyle, 165
Johnson, Lyndon B., 139
Johnson, Mike, 274, 290
Joker, 305, 332–333, 338–339
Jolson, Al, 9, 20–21, 46
Jones, Chuck, 33, 145, 174, 199
Jones, Jennifer, 73, 186–187
Jones, Quincy, 205, 223
Jones, Shirley, 148
Jones, Tommy Lee, 239–240, 248, 254, 266, 276–277, 295
Jonze, Spike, 242, 275, 298, 303, 317–318
Jordan, Michael, 241, 260, 332–333
Jordan, Michael B., 304, 322–323
Jordan, Neil, 239, 256, 262
Journey 2: The Mysterious Island, 313
Joy, Jason, 32
Joy Luck Club, The, 329
Joyful Noise, 313
Juarez, 33–34, 64–65
Judas and the Black Messiah, 336, 339–340
June Bride, 73, 99
Junger, Sebastian, 271
Jupiter Ascending, 322–323
Jurassic Park, 240
Just Mercy, 332–333
Just Tell Me What You Want, 201
Justice League, 304

K

Kahn, Gus, 106
Kahn, Madeline, 186–187
Kaluuya, Daniel, 336, 339–340
Kanter, Jay, 202
Kaplan, Jonathan, 198
Kasdan, Lawrence, 203, 206, 211, 231–232, 238, 249
Katt, William, 196–197
Kaufman, Philip, 173, 204, 216–217
Kay, Stephen, 271
Kaye, Danny, 165
Kazan, Elia, 105, 107–108, 113–114, 122–124, 128–129, 138–139, 144–145, 151, 166

Keaton, Michael, 203, 206–207, 230–231, 233, 238, 249
Keel, Howard, 118
Keighley, William, 34, 55, 58–59, 74–75, 80
Keiko, 239, 252–253
Kellogg, Ray, 162–163
Kelly, Grace, 119
Kelly, Ian, 306–307
Kelly, Jack, 142–143
Kelly, Nancy, 126–128
Kennedy, Byron, 174
Kennedy, John F., 138, 151, 238
Kenton, Erle C., 16
Kerr, Deborah, 142, 155
Kerr, John, 141
Kershner, Irvin, 157
Kessler, Stephen, 263
Key Largo, 72, 100–101
Khouri, Callie, 272
Kidder, Margot, 173, 201, 204, 206, 227
Kidman, Nicole, 207, 242, 265, 267, 274
Kilar, Jason, 335, 337
Killing Fields, The, 204, 220
Kilmer, Val, 240, 274, 289
King, Peter Swords, 315
King, Richard, 297, 308, 321, 327
King, Shaka, 336, 339–340
King, Stephen, 201, 203, 242, 304
King Richard, 337, 342
Kings Row, 83
Kinney National Company, 171
Kinney National Corporation, 140
Kiss Kiss Bang Bang, 274, 289
Kiss Me Again, 32
Kline, Kevin, 242, 254
Klute, 171, 177–178
Knight, Amanda, 312
Knight, Shirley, 139, 142, 166
Knight, Ted, 208
Knotts, Don, 138, 152–153
Korda, Alexander, 36
Korman, Harvey, 186
Korngold, Erich Wolfgang, 49, 60, 65, 76
Koster, Henry, 107
Kramer, Michael, 198
Krasinski, John, 344
Kravits, Zoë, 344
Kristofferson, Kris, 173, 190
Kroll, Sue, 301
Kubrick, Stanley, 171, 173, 178–179, 188–189, 201, 205–206, 209, 228, 241–242, 267, 272, 278
Kunis, Mila, 306, 322–323
Kurosawa, Akira, 237, 244
Kutcher, Ashton, 302
Kwapis, Ken, 274, 290

L

L.A. Confidential, 241, 264
Ladd, Alan, 107
Ladd, Alan, Jr., 202, 343

Ladd Company, 202–204
Lady Gaga, 304, 331
Lady Windermere's Fan, 15
Ladyhawke, 221, 223
Laemmle, Carl, 3
LaGravenese, Richard, 294
Lahti, Christine, 220
Lake, Veronica, 241
Lambert, Christopher, 204
Lancaster, Burt, 106–107, 116
Landaker, Alan, 213, 223, 226
Landaker, Hal, 213, 226
Landis, John, 222
Lane, Diane, 173
Lane, Tami, 315
Lang, Fritz, 118
Lange, Jessica, 237
Lansbury, Angela, 185
Lanza, Mario, 127
Larner, Jeremy, 171
Lasky, Jesse L., 68
Lasky Studios, 8
Last Boy Scout, The, 246
Last of Sheila, The, 171–172, 183
Last Samurai, The, 284
Late Show, The, 194
Laura, 203
Law, Jude, 275, 278, 298–299, 309
Lawford, Peter, 141
Leachman, Cloris, 242
Lean on Me, 206, 234–235
Learning Tree, The, 140, 165
Led Zeppelin, 173, 190–191
Lederer, Francis, 61
Ledger, Heath, 274–275, 296–297
Lee, Bruce, 171, 182
Lee, Christopher, 108, 166, 170, 302
Lee, Malcolm D., 336, 340–341
Lee, Spike, 238, 250
Left-Handed Gun, The, 131
Legend of Tarzan, The, 304, 324
Legend of the Guardians: The Owls of Ga'Hoole, 302
Lego Batman Movie, The, 304
Lego Movie 2: The Second Part, The, 305, 332
Lego Movie, The, 303, 321
Lego Ninjago Movie, The, 304
Lehman, Ernest, 139, 158
Leigh, Vivien, 105, 113–114, 138, 144–145
Leighton, Margaret, 165
Lemmon, Jack, 124, 139, 146–148, 156, 239–240, 252, 258–259
Lennon, John, 206
Leo, Malcolm, 203, 211
LeRoy, Mervyn, 33, 38–40, 44–46, 51, 55, 107, 124, 126–127, 131, 137–138
Leslie, Joan, 80
Lester, Richard, 190, 201, 204
Leterrier, Louis, 302, 306
Lethal Weapon, 205, 227–228

Lethal Weapon 2, 206, 234–235
Lethal Weapon 3, 238
Lethal Weapon 4, 241, 266
Leto, Jared, 304, 324–325
Letter, The, 67, 76
Letterman, Rob, 332
Letters from Iwo Jima, 293
Leuci, Robert, 203
Levin, Ira, 203
Levitow, Abe, 146–147
Levy, Eugene, 271, 282–283
Lewis, Geoffrey, 209
Lewis, Harry, 100–101
Lewis, Jerry, 176
Lewis, Juliette, 239, 255
Li, Jet, 271, 276
Liberace, 122
Liebesman, Jonathan, 314
Life of Emile Zola, The, 31, 54–56
Life with Father, 71, 96–98
Lights of New York, 9, 23
Lilies of the Field, 36
Lillard, Matthew, 281
Lilly Turner, 32
Lilyhammer, 303
Liman, Doug, 320
Lindbergh, Charles, 108
Lindo, Delroy, 238
Linklater, Richard, 273, 288
Liotta, Ray, 243
Liszt, Franz, 172
Lisztomania, 172
Lithgow, John, 203, 215
Little, Cleavon, 172
Little Caesar, 31, 33, 38–39
Little Princess, A, 259
Little Romance, A, 174, 198–199
Little Shop of Horrors, 205, 225–226
Litvak, Anatole, 57, 61, 75
Lively, Blake, 274, 290
Lively, Jason, 222
Lizard's Tail, The, 203
LKO Comedies, 4
Lloyd, Frank, 23–24
Locke, Sondra, 162, 164, 173, 193, 201, 203
Lockhart, Gene, 78–79
Lockley, Andrew, 308, 321, 339
Loew, Marcus, 8
Loewe, Frederick, 154
Logan, Joshua, 130, 137–138, 140–141, 145, 160
Logan, Stanley, 53
Lola Bunny, 260
Long, Richard, 142–143
Longworth, Bert, 39, 51
Look for the Silver Lining, 103
Looney Looney Looney Bugs Bunny Movie, The, 203
Looney Tunes, 33, 48, 69, 174, 239, 241, 337
Looney Tunes: Back in Action, 273, 282–283

Lopez, George, 302
Lopez, Jennifer, 241, 264
Lord, Phil, 303
Lord, Robert, 32, 45, 56
Loren, Sophia, 240
Lorimar Films, 206
Lorimar-Telepictures, 207
Lorre, Peter, 71, 78
Lost Boys, The, 206
Lost World: Jurassic Park. The, 279
Louis, Willard, 14
Louis B. Mayer Productions, 7, 12
Louise, Anita, 48
Lourié, Engène, 106, 116–117
Love, Montagu, 17
Love Affair, 239, 255
Lowe, Rob, 203, 216
Lowther, T. J., 252–253
Loy, Myrna, 29, 201
Lubin, Arthur, 138
Lubitsch, Ernst, 8, 15, 18–19, 241
Lucas, George, 170, 174, 177, 203
Lucas, Nick, 29
Lucretia Lombard, 12
Ludwig, Pamela, 198
Luhrmann, Baz, 303, 317, 335, 343
Lumet, Sidney, 162, 172, 188–189,
 201, 203, 206, 213
Lupino, Ida, 95–97
Lydon, Jimmy, 96–97

M

M. Witmark & Sons, 10
Mac, Bernie, 272
Macchio, Ralph, 204
MacDowell, Andie, 204
MacGraw, Ali, 201
MacLaine, Shirley, 302
MacRae, Gordon, 106, 118
Mad Genius, The, 39
Mad Max, 174, 198
Mad Max 2, 202
Mad Max Beyond Thunderdome,
 205, 222
Mad Max: Fury Road, 304, 322–323
Madame Bovary, 73
Madame Du Barry, 32, 46
Madison, Guy, 107
Madwoman of Chaillot, The, 165
Magic Mike, 313
Magnoli, Albert, 204, 218–219
Magnum Force, 183
Main Event, The, 199
Main Street, 10–11
Malcolm X, 170, 180, 238, 250–251
Malden, Karl, 105, 108, 114, 206
Malick, Terrence, 169, 172, 183
Malkovich, John, 228, 238
Malone, Dorothy, 109
Malone, William, 242
Maltese Falcon, The, 69, 71, 78
Mame, 185
Man I Love, The, 96–97
Man of Steel, 303–304, 317
Man Who Came to Dinner, The, 80

Mandela, Nelson, 238
Mangano, Silvana, 177
Mankiewicz, Joseph L., 176
Mann, Anthony, 127
Mann, Delbert, 137, 152
Mann, Michael, 257, 288
Mann, Thomas, 177
Manpower, 77
Mantell, Joe, 141
Manz, Christian, 308
March, Fredric, 51, 78–79
March of the Penguins, 290
Marked Woman, 53
Marriage on the Rocks, 155
Mars Attacks! 240–241
Marshall, Garry, 302
Martin, Dean, 109, 133, 141, 149, 152
Martin, Steve, 273
Martinson, Leslie H., 151
Masina, Giuletta, 165
Mason, James, 119, 121, 172
Mason, Marsha, 194
Massey, Raymond, 84, 88–89
Massot, Joe, 190–191
Mastrantonio, Mary Elizabeth, 238
Matrix, The, 1, 240, 242, 269, 273
Matrix franchise, 275
Matrix Reloaded, The, 273, 282
Matrix Resurrections, The, 337
Matrix Revolutions, The, 273, 282
Matthau, Walter, 239–240, 252,
 258–259
Matthews, Liesel, 259
Maugham, W. Somerset, 67
Mauldau, Diana, 186
Maverick, 108, 237, 256
May, Donald, 142–143
May, Joe, 55
Mayer, Louis B., 8
Mayfield, Curtis, 170, 190
Mayo, Archie, 42–43, 51
Mazurka, 55
McAvoy, James, 332
McBain, Diane, 142–143, 145
McCabe & Mrs. Miller, 171, 178–179
McCarthy, Kevin, 206
McConaughey, Matthew, 241, 261,
 264
McCormack, Patty, 126–128
McCormick, Kevin, 274
McCracken, Craig, 272
McCullers, Carson, 162
McDowell, Malcolm, 178–179, 183
McGee, Rex, 250
McGee, Vonetta, 193
McGuire, Dorothy, 137
McHugh, Frank, 64–65
McKay, Chris, 304
McKee, Lonette, 173, 226
McKellen, Ian, 315
McKimson, Robert, 33, 138
McLaglen, Andrew V., 175
McMillan, Stephenie, 279, 290,
 308, 312

McOmie, Maggie, 177
McQ, 170, 186
McQueen, Steve, 139, 164, 172,
 186–187, 196–197, 238
McTeigue, James, 292
Mean Streets, 1, 172, 182
Memphis Belle, 238
Men Don't Leave, 237
Mendez, Tony, 303, 315
Menéndez, Ramón, 206, 229
Menges, Chris, 220, 226
Menjou, Adolphe, 14, 42–43
Menken, Alan, 205, 226
Merrie Melodies, 33, 69, 98, 174
Metro-Goldwyn, 8
Metro-Goldwyn-Mayer (M-G-M), 9,
 14, 31–32, 34, 67, 71, 107
Meyer, Barry, 242, 301
Meyers, Nancy, 202, 210
MGM, 171
Michael Clayton, 274, 295
Michael Collins, 262
Midler, Bette, 202, 208
*Midnight in the Garden of Good
 and Evil*, 241
Midsummer Night's Dream, A, 33,
 48, 50
Mighty Wind, A, 273, 282–284
Milchan, Arnon, 240, 264
Mildred Pierce, 71, 90–92, 108
Miles, Sylvia, 206
Miles, Vera, 126–127
Milestone, Lewis, 141
Milius, John, 196–197
Milland, Ray, 119
Miller, Christopher, 303
Miller, George, 174, 198, 202, 205,
 222, 228, 274, 293, 304, 310–311,
 322–323
Miller, Harvey, 210
Miller, J. P., 138
Miller, Jason, 172, 184
Miller, Patsy Ruth, 16
Miller, Robert Ellis, 162
Million Dollar Baby, 1, 273, 287–288
Milner, Martin, 96–97
Mineo, Sal, 122, 124
Minkler, Michael, 210, 248
Minnelli, Liza, 203, 213
*Miracle of Our Lady of Fatima,
 The*, 116
Miranda, Lin-Manuel, 336, 340–341
Miss Congeniality, 272, 276
Mission, The, 205, 224, 226
Mission to Moscow, 68, 70, 72, 84,
 86, 106, 115
Mister Roberts, 107, 124
Mitchell, Grant, 80
Mitchum, Robert, 172
Moby Dick, 108, 126–127
Mohr, Hal, 50
Momoa, Jason, 305, 328
Monroe, Marilyn, 108
Montalban, Ricardo, 108

Montgomery, Robert, 99
Moore, Colleen, 27–29
Moore, Dudley, 174, 203, 213
Moore, Michael, 207, 234–235
Moore, Roger, 142–143, 145
Moorehead, Agnes, 101
Moranis, Rick, 225
Moreno, Rita, 190
Morgan, Dennis, 71
Morgan Creek Productions, 240
Morricone, Ennio, 226
Mortensen, Viggo, 241
Moss, Carrie-Anne, 242, 273, 282
Mostow, Jonathan, 273, 282
Motion Picture Association of
 America (MPAA), 139–140
Motion Picture Patents Company, 3
Movietone, 9
Mowat, Doug, 308, 342
Mr. Skeffington, 88–89
Mrs. Miniver, 69
Mule, The, 304–305, 329
Mulligan, Carey, 317
Mulligan, Robert, 157, 159, 178–179
Mumba, Samantha, 272
Muni, Paul, 1, 31, 33–34, 40, 45,
 51–52, 54–56, 67
Muniz, Frankie, 271
Murder My Sweet, 71
Murray, Bill, 202, 260
Murray, Chad Michael, 273, 285
Murro, Noam, 303, 319
Murrow, Edward R., 290–291
Muschietti, Andy, 304
Music Man, The, 138, 148
Music Publishers Holding Company,
 10
Mustafa, Isaiah, 332
Mutual, 106
My Dog Skip, 271
My Dream Is Yours, 71
My Fair Lady, 138–139, 154
My Four Years in Germany (film), 4
My Four Years in Germany (Gerard),
 4
My Past, 32
My Reputation, 71, 95
Myerson, Alan, 182
Mystery of the Wax Museum, 33,
 43, 106
Mystic River, 273, 284

N

Nancy Drew, 274
Napoleon, Art, 109
*National Lampoon's Christmas
 Vacation*, 233
*National Lampoon's European
 Vacation*, 205, 222
National Lampoon's Vacation, 204,
 216
Natural Born Killers, 239, 255
Nava, Gregory, 241
Nazimova, Alla, 3
Neal, Patricia, 102, 112

Needham, Hal, 195
Neeson, Liam, 202, 262, 302
Negri, Pola, 55
Negulesco, Jean, 72–73, 93, 100–101
Neill, Sam, 207, 231
Nelson, Judd, 238
Nelson, Ricky, 109, 133
Nelson, William, 226
Nelson, Willie, 208, 210
Nero, Franco, 160
Netflix, 302–303, 337
Never Too Late, 155
New Jack City, 238, 246–247
New Line Cinema, 304
New Regency Productions, 240
Newell, Mike, 271, 274
Newman, Nanette, 165
Newman, Paul, 131, 133, 139, 160–161, 164, 172, 186–189
Ngor, Haing S., 204, 220
Nichols, Marisol, 263
Nichols, Mike, 139, 158, 173
Nicholson, Jack, 201, 207, 233, 240, 274, 294
Nielsen, Leslie, 203
Nigh, William, 4, 10
Night and Day, 71, 94–95
Night Cry, The, 18
Night Moves, 188–189
Night of the Iguana, The, 138
Night Shift, 203
Nightmare on Elm Street, A, 302
No Time for Sergeants, 108, 131
Noah's Ark, 24–25
Nolan, Christopher, 272, 274–275, 280, 296–297, 302–303, 308, 314, 326–327, 336, 338
Nora Prentiss, 96–97
Norton, Jack, 53
Novick, Ed, 297, 308
Now, Voyager, 67, 83
Noyce, Phillip, 207
Nun's Story, The, 109, 135
Nuts, 206, 227

O

O Lucky Man, 183
Oates, Warren, 166–167
Oberon, Merle, 159
Objective, Burma! 71, 92
O'Brien, Willis, 127
Ocean's 11, 138, 141
Ocean's Eight, 304
Ocean's Eleven, 272–273, 278
Ocean's Thirteen, 294
O'Connell, Chris, 241
O'Connolly, Jim, 166
Ode to Billy Joe, 190–191
O'Donnell, Chris, 237, 263
Of Human Bondage, 33
Ogg, Sammy, 116
Ogilvie, George, 205, 222
Oh, God! 173, 194, 202
Oh, God! Book II, 202
O'Hara, Catherine, 282–283

O'Hara, Maureen, 149
O'Keefe, Michael, 210
Old Acquaintance, 86–87
Old English, 31
Old Maid, The, 33, 70
Old Man and the Sea, The, 108, 132
Oldman, Gary, 302
Olivier, Laurence, 108, 156, 173, 198
Olmos, Edward James, 206, 229, 232, 304
Olsen, Moroni, 78–79
Omega Man, The, 177
On Moonlight Bay, 106
On with the Show! 27
One Foot in Heaven, 78–79
One Sunday Afternoon, 77
One Way Passage, 45
O'Neal, Ron, 170, 180
O'Neal, Ryan, 171, 173, 179, 189, 199
O'Neill, Jennifer, 178–179
Oppenheimer, Deborah, 271, 277
Orion Pictures Company, 173–174, 203
Orr, William T., 142–143
Osment, Haley Joel, 278
O'Steen, Sam, 158, 190
O'Sullivan, Maureen, 155
Othello, 156
Outbreak, 257
Outland, 203, 212–213
Outlaw Josey Wales, The, 173, 190–192
Outsiders, The, 203–204, 216
Over the Edge, 198
Owens, Michael, 308
Oz, Frank, 205, 225

P

Pacino, Al, 170, 172, 188–189, 257, 272, 280
Page, Geraldine, 118, 152
Pajama Game, The, 129
Pakula, Alan J., 169, 171, 173, 177, 192, 237–239, 243
Pallenberg, Anita, 175
Palm Springs Weekend, 150
Paltrow, Gwyneth, 241, 265
Paramount, 8–9, 31–32, 34, 67–68, 70, 107
Paramount Communications, 207
Parker, Charlie "Bird," 206, 229
Parker, Eleanor, 112
Parker, Mary-Louise, 239
Parks, Gordon, 140, 165
Parks, Gordon, Jr., 170, 180
Parrish, 137
Parrish, Robert, 160
Parton, Dolly, 313
Patric, Jason, 206
Pattinson, Robert, 344
Paulin, Scott, 216–217
Paxton, Bill, 241, 262
Pearce, Guy, 241, 272
Peck, Gregory, 126–127
Peckinpah, Sam, 140, 166–167

Pee-wee's Big Adventure, 205
Pelican Brief, The, 237, 239
Pendleton, Nat, 42–43
Penn, Arthur, 131, 139, 160–161, 188–189
Penn, Sean, 273, 284
Pepé Le Pew, 69
Pérez, Selena Quintanilla, 241, 264
Perfect Murder, A, 241, 265
Perfect Storm, The, 271, 277
Perfect World, A, 239, 252–253
Performance, 170, 175
Peril of the Plains, 3
Perkins, Anthony, 137, 141, 171–172
Perkins, Elizabeth, 272
Perl, Arnold, 180
Personal Best, 214
Pesci, Joe, 241, 243, 245
Pete Kelly's Blues, 124
Peters, Bernadette, 207
Peters, Jon, 207, 237
Petersen, Wolfgang, 257, 271, 273, 285
Petrie, Daniel, 141
Petrie, Donald, 252, 255, 272, 276
Petrified Forest, The, 33, 51
Pevney, Joseph, 141
Peyton, Brad, 313
Pfeiffer, Michelle, 221, 228, 232, 238, 249, 302
Pfister, Wally, 290, 293, 297, 308
Phantom of the Opera, The, 288
Phillips, Edwin, 43
Phillips, Todd, 275, 298, 305, 310, 332–333
Phoenix, Joaquin, 305, 317, 320, 332–333
Phoenix, River, 206, 232
Piantadosi, Arthur, 192, 210
Pierson, Frank R., 161, 173, 188, 190
Pike, Rosamund, 314
Pileggi, Nicholas, 238, 245
Pink Cadillac, 207
Pitt, Brad, 239, 256, 272–274, 278, 285, 294, 297
Plant, Robert, 190–191
Playhouse 90, 138
Pleasence, Donald, 165, 170
Pleshette, Suzanne, 150
Plimpton, Martha, 205, 221
Poitier, Sidney, 172, 185
Pokémon Detective Pikachu, 332
Pokémon: The First Movie 2000: The Power of One, 276
Pokémon: The First Movie— Mewtwo Strikes Back, 242, 268–269
Polar Express, The, 273, 275, 287–288
Police Academy, 204, 219
Polito, Sol, 65, 79, 83
Pollack, Sydney, 172, 295
Ponce, Poncie, 142–143
Poore, Vem, 223, 226, 228, 232, 251

Porky Pig, 33, 48
Porter, Cole, 71
Porter, Edwin S., 3
Portman, Natalie, 292
Poseidon, 293
Post, Ted, 183
Powell, Dick, 71
Powell, William, 71, 96–98, 124
Powerpuff Girls, The, 272
Powers, Stefanie, 150
Practical Magic, 265
Pran, Dith, 204
Pratt, Hawley, 138
Preminger, Otto, 203
Presley, Elvis, 203
Pressman, Michael, 173, 198
Preston, Robert, 137–138, 148
Presumed Innocent, 238, 243
Pretty Woman, 238
Price, Vincent, 106, 116–117, 127
Prince, 204, 218–220
Prince and the Showgirl, The, 108
Prince of the City, 203, 213
Prinze, Freddie, Jr., 272, 281
Prisoner of Second Avenue, The, 188–189
Private Benjamin, 202, 210
Private Lives of Elizabeth and Essex, The, 33, 61, 64–65
Production Code, 32, 46, 162–163, 169
Production Code Administration (PCA), 32–33, 67, 105, 139–140
Protocol, 219
Proval, David, 182
Provine, Dorothy, 107, 142–143
Pryor, Richard, 193
P.S. I Love You, 294
PT-109, 138, 151
Public Enemy, The, 31, 38–39, 139
Pure Country, 250
Purple Rain, 204, 218–220
Puttnam, David, 213, 220, 226
Pytka, Joe, 241, 260

Q

Quaid, Dennis, 206, 216–217
Quan, Ke Huy, 221
Queen Latifah, 302, 313
Quine, Richard, 152–153, 159
Quinn, Aidan, 262
Quintero, José, 144–145

R

Rachel, Rachel, 139, 164
Radcliffe, Daniel, 271–272, 279, 287, 306–307, 312
Raft, George, 74–75
Rain People, The, 139, 166
Rains, Claude, 86, 89
Raitt, John, 129
Ramis, Harold, 202, 204, 208, 216, 242, 267, 280
Ramos, Anthony, 340–341
Rand, Ayn, 67

Rapf, Harry, 7
Raphaelson, Samson, 9
Rapper, Irving, 67, 71, 78–79, 92, 110–111
Rathbone, Basil, 60
Rattigan, Terrence, 108
Raucher, Herman, 170, 178
Ray, Nicholas, 107, 122, 124
Raymaker, Herman C., 18
Reagan, Ronald, 74–75, 83
Rebel without a Cause, 107–108, 122, 124
Records, Max, 298
Red Hot Tires, 16
Redford, Robert, 171, 173, 181, 192
Redgrave, Vanessa, 160, 162
Redmayne, Eddie, 324–325, 330
Reeve, Christopher, 173, 197, 201, 203–204, 206, 227
Reeves, Keanu, 242, 269, 273, 282
Reeves, Matt, 337, 344
Reflections in a Golden Eye, 159
Reiner, Carl, 173, 194
Reiner, Rob, 274, 294
Reinhardt, Max, 33, 48
Reisner, Charles, 17
Reitman, Ivan, 254
Reitz, John, 269, 277, 293, 315, 321
Remick Music Corp., 10
Renfro, Brad, 256
Renner, Jeremy, 308
Rennie, Michael, 159
Requa, John, 322–323
Reservoir Dogs, 240
Reubens, Paul, 205
Reversal of Fortune, 238, 244–245
Reynolds, Burt, 171, 181, 195, 203–204, 211, 214–215
Reynolds, Ryan, 310–311
Rhames, Ving, 241
Rhapsody in Blue, 71, 92
Rhapsody in Rivets, 79, 92
Rice, Anne, 239
Rich, Irene, 12, 15
Rich, Lee, 240
Richard Jewell, 305, 333
Richardson, John, 288, 308, 312
Richardson, Miranda, 272
Richardson, Ralph, 220
Richie Rich, 255
Richter, Jason James, 239, 252–253
Riegert, Peter, 206
Right Stuff, The, 204, 216–217
Rin-Tin-Tin, 7, 12–13, 15, 18
Rio Bravo, 109, 133
Risky Business, 204, 216, 237
Ritchie, Guy, 275, 298–299, 302, 309
Ritchie, Michael, 171, 181, 205, 208, 224
Ritt, Martin, 206, 227
Ritz, The, 190
Rizzo, Gary A., 297, 308, 321, 327
RKO, 33

RKO Radio, 31
RKO Studios, 45, 71
Roach, Jay, 314
Road Runner, 69
Road Warrior, The, 202
Roaring Twenties, The, 34, 64–65, 106, 108
Robbie, Margot, 304, 322–325, 338–339
Robbins, Tim, 255, 273, 284
Robe, The, 107
Roberts, Emma, 274
Roberts, Julia, 239, 272, 302
Robertson, Cliff, 138
Robin and the 7 Hoods, 138, 152, 154
Robin Hood: Prince of Thieves, 238, 246–247
Robinov, Jeff, 301
Robinson, Bruce, 220
Robinson, Edward G., 1, 31, 34, 38–40, 67, 72, 100–101
Robinson, Jackie, 303, 316–317
Robinson, James G., 240
Rocky Balboa, 322–323
Rocky franchise, 304
Roeg, Nicolas, 175, 244
Roger & Me, 207, 234–235
Rogers, Ginger, 110–111
Roman Spring of Mrs. Stone, The, 138, 144–145
Romance on the High Seas, 71, 101
Romanus, Richard, 219
Romayne Superfilm Company, 5
Rome Adventure, 137
Romeo Must Die, 271, 276
Romero, Cesar, 155
Romero, George A., 203
Rookie, The, 237
Roosevelt, Franklin D., 70, 137
Rope, 73
Rose Moline, 73
Rosenberg, Mark, 204
Rosenberg, Stuart, 160–161, 188–189
Rosenblum, Bruce, 301
Rosewood, 241
Rosman, Mark, 273, 285
Ross, Diana, 238
Ross, Gary, 254, 304
Ross, Herbert, 172–174, 183, 194, 219
Ross, Steven J., 169, 171, 201
Round Midnight, 226
Routh, Brandon, 293
Rowling, J. K., 272, 304
Rudin, Scott, 312
Rudloff, Gregg, 269, 277, 293, 315, 321, 323
Running on Empty, 206, 232
Rush, Barbara, 133, 141, 152
Rush, Geoffrey, 242
Rush, Richard, 185
Russell, Chuck, 261
Russell, David O., 242, 267
Russell, Jay, 271
Russell, John, 142–143

Russell, Ken, 171–173, 202, 210
Russell, Kurt, 260
Russell, Rosalind, 108, 132, 185
Russo, Rene, 241, 261
Rutherford, Ann, 99
Ryan, Jay, 332
Ryan, Meg, 206, 237, 241, 243, 266
Ryan, Robert, 155
Rydell, Mark, 162–163, 179
Ryder, Winona, 206, 230–231

S
Sabara, Daryl, 287
Sabbatini, Enrico, 226
Sagal, Boris, 177
Saindon, Eric, 315, 318
Saks, Gene, 185
Sanchez, Jaime, 166–167
Sanders, George, 61
Sandler, Susan, 206
Santana, 170
Santoro, Rodrigo, 319
Sarandon, Susan, 228, 239, 256, 272
Saratoga Trunk, 90, 95
Sarnoff, Ann, 337
Saturday Night Live, 202
Sayonara, 108, 130
Scarecrow, 170–171
Scarface, 33
Schaefer, George, 196–197
Schanberg, Sydney, 204
Schatzberg, Jerry, 170, 208
Schell, Maria, 134–135
Schenk, Nick, 305
Schepisi, Fred, 231
Schlesinger, Leon, 33, 41, 76, 79, 83, 86
Schnitzler, Arthur, 241
School Days, 7, 10
Schoonmaker, Thelma, 170, 176, 245, 288, 293
Schroeder, Barbet, 238, 244–245
Schultz, Michael, 193
Schumacher, Joel, 206, 239–241, 252, 256, 259, 261, 263
Schwarzenegger, Arnold, 241, 261, 273, 282
Scoob! 338–339
Scooby-Doo, 272, 281
Scorsese, Martin, 139, 170, 172, 182, 185, 205, 222, 238, 243, 245, 273–274, 287–288, 293
Scott, Derek, 96–97
Scott, Martha, 78–79
Scott, Randolph, 107
Scott, Ridley, 202, 214, 304, 335
Scott, Robert Lee, 71
Scott, Tony, 240, 246
Scott, Wendell, 193
Scott, Zachary, 90–91
Sea Beast, The, 18
Sea Gull, The, 162
Sea Hawk, The, 67, 75–76
Searchers, The, 108, 125

Sedgwick, Kyra, 257
Seiter, William A., 27–29
Selena, 241, 264
Sellers, Peter, 160, 162
Selznick, David, 72–73
Selznick, Lewis J., 4, 7
Semel, Terry, 202, 240, 242
Semenenko, Serge, 109
Sendak, Maurice, 275
Serenade, 127
Sergeant Rutledge, 138
Sergeant York, 68, 77
Service with a Smile, 34
Seven Arts, 140
Seven Footprints to Satan, 26–27
77 Sunset Strip, 108
Sex and the Single Girl, 152–153
Shanley, John Patrick, 237, 243
Shannon, Michael, 303
Shapiro, Robert, 204
Sharkey's Machine, 203, 211
Sharp, Leo, 305
Sharpton, Al, 238
Shaw, Clay, 238
Shearer, Norma, 12, 14
Sheen, Charlie, 237
Sheen, Martin, 172
Sheltering Sky, The, 238
Shelton, Ron, 261
Sheridan, Ann, 62–63, 68, 74–75, 80, 83, 96–97
Sherlock Holmes, 275, 298–299
Sherlock Holmes: A Game of Shadows, 302, 309
Sherman, Lowell, 34–35
Sherman, Vincent, 86–88, 96–97, 99, 133
Shining, The, 201, 209
Shop Around the Corner, The, 241
Short, Martin, 206
Show of Shows, 29
Shyer, Charles, 210
Siddig, Alexander, 290–291
Sidney, Saniyya, 342
Siegel, Don, 169, 171
Silver, Joan Micklin, 206
Silver, Joel, 240, 242, 271
Silver, Ron, 238
Silverman, Greg, 301
Silverstone, Alicia, 241
Simon, Neil, 173, 194
Simpson, O. J., 186–187
Sinatra, Frank, 138, 141, 149, 152, 155
Sincerely Yours, 122
Singer, Bryan, 293
Singing Fool, The, 9
Singles, 250
Singleton, Demi, 342
Singleton, John, 241
Sins of Rachel Cade, The, 145
Siodmak, Robert, 116
Sisterhood of the Traveling Pants, The, 274, 290
Sisters, The, 57

Six, Bert, 77, 80, 96, 100–101, 105, 110–111, 118, 122–123, 131, 134–135, 144–145, 149–150
Skarsgård, Alexander, 304, 324
Smith, Alexis, 88, 94–95
Smith, Bruce W., 260
Smith, Bubba, 204
Smith, Charles Martin, 310
Smith, Dwan, 173
Smith, Justice, 332
Smith, Kate, 70
Smith, Maggie, 156
Smith, Noel M., 15
Smith, Roger, 142–143
Smith, Will, 242, 304, 337, 342
Snipes, Wesley, 205, 238, 246–247
Snyder, Zack, 275, 294–295, 302–304, 310, 317, 324
Soderbergh, Steven, 272, 294, 309, 313
Solt, Andrew, 203, 206, 211
Something to Talk About, 257
Sondheim, Stephen, 171–172
Song Remains the Same, The, 173, 190–191
Sonnenfeld, Barry, 242
Sorvino, Paul, 243
Space Cowboys, 271, 276–277
Space Jam, 241, 260
Space Jam: A New Legacy, 336, 340–341
Spacek, Sissy, 172, 183
Spacey, Kevin, 241
Sparkle, 173, 190
Spencer's Mountain, 149
Spielberg, Steven, 174, 205–206, 222–223, 228, 239–240, 272, 278, 293
Spies Like Us, 222
Spirit of St. Louis, The, 108, 130
Splendor in the Grass, 138, 144–145
St. Jacques, Raymond, 162–163
Stack, Robert, 120–121
Stage 21, 84–85, 115
Stage Fright, 73, 106, 110–111
Stallone, Sylvester, 225, 252–253, 272, 304, 322–323
Stand and Deliver, 206, 229, 232
Stanfield, LaKeith, 336, 339
Stanley Theatre Chain, 10, 109
Stanwyck, Barbara, 42–43, 71, 95
Star Is Born, A, 107, 119, 121, 173, 190, 192, 304, 331
Star Wars, 174
Star Wars: Episode II—Attack of the Clones, 273
Star Wars: The Clone Wars, 274
Stark, Ray, 173, 194
Starrett, Jack, 170, 182
Starsky and Hutch, 273
Steelyard Blues, 182
Steiner, Max, 52, 60, 65, 76, 79, 83, 86, 89, 92, 98, 101, 103, 112, 116, 124

Stephens, Jack, 226
Stern, Jared, 344
Stevens, Connie, 107, 142–145
Stevens, George, 107, 125, 128
Stevens, Stella, 170
Stewart, James, 73, 108
Stewart, Patrick, 202
Stolen Life, A, 94–95
Stone, Oliver, 203, 238–239, 248, 255
Stoppard, Tom, 206
Storm Warning, 110–111
Story, Tim, 336
Story of Louis Pasteur, The, 33, 51–52
Strait, George, 250
Strangers on a Train, 106, 114
Strasberg, Lee, 174, 199
Strathairn, David, 290–291
Strawberry Blonde, The, 77, 79
Streep, Meryl, 231–232, 239, 258–259
Streetcar Named Desire, A, 105–106, 113–114, 139
Streisand, Barbra, 171, 173, 179, 190, 192, 199, 206, 227
Strode, Woody, 138
Stroheim, Erich von, 8
Studio Relations Committee (SRC), 32
Sturges, John, 108, 132, 186
Sucker Punch, 310
Sudden Impact, 203
Suicide Squad, 304, 324–325
Suicide Squad, The, 336
Sullenberger, Chesley "Sully," 304
Sully, 304, 325
Summer of '42, 170, 178–179
Summer Place, A, 109, 134–135
Sundowners, The, 138, 142
Sunrise at Campobello, 137
Sunset Boulevard, 10–11
Super Fly, 170, 180
Super Mario Bros., 332
Superman, 173–174, 197, 317
Superman II, 201
Superman III, 201, 204
Superman IV: The Quest for Peace, 206, 227
Superman Returns, 293
Susan Slade, 137, 144–145
Sutherland, Donald, 171, 177, 276–277
Sutherland, Kiefer, 206
Swank, Hilary, 273, 287–288, 294
Swarm, The, 196–197
Swayze, Patrick, 204, 216
Sylvester the Cat, 69
Synthetic Sin, 27
Syriana, 274, 290–291

T
Taka, Miiko, 130
Takei, George, 162–163
Tall Story, 137–138, 141

Tamblyn, Amber, 274, 290
Tandy, Jessica, 206, 235
Tarantino, Quentin, 240, 303
Tarkington, Booth, 118
Tarzan of the Apes (Burroughs), 204
Tashlin, Frank, 33
Taste the Blood of Dracula, 170
Tatum, Channing, 313
Taurog, Norman, 150
Tavernier, Bertrand, 226
Taxi, 41
Taylor, Elizabeth, 71, 107, 125, 158–159
Taylor, Robert, 72
Taylor-Young, Leigh, 162
Tea for Two, 106
Teasdale, Verree, 53
Technicolor, 28–29, 31–34, 55, 71
Technirama, 108
10, 174, 199
Tenet, 336, 338–339
10,000 BC, 274
Tequila Sunrise, 229, 232
Terminator 3: Rise of the Machines, 273, 282
Terrio, Chris, 315
Terror, The, 10
Terry, Sheila, 42–43
Tesich, Steve, 203
Thank Your Lucky Stars, 86–87
Them!, 106, 120–121
There Was a Crooked Man, 176
Theron, Charlize, 290, 304, 322
They Died with Their Boots On, 77
They Drive by Night, 74–75
They Shall Not Grow Old, 329
They Won't Forget, 33, 55
This Boy's Life, 252–253
This Is Elvis, 203, 211
This Is Paris, 18–19
This Is the Army, 69–70, 84–86
Thomas, Emma, 308, 327
Thomas, Philip Michael, 190
Thompson, Tiger, 198
Three Kings, 242, 267
Three on a Match, 41
300, 294–295, 319
300: Rise of an Empire, 303, 319
Thurman, Uma, 241
THX 1138, 170, 177
Tightrope, 204
'Til We Meet Again, 67
Time, Inc., 207
Time Machine, The, 272, 281
Time of Your Life, The, 73
Time to Kill, A, 241, 261
Time Warner Inc., 237, 242
Tin Cup, 261
To Have and Have Not, 71, 88, 106
Tolkien, J. R. R., 303
Tom & Jerry: The Movie, 336
Tomblin, Lisa, 312
Tommy, 172

Too Much, Too Soon, 109
Topor, Tom, 206
Torrid Zone, 68, 74–75
Towering Inferno, The, 172, 186–187
Town, The, 302, 308
Towne, Robert, 214, 229
Tracy, Lee, 41
Tracy, Spencer, 108, 132
Train Robbers, The, 170
Training Day, 272, 278–279
Traumnovelle (*Dream Story*; Schnitzler), 241
Travis, Richard, 80
Travolta, John, 239
Treasure of the Sierra Madre, The, 72, 100–101
Tree, Dorothy, 61
Tribune Company, 242
Trilling, Steve, 70
Troell, Jan, 180–181
Trojansky, Stephan, 308
Troy, 273, 285, 288
True Romance, 240
True Stories, 225
Truffaut, François, 172, 187
Truscott, John, 160–161
Trust, The, 3
Tsujihara, Kevin, 301
Turner, Kathleen, 203, 206, 211
Turner, Ted, 240
Turner, Tina, 205, 222
Turner Broadcasting System, 240
Turow, Scott, 238
"Tweetie Pie," 98
Tweety, 69, 337
Twentieth Century Pictures, 32
Twentieth Century-Fox, 34, 106–108, 172
27 Wagons Full of Cotton, 128
Twister, 1, 241, 262
Two Mrs. Carrolls, The, 71
Two Seconds, 40
Tyler, Anne, 206
Tytla, Bill, 138

U
Uhry, Alfred, 206, 235
Ullmann, Liv, 180–181
Under Capricorn, 73
Under Eighteen, 32
Unforgiven, 239, 250–251
United Artists, 33, 174
Universal, 241
Up the Down Staircase, 159
Uptown Saturday Night, 172, 185
U.S. Marshals, 266

V
V for Vendetta, 292
Valenti, Jack, 139–140
Valentine's Day, 302
Valentino, Rudolph, 8, 108
Valley of Gwangi, The, 166
Valli, Frankie, 303
Van der Ryn, Ethan, 315

Van Horn, Buddy, 207, 231
Van Peebles, Mario, 238, 246–247
Vasak, P. H., 220
Vaughn, Robert, 186–187
Vegas Vacation, 263
Verdon, Gwen, 131
Vickery, David, 312
Vidal, Gore, 131
Vidor, King, 73, 102–103
Viennese Nights, 32
Viertel, Peter, 237
Villeneuve, Denis, 304, 336, 342
Vincent, Jan-Michael, 196–197
Vincent, Ra, 315
Vinson, Helen, 74–75
Visconti, Luchino, 140, 166–167, 177
Visnjic, Goran, 265
VistaVision, 108
Vitagraph, 8, 16, 24–25
Vitaphone, 8–9, 17, 21
Vizzard, Jack, 140
Voight, Jon, 171, 241
Voltaire, 31
von Bülow, Sonny, 238, 244–245
von Sydow, Max, 172–173, 312

W

Wachowski, Lana, 242, 269, 273,
 282, 292, 314, 322–323, 337
Wachowski, Lilly, 242, 269, 273,
 282, 292, 314, 322–323
Wadleigh, Michael, 170
Wagner, Robert, 186–187
Wahlberg, Mark, 242, 267, 274, 293
Wait Until Dark, 139, 160–161
Wald, Jerry, 71, 101
Walker, Alice, 205
Walker, Robert, 114
Wall of Noise, 150
Wallach, Eli, 106, 128
Wallis, Hal, 8, 12–13, 31–32, 60, 67,
 69–70, 86, 105, 107
Walsh, Raoul, 64–65, 71, 73–75, 77,
 96–97, 102–103, 107
Wan, James, 303, 305, 317, 324, 328
War Brides, 3
Ward, Fred, 216–217
Ward, Rachel, 211
Warnecke, Harry, 100–101
Warner, Albert, 2–4, 7, 17, 109
Warner, Annie, 4
Warner, Benjamin, 2–4, 240
Warner, Doris, 33, 107
Warner, Fannie, 4
Warner, Harry, 2–4, 7–10, 17, 60, 109
Warner, Jack L., 12–13, 20
Warner, Jack, L., 2–4, 7–9, 17,
 31–33, 62, 67, 69, 72–73, 90–91,
 105–106, 109, 132, 138–140,
 142–143, 151, 154, 160, 345
Warner, Julie, 246
Warner, Pearl, 4
Warner, Rose, 3–4
Warner, Sam, 2–5, 7–10, 17, 21

Warner Bros. Cartoons Inc., 33
Warner Bros. Family Entertainment,
 239, 249
Warner Bros. Feature Animation,
 241, 282–283
Warner Bros. Presents, 108
Warner Communications, 171, 174,
 207
Warner Independent Pictures
 (WIP), 273
Warner's Feature Play Company, 3
WarnerScope, 107
Warren, Harry, 44–45, 50, 56, 60
Washington, Denzel, 237–239,
 250–251, 272, 278–279, 302, 306
Washington, John David, 336, 338
Watanabe, Ken, 284, 293, 303
Watch on the Rhine, 68, 86
Watchmen, 275
Waters, Ethel, 27
Waters, Mira, 165
Waterston, Sam, 204, 220
Watson, Emma, 272, 279, 281,
 306–307, 312
Watts, Naomi, 302
Wayans, Damon, 246
Wayne, John, 106, 108–109, 120–121,
 125, 133, 140, 162–163, 169–171,
 175, 179, 186
WB Network, 242
Weaver, Sigourney, 232, 254
Weaving, Hugo, 242, 273, 292
Webb, Millard, 18
Webber, Andrew Lloyd, 288
Webber, Robert, 206
Weill, Claudia, 169, 173
Weinstein, Harvey, 305
Weis, Don, 150
Weis, Gary, 172
Welbourne, Scotty, 77, 80–81
Welch, Raquel, 172, 183
Weldon, Joan, 120
Wellman, William, 43, 106, 120–121
Wells, Frank, 171
Wells, H. G., 272
Wells, Rebecca, 272
Wells, Simon, 272
Wertmüller, Lina, 169
Wesley, Richard, 185
Western Electric, 8
Westmore, Michael G., 226
*What Ever Happened to Baby
 Jane?* 138, 146, 148
What's Up, Doc? 171, 179
When a Man Loves, 20
When Time Ran Out, 210
Where the North Begins, 12–13
Where the Wild Things Are, 275,
 298
Which Way to the Front, 176
Whitaker, Forest, 206, 229
White, R. Christopher, 315
White Heat, 69, 73, 102–103
White Hunter Black Heart, 237, 244

Whitemore, James, 107
Whitney, Susan, 116
Who's Afraid of Virginia Woolf,
 139, 158
Why Be Good? 28–29
Wickes, Mary, 80
Wiest, Dianne, 329
Wigan, Gareth, 202
Wild Boys of the Road, 43
Wild Bunch, The, 140, 166–167
Wild Wild West, 242
Wildcats, 205, 224
Wilder, Billy, 108, 203, 250
Wilder, Gene, 172
Wile E. Coyote, 69
William Horsely Studios, 5
Williams, Grant, 142–143
Williams, Richard, 342
Williams, Robin, 203, 214–215, 272,
 274, 280
Williams, Tennessee, 105, 108,
 113–114, 128, 138
Williams, Treat, 190, 203
Williams, Vanessa, 261
Williams, Venus and Serena, 337,
 342
Williamson, Mykelti, 224
Willis, Bruce, 246
*Willy Wonka and the Chocolate
 Factory*, 274
Wilson, Dooley, 82
Wilson, Hugh, 204, 219
Wilson, Patrick, 303, 324, 340–341
Wilson, Richard, 150
Wincer, Simon, 239, 252–253
Windust, Bretaigne, 99
Winfrey, Oprah, 205, 223
Winger, Debra, 238
Winkler, Henry, 203
Winkler, Irwin, 217, 245–247
Winter Meeting, 73
Winters, Shelley, 170
Wiseguy (Pileggi), 238
Witches, The, 244, 336, 338
Witches of Eastwick, The, 228
Wolfe, Tom, 172, 204
Wonder Bar, 46
Wonder Woman, 301, 304, 326
Wonder Woman 1984, 336, 338
Wong, BD, 322–323
Wonsal, Aaron (Albert; Abe), 2
Wonsal, Benjamin, 2
Wonsal, Cecillia, 2
Wonsal, Hirsz (Harry), 2
Wonsal, Reisel (Rose), 2
Wonsal, Schmul (Sam), 2
Wood, Natalie, 107, 124, 137–139,
 142–145, 152–153, 156–157
Wood, Sam, 83, 90, 122
Woodstock, 170, 176
Woodstock Music & Art Fair, 170
Woodward, Bob, 173
Woodward, Joanne, 139, 157, 164
Woolley, Monty, 80

World According to Garp, The, 203,
 214–215
Worthington, Sam, 306
Wrath of the Titans, 314
Wrong Man, The, 106, 126–127
Wu, Constance, 329
Wyler, William, 59, 76
Wyman, Jane, 71–73, 100–101, 106,
 110–111
Wymore, Patrice, 116

Y

Yakuza, The, 172
Yan, Cathy, 335, 338–339
Yankee Doodle Dandy, 69, 80, 83
Yates, David, 274–275, 294, 302,
 304, 312, 324–325, 330
Yates, Peter, 164
Yeager, Chuck, 204
Yniguez, Richard, 173–174, 198
Yogi Bear, 302
York, Alvin, 68
Yorkin, Bud, 155
Yosemite Sam, 69
Young, Loretta, 29, 41
Young, Sean, 202, 214
Young, Terence, 160
Young Man with a Horn, 105–106, 111
Young Philadelphians, The, 133, 135
You've Got Mail, 241, 266
Yuyama, Kunihiko, 242, 268–269,
 276

Z

Zane, Billy, 207
Zanuck, Darryl F., 7–8, 12–13, 31–32,
 34, 105, 107
Zaslav, David, 337
Zastupnevich, Paul, 197, 210
Zemeckis, Robert, 242, 264, 273,
 287, 336, 338
Zendaya, 342
Zieff, Howard, 199, 210
Zimmer, Hans, 298, 308, 321, 327,
 342
Zinnemann, Fred, 108–109, 135,
 138, 142
Zukor, Adolph, 8
Zwick, Edward, 284 292